ART,
IDEOLOGY,
AND POLITICS

Edited by
Judith H. Balfe
Margaret Jane Wyszomirski

PRAEGER SPECIAL STUDIES • PRAEGER SCIENTIFIC

New York • Philadelphia • Eastbourne, UK
Toronto • Hong Kong • Tokyo • Sydney

Library of Congress Cataloging in Publication Data
Main entry under title:

Art, ideology, and politics.

 Includes papers presented at the 10th Annual
Conference on Social Theory and the Arts, held at
Rutgers University in Oct. 1983.
 Bibliography: p.
 1. Arts and society—United States—Congresses.
I. Balfe, Judith H. II. Wyszomirski, Margaret Jane.
III. Conference on Social Theory and the Arts (10th :
1983 : Rutgers University)
NX180.S6A7 1985 700'.1'030973 84-26325
ISBN 0-03-000364-4 (alk. paper)

Published in 1985 by Praeger Publishers
CBS Educational and Professional Publishing, a Division of CBS Inc.
521 Fifth Avenue, New York, NY 10175 USA

© 1985 by Praeger Publishers

Printed in the United States of America on acid-free paper

INTERNATIONAL OFFICES

Orders from outside the United States should be sent to the appropriate address listed below. Orders
from areas not listed below should be placed through CBS International Publishing, 383 Madison Ave.,
New York, NY 10175 USA

Australia, New Zealand
Holt Saunders, Pty, Ltd., 9 Waltham St., Artarmon, N.S.W. 2064, Sydney, Australia

Canada
Holt, Rinehart & Winston of Canada, 55 Horner Ave., Toronto, Ontario, Canada M8Z 4X6

Europe, the Middle East, & Africa
Holt Saunders, Ltd., 1 St. Anne's Road, Eastbourne, East Sussex, England BN21 3UN

Japan
Holt Saunders, Ltd., Ichibancho Central Building, 22-1 Ichibancho, 3rd Floor, Chiyodaku, Tokyo, Japan

Hong Kong, Southeast Asia
Holt Saunders Asia, Ltd., 10 Fl, Intercontinental Plaza, 94 Granville Road, Tsim Sha Tsui East,
Kowloon, Hong Kong

**Manuscript submissions should be sent to the Editorial Director, Praeger Publishers, 521 Fifth
Avenue, New York, NY 10175 USA**

FOREWORD:
BEYOND THE PRODUCTION
OF CULTURE
Richard A. Peterson

The first conference on social theory and the arts, the brainchild of Derral Cheatwood and Robert Leighninger, was held at Oswego State University of New York in April 1974. Obviously a growing number of people believe that the nearly annual revivals of this group are a good idea, because there were more sessions at the 1983 Rutgers gathering, where the following articles were presented, than there were papers delivered at the Oswego meeting. But much more has changed besides the sheer growth in numbers over this scant decade, as the broad range and high quality of the articles that follow will attest.

The editors have done an excellent job of integrating and introducing the articles so I will take this opportunity to look back along the way we have come in order to suggest the way forward. Because I am a sociologist and know that literature best, the remarks that follow will focus on developments in sociology, although economists, anthropologists, art historians, artists, and especially political scientists have also been involved in the process in important ways.

Until 1970 there was no sociology of art; there were only a few disparate works. Some of these are excellent and stand today as models of scholarship and ingenuity. But each was created virtually without reference to the others, and stood in splendid isolation; each made a rival claim to found a field.

In 1970, The Sociology of Art and Literature, edited by Milton Albrecht, James Barnett, and Mason Griff, was published by Praeger. The numerous provocative pieces brought together there suggested the potential for a collective enterprise, but to cover the obvious topics the editors had to rely more on articles by historians, art critics, and anthropologists than on works by sociologists or political scientists.

The editors of this anthology faced quite a different if no less difficult task. For each article they chose, they had to exclude several others. What accounts for such a burst in productivity in just a decade? There is only enough space here to suggest a few salient factors.

First, sociologists generally give more credence to the symbolic realm than they did a decade or two ago. This is due as much to the atrophy of functionalist models powered by the engine of economic necessity, and to the shift in the weight of Marxist theorizing from materialist to cultural elements of the dialectic, as to any clear-cut victory of symbol-driven models of society.

Second, although art is an amorphous topic, it has been framed by several paradigms within which researchers can work. These include among others the art world perspective, the production of cultural perspective, the reading of society or ideology through texts, and the audience, or patterns of cultural choice perspective.

Finally, and most importantly, the work has gone forward so rapidly because of the cooperation of the people involved in this enterprise. Rather than treating other researchers as rivals, the architects of this endeavor have pooled their energy and ideas, tying their careers to the collective effort to secure the study of art as a vital domain within sociology and political science. People have generously criticized manuscripts, shared data, and provided contacts with the more or less explicit understanding that they are not in a contest with one another, because everyone in the field gains by the good work of all the others.

Now to suggest the way forward. I will make two assertions and ask a number of questions. First, having lauded and praised quantity, I must add that, perhaps because of the unsettled nature of this new field, some authors of the chapters that follow do not interpret their own data as fully as they could, in light of the relevant theoretical frameworks already developed in the recent literature. Indeed, it is ironic that over the years, these conferences entitled "Social Theory and the Arts" have not given enough attention to formulating, testing, and revising social theory. While mutual support has served us very well over the past decade, I believe it is time for all of us to be more demanding in our criticisms within our circle.

The second assertion is that the sociological or political study of art is now well enough established, such that more effort should be put into bringing its data and conclusions into the social science mainstream. I do not champion the sociology of art for its own sake, because unlike rural and medical sociology, the sociology of art has no large and wealthy federal patron to sustain it in

splendid isolation over the decades. To survive and pros-
per it must merge with the core concerns of the discipline.

Many subfields in sociology and social science gener-
ally seem to be open for new ideas at this time, so that
fresh ideas may find quick acceptance. By way of example,
let me point to two areas that interest me: organization and
stratification. In an age of information it seems quite ap-
propriate to use the culture industry (rather than the steel
industry or the postal service) as the paradigmatic form of
organization. Likewise, the old economically driven theories
of stratification have lost much of their predictive power
over the past 40 years, while questions of status and life
style have come to the fore. Arts participation is an in-
creasingly large component in life style, and there is no
reason why researchers involved in sociological or policy
studies of art cannot make a great contribution to the re-
vitalization of stratification theory.

Now for some open questions. First, what is the
consequence of using the word art rather than culture? Art
has a more definite referent, but is it ultimately too re-
strictive for the field to grow and influence general social
science? And what of popular culture? For the researcher,
is art essentially different from popular culture, or is the
difference that art is the distinctive popular culture of
powerful people and their courtiers?

Second, on art and evaluation: Is a social science
aesthetic possible, desirable, or appropriate? As for textual
analysis, is it possible to read art in order to see society?
Or does one read art to see the ideology created by or for
artists, critics, consumers, or the researcher?

Third, are the "art world" and "production of cul-
ture" perspectives merely different levels of analysis, are
they compatible, or are they based in different views of the
nature of society and do they lead to distinctively different
questions?

Fourth, what will come of the increasing melding of
political science and public administration with sociological
concerns, both for those fields and for society and the arts
themselves? As evidenced in the pages that follow, there
will be a sharpening of focus within arts administration,
arts policy, and the study of the ideologies of the arts.

Finally--but there is no "finally" in a foreword.
Carry on.

PREFACE

In their ideal forms, the social sciences and the arts are usually understood to involve antithetical perspectives on the human condition. The former depend on objectivity and value-free inquiry for their methodologies and social legitimation, while the latter are inherently subjective and value-laden. Social science is concerned with facts and knowledge; the arts are concerned with meaning and interpretation. On one hand, advocates of pure art or pure science have claimed that neither is (nor should be) affected by, or infected with, power and politics--although both art and social science have been used by those with specific political agendas.

On the other hand, revisionists assert the reverse: that the arts and social sciences are so inherently ideological that they often use political methods and institutions for their own "aesthetic" or "scientific" purposes. Such an egg theory of chickens has its salutory effects in correcting the biases of the purists. At the very least, it has forced recognition that there can never be a pure "art for art's sake," nor a comparably pure science; costs in time, if not also in money, are always involved and, of course, artists, scientists, patrons, and audiences are as "impure" and as socio-historically situated as other human beings.

This has long been understood by European artists and social scientists, steeped in the Marxist perspective as advocates or as antagonists. They have always recognized ideological elements (both aesthetic and political) in the arts, even if they have disagreed over the interpretation of this fact. American artists and social scientists, on the contrary, have been primarily atheoretical and empirical in their focus; hence the issues we are raising here are fairly new in this context. Without claiming to be "holier than thou" as social scientists, we are here looking at the arts rather than at our own disciplines, in as objective a manner as possible, to explore their ideological components.

Speaking from within the American tradition, it is obvious that the arts are ideological. Participants in various art worlds not only apply various aesthetic judgments

toward artworks (e.g., "X is beautiful"), but invariably there is some assessment of the active purpose of X as part of its artistic meaning (e.g., "I want X to inspire me--or entertain me"). When any consistent attitude toward the purposes of the arts is linked with particular preferred styles, an aesthetic ideology is developed. Indeed, every aesthetic has purposive elements, even the most morally neutral or "pure." For example, I may believe that the arts release people from other social definitions and roles, by enhancing their unique individuality. But such consummatory release may be considered socially problematic, potentially destructive, and therefore, something to be carefully and politically controlled. Alternately, I may believe that the purpose of the arts is to commit the audience more deeply to society, or to some particular sector of it. This is more obviously an ideological position, but it has comparable implications for issues of social controls over artistic style and content. And both outlooks have effects on the creation of works of high aesthetic quality, in whatever style or medium.

There are other reasons why attitudes toward the arts and the values they express are linked to attitudes about the relationships of individuals to society, and hence to the state. In contemporary America, the arts have an elevated status among the various forms of culture, and are considered "merit goods" valuable for their own sakes. As a result, artists and non-artists alike have used the creation, appreciation, and possession of the arts to advance or maintain their own social status. Such purposes in turn intersect with political ideologies regarding the present or desired structure of society, and the degree to which existing social hierarchies of class and power should be enhanced or diminished via the arts.

These issues are present everywhere and always, to some degree, but in recent years, as arts patronage by government agencies has increased in the United States, the eternal argument between purists and revisionists has increased in intensity. Should art sponsors (either individuals or the state) lean toward the purist pole, insisting that the arts should be patronized apolitically as merit goods only? Or should sponsors follow the revisionists, and recognize that government sponsorship--like individual or corporate sponsorship--will always carry strings of political or stylistic acceptability? And what are the consequences for the arts, and for society, of either choice?

It is time to cast the comparatively cool light of social science on this debate. Sociology and political science (the disciplines best represented in this volume, although psychology, history, and economics are also involved) have much to say in clarifying the social meanings and uses of the arts, at both individual and societal levels, and thus may help us to understand the nature of the controversy.

The perspective here is neither an application of one or another European theory of interpretation of the art-society linkage, nor is it purist or revisionist in the American sense. Unlike the European theorists, we are putting a major emphasis on empirical art worlds and public policies rather than using either to validate or advocate one or another mode of interpretation. Unlike the American revisionists, we accept some crucial distinctions between aesthetic and political ideologies. If the arts were purely political, they would become mere propaganda, they would be recognized as such, and they would soon be politically ineffective. Finally, while agreeing with the American purists that any genuinely aesthetic response is inherently a "release" from other concerns of life, we also recognize that such release carries social and political consequences. Indeed, both the release and the consequences are crucial to the functioning of the arts in society. In sum, while the arts must have more than political purposes in order to work politically, they must have more than aesthetic purposes to work aesthetically.

We are presenting this collection of empirical studies to illuminate this apparent paradox, and to demonstrate various relations of art world issues with the social and political concerns of the wider society. Following a general consideration of sociological theorizing on the arts, the American political tradition regarding their support, and the contemporary social context of their use (Part I), we include several descriptive analyses of art worlds to show the interactions of their participants (Part II), leading to consideration of aesthetic ideological components (Part III), in turn raising issues of political ideologies as components of public policies regarding the arts (Part IV).

Each essay is informed by disciplined social science inquiry as well as an awareness of the aesthetic values of the artistic subject under discussion; as social scientists, these authors are also aesthetically <u>engagé</u>. In

order for the artistry (as well as the science) of each es-
sayist to show, we have done minimal editing of these
papers, most of which were presented at the Tenth Annual
Conference on Social Theory and the Arts, held at Rutgers
University in October 1983. As delivered (along with
others we could not include here), they build on each
other in quite unanticipated ways, to demonstrate the link
between art, society, and politics. As a volume, we hope
this selection of conference proceedings has recaptured and
refined its original cumulative effect.

CONTENTS

INTRODUCTION

By way of general introduction, it is useful to review the findings of recent work in the field, which theoretically, substantively, and methodologically underlie many of the essays that follow. One primary focus of social science inquiry is the elective affinity of styles and social strata. Such affinities are not surprising. If art is an expression of the artist's experience, it is likely to be understood best by those who share enough of that experience, that particular social world, to identify with what is expressed in the art, and to understand the code of its expression. Such understanding can be extended over generations, through socialization into traditions of artistic creation or appreciation, and its results in the diversity of contemporary subcultures, and widely varying art worlds.

To put this more explicitly in a sociological perspective, within any subculture, the artist and responsive audience share certain conventions of interpretation, certain social and political experiences, and certain "intersubjective" social-psychological predispositions and needs which are expressed in, attracted to, and fulfilled by particular artworks. Granted that there is a wide range of individual variation among artists and audience members, there still must be cooperative interaction between artists, patrons, distributors, critics, and the general audience for the art to be produced and consumed at all. Although these roles may overlap, they are distinct and potentially competitive (as well as necessarily cooperative)

because they are likely to be unequal in power and status. Such inequalities may be due to individual traits, but they often correlate with the stratification system of the surrounding social structure. For example, women artists, or art media associated with women (such as needlework) have tended to have lower art world status because women have had lower status than men throughout society. Until recently, the same has been true of various minority artists, media, and styles.

Compounding such distinctions are those determined by an art's stylistic accessibility, that is, the degree to which considerable training and socialization are necessary to understand its symbolism and aesthetic power. The more "sophisticated" the conventions and codes of the art form, or the more restricted for other reasons, the more difficult is general public access to that art. Such limited access has been used by various subcultures, in all social strata, to enhance cohesion among those privy to the artistic code, and to exclude others. High culture styles such as minimalism in both visual art and music speak to, and for, particularly intellectual audiences, and exclude more traditional elites as well as non-elites of lower educational and class levels. Meanwhile, styles such as reggae or punk rock speak to, and for, "lower" or younger subcultures. When any such style is "popularized," or "watered down" (or, perhaps, "watered up") to appeal to a wider, more heterogeneous audience, it may become "slick" and lose some of its aesthetic power and authenticity. As a result, it often ceases to serve some of the specific psychological and social needs of its originally limited and homogeneous art world. In other words, the more constrained and specialized the experience of any subculture, the more particularized and, inevitably, the more stylistically restricted in its art (as evidenced in various folk arts, including music and dance). Such restriction does not necessarily inhibit its aesthetic quality; if gifted artists are found within the group and denied mobility into other broader strata, then the more intense and powerful their artworks may be, as their limited formal vocabulary is pushed to the fullest extent.

Such intensity and power is increasingly recognized across styles and subcultures, first by artists, then by audiences. It is not just through direct access to institutions of higher education and "high" arts that audience awareness and sophistication grow across class lines. All

subcultures are exposed to and by the mass media, which have increasingly carried artworks of virtually every style to mass and elite audiences alike. Cultural pages of the newspapers cover performances of rock bands and dance performances by whirling dervishes along with reviews of string quartets and classical ballet companies; more important, all can be seen on television. Thus even if subcultural audiences do not choose to patronize every style, they are almost inevitably exposed to the range of what is present, and thus can develop a sense of the comparative quality of all available styles, including those of the past.

For many artists, subcultural cross-fertilization is a stimulus to enhanced creativity, and, not incidentally, to individual social mobility as the creators/carriers of innovative work. But acceptance of the new or strange does not always occur among audiences. For many, alternative styles expressing alternative social realities are threatening at best, and oppressive or even tyrannical, at worst. "Wars of taste" are usually masks for wars of class, status, or generation. Styles are readily identified by proponents and antagonists alike as symbols of status or taste differences. Having been so categorized, they can be patronized or anathematized according to real aesthetic preference or simply out of a desire to belong to a group that holds certain views.

Such symbolic uses of the arts can affect their content. Political rivalries engendered by the reward system of the wider social structure may be consciously given artistic expression in works speaking for the "class interest" of a group. But this situation is further compounded by the fact that artworks are not created by groups, but rather by individual artists (although they collaborate at times). Obviously, gifted individuals emerge from many social locations, and in the comparatively open social structure of contemporary America, they do not necessarily remain in their class of origin. As creative, talented, and mobile individuals, some artists may carry their "native" subcultural styles with them as they move upward, enhancing the sophistication, depth, and hence the appeal of those styles to more elite groups. Other artists leave their "native" styles and roots behind, choosing rather to master (and perhaps in time to modify) existing elite styles and media. Indeed, those who create or perform "elite" works almost always come from strata below those who

traditionally patronize such styles. The arts have always
been a means of upward mobility for gifted artists, be-
cause their gifts are rare and therefore prized.

The arts provide avenues of access to higher status
for non-artists, especially members of the original subcul-
tural audience who acquire expertise in their interpreta-
tion and use this as entry into new elite patron groups.
Even more broadly, groups that are seen as creators or
carriers of an "upwardly mobile" art form can be elevated
along with it. For example, white elite acceptance of jazz
and tap dancing contributed to a growing social acceptance
of racial integration. On the one hand, nouveaux artists
and their subcultural fellow travelers are often welcomed
by existing elites (even if somewhat warily) as sources of
enhanced stimulation and innovation. On the other hand,
such elites want to maintain their own superior position
through patronage of new and good art. An "elective af-
finity" between good art and high social status has long
been recognized (or assumed), and elites work to preserve
this belief. It supports their claims that high culture is
deeper, richer, and more universal and significant than
popular culture, since the artists who create it presumably
speak across class and subcultural lines (being originally
non-elite themselves), as those who produce popular culture
may not. The fact that the arts and social structure are
not consistently related contributes to the power of art,
and aesthetic response, to transcend the constraints imposed
by society. By allowing individuals to move upward, in
reality, or to float in fantasy, the arts respectively change
and help to maintain the social structure that they express.
And elites must (at least try to) retain control over this
process.

There are other reasons why patronage of the arts
has so often been dominated by elites. For one thing, be-
cause the arts are non-utilitarian, they may in many situ-
ations be "too good" for average people, who must focus
all their time and energy on their functional requirements
for survival. (Elites have sometimes suppressed the arts
precisely because of their non-utilitarian qualities, as
among New England Puritans.) Generally, elite patronage
occurs because most arts are expensive to produce. Those
with excess capital, in time as well as in money, can in-
vest in artistic production, whereas those lacking in such
capital cannot. Hence the link between "cultural capital"
and economic class. But as suggested above, this linkage

is not altogether predictable for two main reasons. First, non-elite artists determine the quality and quantity of the artistic merit goods available, and however patronized, such artistic "suppliers" can never be totally controlled. Second, in contemporary America, many members of the educated audience (or those who are simply aesthetically sensitive) have more taste than money or status. Despite their lack of economic status, their political and social allegiance is desired by the elites whose position is the more secure if it is seen as legitimate.

All this is widely recognized at all levels of society; accordingly, new pressures have emerged to expand both the audience and, in turn, political patronage of the arts. Concurrently, there is increasing pressure to expand the definition of what is to be included as art, and thus which art forms are to be considered worthy of public attention and financial support. Some of these pressures have come from below, from groups, subcultures, and classes that were previously denied full participation in the benefits of the wider society, including access to its high culture or, alternatively, support for their own arts.

Congruent pressures have come from elites as well. For one thing, through expansion of higher education, elite patron groups themselves have broadened to include many individuals from previously subordinated strata who are now assimilated into the professional upper middle classes. Without inherited wealth, they are unable to sponsor high cultural institutions to the degree that had been taken for granted in earlier generations, when the high arts audience was composed primarily of the rich. Since these new elites cannot afford as much expensive high culture as they want, they want some of the financial costs of the established arts institutions to be shared by the state.

Many in this new arts patron class are also political liberals, and they believe that since the arts are indeed meritorious (to say nothing about their creation by upwardly mobile non-elites), they should be made even more widely available to the rest of the non-elite public, which could learn to appreciate them if given the opportunity. In addition, managerial elites have seen the economic advantages of sponsoring the arts. Not only are tourist dollars attracted by artistic events, providing jobs for many subsidiary industries, but the "meritorious" aura of the arts rubs off on corporate patrons as much as on

individual ones. Thus through corporate sponsorship,
touring companies and exhibitions (as well as shows car-
ried by mass media) have contributed even further to the
expansion of the arts audience across regional and class
boundaries. Given elites with varied motivations for sup-
porting public funding of both traditional high culture arts
and folk/ethnic subcultural art forms, the pressures on the
state to provide financing are large indeed.

There are some who are unconvinced that any form
of art patronage is a proper role for the state at all,
either because they fear that it might lead to censorship
of the arts, or because they simply think that the arts
are no more the state's business than are private family
matters. But however articulate in their advocacy of lim-
ited (if any) governmental funding for the arts (and,
grudgingly, if it is necessary then it should go to estab-
lished high art institutions only), such conservatives are
increasingly ignored, even by those who share their politi-
cal convictions. Pressures for greater arts funding and
state involvement coming from more liberal elites, as noted
above, today coincide with the evident need for government
institutions to legitimate themselves in a time of political
disaffection among conservatives, liberals, and the utterly
apolitical alike. Governments at all levels recognize the
political importance of "quality of life" issues, especially
for their "middle" constituencies; they wish to speak from
the perspective of Athens rather than of Sparta, even as
they maintain military postures worthy of the latter. Thus
various state arts agencies have been established out of a
recognition that the arts do contribute to the welfare and
social solidarity of diverse constituents, as well as the
enhancement of the legitimacy of the sponsoring state patron.
Such enhanced legitimacy is desired on the international as
well as on the domestic scene, and governments have long
recognized that the arts are useful in cultural diplomacy,
to be sent touring abroad as evidence of societal excellence,
creativity, and good will. For its own political reasons,
then, despite conservative doubts about the state's involve-
ment in art patronage, the state is increasingly willing to
support the arts with public monies. So too do corpora-
tions support them for their own economic reasons--again,
often with indirect public subsidy through the tax write-
offs they are able to claim.

Such institutional linkages and mixed interests among
participants have always existed in the arts to some degree,

and they are not to be deplored just because they have been expanding recently in the United States. But the resultant changes in scale and institutional organization must be recognized in all art forms. The consequences for both the arts and the state of such expansion are complex, and not altogether intended by either. Even if public or corporate patrons are not intentionally manipulative, their support contributes to a redistribution of funding sources as well as to the availability of the arts. These in turn create pressures for a redefinition of the artworks and the cultural codes they embody, as we have discussed above. Such codes are now presented to audiences without prior knowledge of them (and hence with less understanding) at a time when audience response is becoming ever more important to legitimate the original public sponsorship. In turn, pressures to appeal to and to satisfy this wider audience affect the arts institutions, both justifying and maintaining their enlargement and the increased staffs of arts managers and bureaucrats.

All of this has consequences for the artists and the art that they produce. At the very least, artists who are working full time to meet the needs of official sponsors trying to reach wide audiences have less time to develop aesthetic innovations that might be less popular, or less politically acceptable. In addition, some of their remaining creative time and energy must be allocated to raising support funds and "working the system," which has become ever more complex and bureaucratized. To be sure, aristocratic patrons of the past may have permitted little innovation, but at least for the arts, the interchange was individualized, and not determined by legislative oversight or bureaucratic regulations and timetables. The arts are inherently more sympathetic to such personalization, and almost always resistant to regulation. Given the latter, they risk going stale and may cease to perform the functions that justify society's support in the first place.

For government patrons, there are unwelcome consequences, too. With finite resources to contribute to the arts, the state cannot respond to all funding requests; and in any case, patronage of arts programs designed to appeal to certain constituencies will often offend others. Charges of elitism and populism continue to be made, in support or as criticism, according to the general mandate and political philosophy of the party in (and out) of office. Not surprisingly, the distribution of arts funding

tends to shift from one perspective to the other. The populist version insists on cultural pluralism, with monies provided for expansion, and folk art programs designed to support the art of all cultural strata, including ethnic and racial minorities and the poor (for example, in Appalachia, on Indian reservations, and in urban ghettoes). Accordingly, not only is there sponsorship of forms that have not yet been universally recognized as fine art or high culture, but there is funding as well of young arts institutions of less than proven quality, to help them get established.

The elitist version insists rather on limiting funding precisely to the recognized fine arts, and within them, to institutions with long records of high aesthetic quality. This should not be interpreted as an undemocratic effort to restrict the arts to elites; rather, it is a different way of approaching the democratization of the arts, and their use as social "glue." Since the thrust is to make high culture more widely available to audiences who had previously been denied access for geographic and economic reasons, great artworks and performers are put on tour or on television so that they can reach these previously untouched audiences, and endow them with previously elite cultural capital.

Obviously, at base are two quite different aesthetic and political philosophies. The first says that whatever people define as art should be accorded respect and public support, as it serves their aesthetic needs at whatever level of sophistication. Baldly stated, this means that the state should help people to have more of the arts that they already want, as not only are all men and women created equal, but so too are their preferred art forms. The second view says that there are indeed differences in the aesthetic (and social) significance of various forms according to some universal standard, and that everyone should be able to have access to the best; no one should be denied this, even inadvertently, as a result of government policies. Comparably stated, this view holds that the state ought to help people to want more of the arts that they should have. The arts are not created equal, but exposure to the best of them will help to equalize men and women in society. Thus aesthetic and political programs mix, in ways that predate even the contrasting perspectives of Jefferson and Jackson. This conflict is certainly alive and well centuries later; indeed, it underlies the

distinctions between purists and revisionists that we noted
at the outset.

A few more comments must be made. Obviously,
political attitudes permeate even nonpartisan government
decisions about which arts and arts institutions should
receive public funding, and under which programs. Per-
haps less obviously, artists and art audiences have their
own attitudes toward the state. Is government support to
be welcomed, as providing material and ideological legiti-
mation for the spiritual and aesthetic welfare of all mem-
bers of society? Or, rather, is such support to be feared
and resisted, as coming from a tainted source which will
inevitably corrupt and even destroy individual creativity?
Should artists embrace society and the state, or should
they flee that embrace?

Such questions are further compounded by the con-
flicting interests of people in the arts. For example, lim-
its put on the creative expression of a choreographer, in
order for an NEA grant application to be approved (e.g.,
no nudity or real sexual activity in the dance), might ex-
pand the opportunity for dancers to perform. More broadly,
censoring the output of one artist or arts institution might
help to protect the entire grants program from scrutiny by
grandstanding political watchdogs, and thus help to main-
tain support for the arts on a wide scale.

Such questions, in one form or another, have been
inherent in the creation and consumption of the arts
throughout history. But once the modern state is involved
in patronage of arts creation (and not merely in regula-
tion of what cannot be performed), the further question
arises, and becomes politicized: Who decides? And on
the basis of what criteria? The ramifications for politics
and for the arts are profound, and one way or the other,
they touch all of the rest of society, including the vast
majority who have no interest in the arts at all. With
these issues on the table, then, it is time to look more
explicitly at various empirical contexts of their unfolding.

I

CONCEPTIONS OF CULTURE AND SOCIAL STRUCTURE

In the opening essay, McWilliams offers a panoramic view of the relation of political thought and the arts in the United States from colonial times to the present. Presuming that society both determines and reflects its politics and, conversely, that a government both shapes and embodies its society, the author demonstrates "the inescapable politicality of the arts."

McWilliams explicates three historical views of the proper relation of art and politics in America. From the Puritan perspective that sought to effect a triumph over sin and the achievement of spiritual virtue, art could be a means of promoting harmony and community. In contrast, the liberal tradition of the Founding Fathers involved a war against nature in which humanity sought to shape and remake its world. Within this perspective, the "useful" arts were publicly valuable, while the fine and refined arts were regarded as a matter of private inclination and, hence (like religion) something to be left unfettered by public judgment. Finally, with the advent of Jacksonian democracy came a pursuit of civic order that required both "attention to the tastes and feelings of ordinary citizens" and the fostering of an educated citizenry. In these terms, the arts became a means of educating the public in civic virtue as well as of counteracting the growing fragmentation and isolation of a modernizing society.

In the course of his discussion, McWilliams touches on many of the perennial dimensions of the art and politics debate, such as the importance and variation of attitudes (both political and aesthetic) toward different art forms, the priority (or trivialization) of the arts in society, and the potential tensions between artistic needs and public ends. Finally, in suggesting certain similari-

11

ties between art and democratic politics (their common reli-
ance on forms and techniques to achieve greater goals;
their requisite demand for dedication, discipline, and effort;
and their shared concern for the promotion and integration
of both the individual and the community) McWilliams dem-
onstrates that the relationship and interdependence of art
and politics can result in positive influences on both art
and politics.

Gans follows with a reconsideration and reformula-
tion of the "taste cultures" which he originally presented
in his classic work <u>Popular Culture and High Culture</u>. In
the decade that has followed since that work was published,
he has seen somewhat porous cultural barriers between
groups become even more open, primarily among the middle
classes. He sees a greater egalitarian eclecticism in a
widely accepted "middle culture," which he here describes
in some detail. In contrast to the education and income
determinants of earlier taste cultures, this expanding middle
culture is found primarily among a single age cohort com-
posed of a large proportion of college-educated young pro-
fessionals, with few ties or obligations to the culture of
their parents (whether higher or lower). Given those edu-
cational and income factors, culture and class remain corre-
lated as they had in the past.

This being so, it is not surprising that in a hetero--
geneous society confronting hard choices about which goods,
services, and programs to support during a period of eco-
nomic scarcity, culture choices have become highly politi-
cized and tinged with ideology, even among those unaware
of the varying political traditions regarding the arts which
McWilliams has discussed. As Gans sees it, even though
the analysis of culture provided by social scientists and
culture critics has increased in influence and extent in the
last ten years, those on both the left and right who defend
high culture do so from different perspectives, and attribute
its ills to different causes. Yet they, too, are speaking
from within the confines of particular taste (and, hence,
class-related) cultures.

Together, these two papers establish the themes and
provide the ground for the other papers that follow. Atti-
tudes and values expressed through and toward the arts (as
explicated by McWilliams) are related to changes and con-
tinuities in the social structure (as described by Gans).
This is not to assert that one determines the other; neither
McWilliams nor Gans would accept such a simplistic view.

Rather, both recognize the complexity of the empirical grounding of the broad trends that they have analyzed here--a grounding that the subsequent papers will establish in considerably greater detail.

1

THE ARTS
AND THE AMERICAN
POLITICAL TRADITION

Wilson Carey McWilliams

John F. Kennedy once implied that Americans fear the public quest for "grace and beauty"; they have reason to. Politics has a quarrel with the arts, a rivalry so ancient as to prove their fraternity, and such contentions can turn murderous. Yet Kennedy's remarks themselves indicate that there is more than fear in U.S. political culture, and that many Americans hope for a politics ennobled by the arts.[1]

I will be discussing three views of the proper relation between art and politics in the United States: Puritanism, Enlightenment liberalism, and ideas of civic education rooted in the Jacksonian era. The terms are drawn from the American past, but the positions I will be describing are historical only in a very loose sense. They are voices in the continuing American debate about the place of the arts in political life. I want to rehearse that grand argument because it has lessons for our times, not the least of which is the inescapable politicality of the arts.

Any definition of art assigns to the arts a role in human life and, at least implicitly, frames a public policy. If art is exalted, political society cannot treat it with indifference; art can be left to its own devices only to the extent that it is trivial or safely subordinate, and is no threat to the order of political life. Just as war cannot be left to generals, there is a point at which art is too important simply to be entrusted to its practitioners. Plato's Republic pays poets a high compliment by arguing

15

that they must be censored. It is possible to argue that the claims of art are superior to those of political society, but that defines art as a ruling principle. If we are not to be ruled by art, we must subject it to some higher public or human good.[2]

In praise of artistic liberty, it is often said that the arts, by challenging conventional ideas and established perspectives, help to set us free.[3] Yet that argument is at odds with the notion that artists must be free to "express themselves," since it makes our liberty the end to which artistic expression is no more than a means. If we champion that art which enlightens, we must condemn that art which obscures. The aim of educating or freeing the public may require an artist to take liberties, but only those that are calculated to instruct or liberate.[4] Democracy needs the arts and defends their liberty, but only when they observe that crucial principle of restraint.

The politicality of the arts was obvious to Puritan thinkers, as it was, in a somewhat less articulate way, to almost all Calvinists in early America. In their teaching, aesthetics is at the heart of the human problem.[5] Human beings are part of the order of creation, and can be understood only in relation to the whole in which they participate.[6] This principle pervades nature, and it evidently holds true in political life. Political society combines many arts and talents; the existence of the whole permits us to specialize, allowing each to do what he or she does best and affording an individual freedom not possible in a clan or simple society. This individual liberty, however, is possible only within political society; the existence of the whole is the condition of the freedom of the part, and it can be said, following Aristotle, that the polis is prior to the individual in the order of nature.[7] In fact, John Winthrop argued, one of God's reasons for giving us different talents was "that every man might have need of other, and from hence that they might be all knitt more nearly together . . ."; political society is not merely the condition of individual freedom, but the purpose of human diversity.[8] We are made different so that we will be miserable alone. Private interest, Gilbert Tennent declared, is "no farther excellent than it is consistent with the Good of the Publick, which we were born to promote."[9] Misconceiving the right relation between the part and the

whole, all private spirit is disproportionate, and hence ugly. All civic virtue has at least some element of beauty.[10]

Nevertheless, sin always taints public spirit and obscures its beauty. Fated by the Fall, human beings reject their own partiality, willing themselves to be the center of creation and resenting their own finite mortality. They see the beauty of the part; they are blind to the greater loveliness of the whole. Even those who discover the order of nature fail to discern its "beauty and rightness."[11] Similarly, human beings neglect love, "the bond and cement of society" and are tempted "against the Law of Nature, to seek a single and independent State in order to secure their Ease and Safety," pursuing individual freedom to the detriment of the public good.[12]

The good city requires the arts, since human beings are meant to "live Bright and Civil, with fine Accomplishments."[13] At the same time, it is necessary to guard against the human tendency to overvalue the contribution and importance of one's own arts and interests, tilting the scale of justice with the weight of self-interest. All human beings share that failing, but it is especially dangerous in those who possess "special gifts," the rare skills that are only quantitatively different from humbler talents. In the Calvinist view, all the arts are one because they are governed by a common purpose—"the author of being is the author of all the arts."[14] Art includes any techne, any way of doing or acting, and arts are worthy of cultivation (and hence, of public support) to the extent that they are "callings," ruled by a purpose above craft and private interest.[15] Techne requires technologia, the ordering of the arts by a master art. Action should lead or point toward the excellence of the soul; private callings should tend toward civic virtue.[16] The arts of government, spiritual and secular—most visibly practiced by minister and magistrate—rightfully order all lesser arts for the greater good and the higher glory.[17]

The governance of the arts, in turn, should be premised on a distrust of the eye and of the aesthetics of vision.[18] The eye sees things in their separateness, as parts; the whole is a construct of the spirit, discerned in the mind's eye. Virtue, Milton wrote, is "contrary to the eye of the world," caught up as that eye is in outward appearances.[19] Moreover, the visual arts have too much power to distract the soul from inward things. On their

own terms, material goods are merely useful, unable to captivate the soul; the bodily needs and desires of human beings, left to themselves, are naturally limited. By contrast, beauty--in form, appearance, or motion--<u>does</u> appeal to the soul. The visual arts enhance the material world, making it easy to forget that the "sweetest beauty" is "but a ray from God's infinite fulness of glory."[20]

The visual arts, consequently, tempt the soul to seek fulfillment in a material world that cannot accommodate the soul's demands. The beauty of earthly things is imperfect and impermanent; in the moment of possessing such goods, we fear their loss and sense their passing. The soul devoted to the beauties of this world must be either <u>inconstant</u>, pursuing the illusion of perfect beauty, or <u>imperial</u>, attempting to dominate nature so as to erase its faults and master its changes. In both cases, this-worldly aesthetics leads to despising the world as it is, rejecting and raging at the good, though limited, things that this life affords.[21]

Beyond the eye's sight, Calvinist teaching appealed to the enduring beauty of the Word. Even less sacred words, moreover, can speak of unseen things through metaphor, leading the soul away from the visible world and toward its proper objects.[22] "The interest of Religion and good Literature," Increase Mather declared, "hath risen and fallen together."[23]

The written word, however, speaks to us silently, and Calvinism's reliance on words involved an aesthetics of hearing or discourse.[24] As dialogue, words acquire a special power. Left alone, each party to a dialogue will be governed, in all likelihood, by his or her passions. In speech, however, the listener implicitly rules the speaker, and language--a sort of common or public law--rules both. Speech imposes on the will and the passions the necessity of ordered discourse, affording reason a kind of ascendancy.

Hearing also makes an appeal to the senses that reading cannot. At least in the early stages of education, the spoken word is needed to "allure the soul," and eloquence is "a fit bait to catch the will and affections," at least until the soul learns to hear inwardly the euphony of what is written.[25]

Rhetoric, a master art, must be governed by its public purpose. Speech is meant to teach: a magistrate should lead private persons toward civic virtue; a minister should point his face-to-face congregation toward the church's invisible communion of spirit.[26] The needs of

the hearer, consequently, shape the art of the speaker. Calvinists prescribed a "plain style," comprehensible to the congregation and designed to instruct rather than impress.[27] Similarly, they worried that the beauty of a preacher's voice or person might make his speaking into a barrier instead of a bridge.[28] The Puritans valued logic because of its impersonality, its ability to discipline reason without oratorical grace and to persuade without the mediation of experience and erudition. By its power to restrain speakers and compel listeners, logic--"the most general of the arts"--is suited to regulate rhetoric.[29]

Puritan theory, however, also had a place for poetry, provided it was judged to be sufficiently edifying.[30] Edwards and his allies appealed to that doctrine in justifying their new rhetoric, with its "lively pictures" in speech and its greater appeal to the emotions.[31] Certainly, the Great Awakening did move away from the disciplined argumentation of Puritan rhetoric, and Old Light Puritans agreed with rationalists like Charles Chauncy in regarding preachers like George Whitefield as dangerously inflammatory. By contemporary standards, however, the preaching of the Awakening seems sober and intellective, and still very much guided by the aesthetics of discourse.[32]

Music inspired mixed feelings. At its best, music is ordered sound and has a rational beauty that uplifts the soul.[33] On the other hand, Calvin warned that admiration for the sound of music--the simple pleasures of the ear--can easily preempt the attention due to words, and Presbyterians and Baptists in colonial America suspected church music when they did not regard it as unlawful.[34] Even though the Puritans were relatively tolerant of secular music, when they admitted singing into their services, they were inclined to adopt a certain nasality as a protection against the beauties of tone.[35] Puritans were persuaded to include music because of its power to harmonize a congregation; they valued it, not as an individual skill, but as an art capable of supporting community. Similarly, when the Mathers argued on behalf of a more musical psalmody, they did so on the basis of its superior ability to produce harmony.[36]

Some visual arts did receive a measure of public encouragement. Sculpture ordinarily came too close to idolatry, but gravestones--especially if they featured texts calculated to inspire reflection on our mortal condition-- had a place in the Calvinist scheme of things.[37] More significant support was available for architecture.

Puritans judged music and architecture by the same standard, in terms of their contribution to agreement and community.[38] In the early days, of course, necessity left little room for refinement, but even so, Puritans planned towns to provide for the common life.[39] Meetinghouses followed Calvinist doctrine, avoiding ornaments that might distract the eye. Later, when Wren's example began to shape church design, architects developed the Word-centered church, contrived to draw all attention to the lectern and the Scripture. Architecture, in any case, was a more-than-visual art; it rested on foundations, that great Protestant word, and hence it pointed to fundamental principles as opposed to surface ornament. "The substance and solidity of the frame is that which pleases the builder," Hooker wrote, "its painters work to provide varnish."[40]

Against theater, by contrast, Calvinists marshaled the arguments of ancient philosophy. Drama counterfeits mere appearance and is no more than a shadow of shadows, "dangerous to the souls of men."[41] The force of drama derives from action, scene, and costume; as an art, it appeals to spectators rather than listeners, and it cannot be justified even by noble words. (It was often possible, however, to circumvent anti-theater laws by presenting performances as "moral dialogues" or dramatic readings, presuming a suitable text.) In some respects, however, the content of theater was as objectionable as its form. Tragedy might remind an audience that the great are not exempt from the common fate. By contrast, comedy (or so Andrew Croswell argued) is based on ridicule rather than fear and pity; it reinforces the secret sense of superiority and immunity, the worst illusions of sinful humanity.[42]

Since dance lacked words altogether, it ranked as a simple spectacle, grouped with masques and lotteries, distracting if not tinged with paganism.[43] Dance was a popular art, too widespread to be prohibited even if Calvinists had been so inclined, but it was the object of suspicion and any public support was inconceivable.[44]

Puritans found some use for painting, provided it was confined to simple and ruthlessly realistic portraiture, depicting its subjects warts and all, but Quakers shrank even from that measure of toleration.[45] At best, painting was acceptable in private life as an aid to pious memory. Even so, it was a concession to human weakness; the best pictures are in the mind, not on canvas, for they capture the human truth rather than its outward semblance.[46]

Richard Baxter's verdict on painting captures the Puritan critique of the visual arts:

> Like handsome pictures, something wants within:
> A painted feast, carved with a painted knife.
> A living soul can feel it wanteth life.[47]

The eye settles for too little. Our deeper sensibilities bid us to seek more, and public policy should ally itself with that nobler striving.

 The founders of the American republic, however, generally adhered to contrary principles derived from Locke and the liberal tradition. Beginning with the proposition that human beings are by nature free, they reasoned that political society is a contrivance intended to serve the private purposes of individuals. The public order, in this view, is more or less narrowly defined, concerned with actions and having no warrant to meddle with the soul.
 The chief goal of political society is greater success in the struggle to master nature, advancing human liberty by increasing human power within a framework of law. In the doctrine of the liberal Enlightenment, the arts merit public support when they are "useful," adding to the ability of human beings to shape and remake their world.[48] In the new aesthetic, the mechanical and industrial arts have a place of honor, especially if they inform and apply science.[49] In that spirit, Cooper's early Notions of the Americans, celebrating the Framers' science of politics, found time to praise the United States for its "beautiful, graceful and convenient" ploughs.[50]
 The "fine" arts, on the other hand, were essentially useless in terms of the public project.[51] In fact, the association of the fine arts with royal and aristocratic patronage (and of artists with sycophancy) encouraged the belief that there is an antipathy between the arts and republican government.[52] The old critique of theater, for example, was buttressed by the argument that drama, harmless at best, can easily undermine public virtue.[53] The liberal tradition never doubted the power of the "refined arts" to form tastes and preferences, but such values were matters of opinion, private inclinations which, like religion, lacked the objective standards necessary for public judgment.[54] For the most part, however, American partisans

of the liberal Enlightenment regarded the fine arts as part of the education of a gentleman, something to be left to individuals and to the private sphere.[55]

The liberal tradition, consequently, helped to free the fine arts—and especially the visual arts—from censorial control by the church and public authority. At the same time, it radically lowered the dignity of those arts, deprecating their importance to human life and politics. Moreover, by privatizing the arts, it left art and artists exposed to the market, open to and dependent on private demand.[56] Both factors help account for Charles Wilson Peale's willingness to be diverted from painting into ventures involving technology and natural science, projects through which he hoped to become less reliant on wealthy patrons.[57]

As Peale's case suggests, however, there was considerable overlap in practice between the "fine" arts and their "useful" counterparts. Architecture, for example, suited enlightened tastes. Given the naturalistic view of God as the "Great Architect," architecture symbolized the human struggle to learn and control the secret workings of creation.[58] The new republic, moreover, needed worthy public buildings: succeeding L'Enfant, Benjamin Latrobe found scope in the building of the Capitol, and the project—part of the ambition to found a new Rome on the Potomac—also engaged Rembrandt Peale and John Trumbull.[59]

Similarly, the founding generation had no doubt that rhetoric affects the character of public life, and there was considerable concern with the kind of rhetoric appropriate for a republic.[60] For the most part, Roman models prevailed, as they did in public design generally. Addison's tragedy, Cato, was much admired as a portrait of the virtue of republican Rome, and speeches from the drama were used as texts for declamation.[61] Some, however, argued against the imitation of antiquity, on the ground that classical rhetoric rested on a philosophy and an aesthetic different from that of a new republic based on modern teaching.[62] And, though the struggle was intense, the latter view gradually gained the upper hand.[63]

The very "democratization of mind" which displaced the older, gentlemanly rhetoric also helped, however, to lead more conservative theorists of the liberal Enlightenment toward a new appreciation of the public role of the fine arts. This reflected an old ambivalence; the great theorists of liberalism had always hesitated to carry out

their principles too consistently.[64] Liberalism presumes civilization. It requires, consequently, a certain humanitarian breadth of vision, "self-interest rightly understood," as opposed to narrower self-concern.[65]

This is evident in relation to the obligation of contracts, the only duty mentioned in the American Constitution. Liberal theory finds it easy to demonstrate that given the insecurities of the "state of nature," I have an interest in making whatever promises are necessary to create political society. It is difficult, however, to make an equally compelling case for keeping my promises when they conflict with my perceived interests.

Following Hobbes, liberal theorists pointed first to the risk of being found out and punished, and second, to the danger that promise breaking, if it goes unpunished, may prove contagious, threatening the very existence of political society.[66] Such arguments may persuade the great and powerful, who—in addition to having the most to lose—are too prominent to escape notice and so placed that their example is apt to be followed. But the liberal defense of promise keeping is evidently weak in relation to the poor and obscure, who are only too likely to go unobserved and unimitated. The desperate have even more reason to risk defying the law; in the early republic, slaves had little to lose but their chains. Moreover, persons with the advantages of property and position may be inclined to disdain convention if (like women and children, in the view that has dominated American political culture) they are too subject to sentiment and passion to appreciate the rational basis of civil order.

Liberalism, consequently, presumes the existence of a society capable of imparting civil manners and moral virtues. With the growing political significance of the lower classes, more and more American thinkers adopted the view that civil order requires some attention to the tastes and feelings of ordinary citizens. Jefferson, for example, rated fiction a better public educator than history because it appeals to the "sympathetic emotion of virtue."[67] The French Revolution only magnified, for the conservatively inclined, the tendency to find new value in pageantry and ornament, in arts to warm reason and broaden vision.

This whiggish persuasion, however, upheld the principles of the liberal tradition. It found a public use for the arts, but only as orthotic auxiliaries to the more

properly useful arts and sciences in their war to transform
nature. In 1770, John Trumbull declared that art sup-
ports patriotism because it inspires the desire for glory,
but he was careful to add that it also nourishes the "ar-
dour of aspiring invention."[68] "Art is man's nature,"
Burke wrote in defense of political convention, because art
serves reason, helping to effect the transition from the
state of nature to the second nature of civil man.[69] In
this view, Geoffrey Clive observed, the office of art is to
contain passion within form, channeling affective nature
in the direction of reason and order.[70] Just so, Benjamin
Rush praised music for its "mechanical effects" in "civiliz-
ing the mind."[71] Art parallels and serves the "science
of politics," especially by reminding us that the forms are
fragile and deserve reverence.

 Artists did more than beautify liberal politics; many
imitated liberal theory. Americans came to remember Ben-
jamin West in the way West intended, as the protagonist of
a new, moral art suited to an age of freedom. West re-
jected the doctrine that art should strive to reveal the
true, inward nature of nobility by portraying its universal-
ity. Instead, West painted the characters in his Death of
Wolfe in modern dress in order to emphasize "the date, the
place, and the parties engaged in the event."[72] By im-
plication, West accepted the liberal teaching that, by na-
ture, human beings are separate bodies, to be understood
in terms of a unique historical situation. In apparent
contradiction to West's self-conscious modernity, his Wolfe
is full of Christian imagery.[73] Yet West invokes those
exalted associations in support of a liberal rather than a
Christian teaching. Wolfe was a soldier pursuing a secu-
lar object; his victory was memorable for Americans because
it opened the continent.[74] West enlists self-sacrificing
love on behalf of the modern project; his painting recalls
a step forward in the war against nature, not a triumph
over sin.

 Similarly, Royall Tyler's play, The Contrast, is ap-
parently a morality play in which law-abiding rectitude
combats anarchy and luxury. Tyler's hero, Colonel Manly,
is engaged in the fight against Shay's Rebellion, and he
speaks the language of Roman virtue, denouncing not only
lawlessness, but the liberal legitimation of the pursuit of
private interest. Doubtless, Tyler expected ordinary citi-
zens to feel supported in their decencies, and the play was
generally applauded for its moral tone. But as Kenneth

Silverman points out, Tyler satirizes what he affects to admire; Manly is quixotic, following ancient texts rather than observing present realities. Closely attended, Tyler teaches that established morality is provincial and conventional, preferable to sheer passion and disorder, but essentially laughable. Moral virtue and piety deserve the outward respect of the arts, but they are not suited to rule.[75]

For late eighteenth-century liberalism, the arts were always dangerous allies, useful in promoting enough public spirit and moral sentiment to support a liberal regime, but no more than that. The arts should glorify tame nature, but not the violent passions, and a human virtue that is simple and unsophisticated, yet basically sympathetic and civil. But the balance is delicate, and there is always a risk that the arts will tilt to the wrong side.[76] In 1789, those who advocated the repeal of Pennsylvania's anti-theater law observed that drama is "capable" of strengthening morality and refining manners, but they spoke less hesitantly of a "natural right" to choose one's "amusements."[77] Fundamentally, in the liberal tradition, the arts belong to the sphere of private liberty, and they perform what may be their most valuable public service as diversions, distracting the public from political life.[78]

In the next century, liberal ideas of the relation between politics and the arts followed the lines marked off during the time of the founding. Utilitarianism supported the enthusiasm of business leaders for education in the industrial arts and for institutes of technology.[79] Similarly, it helped to inspire the conviction that the beauty proper to modern society must be sought in commercial and industrial scenes and objects.[80] At the same time, the Whig appeal to the arts was expressed by the vogue of display--the "conspicuous consumption" of Veblen's polemic. Decoration and ornament, in this view, beautify the common life; elegance benefits the community by softening the harsh present of industrial civilization, offering objects for aspiration, a hint of the future being made possible by progress.[81] Greater artists offered a subtler version of this teaching, following Whitman in seeing through the often dreary lives of Americans en masse to a liberative future immanent in their comings and goings.[82] Art was invoked to depict the end that justifies the means, the promise of affluence and beauty which redeems ugliness and travail.

Yet the more attractive the end, the greater the impatience with the means. Respectable liberalism presumed, however, that art could be safely governed in and through private life. Women were allowed more influence on the arts because their presence, in the bourgeois canon, constituted an imperative for gentility and good form.[83] In the private sphere, the arts were to be domesticated, strictly regulated by morality and good taste, the social code thought to be woman's special concern. The increasing acceptance of the ideal of "art for art's sake," while it made art autonomous in relation to public authorities, also aimed to tie the arts to the more fundamental politics of a liberal regime.

Ars gratia artis suggests, however, a reverence for method as such, for technique judged only in terms of mastery. In fact, the arts were freed from politics and the aesthetics of discourse only to become subject to the aesthetics of technology. Henry Adams saw it: the Dynamo conquered the Virgin, and in the process, shattered the foundations of liberal civilization.[84]

Change outran liberalism. The Framers had trusted that scientifically designed institutions, with some minor assistance from art, could contain and direct the demand to be free from all restraint. By the late nineteenth century, the conviction that liberal institutions are necessary to progress was yielding to the belief that all institutions--and all arts--are historically relative. And in the twentieth century, history itself became unreliable: war, totalitarianism, and depression sapped faith in the long term, and what remains is the process of change, irresistible but unpredictable, a juggernaut run amok.

Confirming Tocqueville's fears, form has been overwhelmed by revolt, in the arts and in social thought.[85] Even the appearances, the ground of Locke's empiricism, seem too rigid, too superficial, too culturally determined to suit modern sensibilities.[86] Aesthetically and politically, the world has come to seem essentially formless, ordered only by great craft combined with great force, and hoping to reassert human control over change, even liberal thought has been inclined to look to leaders, unbound save by their own art.[87] And liberal individualism, having undermined public virtues, has gone on, as Tocqueville predicted, to level private decencies, reducing private life to a matter of personal style.[88]

Abandoned to technology and the market, art is debased. The pace of change has encouraged the ascendancy of the visual arts, but for reasons that imply the degradation of those arts. Sight is quick but superficial, able to keep pace with a world of images to which we relate transiently, without deep commitment. Great art is dangerous because it tempts or compels us to remain attentive, impeding our ability to be modish. In our time, Daniel Bell writes, the arts are apt to be reduced to "the syntax and semiotics of advertising and haute couture."[89] The contemporary arts are allowed to fill vacant time, as Hannah Arendt observed, but they have virtually no effect on the forces that occupy time.[90]

This description of the state of the arts is too bleak; there are other arts and more resistance to the dominant trends than I have indicated so far.[91] Nevertheless, the liberal tradition has become exhausted and self-destructive, particularly in relegating the governance of the arts to the private sphere. In our time, the arts can be genuinely free only with the active support and restraint of politics, and political life has no less need for the arts.

In the Jacksonian era, the advent of mass democracy nudged politics and the arts toward public reconciliation. Artists were more likely to recognize that private liberty offers only imperfect sanctuary. Tocqueville's theory articulated the lesson of practice: as conditions become more equal, and the power of the majority more pervasive, the public's taste gradually comes to set the norm for the arts.[92] At the same time, politics, in one crucial respect, turned toward the arts. Since the quality of a democracy is defined by the excellence of its people, a growing number of Americans argued that the education of citizens is the democratic art of arts.[93]

Certainly, public support for the arts increased, although much of it was indirect. The parties cherished their artists as evidences of their own quality, and Hawthorne's term at the Salem Custom House left an enduring memorial to the role of patronage in supporting artists and intellectuals. Public building continued to employ painters, architects, and sculptors, and the very politicality of the press helped to sustain editors, like Bryant, whose highest talents were not commercial.[94] Meanwhile, second-

ary schools multiplied, almost all under some sort of pub-
lic aegis, and the academies and lycea provided income or
employment. In fact, the public's zeal to be educated it-
self gave impetus to the concern that it be educated well.[95]

The new respectability of drama, for example, was
fostered and promoted by Shakespeare's reputation as a
teacher of citizens. In the schools, Shakespeare's speeches
were models for oratory. At a subtler level, Shakespeare
was valued as a teacher of high politics, revealing the
inner nature of rulers and public men. His plays, conse-
quently, were appropriate instruction for citizens who
would, for the most part, be spectators, lacking acquain-
tance with rulers and compelled to judge public men on
the basis of appearances.[96]

The Framers appealed to the arts chiefly to concili-
ate those whose reasoning was defective or undeveloped,
trusting that sound basic sentiments and moral virtues had
been shaped in private life. In the newer doctrine, the
arts were invoked to overcome a defect of sensibility in the
mass public. Jacksonian theorists observed that the great
relationships of the private order--family, church, and
local community--were being disrupted by the growth of a
national market and the increasing ease of mobility and
communication. The force of change was straining the
bonds of affection, threatening to produce a "nameless
multitude," rootless, unstable, and emotionally isolated,
driven by a combination of self-interest and despair.[97]

In the Jacksonian teaching, democratic life requires
a special artistry able to reweave the fabric of civil so-
ciety.[98] Against the privatizing tendency of society, the
arts are needed to draw individuals toward citizenship,
combating private spirit by revealing the dignity and
beauty possible in and through moral and political life.
The arts are not free to do as they please, George Bancroft
argued; they are limited, as they are honored, by their
high office.[99]

Akin to Puritanism in its intent to mold character,
Jacksonian doctrine was concerned with civic rather than
spiritual virtue. Partly for that reason, it was friendlier
to the visual arts, even though it was devoted to the aes-
thetics of discourse. Citizenship itself is a visual art,
although it is also something more. Public spirit is seen
in deeds even if it is not heard in words, and the fear of
shame and the desire for honor are the ordinary disci-
plines of political virtue. A democracy opens to all its

people the chance to display their political talents, and the conditions it puts on such display test a democratic regime and shape its political life.[100] Mature Jacksonian theorizing, in fact, looked to the arts to counteract the increasing fragmentation of political space and time.

Cooper, for example, argued that a democratic people needs monuments to remind it of an excellence that endures and to establish the continuity of present and past.[101] Similarly, the developing civic tradition regarded parks and public architecture as means to draw citizens into places of public resort and concourse. Later in the century, John Roebling gave some thought to the Brooklyn Bridge as an evidence of the beauty of public things, and Louis Sullivan taught that architecture can moderate the formlessness of democratic society, ordering movement and directing it toward democratic goals.[102]

In literature, there was a widespread effort to tie Americans to the land, investing American locales with sanctity and mystery. Cooper went beyond Irving, seeking a bond with the Indian, finding a story in the "unstoried wilderness." A like impulse created a popular cult around Pocahontas and helped to inspire such diverse works as John Stone's tragedy, Metamora: Last of the Wampanoags and Lewis Henry Morgan's studies of the Iroquois. Bancroft's history rivaled the poets, and Hawthorne and Melville created an American mythology, common symbols formed from the private darkness of the soul.[103]

Portents for the nineteenth century, social fragmentation and personal isolation have become observable facts for us, and the theme of popular arts and letters. Tocqueville's last individualist, entirely confined within the solitude of his own heart, is no longer a creature of theory; we meet him on the street.

Citizens need a civic education for which the private order is inadequate and of which the arts are an invaluable part. The arts, as Richard Wollheim recently remarked, need not be "lavish" to perform their public role. Quite the contrary: in the New Deal years, artists and writers "came home," and the New Deal impulse in the arts—at odds with the centralizing tendency of its economics—ran to local theater, history, and music, to dispersion rather than collection. The arts, in the New Deal tradition, find roots and publics by helping to provide them.[104]

The doctrine of civic education I have been describing argues that the arts, like political regimes, are great when they are founded on and encourage nature. In so doing, it argues implicitly against liberalism and modernity. To cultivate a thing, to care for it according to its nature, is, as Hannah Arendt observed, radically at odds with any attempt to dominate it.[105] The project of domination encourages superficiality; it seeks to be atop, but without obligation, lightly skimming from one place or moment to the next. Cultivation implies piercing the surface, but it also suggests a bond to what is penetrated, a loving relationship meant to last.[106]

Modern political thought, and liberal thought in particular, teaches freedom as the highest human good, but freedom is no friend to art. In fact, the visual arts can teach contemporary Americans the lesson that true sight goes beyond mere seeing, past transient images and instant replays, to discern intention and design. To be free to see is not the same thing as to see freely: to perceive is to persevere.[107] Art demands discipline and dedication; if its rule is self-imposed, it is no less severe. In common with democracy, art teaches that the pain of self-rule is preferable to the comfort of being ruled by others. In principle, art and democracy are austere, exacting regimens that would not be chosen or endured without a goal of the highest human value.

Forms are necessary to democracy and techniques to art, but forms and techniques have only extrinsic value. Great art presumes a yearning for beauty as great democracy presumes a yearning to share the good life. Since the whole takes precedence over its parts, and since beauty is only one part of the good life, political society is logically superior to the arts.[108] The same reasoning, however, indicates that political society must yield precedence to the whole of which it is a part. The polis rules the arts, but true art sees beyond the city and reveals its meaning; such an art deserves to rule.[109] Yet this hypothetical ruling art is defined by its truth, not its artistry, a beauty of soul best determined, as the Puritans taught, not by sight but by words.[110]

NOTES

1. Kennedy's vision of a future America "which will not be afraid of grace and beauty" obviously assumed

that the Americans of the time had such fears. Address
at Amherst College, Massachusetts, October 26, 1963.

2. Walter Benjamin, "The Work of Art in an Age of
Mechanical Production," in Illumination, Hannah Arendt,
ed. (New York: Harcourt Brace and World, 1969), 241-42.

3. T. Adorno, Asthetische Theorie (Frankfurt:
Suhrkamp, 1970), 377-80.

4. Mark Train, "The Legend of the Capitoline
Venus," in The Complete Short Stories of Mark Twain,
Charles Neider, ed. (Garden City, N.Y.: Hanover House,
1957), 22-27.

5. Perry Miller, The New England Mind, Vol. 1
(Boston: Beacon, 1961), 215, 225-26.

6. Jonathan Edwards, Images or Shadows of Divine
Things, Perry Miller, ed. (New Haven, Conn.: Yale Uni-
versity Press, 1948), 48; Samuel Davies, Sermons on Im-
portant Subjects, Vol. 2 (New York: R. Carter, 1845), 65.

7. Aristotle, Politics, 1253a 19-20.

8. John Winthrop, "A Model of Christian Charity,"
in Puritan Political Ideas, 1558-1794, Edmund Morgan, ed.
(Indianapolis, Ind.: Bobbs-Merrill, 1965), 77.

9. Gilbert Tennent, The Necessity of Praising God
for Mercies Received (Philadelphia: Wm. Bradford, 1745), 7.

10. Samuel Davies, Religion and Public Spirit (New
York: Parker, 1761).

11. Augustine, Epistle 137; see my essay, "In Good
Faith: On the Foundations of American Politics," Humanities
in Society 6 (1983):26-27.

12. Gilbert Tennent, Brotherly Love Recommended by
the Argument of the Love of Christ (Philadelphia: Franklin
and Hall, 1748), 3; see also Alan Heimert, Religion and the
American Mind (Cambridge, Mass.: Harvard University
Press, 1966), 95-158.

13. John Wise, A Word of Comfort to a Melancholy
Country (1721), cited in Miller, The New England Mind,
Vol. 2, 329.

14. Cited in Miller, The New England Mind, vol. 1,
106.

15. Ibid., 43-44, 106-7, 125; Gilbert Tennent, The
Danger of Spiritual Pride Represented (Philadelphia: Wm.
Bradford, 1745).

16. Tennent, Brotherly Love, 13; Jonathan Edwards,
Works, Vol. 1 (London: Bohn, 1865), 123.

17. Nathaniel Niles wrote that "Everything, however
trifling that tends to the disservice of the interest of the

the state must also be forbidden." Two Discourses on Liberty (Newburyport, Mass.: Thomas and Tingers, 1773), 9–13; see also Isaac Story, The Love of Our Country Recommended and Enforced (Boston: John Boyle, 1775).

18. Philip Rieff, "Aesthetic Functions in Modern Politics," World Politics 5 (1953):478–502; see also Kenneth Murdock, Literature and Theology in Colonial New England (New York: Harper and Row, 1963), 37–38.

19. John Milton, Complete Prose Works, Vol. 1, Ernest Sirluck, ed. (New Haven, Conn.: Yale University Press, 1953–1982), 824; see also Miller, The New England Mind, Vol. 1, 282. Reginald Heber's great hymn echoes the sentiment: "the eye of sinful man Thy glory may not see."

20. Nathaniel Whitaker, A Funeral Sermon on the Death of the Reverend George Whitefield (Salem, Mass.: S. Hall, 1770), 13–16.

21. Joseph Bellamy, The Works of Joseph Bellamy, D.D., Vol. 2 (Boston: Doctrinal Tract and Book Society, 1853), 277–88. Material goods, even luxury, are not as dangerous, Gilbert Tennent proclaimed, as the desire to be "a sort of independent Being," free from the dependence of humankind. A Solemn Warning to the Secure from the God of Terrible Majesty (Boston: Kneeland and Green, 1735), 56, 59.

22. Richard Baxter, The Saints Everlasting Rest (London: Underhill and Tyron, 1648), 749–51; Miller, The New England Mind, Vol. 1, 253ff.

23. Cited in Miller, The New England Mind, Vol. 1, 84; see also Milton, Complete Prose Works, vol. 2, 570.

24. Rieff, "Aesthetic Functions."

25. Miller, The New England Mind, Vol. 1, 296, 303.

26. DAniel Calhoun, The Intelligence of a People (Princeton, N.J.: Princeton University Press, 1973), 212, 214, 229–30; Ebenezer Devotion, The Mutual Obligation upon Ministers and People to Hear and Speak the Word of God (New London, Conn.: T. Green, 1750).

27. Miller, The New England Mind, Vol. 1, 331–62.

28. The Works of Jonathan Edwards, D.D., Vol. 2 (Andover, Mass.: Allen, Morill and Wardwell, 1842), 61.

29. Miller, The New England Mind, vol. 1, 128, 111–53, passim. It is significant that, following Ramus, Puritans saw logic as an "art for disciplining man's natural intelligence," and fundamentally, a dialectic art rather than a "science of proof." Herbert Schneider, A History of

American Philosophy (New York: Columbia University Press, 1963), 5.

30. Murdock, Literature and Theology, 45, 137-72; Samuel Davies, Miscellaneous Poems, Chiefly on Divine Subjects (Williamsburg, Va.: William Hunter, 1752); compare Sir Philip Sidney, An Apology for Poetry (Indianapolis, Ind.: Bobbs-Merrill, 1970), 18, 28.

31. Edwards, Works, vol. 1, 391; Vol. 2, 14, 289; Bellamy, Works, Vol. 1, 585; Heimert, Religion and the American Mind, 208-36.

32. Heimert, Religion and the American Mind, 229-30.

33. Max Weber, The Rational and Social Foundations of Music, D. Martindale, ed. (Carbondale: Southern Illinois University Press, 1958).

34. John Calvin, Institutes of the Christian Religion, Vol. 3, xx; Thomas J. Wertenbaker, The Puritan Oligarchy New York: Scribner's, 1947), 128; Kenneth Silverman, A Cultural History of the American Revolution (New York: Crowell, 1976), 39; Merle Curti, The Growth of American Thought (New York: Harper, 1943).

35. See, for example, Heimert, Religion and the American Mind, 230-31; the Puritans had always permitted music in the home.

36. Murdock, Literature and Theology, 50-51; Silverman, American Revolution, 42-43.

37. Louis B. Wright, Cultural Life of the American Colonies (New York: Harper and Row, 1962), 207.

38. Harvey Townsend, ed., The Philosophy of Jonathan Edwards (Eugene: University of Oregon Press, 1955), 65.

39. Wertenbaker, The Puritan Oligarchy, 43-44; Sumner C. Powell, Puritan Village (Garden City, N.Y.: Doubleday, 1965).

40. Cited in Perry Miller, Nature's Nation (Cambridge, Mass.: Harvard University Press, 1967), 213.

41. Increase Mather, cited in Silverman, American Revolution, 66.

42. Andrew Croswell, Brief Remarks on the Satyrical Drollery at Cambridge Last Commencement Day (Boston: Russell, 1771); by contrast, see Sidney, An Apology for Poetry, 79.

43. Wright, Cultural Life, 178-79, 190; Nathaniel Hawthorne's story, "The Maypole of Merrymount," speaks to the same point. Tanglewood Tales, in Hawthorne's Works, Globe ed. (Boston: Houghton-Mifflin, 1880), 67-82.

44. In Virginia, by contrast, a dancing school was established in 1716. Even such a privately funded venture gave too much public endorsement for Calvinistic taste. Wright, Cultural Life, 180.

45. Silverman, American Revolution, 16, 23, 27.

46. Baxter, The Saints Everlasting Rest, 751–53.

47. Richard Baxter, Poetical Fragments (London: Pickering, 1821), 29.

48. As in the provision of Article I, which empowers Congress to "promote the progress of science and useful arts."

49. On the new aesthetics, see David L. Schaefer, "The Good, the Beautiful and the Useful; Montaigne's Transvaluation of Values," American Political Science Review 73 (1979):139–53; see also Lyman Butterfield, "Benjamin Rush as a Promoter of Useful Knowledge," Proceedings of the American Philosophical Society 92 (1948):26–36.

50. James Fenimore Cooper, Notions of the Americans, Vol. 2 (Philadelphia: Carey, Lea and Blanchard, 1836), 424–27; see John P. McWilliams, Justice in a Republic: James Fenimore Cooper's America (Berkeley: University of California Press, 1972), 129–42.

51. A partisan of the arts, William Shelby argued that the arts could make a people "happy," but he abandoned any claim that the arts would make such a people "great." Silverman, American Revolution, 482.

52. See, for example, John Rupert Martin, Baroque (New York: Harper and Row, 1977), 140–43; William Gribbin, "Rollin's Histories and American Republicanism," William and Mary Quarterly 29 (1972):611–22. This view of art and artists was superficial at best, as indicated by Wolfgang Stechow, Rubens and the Classical Tradition (Cambridge, Mass.: Harvard University Press, 1968).

53. Silverman, American Revolution, 504–12.

54. Something like this view is evident in Edward Banfield, The Democratic Muse: The Visual Arts and the Public Interest (New York: Basic Books, 1984).

55. On the relation between the arts and gentility, see Louis B. Wright, The First Gentlemen of Virginia (San Marino, Calif.: Huntington Library, 1940).

56. Herbert Read, "The Dereliction of the Artist," Confluence 1 (1952):45–51.

57. Silverman, American Revolution, 19–20, 166–67, 453–54.

58. Eleanor Davidson Berman, Thomas Jefferson among the Arts (New York: Philosophical Library, 1947), 130, 210; Richard Beale Davis, Intellectual Life in Jefferson's Virginia, 1790–1830 (Knoxville: University of Tennessee Press, 1972), 208–19.

59. Curti, The Growth of American Thought, 223–24; James Sterling Young, The Washington Community, 1800–1828 (New York: Columbia University Press, 1966), 1–10.

60. Gordon Wood, "The Democratization of Mind in the American Revolution," in The Moral Foundations of the American Republic, Robert Horwitz, ed. (Charlottesville: University of Virginia Press, 1977), 110.

61. Donald D'Elia, Benjamin Rush: Philosopher of the American Revolution (Philadelphia: American Philosophical Society, 1974), 40; Silverman, American Revolution, 56; Young, The Washington Community, 19, 41–44; Davis, Jefferson's Virginia, 363–86.

62. D'Elia, Benjamin Rush, 76, 80; Meyer Reinhold, "Opponents of Classical Learning in America During the Revolutionary Period," Proceedings of the American Philosophical Society 112 (1968):221–34.

63. Wood, "The Democratization of Mind," 113–25.

64. Or, for that matter, even to proclaim them too openly. See Richard Cox's introduction to his edition of Locke's Second Treatise of Government (Arlington Heights, Va.: Harlan Davidson, 1982), vii–xliii.

65. Alexis de Tocqueville, Democracy in America, Vol. 2 (New York: Schocken, 1961), 145–49; John Hallowell, The Moral Foundations of Democracy (Chicago: University of Chicago Press, 1954), 68–74.

66. Thomas Hobbes, Leviathan, C. B. Macpherson, ed. (Baltimore, Md.: Penguin, 1968), 204–6.

67. Julian Boyd, ed., Papers of Thomas Jefferson, Vol. 1 (Princeton, N.J.: Princeton University Press, 1950–), 76.

68. John Trumbull, An Essay on the Use and Advantages of the Fine Arts (New Haven, Conn.: T. and S. Green, 1770).

69. Edmund Burke, "An Appeal from the New to the Old Whigs," in Works, Bohn Library Ed., Vol. 3 (London: George Bell, 1906), 86–87.

70. Geoffrey Clive, The Romantic Enlightenment (New York: Meridian, 1960).

71. Benjamin Rush, Essays, Moral, Literary and Philosophic (Philadelphia: T. and W. Bradford, 1806),

13-14. Rush spoke of vocal music, but he excluded instrumental music only because he considered it unrepublican, presuming that few Americans would have the time needed to master an instrument. David Freeman Hawke, Benjamin Rush: Revolutionary Gadfly (Indianapolis, Ind.: Bobbs-Merrill, 1971), 334.

72. John Galt, The Life of Benjamin West, part 2 (Gainesville: University of Florida Press, 1960, orig. 1820), 48-49.

73. Silverman, American Revolution, 177; Robert Rosenblum, Transformations in Late 18th Century Art (Princeton, N.J.: Princeton University Press, 1967).

74. William Dunlap, A History of the Rise and Progress of the Arts of Design in the United States, Vol. 1 (New York: Scott, 1834), 43.

75. Silverman, American Revolution, 558-63.

76. See my essay, "Fenimore Cooper: Natty Bumppo and the Godfather," in The Artist and Political Vision, Benjamin R. Barber and Michael J. Gargas McGrath, eds. (New Brunswick, N.J.: Transaction, 1982), 233-44.

77. Silverman, American Revolution, 593, 595.

78. For example, see the argument that the lack of "public amusements" caused Shay's Rebellion. Ibid., 553.

79. Edward Chase Kirkland, Dream and Thought in the Business Community, 1860-1900 (Ithaca, N.Y.: Cornell University Press, 1956), 75-113.

80. James Jackson Jarves, The Art Idea: Sculpture, Painting and Architecture in America (New York: Hurd and Houghton, 1866).

81. Bliss Perry, ed., The Life and Letters of Henry Lee Higginson (Boston: Atlantic Monthly Press, 1921); Kirkland, Dream and Thought, 29-49. For a fine discussion of the public dimension in architecture, see Richard Thomas, "From Porch to Patio," Palimpsest 56 (1975):120-27. Thorstein Veblen's critique, in The Theory of the Leisure Class (New York: Macmillan, 1908), is paralleled by Hannah Arendt's comments on "cultural philistinism" in the nineteenth century, Beyond Past and Future (Cleveland, Ohio: World, 1955), 203.

82. Despite Thomas Eakins' democratic sympathies, something of the sort is at work in his discovery of the heroism in the private lives of ordinary Americans. Elizabeth Johns, Thomas Eakins: The Heroism of Modern Life (Princeton, N.J.: Princeton University Press, 1984). On the general point, see Tocqueville, Democracy in America, Vol. 2, 89-90.

83. Of course, involvement in the arts also helped to distract middle- and upper-class women from pursuits judged to be less seemly.

84. Henry Adams, The Education of Henry Adams (Boston: Beacon, 1961), 379-90.

85. Tocqueville, Democracy in America, Vol. 2, 389-91; Harold Rosenberg, The Tradition of the New (New York: Horizon, 1959); Morton White, Social Thought in America: The Revolt against Formalism (Boston: Beacon, 1957).

86. C. H. Waddington, Behind Appearance: A Study of the Relation Between Painting and Natural Science in This Century (Cambridge, Mass.: MIT Press, 1960).

87. Robert Eden, Political Leadership and Nihilism (Tampa: University of South Florida Press, 1983).

88. Tocqueville, Democracy in America, Vol. 2, 117-18.

89. Daniel Bell, The Cultural Contradictions of Capitalism (New York: Basic Books, 1976), 20; James Sloan Allen, The Romance of Commerce and Culture (Chicago: University of Chicago Press, 1984).

90. Arendt, Beyond Past and Future, 205-6.

91. For example, see Richard Wightman Fox, "Modernism Meets Consumerism," Commonweal, June 15, 1984, 377-79.

92. Tocqueville, Democracy in America, Vol. 2, 56-62.

93. Robert G. Rantoul, Memoirs, Speeches and Writings of Robert G. Rantoul, Jr., L. Hamilton ed. (Boston: Jewett, 1854), 73-112; George Bancroft, "The Office of the People in Art, Government and Religion," in Literary and Historical Miscellanies (New York: Harper, 1855), 428-30; Tocqueville, Democracy in America, Vol. 2, 128-35.

94. Charles H. Brown, William Cullen Bryant (New York: Scribner's, 1971).

95. Rush Welter, Popular Education and Democratic Thought (New York: Columbia University Press, 1962); Curti, The Growth of American Thought, 360-68.

96. Esther Cloudman Dunn, Shakespeare in America (New York: Benjamin Blom, 1968, orig. 1939); Norman Rabkin, Shakespeare and the Common Understanding (New York: Free Press, 1967); Howard White, Copp'd Hills Toward Heaven: Shakespeare and the Classical Polity (The Hague: M. Nijhoff, 1970). Tocqueville's comment that "The dramatic authors of the past live only in books" fails to account for the vogue of Shakespeare, but Tocqueville is speaking of theater that entertains, while in order to over-

come the Puritan and republican suspicion of theater, it
was necessary to demonstrate that theater educates.
Tocqueville, Democracy in America, Vol. 2, 101.

97. James Fenimore Cooper, Works, Mohawk ed.,
Vol. 14 (New York: Putnam, 1896), 103, 164–66; Bancroft,
Literary and Historical Miscellanies, 45–63; Rush Welter,
The Mind of America, 1820–1860 (New York: Columbia Uni-
versity Press, 1975), 276–97; Tocqueville, Democracy in
America, Vol. 2, 117–21.

98. I am aware of the complications and contradic-
tions of the term "Jacksonian," and I use it advisedly.
Nevertheless, in this case, the view I am describing was
broadly characteristic of the "persuasion." Marvin Meyers,
The Jacksonian Persuasion (New York: Vintage, 1960).

99. George Bancroft, "Mrs. Hemans' Poems," North
American Review 24 (1827):443–63, and Literary and His-
torical Miscellanies, 103, 147–48, 511, 516; see also Roger
Cahill, The Art of the Common Man in America (New York:
Museum of Modern Art, 1942).

100. Arendt, Beyond Past and Future, 218–19.

101. Cooper, Works, Vol. 14, 225. Cooper's case is
akin to John Adams' emphasis on the need to regulate
emulation, and is closer to Tocqueville's prescription of
the study of Latin and Greek than to Tocqueville's own
discussion of monuments. C. F. Adams, ed., The Works of
John Adams, Vol. 6 (Boston: Little Brown, 1855), 232, 234;
Vol. 8, 560; Tocqueville, Democracy in America, Vol. 2, 63–
64, 73–75. A similar view inspired Hawthorne's insistence
that Shakespeare be preserved as a monument. To know
that Shakespeare was a man like the rest of us—or worse,
in ordinary terms—could too easily lead to "moral bewilder-
ment and intellectual loss." Hawthorne, Our Old Home, in
Works, Globe ed. (Boston: Houghton Mifflin, 1880), 117–18.

102. Lewis Mumford, The Brown Decades (New York:
Harcourt Brace, 1931), 87, 162–63; Hugo Dalziel Duncan,
Culture and Democracy: The Struggle for Form in Society
and Architecture in Chicago and the Middle West During
the Life and Times of Louis Sullivan (Totowa, N.J.: Bed-
minster Press, 1965).

103. Wilson C. McWilliams, The Idea of Fraternity
in America (Berkeley: University of California Press,
1973), 301–71; David Levin, History as Romantic Art: Ban-
croft, Prescott and Parkman (Stanford, Calif.: Stanford
University Press, 1959).

104. Wollheim is cited from Walter Goodman, "Scholars Debate Aid to the Arts," New York Times, May 2, 1984, C25; I find myself in sympathy with the views Goodman attributes to William Bennett and, in a somewhat more qualified way, with those of Ronald Dworkin.

105. Arendt, Beyond Past and Future, 212.

106. John Steinbeck's indignation in Grapes of Wrath derives from the violation by "agribusiness" of this aspect of cultivation.

107. Benjamin R. Barber, "Rousseau and Brecht: Political Virtue and the Tragic Imagination," in Barber and McGrath, eds., The Artist and Political Vision, 1.

108. Arendt, Beyond Past and Future, 213-15.

109. Plato, Politicus, 262 C10-263 A1.

110. Ibid., 277 C4-7.

2

AMERICAN POPULAR CULTURE AND HIGH CULTURE IN A CHANGING CLASS STRUCTURE

Herbert Gans

America's leisure-time activities (artistic, entertaining, informational, and other) have usually been divided into elite and mass components, high culture and popular culture. However, because leisure-time culture is in part a reflection and an effect of class, a more accurate analysis calls for a set of cultural strata or subcultures parallel with class strata. I proposed such cultural strata in an earlier study (Gans 1974); the purpose of this paper is to update the previous analysis, describing some recent changes in the American class structure and therefore in American culture.

In the earlier study, I also distinguished between culture and the people who used or practiced it, between taste cultures and taste publics. I made the distinction partly to suggest that cultures do not always satisfy people or meet their needs, but also to indicate that giant mass media such as television networks, film studios, and

An earlier version of this paper was prepared for an international conference on Popular Culture in Europe and America at Cornell University in April 1982. It was also presented at the Tenth World Congress of Sociology in Mexico City in August 1982. I am indebted to Paul DiMaggio for a close reading of that version and for a number of comments that were very helpful in revising it. A somewhat longer version of the present paper appears in Prospects, vol. 10, no. 1, Spring 1985.

publishers of mass circulation magazines often seek to, or
have to, serve several taste publics with a single cultural
product.

I defined taste publics as aggregates of people who
make similar choices for similar reasons and therefore
have roughly the same tastes and aesthetic standards.[1]
Taste cultures were the array of arts, forms of entertain-
ment, and information, as well as consumer goods avail-
able to the different taste publics. My feeling was and
still is that people's choices in fiction and nonfiction
books, films, music, dance, art, as well as in television
programs, cars, sports, hobbies, and so on are related
because both their choices and the cultural products they
choose reflect and express the same tastes and aesthetic
standards. Thus, it is understandable that working-class
men who like action dramas on the large and small screens
may also participate in active and aggressive sports like
football, boxing, and bowling.

My basic idea was a reformulation of Russell Lynes'
thoughtful and witty analysis of highbrows, upper middle-
brows, lower middlebrows, and lowbrows (Lynes 1955; Chap-
ter 13). I related his conception and categories, without
his ironic value judgments, to W. Lloyd Warner's class
strata and ideas about symbolic behavior (Warner and Lunt
1941), updating the former. Ultimately, I outlined five
taste publics and cultures, which I called high culture,
upper-middle culture, lower-middle culture, low culture,
and quasi-folk low culture, the latter describing the arts,
music, literature, and so on of people both too poor to be
served by the commercial mass media, and much involved
still with the folk cultures they had brought with them
from overseas or from the American Deep South. What I
had in mind can be gleaned from the following capsule
descriptions of two major American taste cultures: upper-
middle and lower-middle:

> The people who read Harper's Magazine or
> The New Yorker are also likely to prefer
> foreign movies and public television, to
> listen to classical (but not chamber) music,
> play tennis, choose contemporary furniture,
> and eat gourmet foods. Subscribers to the
> Reader's Digest, on the other hand, prob-
> ably go to the big Hollywood film if they
> go to the movies at all, watch the family

> comedies on commercial television, go bowl-
> ing, choose traditional furniture and repre-
> sentational art, and eat American home-
> style cooking (Gans 1974: 68).

Although class was not the only differentiating cri-
terion in my analysis, its primacy was based in part on
the fact that it takes money to buy culture and that
people have different incomes. More important, the abil-
ity to understand and appreciate some forms of culture im-
plies educational prerequisites, and access to education is
regulated by class. The educational prerequisites are
particularly important in literature and other "verbal cul-
tures," taste cultures differing therefore by the complexity
of their vocabularies as well as their ideas. Other kinds
of prerequisites exist in the arts and music, however.
Furthermore, many cultural and social institutions discrimi-
nate on the basis of class. Museums have traditionally
exhibited art and sculpture on the assumption that the
visitor has some training in the fine arts, but in the past
they also offered strong hints that working-class and even
lower-middle-class people were not particularly welcome.
Conversely, burlesque houses and working-class bars have
used other mechanisms to discourage visits from the people
who are welcomed by museums.

In addition, I made the functionalist assumption
that all human beings have cultural wants and perhaps
even needs, but that partly because of class and class
position, they satisfy these in different ways, at least in
America. This led to the relativistic hypothesis that all
taste cultures are in some respects similar and can be com-
pared because they perform more or less the same functions.
For example, some taste publics use rock stars as heroes
and heroines or as objects of entertainment and titillation;
some prefer movie stars; and the practitioners of high cul-
ture use a handful of "serious" but also exhibitionistic
novelists, artists, and composers.

The relativist hypothesis is, however, rejected by
adherents of high culture, who argue that their culture is
inherently different from all others. They believe that
high culture's aesthetic standards are universal, and must
be met by everyone. Resembling in many ways the practi-
tioners of orthodox religions, they conclude therefore that
all other taste cultures and standards are aesthetically
and otherwise invalid, harmful to both individuals and
society.[2]

Finally, my analysis sought to understand how class affects people's cultural choices but it did not attempt to explain all cultural choice. While class influences the kinds of music people prefer, liking music is not a matter of class. Furthermore, class alone cannot explain why people like specific kinds of music. Country music is probably preferred by lower-middle and low-culture publics, but not all of the people in these publics like country music. Why some people enjoy country music while others with many of the same tastes do not remains to be studied.

RECENT CHANGES IN TASTE CULTURES AND PUBLICS

My original five-strata hierarchical model of taste cultures and publics was qualified in several ways, for each taste public was divided into age groups and also into avant-garde, conventional, and traditional factions. Moreover, I visualized it as less static than suggested by my (overly) large number of groups and categories, proposing for example that even by the early 1970s, the then still emerging "counter-culture" was already moving away from its origins as a predominantly but hardly entirely upper-middle avant-garde youth culture. Thanks to the efforts of commercial entrepreneurs but especially the readiness of young people to move away from their parents' culture, apolitical versions of the counter-culture were already becoming popular among lower-middle and working-class adolescents and young adults.

I also noted that post-World War II affluence and the increase in schooling had on the one hand reduced the size of the low-culture public, and with it the importance of low culture; but on the other hand they had brought about a drastic expansion of upper-middle culture, partly to serve the large number of new college-educated professionals working in what was even then beginning to be thought of as a postindustrial economy.

Since the early 1970s, the changes both in the American occupational distribution and in the taste cultures and publics in American society have been so dramatic that some cultural observers suggest that the old distinction between high and popular cultures has been erased, forecasting a nearly culturally classless utopia in which all socioeconomic groups would choose from what is a single culture. That people were now free to go to classical and

rock concerts without being criticized by classical music audiences as vulgar, or by rock devotees as snobbish; that they could be practicing intellectuals but also enjoy TV sports without indulging in "camp" or "slumming" all inspired the belief that earlier divisions and conflicts over taste had ended. Accordingly, some sociologists have begun to doubt the connection between culture and class, arguing that class position is no longer the best predictor of cultural choice (Peterson 1983).

Although I will later question this argument and offer some alternative explanations, I shall first describe what seem to be the three most important changes of recent years. One is the now completed transformation of the original counter-culture into conventional culture. In the 1980s, long hair on men is no longer a sign of rebelliousness, left-wing politics, or a Bohemian life style. A second is the widespread change in the commercial culture serving the lower-middle and low-culture taste publics. The mythic Golden Age of the 1950s notwithstanding, commercial television is today far more sophisticated than it was 30 years ago. Words, ideas, and plots are more complicated; the simple Western and crime melodramas with their black-hatted villains are virtually extinct, and so are several of the once invincible religious and sexual taboos that constrained popular entertainment. What is true of commercial culture also applies to many of its lower-middle and working-class customers. Television's Archie Bunker was not only a middle-class caricature, but represented an older white working class that has little in common with today's young workers.

The third change is the apparent emergence of a new taste culture that seems in some ways to cut across and blend upper and lower-middle culture, and which, for want of a better term, I will label middle culture. The public associated with the new culture consists mainly of young college graduates who have taken the new professional, technical, and white-collar service jobs that have been created in the U.S. economy over the last several decades; people who in 1984 also became known as "yuppies" (young urban professionals). Some of them will eventually wind up in the upper-middle class and others have already arrived there, but their cultural choices and tastes are different from older members of that class--and the difference is not simply explained by age.

In the absence of good data, the basic characteristics of the new culture can only be guessed at, but its public seems to be less interested in symbols than in goods; more in a set of hobby-like activities than in the traditional arts. As a result, gourmet cooking, eating out, foreign travel, jogging and other kinds of exercise, the acquisition of "collectibles," and the pursuit of fads and fashions take up more time, energy, and money than they have in past leisure cultures. Concurrently, the public's symbolic choices are also different, with people feeling little obligation to offer allegiance to high culture or participate in its upper-middle culture derivatives.

The outlines of the new culture are most visible in the print media. For example, Harper's and The New Yorker now share magazine racks with periodicals like Cuisine, Rolling Stone, Runner, and Self, which offer information, advice, and other features about the variety of hobby-like activities mentioned above. Although their readers are affluent and well educated, the magazines are not as serious by literary standards as the traditional "class" magazines, and in effect eschew both literature and politics, suggesting that the new culture is little indebted to high- and upper-middle-culture concerns. A similar pattern exists in book publishing, for the increase in nonfiction titles has involved the same hobby-like topics. The New York Times, once a bastion of upper-middle culture, invented five once-a-week, back-of-the-book sections in the mid-1970s which speak partly to the concerns of the new public, while its music pages now include reviews and criticisms of rock and country music.

In the graphic arts, the new culture is less immediately apparent, for the museum and the art gallery, as well as the high and upper-middle art they exhibit, remain dominant. Perhaps the new culture is represented by some kinds of pop art and photographic realism, by the products sold in the burgeoning museum shops, or by the shops themselves. Alternatively, middle-culture art may be found outside the museum, in poster art and in the stores that sell it. As noted earlier, the middle public probably constitutes a major market for "collectibles," but it may also be a constituency for so-called post-modernist architecture. Modern or "international" style design is so severe that it never became accepted anywhere other than in high culture and related circles. The popular hostility and scorn it evoked could not have pleased the corporations

that commissioned skyscrapers and factories from world-famous international style architects in order to demonstrate their good taste and advertise their good will.

The new culture is hardest to discern in television and films because both must serve several publics at once. Perhaps middle culture made its start on the small screen with the first "yuppie" sitcom, "The Mary Tyler Moore Show"; but by 1984 it was probably represented by "Cheers," set in a multiclass singles bar; and by "Family Ties," in which a two-career household finds an apolitical but happy medium between the radical protest of the 1960s and the conservative protest of today. Perhaps middle culture is also visible in "Hill Street Blues," a police drama that treats its characters as professionals rather than heroes; and in "General Hospital," an afternoon soap opera about professionals. The prototypical middle culture movie may be the genre that describes, in seemingly naturalistic fashion, the increasing maturation and sophistication of today's young people, beginning with American Graffiti.

I do not want to exaggerate either the distinctiveness or the novelty of middle culture. Also, its most visible current examples are the activities of and the products for young adults. In a way, the validity of the middle culture hypothesis cannot be tested until later, when it will be possible to see what cultural choices these people will make in middle age, when they are too old for rock music and too overweight for jogging.

EXPLAINING THE CHANGES

The primary explanation of the cultural changes that have taken place since the end of World War II is the long-term transformation of the U.S. economy, its need for well-educated technicians to staff and manage the new manufacturing, service, and communications activities, as well as the new technology that have been developed in the last several decades. Of course, the economy alone cannot explain the cultural change, but still, it provides the jobs that in turn supply money and leisure time to the new taste public. Perhaps the new jobs themselves are also causally significant, creating needs and demands that people then want to satisfy in their spare time.

A second explanation is the general rise in the amount and quality of schooling, for all but the children

of the poor, which has come about not only because the
economy seeks better-educated workers with high creden-
tials, but also because education itself has become a con-
sumer good in great demand. Furthermore, the mass media
themselves have supplied schooling, beginning with radio
and movies in the pre-television era, and increasing when
the small screen became the basis of everyday spare-time
activity. Poorly educated viewers often say they learn
from entertainment television, and partly, I suspect, be-
cause they must do so to keep up. Since advertisers are
interested in "upscale" audiences, television programs are
increasingly aimed, not at the traditional lowest common
denominator, but at the more affluent and better-educated
members of the lower-middle public, making it difficult
for other viewers to comprehend fully what they see and
forcing them to learn.

A third, less often noted, explanation is related to
a structural change in American mobility patterns, itself
partly a function of economic and educational changes.
Once upon a time, probably until the 1960s, class position
and mobility were intergenerational. That is, the class
position of the younger generation was best explained by
parental background, mainly because the youthful cohort's
occupational and other achievements were significantly in-
fluenced by the money, schooling, personal networks, and
other advantages that parents were able (or unable) to
give their children. As a result, children often moved into
the occupations and social worlds of their parents (Blau
and Duncan 1967).

These socioeconomic connections also affected, and
indeed required, cultural connections. For example, once
upper-middle-class young people had finished college,
they were expected to drop their interest in popular music,
and listen instead to classical, or at least semiclassical
music, concurrently rejecting the jukebox of that era for
the concert hall. Just as young people had to move to
the right suburbs, they also had to choose appropriate
films, books, and fine arts. In fact, preferences were
virtually prescribed for a large array of leisure activities,
cultural products, and other consumer goods. Market re-
searchers studied these, advertisers encouraged them, and
upwardly mobile households moved "up" from Chevrolets to
Buicks and from beer to wine.

The "status attainment" studies of the 1970s showed,
however, that in the middle and upper-middle classes at

least, class position is now better explained by personal achievement, notably education, and that it can no longer be as easily predicted from parental position. While the older generation's ability to supply children with educational advantages remains important, parental supports as a whole now seem to be less significant, and far more young people are able to attend and succeed in college even if their parents obtained little schooling. In short, sometime during the period of rapid economic growth that began after World War II, many of the intergenerational class connections were broken (Featherman and Hauser 1978).

The breakup of intergenerational continuity had cultural consequences. Parental as well as school-induced prescriptions for cultural choice lost much of their influence, and young people no longer had to participate in parental culture. For example, upper-middle-class young adults who disliked classical music could continue to develop their adolescent tastes, and if they preferred rock or country music or both, they could pursue these preferences in adulthood without loss of face or prestige, at least among peers.

I do not mean to suggest that either social mobility or cultural choice have become individual, and therefore asocial processes. Indeed, so-called personal achievement is often publicly supported, for instance by governmental expenditures for higher education. Rather, some intergenerational social processes have been replaced by intragenerational ones, and each cohort is now more on its own.[3] Culturally, age within class now becomes a significant causal factor or indicator.

The new middle culture is further supported by the general decline of intergenerational obligations, for upper-middle-class people can participate in the new culture if they dislike upper-middle culture. So can lower-middle-class people, however. In fact, they may be attracted by the new culture, partly because it has distanced itself from upper-middle and high cultures, but also because it has some lower-middle-culture forebears.

While upper-middle culture has borrowed a good deal from high culture, middle culture does more of its borrowing from lower cultures. Rock, like country and folk music, has some ancestors in the rural and urban slums of America, even if these have been denied as the music moved up the cultural hierarchy. Similar trajectories can be charted for many of the new magazines, which are

transformations of old lower-middle homemaker and hobby publications. Pop art borrowed considerably from the commercial art that persuaded earlier middle- and working-class people to buy consumer goods; and many of today's collectibles are the lower-middle- and low-culture consumer goods and knickknacks of the past.

That the new products have often come from below may not be coincidental, for many members of the middle public have come from lower-middle- and even working-class backgrounds. They may therefore not object to drawing culture from the same origins; or for that matter, sharing it to some extent with people who are still in the lower-middle class.

Despite its somewhat more lowly origins, middle culture does not deny people the opportunity to use culture for upward mobility. Although data on how much anyone chooses culture for its substance and how much for its prestige are scarce, given the disrepute attached to "culture vultures," high and upper-middle cultures have always been used for status. Indeed, they may be so used more often in the future, especially if economic conditions reduce occupational mobility. The same opportunities for obtaining prestige through the exercise of taste are available in middle culture, judging by the immense number of how-to books and manuals published for many leisure activities. Besides, $150 jogging shoes and $5000 stereo systems are obtainable by those who seek prestige through expenditure.

THE DECLINING POWER OF HIGH CULTURE

The rise of middle culture has coincided with, and perhaps partly caused, the declining influence of high culture. Although that culture and its public have also grown in numbers since World War II, with attendance at museums, theaters, concerts, dances, and other performances increasing considerably, much of the new audience comes from the upper-middle public, putting further "commercial" pressures on high culture itself. Partly as a result, high culture now seems more marginal than ever, becoming an almost exclusively expert culture increasingly dominated by cultural professionals: creators, critics, and especially academics.[4] Highly educated amateurs can of course still be found in its public, but I suspect that their proportion is

smaller than a generation ago. The upper-class "aesthetes," the self-educated socialist working-class intellectuals, and the Central and Eastern European refugees of the 1930s and 1940s are all disappearing. Replacements for them do not seem apparent among the native-born or immigrant population.

High culture is also becoming less influential because of the declining credibility of its claim that its cultural standards are universal. Today's upper-middle and other publics do not stand in quite the same awe of high culture as did earlier generations. Nor do they seem to seek the kind of prestige that high culture can offer, or could offer in the past. Partly as a result, the culture is also becoming more isolated: in Manhattan and a few other cities; on Cape Cod and its equivalents; but especially in English and humanities departments on a number of campuses and around "little magazines," most of them also connected to academic institutions. In literature at least, the free-lancer who had to straddle upper-middle culture in order to make a living and thus maintained some contacts outside high culture may be giving way to the academic who, once tenured, need not venture outside again.

Free-lancers have been particularly important because, whether they also served upper-middle culture or not, they have been a major source of innovation in high culture. Moreover, through them, high culture has supplied new themes, ideas, and genres for adaptation by the more commercial cultures, for sometimes what lower-middle culture borrowed from upper-middle culture had initially been borrowed by the latter from high culture. During the 1970s, high culture had lost so much influence in America that some erstwhile literary and arts critics became political analysts for the growing conservative and neoconservative movements, criticizing liberal redistribution and desegregation policies, defending capital punishment, and advocating a military showdown with the Soviet Union.

In the 1980s, however, some of the older critics, aided by new recruits, have gone back to cultural criticism, but the high culture they are now advocating is explicitly political as well. New journals funded by foundations also supporting conservative economic policies are once more fighting old battles among high-culture factions and attacking the perceived deficiencies of other taste cultures. These battles are fought with ideological weapons, the cultural enemies being exposed also as politically liberal or radical.[5]

CULTURE AND CLASS

Middle culture's occasional resemblance to upper-middle and lower-middle culture, as well as its ability to attract both upper-middle- and lower-middle-class people to its publics, helps to explain why some observers believe that the class barriers between cultures have come down. When cultural critics can find explicit political commentary in television sitcoms, and can see young professors buying the same rock records as their secretaries, it is possible to conclude that cultural classlessness is on the way. The massiveness, visibility, and vitality of the new culture, as well as its lack of inhibition about borrowing from above or below, can readily suggest that all the classes are now choosing from the same overall culture.

Nonetheless, the majority of class differences in the use of culture remain strong. The low-culture public still reads many of the same newspapers, magazines, and paperback books as it did a generation ago, and its choice of furniture and art has changed little. Vernacular architecture for lower-middle-culture home-buyers remains as solidly wedded to colonial and California ranch styles as before. Tennis continues to be a mostly upper-middle-class sport, its increasing popularity on television notwithstanding; and museum as well as concert audiences are still largely drawn from the same class (DiMaggio and Useem 1978; Hughes and Peterson 1983: Table 3). The new cultural forms are stratified too; working-class rock enthusiasts lean more to "heavy metal" than do middle-class ones; and paperback romance novels come in enough varieties of character, locale, sexual norms, and class background of heroines, heroes, and villains to satisfy several taste cultures from middle down, and various factions within each (Radway 1984: Chapter 1).

Class barriers to the affordability of culture persist as well. Patterns of economic inequality change very slowly. The proportion of Americans earning less than half the median income has remained virtually stable, at about 20 percent of the population from the end of World War II. Since the mid-1970s but particularly since the November 1980 election, the rich have been getting richer again, and the number of poor people has increased, while real income has been declining for almost everyone except the very affluent. Economic patterns have educational implications, and the number of high school dropouts appears

to be rising again, and the proportion of youngsters graduating from college, declining.

When money is needed to purchase cultural products or education to find and use them, the people who have the money and education can continue to differentiate and segregate themselves from those who have less of both. Moreover, changes in the economy continue to maintain the relation of class and culture. For example, the continuing disappearance of fairly secure manufacturing jobs will eventually reduce both the working-class population and low culture, although in the short run, it may increase both escapist and protest themes in that culture. The arrival of a new flood of immigrants, legal and illegal, to take the lower-paying jobs opening up in the economy is once more enlarging quasi-folk low culture.

In comparison to past decades, class barriers between cultures have undoubtedly come down, but mostly inside the middle classes. Some cultural egalitarianism has survived from the 1960s, but some has been spawned by the new middle-class populations, jobs, and cultures described earlier. Perhaps the dominance of television in the leisure diet and the pervasiveness of three-network commercial television fare in that diet have also helped; in that case, the emergence of cable television could stratify the viewer population. So far, however, the viewers have opted for pay television fare that is, in terms of taste, little different from that of the networks, the sizable constituency for R- and X-rated entertainment excepted.

Actually, the correlation of culture with class always has been, and remains, far from perfect. Very expensive products must appeal to several classes, network television being the most prominent example. Culture that is closest to home and family seems to express class position more than does culture that is publicly consumed. Consequently, language habits and home furnishings correlate more strongly with class than do public entertainment choices, other than those chosen with prestige and display in mind. As noted earlier, products with built-in educational prerequisites, notably those requiring a good deal of reading, will show a much higher correlation with class than with culture that can be enjoyed with little or no prior training. Although they may not do so, bettereducated people can choose from more taste cultures than can poorly educated people (Wilensky 1964). The cultural choices of the latter are most constrained by class factors.

The fact is that we know virtually nothing about people and taste, and even the theories and methodologies for acquiring such knowledge are still primitive. Descriptive concepts and measures of cultural choice remain gross. Research on leisure-time budgets shows little in a society in which nearly all the employed spend 16 hours working and sleeping. Surveys of cultural activities and preferences produce data about general tendencies, which are made more general yet by currently fashionable forms of statistical analysis. The ethnographic and life-history data that can identify fundamental patterns and processes of cultural choice and that are needed prerequisites to surveys, have not yet been gathered. Class concepts remain primitive as well, and the revival of interest in Marxist concepts of class has helped to produce a virtually complete neglect of the cultural aspects of class. Coleman and Rainwater (1978) is the exception proving the rule.

Future empirical research may show that cultural choice is only weakly related to class, but so far I have seen no evidence that any other variable is more strongly related.[6] True, age is highly significant, and as I suggested earlier, age within class may be becoming more important. Moreover, some cultural products and practices remain segregated by sex. While I am not wedded to describing taste publics and cultures with class labels, it is too early to consider alternatives.[7]

Nor am I prepared to give up the class-based hierarchical or "ladder" model of cultural diversity. As long as economic and educational inequality continues to bar many people from access to jobs requiring verbal and related skills, the model must remain hierarchical. To be sure, the ladder metaphor does not fit perfectly. The high-culture public, being mostly upper-middle class, has never been atop the ladder; and although the upper class still helps to finance high culture, its own tastes run to a traditional upper-middle culture which became known as "preppy" in the early 1980s. Lower-middle- and low-culture publics have never been much impressed by the cultural power or social prestige of high culture. George Lewis (1981) has placed the ladder on a horizontal plane in his "multi-nucleated" model, but I would put it on at least a 45-degree incline.

Finally, in the 1980s, the analysis of cultural choice is once more embroiled in ideology, which can only help to stimulate interest in the subject, even if some waters

are muddied in the process. Neo-Marxist analysts make fairly direct connections between class and culture, even if they increasingly pay more attention to the role of the state than to that of a capitalist class. Neoconservatives have fastened on the changes in the class-culture relation to proclaim that class per se is no longer very relevant in today's America. Meanwhile, however, the Reagan administration took National Endowment for the Arts and for the Humanities funds away from a variety of small, local, and even folk-culture efforts that its officials thought to be leftist and diverted them to large and powerful upper-middle- and high-culture Establishment institutions. The denial of the relevance of class analysis in combination with schemes that redistribute money from the poorer to the richer is traditional Republican practice, but in the process, new alliances are being forged between the higher cultures and the higher classes. If these persist, they will require new sociological efforts to understand the relations between class and culture.[8]

NOTES

1. _Aesthetic_ is used very broadly in this essay, for I am discussing standards of what people think is beautiful and good, as well as enjoyable, informative, and inspiring.

2. In my original study, I questioned these beliefs, arguing that because cultural choice is influenced by income and education, people should not be expected to develop tastes or standards that required access to both. I still hold the same view and see no need to update it. Further, I continue to feel that the higher taste cultures are better than the lower in the same way that more money and schooling are better than less.

3. This analysis harks back to David Riesman's emphasis on the rise of peer influence and other-directedness (Riesman 1950).

4. The central role of professionals is not new, of course, for Paul DiMaggio has discovered that in nineteenth-century Boston, imported professionals from Europe carried out what he calls purification, that is, setting and implementing universal high-culture standards for the Brahmin founders of museums and symphony orchestras who hired them to determine what art and music was to be excluded as vulgar and popular (DiMaggio 1982).

5. Concurrently, a new defense of high culture has also developed on the left. Advocated most energetically perhaps by Christopher Lasch (1981), it is as elitist in tone as the defense from the right and equally critical of the tastes of the lower classes, but it blames these on capitalist exploitation, in much the same way as Dwight Macdonald (1957). Lasch is, however, less interested in socialism than in a return to Gemeinschaft through a mixture of preindustrial pastoralism and contemporary decentralism (Gans 1982). For a current defense closer to the traditional left position on high culture, see Gitlin (1983).

6. Davis (1982) has reported extensive NORC attitude data which he interprets as questioning the validity of the class-culture concept, but he reports also that education, which is an important class variable, remains the best predictor of attitudinal variation. In addition, answers to standardized opinion-poll attitude questions strike me as poor indicators of culture.

7. I am not wedded either to general concepts such as taste culture and public, which are difficult to operationalize for empirical research. Unfortunately, the study of taste publics or audiences is so expensive that scholars can rarely afford to conduct empirical research and must often depend on secondary analyses of data collected for very different objectives. Market researchers, who for obvious reasons are very much interested in class differences among consumers, have gathered a great deal of data relevant to culture and class, but it is proprietary and not available to scholars. In fact, the Caritas Corporation has developed an analysis of "market clusters," which resembles my notion of taste publics, and analyzes their class by a matchup of postal service ZIP codes with census demographic data (Heller 1984).

8. A provocative critique of the new upper class-government-high culture alliance, from the libertarian right, has been developed by Banfield (1984).

BIBLIOGRAPHY

Banfield, Edward C. 1984. The Democratic Muse: Visual Arts and the Public Interest. New York: Basic Books.

Blau, Peter M., and Otis D. Duncan. 1967. The American Occupational Structure. New York: John Wiley & Sons.

Coleman, Richard P., and Lee Rainwater. 1978. _Social Standing in America_. New York: Basic Books.

Davis, James A. 1982. "Achievement Variables and Class Cultures." _American Sociological Review_ 47, no. 5 (October):569–82.

DiMaggio, Paul. 1982. "Cultural Entrepreneurship in Nineteenth Century Boston." _Media, Culture and Society_ 4, no. 1: 33–50.

DiMaggio, Paul, and Michael Useem. 1978. "Social Class and Arts Consumption: The Origins and Consequences of Class Differences in Exposure to the Arts in America." _Theory and Society_ 5, no. 1: 41–61.

Featherman, David L., and Robert M. Hauser. 1978. _Opportunity and Change_. New York: Academic Press.

Gans, Herbert J. 1974. _Popular Culture and High Culture: An Analysis and Evaluation of Taste_. New York: Basic Books.

————. 1982. "Culture, Community and Equality." _Democracy_ 2, no. 2 (April):81–87.

Gitlin, Todd. 1983. _Inside Prime Time_. New York: Pantheon Books.

Heller, Karen. 1984. "Hot on the Press." _Washington Journalism Review_ 6, no. 3 (April):26–31.

Hughes, Michael, and Richard A. Peterson. 1983. "Isolating Cultural Choice Patterns in the U.S. Population." _American Behavioral Scientist_ 26, no. 4 (March–April): 459–78.

Lasch, Christopher. 1981. "Mass Culture Reconsidered." _Democracy_ 1, no. 4 (October):7–22.

Lewis, George H. 1981. "Taste Cultures and Their Composition: Toward a New Theoretical Perspective." In _Mass Media and Social Change_, edited by Elihu Katz and Tamas Szecsko, 201–18. Beverly Hills, Calif.: Sage Publications.

Lynes, Russell. 1955. The Tastemakers. New York:
 Harper and Brothers.

Macdonald, Dwight. 1957. "A Theory of Culture." In
 Mass Culture: The Popular Arts in America, edited by
 Bernard Rosenberg and David M. White, 59–73. Glencoe,
 Ill.: The Free Press

Peterson, Richard A. 1983. "Patterns of Cultural Choice:
 A Prolegomenon." American Behavioral Scientist 26,
 no. 4 (March–April):422–38.

Radway, Janice A. 1984. Reading the Romance: Women,
 Patriarchy and Popular Literature. Chapel Hill:
 University of North Carolina Press.

Riesman, David, with Nathan Glazer and Reuel Denney.
 1950. The Lonely Crowd. New Haven, Conn.: Yale
 University Press.

Warner, W. Lloyd, and Paul S. Lunt. 1941. The Social
 Life of a Modern Community. New Haven, Conn.: Yale
 University Press.

Wilensky, Harold L. 1964. "Mass Society and Mass Cul-
 ture: Interdependence or Dependence." American
 Sociological Review 29, no. 2: 173–97.

II

ARTISTS AND
ART-WORLD INSTITUTIONS:
SOCIAL AND ECONOMIC FACTORS

Regardless of art form, public acceptance of the aesthetic characteristics of artists' work, and hence its potential social and political impact, are affected by the sociological characteristics of the art–world organizations within which they produce those works. (Otherwise, they paint, write, and compose for family or friends, or, like Emily Dickinson, for the eyes of the artist alone.) Leaving politics aside for the moment, all social art worlds bring together two often antagonistic principles of order: aesthetic principles of quality, and economic principles of comparative worth. Artistic value and price are not easily equated. The process by which even a temporary equation is made involves negotiation of agreement among various participants in the particular art world--first between the artist and the institutions of distribution (galleries, theaters, publishing houses, recording studios, etc.), and second between these institutions and the wider audience. It is at this second stage that politics are increasingly involved, even as they then work back on the first stage of negotiation.

Given the variety of art worlds, as well as differences in complexity and scale of arts institutions, it is useful to examine several cases in detail to see how artists, and arts institutions, operate to build a consensus around definitions of aesthetic value, and thus come to agreement with audiences about their economic worth as well. The four papers in this section move us from the micro–world of individual artists (respectively, painters and musicians) to the macro–level of art institutions (respectively, a visual arts center and resident theaters). All can be seen as actors trying to persuade audiences of the value of their products, and, at the same time, all are subject to factors in the wider environment that contribute much to the success or failure of their strategies and of their art.

Rosenblum focuses on the strategies used by visual artists to establish the economic worth of their paintings by, among other things, selling themselves as artistic personalities. She considers not only individual artists, but also the immediate mediators of their acceptance into the art world: the dealers, collectors, critics, and curators. Like the artists on whose work their own depends, these mediators also combine aesthetic and economic interests in their professions or avocations. Their success (and, indirectly, that of the artists whom they thus help to enter and survive in the art world) depends on their reputations as perceptive taste makers and thus on widespread acceptance of their assessment of the artistic value of particular works by particular artists. Although such economic or commercial factors are often seen as corrupting the "higher" spiritual or artistic impulses, they are inherent in the dissemination--and hence in the creation--of every art form.

Bodinger-deUriarte provides another example of individual artists trying to establish unique careers, in this case free-lance musicians. Like Rosenblum's painters, musicians compete with each other for work and recognition; unlike visual artists, their art form requires much more cooperation among peers. Thus their ultimate economic success and artistic reputation depend not just on superior "gatekeepers" (critics, or those who hire them), nor only on audience approval, but also on the judgments of other musicians equal in status with themselves. The values that emerge from the common difficulties which all face in establishing their individual careers stress qualities of social interaction even more than those of unique talent. Thus individual success in this art world depends on social, as much as artistic, skills.

If individual artists and musicians can be seen as economic and social actors striving for artistic and financial success, so too can art-world institutions. In recent years, these have frequently commissioned studies by social scientists to determine who their audience is, or more importantly, who it might be if they would change their marketing strategy in key ways. It is not merely that their societal role is to serve as mediator between artists and audiences, bringing the two together. In addition to cultivating audiences so that they will be willing to understand and to support the arts on their own, nonprofit arts institutions must increasingly legitimate themselves to

publics with no interest in the arts at all, but who, none-theless, support the arts (as well as other charitable and philanthropic activities) through the tax system. For these wider publics to be persuaded, impressionistic or small-scale studies are insufficient, hence large surveys and statistical and/or computer analysis of the engendered data have become common. Two examples are included here, not just for their substantive content about how art-world institutions operate, but also as demonstrations of how social scientists studying such institutions use differ-ent theoretical perspectives and techniques of data analysis.

Fritschner and Hoffman describe a study that they were commissioned to do for a local art center in the Mid-west. While their original study was far more detailed, here they review the variety of possible theoretical inter-pretations which, differently applied, would contribute to the development of different "market strategies" with pre-sumably different degrees of popular and hence political success. Their data on the characteristics of the audiences attracted to the center, for different art programs, enabled them to evaluate not just the success of the programs them-selves but also the interpretations that might have been made of the reasons for the attraction of the art center to those audiences and not others.

In the final paper here, DiMaggio and Stenberg cast a wider net, and discuss not just one art institution in a particular setting, but rather the entire American resident theater movement. Their study was conceived as an attempt to provide both a rationale for, and an empiri-cal example of, data analysis of repertoire changes in theater to indicate degrees of innovation and diversity, or, in contrast, greater conformity, in the theatrical art world as a whole. In the process, they consider changes that have occurred regarding the survival of innovative or more conforming theaters for the ten years of the study period. Concluding with suggestions for public policy (of which we will see more in Part IV), implicitly and explic-itly they summarize the factors, otherwise raised by the preceding three papers, that contribute to artistic success and to the costs paid for that success by artists and arts institutions alike.

3

THE ARTIST AS ECONOMIC ACTOR IN THE ART MARKET

Barbara Rosenblum

In the last decade, a good deal of the work in the sociology of art has sought to dispel the myth of the individual artist working as a solitary practitioner. Instead, we have replaced the "isolated artist in a garret" image with another one, that of the "artist enmeshed in a network" (Becker 1982; Bennett 1980; Bystryn 1978; Faulkner 1971, 1973; Kealy 1979; Lyon 1975; McCall 1977; Mukerji 1977; Ridgeway 1975; Rosenblum 1978; Wolff 1981). To this imagery, I wish to add another, that of the artist as an economic actor in the art market.

An artist is, after all, a producer of something. If it has substance and durability over time, the object sooner or later will enter a world of objects to be classified, evaluated, assessed, and priced. There, it will acquire a life of its own, independent of whatever inspired its creation. If the thing produced by an artist is consumed in its production, so to speak, then it is produced for a live audience and the price of admission is dependent on a variety of economic and noneconomic factors (Baumol

I would like to thank the members of the Bay Area Sociologists for Women in Society Writing Group for their comments on previous drafts of this paper. They include Kathy Charmaz, Anna Hazen, Elinore Lurie, Margot Smith, Linda Stoneall, and Joan Torykian. Grateful acknowledgment is given to the National Endowment for the Humanities for their support (grant no. RO–23892–76–846).

and Bowen 1968; Martorella 1977). No matter what the medium, the content, or the style of the object, every artist who puts his or her objects into the art market can be viewed as a producer of something to sell.

In this paper, I put forward the view that an artist, like any other producer of commodities, must behave in strategic ways in the art market. Art markets are generally regarded by economists as particular kinds of oddball markets in which normal market mechanisms do not obtain. As a consequence, there are hardly any economic analyses of art markets (Balug 1976; Peterson and Berger 1975). Some people believe that the primary reason that an art market has not been conceptualized with sufficient depth is that it consists of a collection of noncompeting connoisseur items (Moulin 1967). Put another way, each object has, theoretically, its own market, with its own constellation of supply and demand. Because an art market consists of unique and noncomparable items, the assumptions of comparability, substitutability, and complementarity (that is, the standard assumptions of the "production plus profits" formula) cannot be met. Yet, if the art market consisted of noncompeting items, we would expect to find pricing patterns randomly distributed, each with its own market, each price bearing little relation to all other prices. This scenario, however, is not the case. At any given time, we find that the price structure in the art market is much more predictable, in terms of a given range for an object of its type and its relationship to other types, than this assumption would predict. Since these considerations do not illuminate much about pricing art objects, what, then, are some determinants of pricing structure in the art world?

Name recognition is one of the strongest determinants of the patterning of prices in the art market, just as a brand name is in ordinary commodity markets. Name recognition should not be confused with artistic reputation, which has recently been discussed in noneconomic ways by Howard S. Becker (1982) and Pierre Bourdieu (1980). Becker's emphasis on collective definitional processes neglects the economic consequences of artistic labeling (Becker 1982, pp. 351-71). Similarly, in an otherwise incisive analysis, Bourdieu (1980) tends to underestimate how symbolic capital translates into real capital. Brand names are like special emblems on a road map: out of the cartographer's landscape crowded with thousands of names,

a few special places, larger and more important than all
the rest, are made visible with bold print, unusual color-
ing, and other signaling devices. A brand name in the
art world differentiates one artist's work from a sea of
thousands of other artists, all competing for fame and
recognition.

A brand name or trademark in modern economic
organization is the quintessential code word for distinguish-
ing hierarchies of taste in the realm of consumption.
There is no better way to understand how prestige is at-
tached to consumption than to understand how brand names
operate. From the point of view of the consumer, buying
a pair of shoes is one thing, but buying Guccis is an-
other; a brand name attaches prestige to a functional com-
modity. The item comes to stand for one's personal taste,
and is an expression of life style and status group. Brand
names are important in economic life because they are, in
part, autonomous determinants of consumption and, as this
paper will try to show, of other aspects of social behavior.
For recent evidence, witness IBM's domination of the per-
sonal computer market, an economic fact based not solely
on the intrinsic merits of electronics but rather on the
power of a brand name.

Classification of art objects (usually by style and
period) by critics, connoisseurs, and academic art histo-
rians was originally developed to establish authenticity.
The codification of the aesthetic world has been borrowed
by dealers to ascribe value to both object and artist. By
using aesthetic classifications and vocabulary generated in
other domains, dealers can use labels as a mechanism to
set the outer boundaries of the price structure and to es-
tablish price levels within these limits. By using the
classification system generated by critics and art histo-
rians, the dealership system thereby functions in a regu-
latory way by inducing artificial comparability and sub-
stitutability, artificial constraint, and homogenization
among unique and dissimilar products, a consequence not
discussed by White and White (1965) in their classic study
of the dealership system.

Artistic labeling can be generic or specific. Usu-
ally, a generic label refers to a particular style, such as
"postimpressionist" or "minimalist," and allows dealers to
group together objects for sale within a given price range,
based on some common stylistic features of the work. The
specific brand name, on the other hand, usually refers to

a group name, such as the group organized by Robert Motherwell known as "The Irascibles" or, in the world of literature, the well-known Bloomsbury group. Also, a specific brand name can be the surname of the artist, such as Picasso.

In the application of these labels, the brand and generic names are transformed into price tags. When an artist obtains an aesthetic designation, he or she is automatically placed in the economic stream of the market, because obtaining an aesthetic designation is tantamount to obtaining an exchange value. On the individual level, a brand name is the most important step in the artist's career. Artists are both externally pressured and internally driven to acquire fame and visibility in the art world. On the institutional level, we can understand how the dealership system is, at this moment in history, a Janus-faced institution, with one face looking at the economic marketplace and the other at aesthetics. Taken together, we can understand how the allocative processes that distribute fame and recognition affect and influence individual artists' socioeconomic behaviors.

There are two assumptions that need to be made explicit. I assume that the allocation of rewards in the art market is not based solely on the intrinsic merits of the art object. Some artists obtain fame on the basis of nonaesthetic or extra-aesthetic criteria. Social, behavioral, economic, and political factors enter into the allocation of fame and recognition. Fads and changes in taste enter the picture as well.

My second assumption is that most artists know that reputations are not based on perceived aesthetic merit alone and consequently engage in varieties of strategic behavior to maximize the likelihood of their recognition. In this instance, a strategy may be conceptualized as a behavior that has the consequence, not necessarily the intention, of maximizing recognition. An artist need not consciously seek economic gain and social recognition for his or her actions to ultimately serve that end. For instance, an artist may not consciously intend to increase her own visibility through friendship with a group of like-minded, sympatico painters and poets but, should they collectively open a cooperative gallery which is then labeled by an art critic, we may regard these outcomes as strategic. Consciousness and intentionality are not necessary (but may be sufficient) ingredients for the claims of

this argument. People often behave in patterned ways without realizing that their behavior is conditioned by the economic and social forces that operate on them.

In this paper, I have distinguished several ways artists come to obtain recognition, an aesthetic designation, and ultimately a brand name which, in turn, places them into a price slot. These are achieved through: (1) individual strategies; (2) group strategies and; (3) art market strategies.

INDIVIDUAL STRATEGIES

Developing an Artistic Persona

In no other social world is the development of a personal eccentric style as important as in the world of the creative arts. Born of the social processes that began when "Art" became separated (and subsequently autonomous) from its guild organization, and nurtured during the heyday of "art for art's sake," the social role of "artist" is fraught with many bohemian, rebellious, and iconoclastic connotations. "Artistic temperament," as expressed by overdeveloped egos, moodiness, unpredictability, and reclusive behavior, is license given to artists.

Art historian Peter Selz recounts the example of an artist whose accountant advised him to "dress more like an artist" and to develop a form of eccentricity that would not be unduly threatening to the contractual economic relationship between himself and the gallery director.[1] Thus, personal eccentricity must be balanced by some degree of responsibility and affability. Because the normative expectation of originality operates so strongly in the art world and because eccentricity is regarded as an indicator of creativity, there are structural inducements for artists to develop a nonconformist personal style. Julian Schnabel is an excellent case in point. Schnabel's work is called "neo-expressionist" because of the surface energy and movement on the canvas. In addition, Schnabel has also painted on plates and rugs as well as using these as media to "paint" with. Even before Schnabel met Mary Boone and signed with her gallery, which subsequently launched him on a trajectory as one of the highest-paid painters today, Schnabel acquired some local notoriety in New York as an aggressive go-getter:

> Before he had a gallery, he invited every-
> one he met to come to his studio. Gregar-
> ious and direct, he worked parties like a
> political candidate at a Fourth of July pic-
> nic. He was not shy about approaching
> important collectors he hadn't met before
> to persuade them to come see his work. He
> proclaimed that Jasper Johns and he were
> the two greatest painters of the twentieth
> century (McGuigan 1982, p. 88).

The Houston Museum director said, "I thought it was ex-
traordinary that he had so much self-confidence when he
had no audience" (McGuigan 1982, p. 88). Everyone inter-
terviewed by McGuigan concurs that Schnabel's chutzpah
was a major factor in his personal style.

Other artists, of course, may have developed other
aspects of their character, such as moodiness or the need
for solitude, as the basis of their idiosyncratic personal
style. Structural pressures for nonconformity probably re-
quire artists to exaggerate real aspects of their own per-
sonalities and, without a doubt, artists carry into their
personal lives aspects of the personages they have created.

GROUP STRATEGIES

Socializing Institutions

Schools bring together lively and energetic people
who work and share ideas in an atmosphere of excitement,
creativity, generativity, and experimentation. An institu-
tion or group also legitimates its own enterprise to the
outside world in the sense that its members are engaged
in an organization that has some reality and vitality to
it, in the form of real membership, students, ideology,
and resources. Schools pass on new ideas to the next
generation, a socially legitimate function. Pevsner's
(1940) classic study of art academies provides many richly
illustrated discussions of the social functions of the acad-
emy, particularly the establishment of both aesthetic and
social legitimacy.

Setting up a new school, studio, or atelier, then,
is more than simply creating new space. It is a powerful
means by which a group of artists asserts its identity.

The artists feel confident enough to compete with already
legitimated forms of art education. The history of art is
filled with examples of groups of artists who set up their
own schools, ranging from Kandinsky's group, the Phalanx,
to the Bauhaus.

The notion of alternative socializing institutions
must be broad enough to encompass and subsume many
kinds of teaching and learning situations that are not tra
ditionally academic. Pont-Avon was a small fishing vil-
lage on the coast of Brittany where Gauguin went to paint.
A small group formed around him as he began to share his
ideas about painting. Art historian Haftman (1965) notes:
"It should not be supposed that Gauguin started a full-
fledged academy; the group consisted of artists who lis-
tened to him talk informally." It is the sociologist's job
to recognize these other forms of collective life as alter-
native educational modalities. Such a concept can even
incorporate the form of the café, which has come to repre-
sent the symbolic center of artistic group life. The Nabis
are associated with the Café Volpini in Paris, the symbol-
ists with the Café Voltaire, and abstract expressionists
with the Cedar Tavern in New York. Such diverse forms
provide increased visibility and legitimacy for artists.

Obtaining a Group Name

Obtaining a group name is an excellent way to
achieve visibility. The history of art is filled with ex-
amples of groups of artists: the Cubists, the Fauves, the
Impressionists, the Eight, the Ten, the Blaue Reiter, and
so on.

Artists can acquire a group name either from an
external source, such as a critic, or by collectively gen-
erating a name for themselves. On inspection, there are
two significant differences between the labels given by
art critics and self-generated group names. In the first
place, art critics usually label a group by style. On the
other hand, artists who self-label pick a name that has
significance for themselves and may reflect a symbolic
stand or simply the number of members in the group.

In the second place, when an art critic applies a
label, it usually has much more "sticking power" than a
self-label. For example, Robert Motherwell organized a
group of New York painters called "The Irascibles." Art

critics, however, called them "The Abstract Expressionists," and this is how we know them today.

While artistic groups and circles have been studied from a variety of perspectives (Bystryn 1978; Kadushin 1976; Ridgeway 1978), I am suggesting that we need also to pay attention to the processes by which groups acquire tags and under what conditions. My hypothesis is that groups self-label when they are ready to enter the art market and, by doing so, attempt to wrest the power to label from critics. Economic necessity constrains different painters with individual approaches to find commonalities in their work, so they can band together as a group.

ART MARKET STRATEGIES

Obtaining Recognition Through the Economic System

There are many ways artists can obtain recognition through the economic organization of the art world. The most prominent and common way is to be represented by an established gallery/dealer which, in turn, confers legitimacy on the artist's work and thereby makes a "good bet." Certain gallery owners/dealers become linked with specific styles. Herman Baron, founder of the American Contemporary Art Gallery in 1932, was a champion of social realism and regionism in America. Some of the early members of this gallery included William Gropper, Philip Evergood, and Ben Shahn. Leo Castelli virtually launched "Pop Art." Gallery owner Louis Meisel was a champion of photo-realism and represented such artists as Richard Estes and Audrey Flack.

Other artists bring attention to themselves by their strident rejection of the dealership system. New York painter Neil Jenery's iconoclastic business style is known in Europe. If he does not like a prospective client, he will not sell. If he does, he negotiates a "just price," based on a sliding scale. Clients come to his studio by invitation only and have only one opportunity to decide about a purchase.

A third way to penetrate the art establishment is to cultivate a foreign market and then be invited back home as a success story. This pattern is commonly associated with black jazz musicians who left America's racism to find a more compatible artistic environment in Europe.

When Castelli opened his gallery in New York, his European network was already in place: he had an established gallery in Europe. Rauschenberg, Johns, Lichtenstein, and Warhol made their gallery debuts with shows in both Europe and America.

This pattern need not be international. One variation is geographical relocation of artists to cities that are able to sustain a viable art market. Contemporary artist Hap Tivey left Los Angeles "to make a living of art. In L.A., I have to live as a teacher. But the juggernaut of commerce creates the necessity to enter the marketplace in order to be an artist" (Wortz 1983, p. 69). Now Tivey is not only making marketable objects, but also has both a New York dealer and a Los Angeles dealer. Geographical mobility is associated with upward mobility in occupations such as banking and industry. Similarly, an artist's shift in geography may also contribute to his or her upward mobility.

The creation of new distribution outlets is another economic strategy (Sharon 1976). Alternative spaces give artists another distribution channel for their work. Lofts became important for avant-garde musicians like Sam Rivers as a way to create an atmosphere in which the music could be heard without the commercialization commonly associated with jazz clubs. Similarly, painters have created alternative spaces for the exhibition and distribution of their work. Every major city that can support local artists probably has at least two ecologically distinct areas: one for the established, traditional galleries, such as Madison Avenue, and one for more experimentally oriented galleries. A recent survey by Philips (1981), confirms that alternative spaces, such as P.S.#1, The Kitchen, and Franklin Furnace (all in New York), originally began as avant-garde centers, providing outlets for various media, and such avant-garde artists as Philip Glass and John Cage. Fashion Moda, in the South Bronx, is political in orientation and ideology and exhibits many local black and Hispanic artists. While many began as alternative spaces for avant-garde artists, they have become institutionalized as major outlets of avant-garde art for corporation purchase. As these alternative spaces become institutionalized, the definition of avant-garde is pushed beyond its present boundaries.

Another economic strategy utilized by artists is to cater to the tourist market. Resort areas are outlets for

images that fulfill the tourist demand for a representation of their holiday. Art of this sort is usually denigrated by the art establishment and not regarded as being motivated by the pure light of artistic inspiration, but rather by the pure green of making a living.

Peter Selz argues that, at one time, museums were the arbiters of taste. An artist required the museum's stamp of approval before he or she could command a price. Now, Selz believes, the art market is dominated by dealers. Art critic and historian Phyllis Tuchman takes a more radical stance and argues that collectors dominate the market today.[2] Collectors, she believes, view the dealer much like a stockbroker, telling the dealer whom and what to buy and sell. The fact that the art world can be divided into the connoisseurs, aestheticians, and critics (the experts on the "sacred"), and the dealer-middlemen (the experts on the "profane") poses some very interesting questions for the sociologist. Some artists are economically successful but never achieve aesthetic legitimacy. The paintings of Walter and Margaret Keane, which depicted children with huge, sad eyes, were virtually reproduced from coast to coast; yet they never were taken seriously. Similarly, today the romantic novels of Barbara Cartland sell millions of copies and she, too, has not received serious literary attention.

It would make life much easier for a sociologist if the art world's categories were neat and simple. Yet, a recent example of the intersection of marketing and aesthetics blurs such simplistic distinctions and makes more visible some economic processes in the art world. Mary Boone virtually created a neo-expressionist market and illustrates the ways in which dealers can both obtain recognition for the artist and influence the point at which the price is set, through their entrepreneurial efforts.

As we saw earlier, Julian Schnabel was not opposed to aggressive marketing before meeting Mary Boone. In 1978 Boone decided to open her gallery in the same Soho location that housed the prestigious Castelli, Sonnabend, and Andre Emmerich galleries. Boone's marketing strategies for her painters are extraordinary in the history of the dealership system. Schnabel's first show in Houston in 1976 drew bad reviews; nonetheless, he persisted in coming to New York, met Boone, and in 1979 had his first solo show at the newly established Mary Boone Gallery. Boone had begun to cultivate collectors long before the show

opened, taking potential buyers to her studio, pressing hard for sales. The last painting in the show sold at 10:00 A.M. on the morning the show opened. Boone had succeeded in driving a wedge between aesthetics and economics and was marketing her client, independent of the legitimatized critical evaluation of his work. Many hours later, the reviews were mixed.

Schnabel's second show at the Boone Gallery opened nine months later after his first solo show—another unusual piece of marketing. All four of his plate paintings were sold before the show opened at prices double those of the first show in February.

A year and a half later, Schnabel had a joint show at both the Boone and Castelli galleries. During the intervening year and a half, Leo Castelli and Mary Boone signed a contract for joint representation of Schnabel. Castelli thereby extended his powerful seal of approval. One interesting and plausible inference to be made from Castelli's joining with Boone is that dealers, too, establish and maintain their reputations by association with one another; Castelli, whose reputation was made by monopolizing the "newest," had to keep Boone from cornering the market on whatever was newest in the art world.[3] All the reviews of this show were uniformly positive. Julian Schnabel was elevated to mythic status. Again, Boone sold every painting before the show opened, and placed next to each painting a card listing its title and date, as is customary, but also added the name of the new buyer. Prices for the show ranged from $9,000 to $40,000. Although Boone was criticized for her "unorthodox display," its net effect was to elevate the prices and reflect demand. Boone's dual marketing strategy for Schnabel—high profile and false scarcity—secured the economic/collector market before she secured the stamp of approval from art critics.

As of this writing (spring 1984), Schnabel's paintings have not been bought by major American museums, although some European museums have purchased his work. Schnabel's case is very significant because his reputation is based on his initial success in the economic domain, not the aesthetic-ideological domain.

Obtaining Recognition Through the
Aesthetic-Ideological System

Artists gain recognition often through critical review or evaluation by cultural capitalists. Critics,

dealers, collectors, and academic historians are all in the position to help artists acquire a brand name. Bourdieu notes (1980, p. 262):

> For the author, the critic, the art dealer, the publisher, the theatre manager, the only legitimate accumulation consists in making a name for oneself, a known recognized name, a capital of consecration implying a power to consecrate objects (with a trademark or signature) or persons (through publications, exhibitions, etc.) and therefore to give value and to appropriate the profits from this operation.

In this history of art, certain critics have become associated with particular artists or styles. When an artist obtains the support of a critic who acts as a propagandist for the artist, a substantial degree of aesthetic legitimacy is achieved. Harold Rosenberg was a spokesperson for De Kooning, Barnett Newman, and other abstract expressionists. Clement Greenberg similarly championed abstract expressionism in general, but favored Jackson Pollock in particular.

Recently, Hilton Kramer, former art critic for the New York Times, noted in a telling remark that De Kooning's recent show in New York revealed that "without the verbiage, the emperor had no clothes," suggesting that, without the favorable writings of Thomas Hess and Harold Rosenberg (both are now dead), De Kooning's work lost value.

Another strategy involves the support of a museum curator who wishes to create and establish, rather than reflect, taste. Photography curator John Szarkowski of the Museum of Modern Art in New York functioned as a taste maker and did much to create demand for photographs as artistic objects. His early shows introduced the work of Lee Friedlander and Diane Arbus; later shows promoted Richard Avedon's larger-than-life portraits as aesthetically valuable.

Museum curators play an especially important role in a locale in which the dealership system is small and regarded as virtually nonexistent. In San Francisco just after World War II, when there was virtually no commercial gallery system, three significant curators helped launch

the careers of such painters as Joan Brown and Richard
Diebenkorn, now nationally known (Leonard, in progress).

Phyllis Tuchman believes that collectors are much
more influential today than either museums or dealers or
even critics in terms of setting trends in the market. At
the mercy of legislatures and budgets (Zolberg 1978), mu-
seums are often constrained to give shows to private col-
lectors, in the hope that the courted collector will even-
tually make a donation to that museum. Similarly, muse-
ums are mandated to represent the public interest and
create shows that have wide appeal and generate revenue.
Given these two constraints, the curatorial mission of
bringing new works of art to the public and creating new
definitions of art seems radically diminished.

In addition to art critics and museum curators, ac-
complished creative artists in other fields can play the
role of both protector and propagandist. Playwright
Edward Albee curated an exhibition at the Guild Hall Mu-
seum in East Hampton, Long Island which included the
work of artists in residence at Albee's own foundation,
located in Montauk, New York.

Finally, artists can bring attention to themselves
through the aesthetic–ideological system by the proclama-
tion of a manifesto. A manifesto is a socio–literary form
that has its own theory of artistic change. Its formula
is: everything that has gone before is worthless (conser-
vative or reactionary) and everything that we do is real,
true, and good art. It is no surprise, therefore, that a
manifesto that separates the old from the new is associated
with avant–garde groups and movements, such as the
Futurists, Dadaists, Surrealists, and the De Stijl groups.
From a sociological view, a manifesto is an assault on
order and, at the same time, the revelation of a new order.
It challenges the art establishment to take its proclaimed
criteria and values seriously while simultaneously rejecting
the validity of the art establishment's own categories.

CONCLUSION

Artists are producers of goods that eventually enter
a market for sale. Aesthetic evaluation and critical no-
tice, especially favorable reviews, are the necessary
aesthetic–ideological and symbolic prerequisites that con-
sequently establish a price range. To ensure that their

work will be distinguished from that of thousands of competing artists, the artist qua economic actor engages in behavior that brings attention to herself and/or the artists with whom she is associated. Their behaviors are geared toward increasing visibility and recognition as intermediary steps to fame and long-lasting reputation.

The art market, by extension, requires the commodification of the producer as well as the work of art. Continually selling oneself, as well as one's products, according to this perspective, is deeply alienating for many artists. Evidence for the commodification of the artist as well as the product can be seen in various formal ceremonies and rituals in our culture. Once an artist achieves public acclaim, the name can lend prestige and legitimacy to others. For example, Robert Frost read his poetry at John F. Kennedy's 1960 inauguration, each one mutually enhancing the other's prestige and fame. Similarly, such disparate artists as Dolly Parton and Leontyne Price have appeared at televised White House cultural functions. When a political figure has a stable of celebrities, the legitimacy and prestige of both parties are mutually enhanced.

Artists can lend their names to a particular cause or world view. For example, artists' names have been extended to and associated with their "causes": Jerry Lewis for muscular dystrophy; Beverly Sills for retarded children; Joan Baez for the antiwar movement.

Once established, a brand name can take on a life of its own. Picasso's daughter, Paloma Picasso, became a top-ranking jewelry designer associated with the New York-based Tiffany company. Unlike most children of artists who are unable to translate their parent's successful name into their own prestige, Paloma Picasso was eminently successful in borrowing her father's prestige until she could establish her own.

Finally, the gatekeepers' social mandate to make aesthetic judgments has traditionally derived from their relatively independent and autonomous position in relation to the art world's economic side. Art critics are committed to "aesthetic excellence" and presumably apply judgments universally, without favoritism. Like other professionals, they are not supposed to have vested interests, especially financial ones, in the outcomes of their own criticism. Art critics and historians are thought to be beyond conflict of interest, committed to excellent art

journalism and the professional standards of both the profession and their colleagues.

Yet, critics are often asked to serve as consultants for both corporate and governmental agencies. As a result, they become involved in aesthetic judgments that may have the consequence of influencing the price structure of the art market, particularly that of individual artists. Many civic commissions, for instance, require the participation of an art critic in order to decide whether a particular sculpture, such as one by Picasso or George Segal or Arneson, should become a public sculpture. While they may have the public interest at heart, surely art critics must be vulnerable to the potential moral ambiguity of such a position.

The social acquisition of fame and recognition in the art world results from the complex interplay of networks, politics, and economics. Many common-sense accounts may attribute artistic recognition to "luck" or to the enormous talents of the artist or to the aesthetically compelling aspects of the work. While some of these accounts may have some validity, the perspective put forward here--artist as strategic economic actor--deepens our appreciation for the constant and sometimes difficult backstage work that artists are required to perform in the social structure of the art world.

NOTES

1. Personal communication.
2. Personal communication.
3. Personal communication, Judith Balfe.

BIBLIOGRAPHY

Balug, Mark, ed. 1976. The Economics of the Arts. London: Martin Robertson.

Baumol, William J., and W. G. Bowen. 1968. Performing Arts: The Economic Dilemma. Cambridge, Mass.: MIT Press.

Becker, Howard S. 1982. Art Worlds. Berkeley: University of California Press.

Bennett, H. Stith. 1980. On Becoming a Rock Musician. Amherst: University of Massachusetts Press.

Bourdieu, Pierre. 1980. "The Aristocracy of Culture." Media, Culture, and Society 2, no. 3:225–54.

Bystryn, Marcia. 1978. "Art Galleries as Gate Keepers: The Case of the Abstract Expressionists." Social Research 45:390–408.

Faulkner, Robert. 1971. Hollywood Studio Musicians. Chicago: Aldive Publishing.

_____. 1973. "Orchestra Interaction: Some Features of Communication and Authority in an Artistic Organization." Sociological Quarterly 14:147–57.

Haftman, Werner. 1965. Painting in the Twentieth Century. New York: Praeger.

Kadushin, Charles. 1976. "Networks and Circles in the Production of Culture." American Behavioral Scientist 19, no. 6:769–84.

Kealy, Edward R. 1979. "From Craft to Art: The Case of Sound Mixers and Popular Music." Sociology of Work and Occupations 6:3–29.

Leonard, Michael. In progress. "History of Painters at the San Francisco Art Institute, 1940–1960." M.A. thesis, Department of Art, San Francisco State University, San Francisco.

Lyon, Eleanor. 1975. "Behind the Scenes: The Organization of Theatrical Production." Ph.D. dissertation, Northwestern University, Urbana, Ill.

Martorella, Rosanne. 1977. "The Relationship Between Box-office and Repertoire: A Case Study of Opera." Sociological Quarterly 18:354–66.

McCall, Michael M. 1977. "Art Without a Market: Creating Artistic Value in a Provincial Art World." Symbolic Interaction 1:32–43.

McGuigan, Cathleen. 1982. "Julian Schnabel." ArtNews
 (Summer):88–94.

Moulin, Raymonde. 1967. Le Marche de la Peinture en
 France. Paris: Les Editions de Minuit.

Mukerji, Chandra. 1977 "Film Games." Symbolic Inter-
 action 1:20–31.

Peterson, Richard A., and David G. Berger. 1975.
 "Cycles in Symbol Production: The Case of Popular
 Music." American Sociological Review 40:158–73.

Pevsner, Nicholas. 1940. Academies of Art: Past and
 Present. Cambridge: Cambridge University Press.

Philips, Deborah C. 1981. "New Faces in Alternative
 Spaces." ArtNews (November):90–100.

Ridgeway, Sally. 1975. "When Object Becomes Idea: The
 Social History of an Art Movement." Unpublished Ph.D.
 dissertation, Graduate School of CUNY, New York.

_____. 1978. "Cliques, Gate-keepers and Structural
 Change." Paper presented at American Sociological
 Association, San Francisco, 73rd Annual Meeting.

Rosenblum, Barbara. 1978. Photographers at Work. New
 York: Homes and Meier.

Sharon, Batia. 1976. "Social Stratification in Art:
 Chicago's Art Community." Unpublished paper.

White, Harrison, and Cynthia White. 1965. Canvasses
 and Careers. New York: John Wiley.

Wolff, Janet. 1981. The Social Production of Art. New
 York: St. Martin's Press.

Wortz, Melinda. 1983. "The L.A. Flash New York Shift."
 ArtNews 82, no. 1 (January):67–71.

Zolberg, Vera. 1978. "Autonomy for the Arts: The Di-
 lemmas of Public Funding." Paper presented at 9th
 World Congress of Sociology.

4

STATUS JUDGMENTS AMONG FREE-LANCE MUSICIANS

Cristina Bodinger-deUriarte

A person earns status if he has a good attitude, is a hard worker, is responsible, respects his art and that of others, and has the art of listening and being very humble.

> --Avant-garde, jazz, and pop musician

Status comes from sincerity in all aspects of music production and teaching; the degree of expressiveness and what is felt by the listeners of a particular artist.

> --Classical, jazz, and rock musician

Status? It's based on a personal and musical chemistry--being able to bend and blend with the other musicians.

> --Jazz, reggae, and salsa musician

I am not interested in status, only in music.

> --Funk, fusion, and jazz musician

I would like to thank all of the musicians who patiently filled out lengthy questionnaires and who allowed me to interview them. My special thanks to guitarist Bruce Arnold, who acted as general consultant and technical expert in all things musical.

Current literature on occupational prestige deals with well-structured occupational settings, like corporations, in which the definition of success at each level and the career paths leading to various occupational rewards are readily discernible by members of that occupation (Garbin and Bates 1966; Inkeles and Rossi 1956; Smith 1943; Spaeth 1979). Not too surprisingly, the studies suggest that occupational prestige is strongly linked to the attainment of the occupation's institutionally recognized rewards, or to elements of personal power and control. This paper will examine occupational prestige patterns within the career of music in which not only the paths to success, but even success itself are interpreted differently by different musicians.

The sparse literature on music occupations largely mirrors the work done on occupational prestige in general (Berger 1971; Faulkner 1971, 1973; Peterson and White 1979; Westby 1960). The studies have, for the most part, concentrated on relatively well-structured areas of the music profession: symphony orchestras, radio or television staff positions, and established networks of studio ties. These music specialty areas tend to have clear definitions of success and commonly recognized career paths. However, early career-phase musicians who have not yet settled into a niche, in addition to other free-lance musicians (e.g., sidemen*), are less likely to share such an understanding. This paper focuses on early career-phase free-lance musicians.

A brief mention of research methods is in order before moving to a discussion of the findings. This paper is the result of several distinct research endeavors on my part. The data were gathered through questionnaires on many aspects of status; two sets of interviews, one concerning careering strategies and one concerning motivation; and a year-long ethnography involving all the commercial aspects of the local music scene.

My study took place in Boston and may, therefore, be somewhat specific to Boston in certain details. This is a pilot study. The typical subject was a white male in his mid-twenties, of suburban middle-class background. However, minorities and females were included in the study

*See the glossary of music-related terms at the end of this chapter.

sample, in proportions reflecting the actual makeup of the
Boston free-lance community. Two-thirds of the musicians
had earned degrees in music and the rest had studied
music in college-level programs. Typically, these young
professional musicians had studied music for 18 years.

Though a small Boston-based study, this chapter
provides insight into the wider issue of status attribution
in a nonstructured, creative occupation. For the free-
lance musician, a structured occupational context, such as
the station or studio, is only tangential. This means that
the career patterns of free-lance musicians are relatively
informal and may vary widely since there is no grounded
institutional context. Consequently, there is no stable in-
come or job security:

> God knows how they [club managers] decide
> who to hire. Most of them are pretty un-
> realistic--they get ideas in their heads.
> Somehow they justify it to themselves be-
> cause they are not great judges of music.
> They have this big feeling of authority,
> they want to be tough guys, act like they
> own you. They want somebody who is real
> submissive. . . . But when I see the
> "boss," so to speak, I always say how
> much I like playing in his club and all
> that . . . and talk with him so he'll re-
> member me.
>
> --Bass player

Active free-lance musicians may face a "feast or
famine" problem; either they have no prospects at all, or
they have to choose between multiple demands where priori-
ties are often unclear.

> Well, it's like you don't know what you
> should turn down. So much depends on
> luck out there that you get to where you
> feel like you can't say no to anyone . . .
> that might have been your mysterious once-
> in-a-lifetime chance. But now it's gotten
> to where I have people come up to me after
> every gig and ask me to audition or just
> to join their bands. I got to say no. I
> don't even have time to check most of them

out to see if they are the good thing. . . .
Also, before I started teaching, I felt like
I had to play every possible gig; this
month might be good but I might starve
next month. It took me a year to realize
that I was booking myself solid all the
time--Lately I'm so burnt-out that I can't
cope with anything but doing my gigs and
sleeping. Sometimes I'm too tired to eat,
and it's ruining me as any kind of a legit
human being. But when I think about
where I should cut down, I go into a panic.
It's brutal, man.

--Guitarist

The stress inherent in the free-lance musicians' situa-
tion is magnified by the intense competition and high fail-
ure rate in the music world. (Here failure is defined as
the inability of a musician to obtain his or her personal
occupational goals.) Some musicians react to the built-in
uncertainty by becoming fatalistic, mentally reducing the
complexities of achieving success to a single factor, luck.

[My teacher] said that he knew I was go-
ing to get that big break soon, that he
could just tell, but that if I wasn't ready
for it, I'd blow it. He said that you only
get one chance. He said that all the
gigging in the world wasn't going to help
me if I wasn't ready to grab that chance
and run with it.

--Guitarist

Most of the musicians in my study, however, devel-
oped career strategies in which status--in the absence of
known steps and a recognized linear direction--provides a
measure of their progress and their position in relation to
others in the profession. But status does not provide a
clear and simple measure of success. As previously men-
tioned, the definition of success itself is problematic, both
from the view of musicians as a group, and often within
the thoughts of the individual musician as well. Musicians'
images of success embrace pictures of both the rich and
famous but mediocre player and the starving, unrecognized

musical artist. Consequently, status judgments can be quite complex.

Non-musicians' views of musicians' status are, in contrast, quite simple. Laymen commonly perceive "great" musicians to be something more than extensively trained and highly competent workers. The image is one of individuals imbued with the mystic qualities of inspiration and talent, driven to the musical arts as to a spiritual calling. To assume such a layman's perspective might lead to the further assumption that musicians assign status to one another solely on the basis of perceived skill (as the tangible manifestation of inspiration and talent) and dedication (as the manifestation of response to a calling). Then again, in contemporary times, the image of a "star" also figures into the layman's view of high-status musicians. In this regard, one might think that musicians credit each other with status through a formula weighing skill, acclaim, and income. Of all such lay criteria for a musician's status, skill was the only factor of the four suggested above that musicians named as a primary status determinant. Dedication and acclaim were considered to be only moderately important in status judgments, and income was practically ignored. In other words, musicians do not generally attribute status to one another in accordance with how they accrue status from non-musicians. However, as will become clear in this paper, this does not mean that despite very different views of ultimate success and a multiplicity of career strategies, musicians have a status system only marginally distinct from that associated with more structured careers (e.g., white-collar corporate positions).

An overlapping of factors becomes apparent in moving from lay assumptions about a musician's status to collected sociological understandings about occupational status. Acclaim, income, promotion, and control over work are the primary status determinants drawn from occupational prestige literature. In music-related terms these are identified with: reputation in the local music scene; ability to get high-paying gigs; advancement in an individual career scheme; and control over idiom, gig-type, and venue. The study of early career-phase free-lance musicians facilitates a comparison between the status systems of structured and nonstructured occupations. I anticipated differences in the two systems due to the ambiguity and uncertainty involved in pursuing a career in music, but the differences

in the relative importance of status factors exceeded my expectations. In fact, none of the factors drawn from occupational prestige literature were identified as having major importance in the musician status system and (as noted) only one, acclaim, is considered to be even moderately important. Obviously, status within the music world differs significantly from status within other, more structured occupational settings. My argument is that a common thread in the very nature of these unstructured career patterns provides the basis for a coherent alternative status system among free-lance musicians.

Free-lance musicians live in a world where, because there is no fixed workplace or stable set of expectations, social life and professional life are inextricably intertwined. First of all, time devoted to gigs encompasses not only performance, but setting up, sound checks, breaking down, rehearsals, and in some instances auditions and/or demos as well as band-member recruitment. Second, professional involvement extends far beyond the requirements for a given set of gigs; most musicians are involved in some ongoing form of self-improvement. This might include practicing, ear training, sight reading, transcription, and private lessons for vocalists and players. For composers and arrangers it might also entail hours of uncommissioned labor with no guarantee of eventual marketability. Finally, the actual career process includes building a reputation, sitting in, cultivating contacts, subbing, making demo tapes, and hustling gigs. Musicians also spend most of their leisure time in occupation-related activities. These include scoping out a competitor; keeping in touch with what the musical heavies in the same area of endeavor are doing; making the scene; sessioning with friends, occupational acquaintances, and real or potential contacts; following relevant developments in the music world; keeping aware of relevant technology (especially in electronic equipment); and so on. This led me to consider that, for free-lance musicians, indicators of occupational status might be a reflection of the traditional <u>social</u> status indicators.

Turning from occupational prestige literature to that concerning social stratification yields four measures of social status appropriate to this study. These are income, social circle, education, and material goods. As noted above, the first was ruled out as a primary factor. The three remaining factors, when translated into music-world

terms, become professional associates and performance venue, training in music, and type of equipment and other occupationally useful goods owned. These factors are certainly important as, both in questionnaires and interviews, musicians often mention contacts, particular learned skills, and certain equipment as crucial in obtaining gigs:

> I find out what they [potential contacts] are into and rap with them on that for awhile. Then I give over my card. Hey, a lot of times it went nowhere, but those few times it paid off it opened a whole new circle, see?
>
> --Guitarist

> I let people know I can read good. A lot of musicians they play good. I mean, they might blow my shit right out the door, but they can't read-down a part without taking it home and shedding it. Sight reading is one of the things I practice every day.
>
> --Guitarist

> I let people know I had an answering machine and could always be reached in a matter of hours that way. See, somebody might call once with a gig, I'm not home and they go getting themselves some other guitarist. . . . It happens a couple of times and you get a rep of being the hard-to-reach type and it really cuts into your ability to be considered for short notice gigs. . . . I also make it known that I have a car. Go anywhere, go any time, that's me. I may even have gotten a couple of gigs because the band needed transportation. Hey, that's fine with me-- any foot in the door, any finger in the pie.
>
> --Guitarist

However, the importance of these factors in building a career is not necessarily reflected in the status system of that career. More simply, the things you need to get

gigs are not necessarily what earn you status points. Thus, social stratification literature offers no new insight in this respect. None of the status indicators drawn from this source were considered to be of major importance in the status system of free-lance musicians, and social circle and education were named as only moderately important.

I will recap the findings to this point.

TABLE 4.1

Non-musicians' Views of Musicians' Status

Lay Views of Musicians' Status	Occupational Prestige Literature	Social Stratification Literature
Skill[a]	Acclaim[b]	Social circle[b]
Acclaim[b]	Promotion	Education[b]
Dedication[b]	Control	Material goods
Income	Income	Income

[a]Status factor musicians name as of primary importance.
[b]Status factor musicians name as of only moderate importance. Lack of footnote indicates lack of importance.

The above table illustrates this review paragraph. Nine possible status indicators were generated from three different sources. The lay images of musicians, occupational prestige literature, and social stratification studies combined to yield these possible status indicators: skill, acclaim, dedication, income, promotion, control over work, social circle, education, and material goods. Musicians named only one of these, skill, as integral to their own status system. None of the key factors derived from non-music-world occupational or social stratification literature was also identified as key in judgments made by free-lance musicians within the music world. Only four additional factors were considered to be even moderately important by the musicians in their status evaluations. These were: acclaim, dedication, social circle, and education. However, musicians do judge one another on more than skills alone.

While musicians consider themselves to be in a
talent-based occupation in which skill is a major factor of
status attribution, they deny that it is the sole factor.
Musicians disagree on which instruments and idioms re-
quire the most skill or provide for the best self-expression.
Nor do they agree on whether instruments and idioms can
be ranked when speaking of skill. However, the question-
naires revealed consensus on ranking idioms and instru-
ments according to status. It might appear that free-lance
musicians have no consistently important measures of status
aside from the problematic assessment of skill. However,
this is not the case. My study reveals that the status
system is less atomized and particularistic than one might
expect.

The special nature of music as an arts-oriented,
talent-based occupation makes the connection between musi-
cians' status and perceived talent readily understandable.
Musicians agree that particular adaptability/versatility
traits and interpersonal traits are as important as skill
in the determination of status among musicians. These
two major status determinants are equally linked to the
specific character of the free-lance musicians' occupational
context.

Versatility/adaptability is valued because of the
unstructured nature of the occupation--the unpredictability,
the fluidity, the sudden opportunities, and the constant
changes of fellow workers, employers, and venues. Free-
lance musicians identify versatility/adaptability as impor-
tant in the struggle for success:

> I did a lot of sessions. I'd play a session
> with anybody, any style music. You see, I
> didn't want to get typed as a jazzer, even
> though that's my preferred idiom. Once you
> get typed as a jazzer, then a lot of people
> would associate you with this particular type
> of attitude that a lot of jazzers have, that a
> lot of other music just doesn't interest them.
> I also didn't want to get typed as a rocker
> though, because then the jazzers, they'd
> look down their noses at me. So . . . I'd
> jam with anybody.
>
> --Guitarist

> I'm versatile. I can play all different
> styles, I read well, and I'm quick to

learn things. I mean that was one of the
problems with Berklee [Berklee College of
Music in Boston]--people kind of divided
into these musical camps that turned their
noses up at other styles. That's just not
where it's at. I mean, if you get this
studio gig for some country-western type
of thing, they [employers] don't want to
have a bunch of jazz riffs played through
it. Some people don't seem to be able to
understand that. They carry their particu-
lar idiom with them into whatever else they
try to do. . . . They're still coming from
a particular feeling that's just not appro-
priate. I aim to be real flexible--to be
able to get inside whatever style it is.
. . . There's a real talent in being able
to do the most you can with something and
not violate its natural idiom.

--Bass player

In contrast, versatility and adaptability may be
appreciated as general traits in the more structured occu-
pational settings, but they do not figure prominently in
status judgments within those occupations, and are not
mentioned as important variables in the literature. The
significant difference rests partly on the nature of the re-
spective job requirements. In structured settings, require-
ments are usually known from assignment to assignment,
and the important capabilities are a given. However, the
free-lance musician lives with the unpredictable nature of
job requirements and personnel from assignment to assign-
ment, rendering essential any skills that enhance band or
group performance and community presentation. A brilliant
soloist does not necessarily have the ability to meld with
and be part of shifting performance contexts. This ex-
plains why individual virtuosity and skill cannot be the
sole basis of status for the free-lance musician. In sum,
the amorphous nature of the occupational culture is re-
flected in the factors musicians stress in their status judg-
ments, so musicians accrue status partly in terms of poten-
tial "fit" with other musicians in performance situations.
Thus, adaptability/versatility traits are balanced with
perceived skill traits when musicians assess one another
in terms of status.

A further part of this potential "fit" with other musicians takes place on the level of personal interaction. Again, this seems to be due to the specific character of the free-lance musician's occupational context. The intense interpenetration of social and professional life, as well as the constantly shifting demands, lends an emphasis to interpersonal traits as part of job status for free-lance musicians. This emphasis is not generally found in more structured occupations.

In structured settings, personality and attitude are often rated on standard evaluation forms as part of the formal evaluation system. However, they are not an essential part of assigning work nor of granting occupational prestige. Further, worker evaluations that include personality/attitude components tend to focus on certain task-specific aspects (e.g., "is good with clients"). A grating personality, in isolation, is not a real threat to job security in most occupational institutions. For example, a college professor, businessman, or lawyer can be reputed to be thoroughly obnoxious yet still enjoy a great deal of occupational prestige and success. In contrast, free-lance musicians feel that personality and attitude play a highly significant role in determining status, as well as in providing an axis of decision in hiring and making recommendations.

Even within the music world, solo performers, studio staff, and members of stable bands or orchestras have more behavioral leeway than do free-lance musicians. Most people can think of at least one anecdote about a superstar musician's obnoxious behavior that was tolerated because of special talent or commercial popularity. The musicians in my sample, however, insist that in the free-lance music world such behavior would be the rare exception. As previously mentioned, free-lance musicians devote relatively large amounts of time to sessioning, jamming, making the scene, scoping-out competitors, and so on. This means that outside the context of any band or set of gigs, a lot of time is spent with a wide range of fellow musicians—who may someday be co-workers in a future performance. In fact, this non-performance-specific time spent together is part of the larger career process of making contacts, building a reputation, and keeping informed about auditions and openings. Personality and attitude are major considerations in decisions about who to spend this professionally essential "leisure" time with. Finally,

where talent issues are tricky and competition is intense (after determinations of "who fits the bill"), personality and attitude may be the deciding factors.

> Attitude is real important. The way you're going to make it is word of mouth. The music scene is like a ladder—that's why I can't leave town or take a vacation— you've got to stay on that ladder. Your attitude is just one of the ways you can secure your footing on the step you've already climbed up on, or it can be one of the real quick ways to lose your footing altogether. If word gets around that you have some kind of an attitude problem, people just won't gig with you. It can really keep you down. It's because no matter how good you are, there's always someone of at least similar abilities who's a nice guy, and people would rather work and rehearse and all that with a nice guy.
>
> —Bass player

> A lot of guys who are real good can't get into a band and can't get anyone to join a band with them because they've got the rep of having an "attitude." Me, I don't let anything get to me. I mean, I may think that somebody's music is trash and that they're a real idiot as well, but I always make'm feel like I dig their music— that I dig playin' with'm, man. And you know, word gets around, "Hey man, that [guitarist's name] may not be the heaviest cat, but he can fit into a band, you know—not cause static."
>
> —Guitarist

In more structured occupations, the time and/or expense of interviewing, hiring, and training make workers less readily interchangeable, especially in the higher levels of the hierarchy. In addition, most structured occupations offer some form of job security. Both conditions combine to discourage firing a worker for an attitude problem that does not specifically interfere with that per-

son's work. Furthermore, most structured occupations have publicized openings, they have standard hiring procedures (however such openings may be filled through networking), and generally not so much weight is put on personal recommendations alone. In contrast, for free-lance musicians, circumscribed word-of-mouth networks provide the major form of communicating opportunities—auditions, gigs, and band openings. Recommendations are a key part of this informal career process. A musician getting a pick-up band together for a short-notice gig usually has particular musicians in mind. If one of those musicians is already booked, it often falls to that musician to recommend a replacement. Free-lancers are often sidemen for several bands simultaneously; when there is a scheduling conflict, the musician who is double-booked often arranges for a temporary sub. Musicians obviously have an interest in protecting the gig-source and maintaining the respect of their peers by recommending someone who is both competent and amiable. Someone with a bad rep is less likely to hear word-of-mouth news or to be recommended for a pick-up band or as a sub. Clearly, while negative gossip is unpleasant and potentially damaging in any context, it can completely ruin a free-lance musician in a given locale. Obviously then, the relative importance of personality and attitude reflects the difference between a shifting, insecure environment and a structured environment in terms of competition and career paths.

To summarize the findings thus far, the status system of the free-lance musician is based on a balancing of three sets of traits: skills, adaptability/versatility, and personality/attitude. Table 4.2 provides a list of the traits that musicians identified as important in each of these three categories.

Table 4.2 lists personal traits identified as important in status judgments made by free-lance musicians. While these traits have the greatest impact on status judgments, various non-personal, occupation-related elements also influence such judgments. These elements include idiom, instrument, and venue (despite musicians' reluctance to rank these same elements on a skill-related continuum). Free-lance musicians agreed on the relative status rank of most occupational elements, regardless of personal idiom and instrument played. For example, musicians of all idioms agreed on the relative status of 14 different idioms (Table 4.3); and musicians with different primary instruments agreed on the relative status of 16 different instruments (Table 4.4).

TABLE 4.2

High-Importance Traits in Musicians' Status Judgments

Skill Traits	Adaptability Traits	Personality Traits
(45) Keeps time well	(43) Learns material	(46) Good attitude
(44) Consistent in	quickly	(42) Dependable
performance	(41) Versatile	(41) Good person-
(42) Reads well		ality
(41) Innate ability		
(41) Improvises well		
(40) Pitch-related		
ability		

Traits are listed under relevant category in order of importance. Numbers indicate average status scores given traits on a 0-50 point scale: 50 = highest possible; 46 = highest actual.

TABLE 4.3

Idiom Status Ranks

Idioms (Listed high to low)
(46) Classical
(42) Mainstream jazz
(31) Fusion
(28) Pop
(27) Progressive rock
(25) Rock
(24) Gospel
(23) Folk
(21) New wave
(20) Rhythm and blues
(17) Country-western
(15) Reggae
(12) Disco
(9) Punk

Numbers indicate the actual status scores given (averages), on a 0-50 point scale with the highest actual score average equaling 46.

TABLE 4.4

Instrument Status Ranks

Instruments (Listed high to low)
Strings (bowed instruments only)
Keyboards
Guitar
Woodwinds
High brass
Drums
Voice
Harp and recorder
Banjo and harmonica
Electric bass
Low brass
Percussion (not including drums)
Kazoo and mouth harp

Instruments were simply ranked without specific scores. The instruments listed on the same line received equal average ranks.

Strong agreement was also evident in judgments concerning career goals and specialty areas, and so on, just as agreement was strong in terms of personal traits in status judgments. Thus, even in this unstructured occupational context, there is a shared understanding of the criteria for status attribution. However, there were two discernible patterns of disagreement.

The first disagreement pattern is minor and does not really challenge the overall status schema. Free-lance musicians agree that classical music is the idiom at the highest status level, but classical musicians see a greater distance between the highest and the second highest than do the others. Similarly, members of the lowest-status stylistic groups, punk and disco, see more distance between themselves and others than is generally perceived by the other musicians. Interestingly, this situation reflects the findings of more general social stratification studies that show either end of a status continuum to be more sensitive to the extremity of its position than are others in the con-

tinuum (Coleman and Rainwater 1978). However, while the highest and lowest stylistic groups exaggerate the gap between their positions and immediately adjacent positions, they still agree on the overall rank order. This directional shift, then, concerns only the comparative distance between music idiom status ranks, not their comparative ordering.

The second disagreement pattern was quite rare and involved only one primary trait (versatility) of the 11 listed in Table 4.2; and two mediating elements (instrument and venue) of those mentioned in Tables 4.3 and 4.4. Disagreement concerning the relative importance of these three factors is closely tied to known career obstacles for particular subgroups of free-lance musicians.*

Networking and job entry in the free-lance music world are acknowledged to be more difficult for women than for men. Women consequently feel additional pressure to prove their professional worth. This differential pressure is reflected in the added stress women place on versatility as an attribute. Musicians agree that versatility is a primary status factor, but women consistently allocate more status points to versatility than do men. Job entry is especially difficult for female classical pianists due to the scarcity of openings in classical music settings, and the preponderance of female pianists, in general. Not too surprisingly, female classical pianists generally emphasize the importance of venue more than do their male counterparts, or other musicians. Finally, career pressures experienced by female vocalists are reflected in the relatively important position they give "instrument played" in attributing status. Vocalists are viewed with skepticism by both male and female players, who consider them to be an encroachment on serious performance. The mid-level rank of voice in the status continuum of instruments is misleading in that it reflects the prominence of voice in a performance situation and not the general disaffection with which most vocalists are viewed. Female vocalists' stress on instrument played indicates their sensitivity to specializing in one of the least respected instruments in the music world, compounded by the fact that they are female in a male-oriented

*The discussion on known career path obstacles is probably the most regionally influenced of all my findings.

environment. As can be seen, gender, mediated by other occupational elements, provided the strongest axis of disagreement in the status system of the free-lance musician (see Table 4.5).

TABLE 4.5

Instances of Status Disagreement

Category	Versatility	Venue	Instrument
Overall average score	41	30	13
Male average score	37	--	--
Female average score	45	--	--
Female classical piano	--	40	--
Female vocalists	--	--	35

Scores are recorded only where disagreement exists. No score indicates no disagreement pattern for that cell of the table.

It should be emphasized, however, that status disagreements are rare. Free-lance musicians, regardless of sex or other occupational elements, generally hold a common view of the status system operating in their occupational world. Nonetheless, the above examples show that status frictions may be felt by subgroups within the social unit for whom the status system is relevant. It follows, then, that separate status systems may evolve from different views of what makes up the social unit. More simply, if subgroups generate patterned status frictions, subcultures may generate whole new status systems. The fact that free-lance musicians maintain a status system in contrast to that found in other occupations can therefore be explained by looking at the free-lance music world as an occupational subculture.

A distinct cultural view emerges through an examination of the musicians' alternative status system. This view is expressed both in the specific traits attached to status attribution, and in the values underlying those traits. In more traditional occupations, prestige and social-standing

judgments stress individual gains in either demonstrable "progress" (i.e., promotion, education level, etc.) or in manifestations of material wealth. In contrast, free-lance musicians share a status system that stresses interactive abilities and the communal skills involved in group performance.

In conclusion, it is significant that in the absence of a stable structural context, there is still a commonly held status system and a shared understanding of important values. Constant flux, fluidity, and intense competition, far from generating chaos, actually form the standard features of the free-lance music world. Therefore, musicians do not hold atomized and particularistic status ideas that merely reflect individual career goals. Instead, a stable status system has evolved out of the values that facilitate day-to-day negotiation of this amorphous occupational setting. That is, the musicians do not ignore the uncertainties inherent in their occupation, but develop values in direct response to it. These values are expressed in the ways in which they attribute status to one another.

GLOSSARY OF MUSIC-RELATED TERMS

Blow my shit out the door To demonstrate superior skill.

Demo A recorded example of the musician's work.

Dig To enjoy.

Gig A music job.

Heavy An impressive talent or reputation in music.

Idiom A particular genre or language of music.

Jam To play improvised music together, socially.

Jazzer Musician who plays jazz exclusively.

Legit Legitimate.

Making the scene Hanging out socially with other musicians.

Pick-up band Temporary band recruited for specific gig.

Rap Talk.

Read (down a part) To sight-read a piece of music.

Rep Reputation.

Riff Improvised (usually) musical phrase.

Scoping out Checking on.

Sessioning Playing music together, socially.

Shedding Practicing.

Sidemen Non-permanent band member playing same position in several relatively stable bands.

Sight reading To be able to play a piece of music at first sight.

Sitting in Playing a piece at a gig while one of the band members takes a break.

Static Trouble, especially personality conflicts.

Subbing Filling in at a particular gig for a musician who could not make that specific gig.

Venue Performance setting (e.g., club, theatre, etc.).

BIBLIOGRAPHY

Becker, Howard, and Anselm Strauss. 1956. "Careers, Personalities and Adult Socialization." American Journal of Sociology 62 (November):253.

Berger, David G. 1971. "Status Attribution and Self Perception among Musicians." Sociological Quarterly 12 (Spring):259.

Coleman, Richard, and Lee Rainwater. 1978. Social Standing in America. New York: Basic Books.

DiMaggio, Paul, and Richard Peterson. 1975. "From Region to Class, the Changing Locus of Country Music: A Test of the Massification Hypothesis." Social Forces 53 (March):497.

Faulkner, Robert. 1971. Hollywood Studio Musicians. Chicago: Aldine-Atherton.

_____. 1973. "Career Concerns and Mobility Motivations of Orchestra Musicians." Sociological Quarterly 14 (Summer):334.

Garbin, A. P., and Frederick Bates. 1966. "Occupational Prestige and Its Correlates: A Re-Examination." Social Forces 44 (March):295.

Inkeles, Alex, and Peter Rossi. 1956. "National Comparison of Occupational Prestige." American Journal of Sociology 61 (January):329.

Nash, Dennison. 1957. "The Socialization of an Artist: The American Composer." Social Forces 35 (May):307.

Peterson, Richard, and Howard G. White. 1979. "Simplex Located in Art Worlds." Urban Life 7 (January):411.

Smith, Mapheus. 1943. "An Empirical Scale of Prestige Status of Occupations." American Sociological Review 8 (April):185.

Spaeth, Joe. 1979. "Vertical Differentiation among Occupations." American Sociological Review 44 (October):746.

Westby, David. 1960. "The Career Experience of Symphony Musicians." Social Forces 38 (March):223.

5

THE COMMUNITY AND
THE LOCAL ARTS CENTER

Linda Fritschner and Miles Hoffman

In the past ten years, community-level art councils, commissions, and public relations committees have developed to make the arts more central to the community. There are many reasons for this development and the concomitant concerns with audiences and the arts. The first and perhaps most important reason for this concern is the belief that participation in an arts audience contributes to the welfare of the individual. If the arts are a "good thing," then we must concern ourselves with those who are deprived of that experience.

A second reason for the concern with audiences is associated with the issue of financial support for the arts. Government support for the arts has a long-standing tradition in Europe and is coming of age in the United States. The National Endowment for the Arts, established in 1965 with a budget of $2.5 million, had grown to $166 million by 1984. As government support for the arts has grown, so too have conflicts over beneficiaries of this support, and over the functions of it as well.

Third, if the arts are considered dispassionately as a service and a product and nothing more, an effective marketing policy depends not only on some knowledge of those who want the commodity, but also on some knowledge of the arts as a service to be marketed. If arts organizations are to legitimate their public funding, they must demonstrate a certain amount of audience appeal for the services and products that they supply.

AUDIENCE SURVEYS AND THEIR INTERPRETATION

Audience surveys of arts organizations have been conducted for years, but few have been published, and many have been lost or buried in the organization that conducted them. Recently, some social scientists have tried to recover these surveys and compare their results (National Research Center for the Arts 1975; DiMaggio, Useem, and Brown 1978; DiMaggio and Useem 1983: 199–225); others have compared art audiences with the profiles of urban populations generally (Baumol and Bowen 1967: 71, 97; Paterson 1983); and some have concerned themselves with how art audiences vary from one art form to another (DiMaggio and Useem 1978a: 142–61).

The unambiguous result of these surveys and comparisons is that art audiences are generally more elite than the general public. In particular, the core of those audiences (those who attend arts events frequently) is more elite than the periphery (DiMaggio and Useem 1983: 217–18). Education (and, to a lesser extent, income) were the best predictors not only of who consumes the arts but also of the intensity of their consumption. When art audience characteristics are compared among several art forms, the remarkable finding is that the audiences are very similar. In the main, the audiences of high art forms (theater, symphony, opera, ballet, art museums) consist of people who are well educated, who have high incomes, and who are in their late youth and early middle age. These groups represent a median of 77 percent of theater goers, 75 percent of those attending ballet and dance performances, and 76 percent of audiences for symphonic music (DiMaggio and Useem 1978b: 364). Clerical, sales, service, and blue-collar workers are underrepresented among all art audiences. Not only are these findings consistent from one art form to another, but they are consistent from city to city, and from one performance to another (Baumol and Bowen 1967: 96).

ALTERNATIVE EXPLANATIONS OF THESE FINDINGS

Any number of explanations can be found for these patterns of arts consumption, and the choice of one over another will have effects on the marketing strategy selected by an organization seeking to expand its audience, and

legitimate its public financial support. One of the most common perspectives holds that the unequal consumption of urban services, including those of museums and other cultural organizations, is a function of discrimination against an "underclass." According to this hypothesis, a social group suffers from inadequate services because of certain characteristics of the service providers rather than attributes of the recipients (Lineberry 1977: 57). Inequalities in services are explained in terms of "bad motives, bad values, or even bad people" found in the service organization (Lineberry 1977: 62).

This underclass hypothesis requires two steps. First, a variation is noted among different demographic groups in the consumption of a service. Second, this variation is related to a discriminatory decision made by the provider of the service. In order to examine this hypothesis, it is useful to differentiate two types of demographic characteristics by which populations can be distinguished: ascriptive attributes and achieved attributes. Ascribed characteristics are those over which an individual has essentially no control. Age, sex, race, and ethnicity are ascriptive criteria. In contrast, education, occupation, income, marital status, and religion are examples of achieved attributes. Through personal efforts or failings, an individual has some control over achievement. Of course, those individual efforts can be thwarted by institutional arrangements.

When this hypothesis is applied to the arts, the case of suspected or demonstrated discrimination on the basis of ascribed attributes is weak. For example, DiMaggio and Useem's (1983: 204) analysis of 72 studies of 112 art audiences for which the sex of respondents was reported found that women were slightly overrepresented among art attenders, but that variation among audiences was significant. Men make up 49 percent of the U.S. population; they make up 46 percent of all types of museum audiences, and 43 percent of performing arts audiences. Sex composition varies also among art forms. Ballet and dance audiences are more heavily female (a median of 60 percent). Opera audiences draw the largest proportion of men (46 percent). Art museums draw a large female attendance (median 57 percent), while history and science museums attract slightly more men (52 percent). There is also wide variation among audiences within an art form: male proportion ranges from 30 to 71 percent in different

art museums, and from 31 to 58 percent at different per-
forming arts events. The variation between and within
art forms with respect to sex of audiences may, in part,
be accounted for by the survey time, performance or ex-
hibit content, or geographic area (DiMaggio and Useem
1983: 204-5).

There is also extensive age variation between and
within art forms. Baumol and Bowen (1967: 78-79) reported
that the typical art audience was far younger than the
urban population as a whole, and that the older the age
group, the smaller its relative representation in a typical
audience. Writing 15 years later, when the earlier arts
audience might simply have aged, DiMaggio and Useem
(1983: 205) report that typical art audiences had age pro-
files similar to that of the U.S. adult population, but that
specific audiences frequently diverged from this central
tendency. For example, of the performing arts, ballet and
theater attracted the youngest audiences with median ages
of 33 and 34, respectively, while opera and symphony drew
the oldest, with median ages of 41 and 40. The median
age for science museum visitor populations was 29, for art
museum visitors 31, for history museum visitors 33. There
is evidence to suggest that age composition varies by sea-
son, performance time (National Research Center for the
Arts 1976a, b, c), and type of program (Moore 1968;
National Research Center for the Arts 1976c).

There are very few art audience studies for which
data on race or ethnicity were collected. The existing
data indicate that blacks and other minorities are under-
represented in performing-arts audiences and among mu-
seum visitors relative to their share in the population.
However, it is likely that achieved attributes of poverty
or low levels of education, or preference for particular
subjects or performances, are largely responsible for the
low level of minority art audience attendance, not overt
discrimination by the arts organization on the basis of
the ascribed attribute of race. In fact, Baumol and
Bowen (1967: 75) reported that several persons experienced
in arts management noted that blacks do attend art per-
formances in considerable proportions when "Negro themes
and performers are presented," but infrequently otherwise.

In sum, except for race (and there the data are
absent, vague, or indecisive), a strong case can be made
that consumption of the arts is not related in any signifi-
cant way to the ascribed attributes of would-be audiences.

It would seem conclusive that arts organizations themselves do not discriminate on the basis of age or sex, and it is unlikely that they discriminate on the basis of race.

The data on achieved attributes are also unambiguous, but opposite in effect. The public for visual and performing arts is distinctly elite with regard to level of education, occupation, and income. And the data on achieved attributes and art audiences do not reveal any striking changes over the past 15 years.

Although arts audiences are elite in terms of achieved attributes, this does not mean that arts organizations discriminate against less educated and poorer non-elites (Peterson 1983). Rather, it may be the reverse: that is, the consumers of the arts discriminate. People use or consume public services, including the arts, for a variety of reasons. It may be that tastes, needs, or preferences are the primary factors that determine consumption, and not education, occupation, or income.

These observations suggest an explanation of art audience variations that not only looks at the demographic characteristics of consumers, but also inquires about the interests and motivations of consumers and nonconsumers. What we call the "consumer attribute hypothesis" suggests that art consumption is a function of consumer characteristics, not of overt or covert discrimination by artists or arts organization personnel. Cultural literacy (i.e., familiarity with the arts and art styles, personal involvement with them, etc.), informal networks for dissemination of information about art events, and peer pressure are consumer attributes that can affect participation in arts audiences.

On the other hand, consumption patterns may also reflect decisions of the service providers. The "service attribute hypothesis" suggests decisions made by service providers have an impact on consumption patterns (Lineberry 1977: 64–66). These decisions may not reflect a consistent class bias but rather are made for "administrative" reasons. Formal publicity for art events, the focus of the publicity, the location of the art event, access to that location, and the setting in which the arts are presented are examples of service attributes that can affect audience composition.

Obviously, the underclass hypothesis, the consumer attributes hypothesis, and the service attributes hypothesis are not inherently incompatible. People become arts con-

sumers because of their own attributes, and the attributes
of the arts themselves. However, by separating service
attributes from consumer attributes, we can determine if
there are differences in the way the arts are delivered
which distort consumer preferences, and which, if identi-
fied, could be changed to make the arts more democrati-
cally available.

THE LOCAL ART CENTER STUDY: METHODOLOGY

The "Home County" Art Center of this report is a
nonprofit organization governed by a volunteer board of
local notables and artists. It promotes the visual arts by
displaying paintings, photographs, and sculpture, by pro-
viding studios and darkroom space to professional and
amateur artists, and by offering classes and lectures. It
is located in the county seat of a Midwestern state, in a
city of some 110,000.
The Art Center has been located in several different
buildings since its founding in 1947 and, in the late 1970s,
it joined a historical museum and a theater company as
occupants of a new downtown convention center. Local and
out-of-town groups regularly use the convention center for
trade shows and sales, exhibits, banquets, and other
functions. In this location, the Art Center has two gal-
leries, a number of studios and darkrooms, and classroom
facilities. The Center is staffed by a director, an edu-
cational coordinator, a curator, and two other full-time
employees, plus ten part-time staff members. The art
faculty numbers 25. The annual budget at the time of our
survey was approximately $250,000, about half of which
was contributed by the school corporation, the city, Home
County, and the state arts council. Other funds came from
class fees, memberships, and fund drives.
The board of directors and the public relations com-
mittee of the Art Center commissioned our study to deter-
mine what portions of the community they reached with
what activities, and what portions they did not reach.
The basic technical operation of our survey involved com-
paring the 1,207 visitors to the Art Center during March
1982 to the population of the same geographical area ("Home
County," with a population of nearly 242,000) using U.S.
census records for 1980.

Like other art audience surveys, our questionnaire
provided information on ascribed attributes (sex and age)
and achieved attributes (education, occupation, and resi-
dence). We did not inquire specifically about race or
income because it was felt by the members of the Art Cen-
ter board that such questions might offend some visitors.
If we were to collect the data at all, we had to make
some compromises. Information about income can be deter-
mined from responses to questions about occupation, educa-
tion, and place of residence. Race could be inferred
visually; in this case, very few members of racial minor-
ities attended the Art Center during the month of the sur-
vey, although they make up 9 percent of Home County
population and 18 percent of the city population. Their
low level of arts involvement (as measured by participation
in the formal "art world" of this Art Center) is consistent
with the findings of other audience surveys.

Comparable data on Home County population were
abstracted from the 1980 census for sex, age, occupation,
and education. While the county, with an area of 466
square miles, accounts for over 60 percent of Art Center
visitors, obviously the center serves a wider constituency
as well. In any event, the results of this demographic
comparison tell us how the Art Center audience is differ-
entiated from the county population in general on the basis
of both ascribed and achieved attributes.

Our data also allowed us to examine other variables
that, either separately or together, may influence art con-
sumption patterns. These are both consumer attributes
(other than race and social class) and art-world institu-
tion attributes. Our survey asked two types of questions
concerning consumer attributes. First, we inquired about
involvement in art and about various artistic activities
that people were presently engaged in. Second, we asked
Art Center visitors for their home addresses. By locating
the addresses by area within a census tract, we could
make some observations about informal art networks or peer
pressures which might affect art audience participation.
It is not an unreasonable supposition that one's involve-
ment in art and friendship networks may affect art audi-
ence participation despite education or occupation. At any
rate, we wanted to test the hypothesis. Although other
surveys of arts audiences have asked Americans about their
interest and involvement in art, they have not analyzed

the results to see if these consumer attributes explain art audience participation.

Attributes of the art world institution also account for consumer decisions to attend or to avoid a particular art event. To test this service attribute hypothesis, we compared visitors who attended the local Art Center on a widely publicized special open house, "Bigday," with those who visited the Art Center at other times. We also compared gallery goers with class attenders.

The Art Center offers classes in addition to serving as an art gallery. Through the classes it not only reaches out into the community to acquire active participants, but it also attempts to broaden its audience base through education in the arts. However, the classes may discriminate against certain groups. It costs money to enroll in the classes, while the galleries are free. The price of the classes might discourage poorer groups from participation. They might have personal motivation to attend, but could not act on that motivation because of the price of the service itself. Thus we compared art class attenders with gallery visitors on the basis of education and occupation. The results of our tests of the service attribute hypothesis are surprising and interesting.

FINDINGS FROM THE LOCAL ART CENTER STUDY:
THE UNDERCLASS HYPOTHESIS

Very generally our findings on audience composition replicate those of other studies. Women make up 58 percent of the Art Center audience, a higher proportion than they make up in the general Home County population. There is a much greater difference between visitors and county population in terms of age, the other ascriptive attribute: while only 26 percent of the county is between the ages of 25 and 44, fully half of Art Center visitors fall within this age bracket. Those under 19 and those over 64 years of age are most underrepresented at the Art Center, compared with their respective proportions of the county population.

Not surprisingly, achieved attributes of education and occupation also distinguish visitors from the wider population. Eighty-one percent of the visitors and only 27 percent of the county population had 13 or more years of schooling. Consistent with their education, Art Center

visitors are drawn most noticeably from managerial and professional occupants (64 percent, compared with a county proportion of 22 percent). Technical, sales and administrative support occupations, service, household, and blue-collar workers are correspondingly underrepresented as visitors. However, skilled workers (precision production, craft, and repair occupations) who visit the Art Center do so in the same proportion as their distribution in the county (12 percent).

Obviously, attendance patterns here are related to demographic attributes, both ascribed and achieved. The correlations tell us little about why these relationships exist, however. While they are consistent with the underclass hypothesis, which would cast blame on the Art Center for failing to reach excluded groups, other explanations are possible.

FINDINGS FROM THE LOCAL ART CENTER STUDY: THE CONSUMER ATTRIBUTE HYPOTHESIS

This hypothesis seeks explanations for the demographic composition of art audiences on the basis of attributes of the consumers themselves. Our data permitted measurement of two such attributes: "art involvement" and "informal networks."

To construct a measure of art involvement, we asked visitors to indicate whether they were professional artists, amateur artists, appreciator-dabblers, or appreciators-who-used-to-dabble in art. Forty-nine percent selected one of these responses, which we term "active involvement in art." Another 35 percent said that they "appreciated" art but were not actively involved with it, not even as ex-dabblers, and 16 percent indicated that they had "no involvement" with the arts at all, not even as "appreciators."

This consumer attribute varies significantly among Art Center visitors from different places of residence. Those from Home County are much more likely to be involved in art than are visitors from other areas (54 percent compared to 40 percent). Moreover, for the 40 percent non-county residents who are arts-involved, there is a strong relationship with upper levels of occupation and education. But our data for the 54 percent of arts-involved Home County residents show no relationship between art involvement and education or occupation.

We do not have the data to explain why so many visitors come to the Art Center from outside the county despite such a low level of art involvement. We assume that for them, Art Center attendance may have happened casually as a weekend outing or as a result of visiting relatives. In other words, they came as tourists to the Art Center, one of the main attractions of the local area.

In any event, there is a diversity of factors associated with Art Center attendance. Certainly for Home County residents, art involvement is a key ingredient: blue-collar workers without the educational or occupational training to decode artworks, and without the tourist orientation noted for noncounty visitors, are as likely as county professionals and managers to be actively involved in art. This is evidence that a distinct consumer attribute (arts involvement) motivates some of the visitors to the Art Center.

Among other important consumer attributes that affect attendance at art events are informal social networks. Obviously, visitors at the Art Center were voting with their feet. Our survey did not probe the relationship between those who were nonarts-involved and any particular interest they might otherwise have had in a specific exhibit for nonaesthetic reasons. But the survey did ask visitors for their home addresses, so that we could furnish the Art Center with a mailing list. These data permitted us to investigate the existence of informal social networks that might have affected audience composition.

By locating Art Center visitors by census tract, we could determine if attenders were drawn from particular areas, and further if they tended to cluster within these areas. Certainly, such data are imperfect measures of the effect of informal networks, of family, friends, and acquaintances, on attendance or nonattendance. For example, the telephone can shorten geographic distances, in which case we might expect that visitors to the Art Center would be randomly distributed within the geographic area, and still a social network could have its effect on attendance. However, the tract analysis revealed that geographic clustering did occur, by census tract (itself a measure of class to some degree), as well as by sectors within particular tracts. The residence patterns of attenders suggest that informal networks do have an effect irrespective of occupation and education, and that the effect can be two-pronged: they can work to encourage (high cluster areas)

or discourage (low cluster areas) attendance at the Art Center and perhaps at other art events as well.

FINDINGS FROM THE LOCAL ART CENTER STUDY: THE SERVICE ATTRIBUTES HYPOTHESIS

Almost all discussions of the relationship of culture to democracy have focused on the creators of the arts, or on the consumers, but seldom on the distributor. Yet decisions made by such service providers may have a powerful impact on the composition of art audiences independent of their attributes as consumers or their demographic characteristics. Our study includes data on two service delivery choices of the Art Center: the marketing of classes and the extensive publicity for an open house. Both of these service attributes were initiated by the Art Center in an attempt to broaden its audience base, with, as we discovered, different degrees of success.

Each calendar quarter the Art Center offers a five-week series of day and evening classes, plus special one-time workshops. The subjects range from basic drawing, oil painting, and pottery, to wood carving, photography, and spinning. There are classes for children as well as adults, and at various levels of skill. The education staff markets these classes extensively, searching for ways to reach the class-taking consumer ahead of competition from continuing education programs of the local state university, as well as from the YMCA and YWCA. Marketing tools include traditional advertising plus such lures as a 10 percent discount on class fees for members and, until recently, free parking. Class fees at the time of our survey ranged from $20 to $55 for ten class sessions; individual workshops and children's classes were less expensive.

Are there systematic differences between the audience for the free galleries and the clientele of the classes on any of our measures, and are these measures related to the service attribute of marketing? The most striking difference between the two audiences was in their place of residence: 94 percent of class attenders reside in Home County, while only 58 percent of gallery goers do so. Of course, classes demand regular attendance, and thus participants are likely to live nearby. Still, many of those from outside the county need drive only half an hour or so to reach the Art Center, so that greater driving time

would seem insignficant if the motivation to take a class was strong. In any event, the Art Center's outreach efforts in promoting its classes may increase its local draw, but they seem to have had little impact on the enrollment choices of out-of-county residents.

Although there are limitations on the reach of this marketing, the promotion of art classes does have an effect on the class composition of Home County enrollees. Professionals and managers comprise 42 percent of the gallery audience, but 49 percent of class enrollees. Sales, clerical, and blue-collar occupations contribute only half as many class attenders as they do gallery viewers. The picture is less distinct for education, but there is a tendency for class participants to have a higher level of education than gallery visitors.

In sum, by offering and promoting classes, the Art Center is attracting from Home County a clientele of a higher occupational and educational status than it is otherwise attracting to its galleries. To put the same thing another way, the center is attracting to its galleries a more broadly representative public than it is to its classes. The marketing techniques used by education staff are bringing in only a very few lower-status consumers.

This is not the only marketing program of the Art Center, however. During the time of our survey the center launched a major effort to attract visitors, through a widely publicized Sunday afternoon open house. Art class studios were open and free, new exhibits in both galleries were on display, and members of the board of directors were on hand to welcome visitors.

The large turnout on this Bigday was gratifying to the Art Center's board and staff: 37 percent of our entire month's sample attended on that one afternoon. And those who came were less likely than visitors on other days to be high in occupational and educational status. This suggests that democratization of art consumption is not beyond the capability of cultural providers. Perhaps this is true of the "blockbuster" exhibits scheduled by major museums (such as the "King Tut" show several years ago), which also seem to attract a much more demographically mixed audience than is typical for regular shows.

Before concluding that service attributes, at least the promotion of an open house, can seriously affect art audience composition, it is worthwhile exploring the

extent of correlation between this service attribute and
the consumer attribute of art involvement. In other words,
is the audience composition on Bigday the "pull" of Art
Center publicity and novel programming, or the "push" of
an existing high level of art involvement?

Here, we disaggregated our category of "art in-
volvement" to record separately the responses of "profes-
sional or amateur artists" and "dabblers." This revealed
that the former attend in greater proportions on days
other than Bigday, while the latter were overrepresented
at that special event. "Appreciators" were present in the
same proportion, and those with no arts involvement formed
a slightly larger share of the Bigday audience than that
of other days. It would seem, then, that the service at-
tribute rather than the consumer attribute of "arts involve-
ment" was the significant factor in accounting for the
audience composition on Bigday. This outreach program by
the Arts Center did seem to work in attracting a new and
more representative audience.

CONCLUSIONS

The data from this survey of visitors to one Art
Center are highly consistent with the findings reported in
other audience studies of the arts. Except for race (where
the data are absent, vague, or inconclusive), the con-
sumption of the arts is not related in any significant way
to ascribed demographic attributes. The arts are not dis-
criminating on the basis of age and sex. The data on
achieved attributes are also clear: The composition of art
audiences is biased toward the occupationally and educa-
tionally elite strata of the population.

These clear findings, however, could not account
for the pluralism of motivations behind aggregate audience
composition patterns. To develop more variegated ap-
proaches to this issue, we drew on the work of Lineberry
(1977) and constructed hypotheses based on consumer at-
tributes, as well as on attributes of the cultural service
provider. The data from this survey provide support for
these hypotheses and begin to suggest why certain types
of people consume the arts more than others, and how the
role of arts institutions and their managers contribute to
consumption patterns.

The data support the proposition that two "consumer attributes" (art involvement and social networks) are not merely reflections of audience demographic characteristics. They each tap factors that are important in motivating consumers to attend art galleries or classes. A high level of art involvement, for instance, appears to explain the attendance of both blue-collar workers and of professionals alike. Thus the consumer attribute hypothesis directs attention to the motivations of those who do attend art events, as well as those who do not attend.

Social networks also have an effect on art audience attendance. Visitors to the local Art Center were not randomly distributed within the census tracts, but rather clustered. Although we do not know specifically how informal networks operate in this regard, their patterns suggest that they do work to encourage or discourage attendance at the Art Center.

Motivational and social network data illuminate the factors that weakly or strongly "push" audiences toward cultural disseminators. But the museums and other arts institutions are clearly not passive; as we have demonstrated here, they are actors engaged in "pulling" or "repulsing" different groups. While decisions made by service delivery administrators are sometimes invidious and discriminating toward some demographic groups, there is no reason to assume that they are always thus. Such decisions can discriminate for groups as well as against them. For example, the staff and board members of the Art Center commissioned our audience survey so that they could rethink and perhaps alter their marketing and service patterns. Both routine decisions of cultural providers and the exceptional choices (e.g., to stage a Bigday) can significantly affect the composition of their audience.

The data from our survey showed that the service attributes of the Art Center produced mixed results. Marketing art classes has not created a more democratic audience structure, but the publicity of an open house did lend to a one-day audience profile that was more heterogeneous. In fact, the large proportion of blue-collar workers and of those with no arts involvement who were attracted by Bigday advertising suggests that the Art Center is indeed open, providing access to the as-yet-uninvolved who might become interested in the arts.

Clearly, this study suggests that both the consumer attribute hypothesis and the service attribute hypothesis

have merit. There is a need for direct motivational data on why consumers, elite and nonelite, attend or avoid various art institutions. The impact of a variety of service attributes on art audience composition is another fruitful area where sociological investigation could be useful. By exploring both consumer and service attributes that affect art audiences and in turn, arts institutions, we are directly investigating the agencies of change in cultural consumption.

BIBLIOGRAPHY

Baumol, William J., and William C. Bowen. 1967. Performing Arts--The Economic Dilemma. New York: The Twentieth Century Fund.

DiMaggio, Paul, and Michael Useem. 1978a. "Social Class and Arts Consumption: The Origins and Consequences of Class Differences in Exposure to the Arts in America." Theory and Society 5 (March):141-61.

_____. 1978b. "Cultural Property and in Public Policy: Emerging Tensions in Government Support for the Arts." Social Research 45 (Summer):356-89.

_____. 1983. "Cultural Democracy in Period of Cultural Expansion: the Social Composition of Art Audiences in the United States." In Performers and Performances: the Social Organization of Artistic Work, edited by Jack B. Kamerman and Rosanne Martorella, 199-225. New York: Praeger.

DiMaggio, Paul, Michael Useem, and Paula Brown. 1978. Audience Studies of the Performing Arts and Museums. Washington, D.C.: National Endowment for the Arts.

Lineberry, Robert L. 1977. Equality and Urban Policy: The Distribution of Municipal Public Service. Beverly Hills, Calif.: Sage Publications.

Moore, Thomas Gale. 1968. The Economics of the American Theater. Durham, N.C.: Duke University Press.

National Research Center for the Arts. 1975. Americans and the Arts: A Survey of Public Opinion. New York: Associated Council of the Arts.

_____. 1976a. A Study of Washingtonians' Attendance at Performing Arts Events and Museums. New York: National Research Center for the Arts.

_____. 1976b. The New York Cultural Consumer. New York: New York Foundation for the Arts.

_____. 1976c. The Joffrey Ballet Audience: A Survey of the Spring 1976 Season at the City Center Theater. New York: National Research Center for the Arts.

Netzer, Dick. 1978. The Subsidized Muse: Public Support for the Arts in the United States. Cambridge: Cambridge University Press.

O'Hare, Michael. 1974. "The Audience of the Museum of Fine Arts." Curator 17, no. 2:126–59.

Peterson, Richard A. 1983. "Patterns of Cultural Choice: A Prolegomenon." American Behavioral Scientist 26 (March–April):422–38.

Toffler, Alvin. 1965. The Cultural Consumers. Baltimore, Md.: Penguin Books.

6

CONFORMITY AND DIVERSITY IN AMERICAN RESIDENT THEATERS

Paul DiMaggio and Kristen Stenberg

A key tenet of public policy toward the arts in the United States and abroad is that cultural diversity and innovation are goods that are to be encouraged. Innovation is seen as central to the progress of art, while diversity serves the interests of both artists and their publics. Despite the centrality of these closely related values to public policy, arts agencies do not monitor systematically the product diversity of the industries they support. Nor have social scientists, in general, exhibited much interest in measuring and explaining variation in the diversity of artistic products available to the public.[1]

Two exceptions--the work of Peterson and Berger (1975) on the recording industry and of Griswold (1981) on American publishing in the nineteenth century--concern commercial media settings too different from contemporary U.S. nonprofit arts production to permit easy generalization of their findings. For Peterson and Berger, innovation in popular music arose from a conjunction of technological and regulatory change and unsated consumer demand. Griswold found that America's failure to adopt the international copyright convention before 1891 made it cheaper for U.S. publishers to pirate British work than to publish

We are grateful to Wendy Griswold and to the editors of this volume for sage comments on earlier versions of this paper.

novels by Americans. Consequently, those U.S. authors whose work was published tended to treat topics and adopt perspectives that were unavailable from their British counterparts.

Performing-arts production has faced neither regulatory upheaval nor dramatic technological change in recent years. Nor can we posit with much plausibility the existence of pent up demand for unconventional or innovative dance, music, or theatre. Consequently, if we are to explain change in the diversity of high-culture performance, we are likely to find that the driving factors are different from those in commercial culture production. Some trend data on performing-arts repertoires have been offered by Mueller (1951), Mueller (1973), and Martorella (1982), for symphony orchestras and operas. In this paper, however, we report on a new approach to measuring and identifying trends in product diversity in a high-culture art form.

The focus of this research is the repertoire of American resident theatres between the years 1971 and 1981. After describing the institutional context of the American resident stage and the population of theatres we have studied, we shall introduce our measures of diversity, demonstrate how diversity has changed over the past decade, and provide some preliminary evidence to explain the changes we observe. In conclusion, we shall discuss the relevance of our findings to public policy toward the arts.

THE AMERICAN RESIDENT STAGE

The resident-theatre movement developed slowly throughout the 1940s and 1950s, primarily sponsored by enthusiastic amateurs as an effort to bring serious dramatic performance to communities outside of New York City. Embraced by the Ford Foundation in the late 1950s, these local efforts developed into a national movement to create resident professional companies of actors in every corner of the nation. In its early years, partisans referred to their cause as "the regional theatre movement." As the campaign swelled, however, and other foundations, the National Endowment for the Arts, and state arts agencies joined the Ford Foundation in support, the movement came to include permanent companies in Off- and Off-Off-Broadway,

as well as in the hinterlands. In recent years, the resident stage has established for itself a substantial role in the national theatre industry as a training ground and source of regular employment for actors, directors, and technicians; and increasingly as a source of new plays and musicals for commercial Broadway producers.

In the course of its brief but successful history, the resident stage has both prospered and undergone several crises of confidence. As Joseph Zeigler (1977), the movement's historian, has noted, many of the pioneer theatre founders were committed to a new and more artistically dynamic view of the stage. They "sought to dislodge the overwhelming psychological power of the New York commercial theatre," which they "saw as moribund and perverse" (170-71). In the last decade, however, as many resident theatres have become large, complex, established entities, some participants in and observers of the resident-theatre world have come to question the extent to which these theatres still serve the cause of artistic dynamism and innovation. As early as the late 1960s and early 1970s, critics contended that the institution-building approach favored by the Ford Foundation and the Arts Endowment had generated creative malaise and "the spectre of boredom" (Zeigler 1977: 186). More recently, Joan Jeffri (1980) has noted the tendency in large theatres for commercial considerations to overwhelm artistic urges. The director of the National Endowment for the Arts Theatre Program writes that "despite its many successes, the movement has not realized some of the important ideals on which it was founded . . . if the movement is to give priority to artistic goals at all, changes must be made in its support and governance structures" (Martenson 1983: 9-10). Indeed some critics contend that resident theatres have traded artistic vitality and red ink for fiscal health and an "artistic deficit" (Zeisler 1984).

Contentions that the resident stage has become more conservative and less adventuresome in its selection of repertoire have had implicit in them three rather distinct arguments.

First, it is sometimes argued that aging causes conservatism, that older theatres lose the creative spark. Artistic directors burn themselves out, new aesthetic philosophies reach their limits and turn stale, or turnover of key staff causes the theatre to drift from its initial artistic mission.

Second, loss of artistic vitality is often attributed to growth. Growth in organizational scale and complexity requires larger and more influential administrative components and relatively long-term planning (which by theatre standards may refer to horizons of two years or less). Large budgets and planning require reductions in uncertainty posed by the theatre's market, which in turn leads to more commercial and less adventuresome repertoires. "The larger and more complex the operation, the more likely a theater is to shift its major emphasis from putting on plays to insuring its growth and survival as an institution" (Poggi 1968: 235).

Third, artistic conformity is said to arise from "institutionalization." In contrast to its usual social science definition referring to internal development, participants in the resident stage use the term as well to refer to the process of developing close ties to the external environment, that is, to the community in which a theatre resides. Such ties, in turn, provide legitimacy and stability. In practice, institutionalization usually involves four related components: placing community leaders on the theatre's board of trustees; building a permanent house for the theatre company; earning an increased proportion of the theatre's income through sale of services; and expanding the subscription audience. Any of these steps, it is argued, may induce conservative programming. Community leaders, especially businessmen, say, as board members, bridle at controversial or experimental programs, as may subscribers. Dependence on earned income and the need to keep up a permanent house raise the cost of box-office failure.

These arguments suggest a paradoxical conflict between two of the key missions of the resident theatre movement: developing a broad popular audience for theatre and serving as sources of innovation and breadth in the dramatic literature. If these arguments are correct, precisely those theatres best equipped to serve the first purpose may be least able to serve the second.

The debate over the vitality of the resident stage has been passionate and anecdotally rich, but it has been conducted in an empirical vacuum. We shall attempt to establish the extent to which one dimension of artistic vitality—the diversity of repertoire that resident theatres offer to the public—has changed over the past decade. But first we must consider the problem of measuring diversity.

MEASURING DIVERSITY OF REPERTOIRE

We take as our population theatres that were mem-
bers of the Theatre Communications Group, the service
organization of the resident stage, during the period 1971
through 1981. The membership of the Theatre Communica-
tions Group (TCG) increased steadily over this period (as
did the number of resident theatres in existence) from 88
in 1971–73 to 166 in 1979–81.[2] TCG was created by the
Ford Foundation in the early 1960s in order to facilitate
interaction among theatres to which the Foundation had
made grants. By the late 1960s, TCG had separated from
Ford and become an open-membership service organization
for the nonprofit resident stage. By the 1970s, theatres
that identified with the resident-theatre movement tended to
join TCG, much as any significant firm might join its in-
dustry's trade association. TCG membership includes vir-
tually all large resident theatres in the United States
(including the members of the League of Resident Theatres,
the industry's collective-bargaining group); and it in-
cludes all theatres from which National Endowment for the
Arts Theatre Program panelists were selected in three sam-
ple years. TCG tends not to include theatres that are
very small, very poor, exclusively local in orientation, or
primarily directed to political or social rather than con-
ventionally defined aesthetic goals. Consequently, while
TCG membership does not exhaust the number of American
theatre companies (some 620 according to a recent report
[Mathematica Research Inc. 1981]), it does include vir-
tually all aesthetically oriented U.S. resident theatre com-
panies of influence or magnitude. One hundred sixty-six
theatres appeared in the 1980–81 TCG directory, the most
recent source consulted for the purposes of this paper.

The measures of diversity that we have used are
based on lists of productions published in TCG's biennial
directories, covering each theatre season from 1971–72
through 1980–81. In charting trends over the decade, we
developed two different measures, the first based on the
play and the second based on the theatre as the unit of
analysis.

The first is the Herfindahl index, a measure of
concentration used widely in industrial economics. Ap-
plied to theatre repertoires (i.e., to plays), the Herfindahl
index is the sum of the squares of the percentage of the
total number of all productions represented by the number

of productions of each play produced during each two-season period.[3] The more homogeneous the programming, the higher the Herfindahl index figure; the more diverse, the lower the index figure.

Our second measure is based on an aggregation of data in which the theatre rather than the play is the unit of analysis. For each theatre in each two-year period, we constructed a conformity index. This index is the mean number of times that each play a given theatre produced was produced by all theatres in a given two-year period. A score of 1 on the index means that no other theatre produced any of the plays in that theatre's repertoire. A score of 8 means that, on average, each play in that theatre's repertoire was produced by seven other theatres during the period in question. To establish the level of diversity for the field as a whole for a given two-year period, we simply take the mean of this measure for all theatres active during that period. The higher it is, the lower the level of diversity.

The raw conformity indices are suitable for comparing theatres within each of the time periods. In order to compare diversity levels over time, however, it is necessary to correct this measure to account for the fact that there are varying numbers of theatres (and varying numbers of productions) from period to period. This corrected conformity measure is simply the raw conformity measure divided by two times the number of theatres producing plays during that period. (The number of theatres is doubled in the denominator because theatres could produce the same play in each of two seasons.) Thus the adjusted conformity index is the average number of times each theatre's typical play was produced by all theatres over a two-year period as a percentage of the maximum number of times it could have been produced if (1) all theatres produced the same plays and (2) each theatre mounted the same number of productions in every season. Hereafter, we shall refer to the raw conformity measure as the "conformity index" and to the adjusted conformity measure as the "conformity ratio." We shall use the latter for all intertemporal comparisons.[4]

At the level of the resident theatre field as a whole, there is no question that the measures used here measure diversity of repertoire in a very literal sense. Nonetheless, there are two dimensions of diversity that these measures cannot capture. They cannot tap change

TABLE 6.1

Sample Repertoires from Two Theatres in the Most and Two
Theatres in the Least Conformist Quintiles, 1977–79 Seasons

Highest quintile conformity ratio

 Theatre 1
 1977–78

 Tartuffe, Molière
 The Odd Couple, Simon
 Bus Stop, Inge

 1978–79

 The Importance of Being Earnest, Wilde
 Wait Until Dark, Knott
 They Knew What They Wanted, Howard
 Of Mice and Men, Steinbeck

 Theatre 2
 1977–78

 Cyrano de Bergerac, Rostand
 Violano Virtuoso, Suyker
 Othello, Shakespeare
 Streamers, Rabe
 Absurd Person Singular, Ayckbourn
 The Drunkard, Smith/Herod/Manilow

 1978–79

 As You Like It, Shakespeare
 The Night of the Iguana, Williams
 A Flea in Her Ear, Feydeau
 The Shadow Box, Cristofer
 The Member of the Wedding, McCullers
 Irma la Douce, Breffort

Lowest quintile conformity ratio

 Theatre 3
 1977–78

 Cockfight, Jackson
 Passing Game, Tesich
 Fetu and Her Friends, Fornes
 Conjuring an Event, Nelson

1978-79

The Grinding Machine, Alexander
Touching Bottom, Tesich
Seduced, Shepard
Tunnel Fever or the Sheep is Out, Reynolds

Theatre 4
 1977-78

Losers, Wollner
The Booth Brothers, Kliewer
The Man Who Drew Circles, Somkin
The Verandah, Mason
The Sugar Bowl, Taikeff
Avenue B, Gilhooley
Filigree People, Dee
Marvelous Brown, Kagan

1978-79

Father Dreams, Gallagher
The Ravelle's Comeback, Gilhooley
Flagship, Wollner
Metro Park, Radano
Singles, Lord
The Corridor, Kagan
Mothers and Daughters, von Hartz
Roosters, Yaven
A Cock to Asclepius, Taikeff
Stray Vessels, Yaven
Dancin' to Calliope, Gilhooley
The Feathered Serpent, Mabley

Source: Compiled by the authors.

in the boundaries of topics that audiences find acceptable.
Nor are these measures sensitive to variation in performance
styles: conventional and experimental productions of the
same play are treated as identical in these measures. We
are less discomfited by these limitations than we might be
because we believe that, in general, conformity in the
selection of plays produced is positively associated with
conventionality in theme and style of performance (neither
of which is so amenable to measurement); and because we
believe that diversity of repertoire is important in its own
right, as an index of the ability of playwrights to have
their works produced, criticized, and thus entered into the
dramatic literature.

Diversity, by definition, is a characteristic of
aggregates, not of single cases. We are inclined to re-
gard "diversity" at the level of the field as a whole as
being comparable to "innovativeness" at the level of the
individual theatre. The definition of innovation is murky
even in the study of technological advance, and all the
more so in the case of the arts. Theatres (and other arts
organizations) are routine product innovators, consistently
changing their presentations to the public. Some go be-
yond routine innovation to offer presentations of work that
is rarely produced. Some innovate in style of performance
or interpretation. We believe that our measure of con-
formity captures the first sense of nonroutine innovation
and is a good proxy for the latter.[5] Because we are con-
cerned with the diversity of the active repertoire of U.S.
theatres, we regard a theatre as innovating as much if it
produces a classic work that has gone unperformed for many
years as if it produces a new play.

To permit the reader to subject this measure to his
or her own intuitive test, we have selected at random two
theatres in the highest and two theatres in the lowest
quintile of the conformity measure during the 1977-79 pe-
riod, and display two season repertoires from each in
Table 6.1. We believe that these illustrations suggest that
the conformity index has a high degree of face validity.

TRENDS IN DIVERSITY

Throughout the brief history of resident theatres,
it has been argued that the movement has lost its artistic
spark. We cannot assess these contentions for the period

prior to 1971 because adequate data are not available.
But to the extent that diversity in repertoire is associated
with artistic vitality, we can cast some light on the past
decade. Table 6.2 illustrates change in the Herfindahl
index of concentration of productions, while Table 6.3 re-
ports change over time in the mean conformity ratio over
the decade in question. (Recall that for each measure
high scores indicate more conformity and less diversity
than do low scores.)

Although the Herfindahl indexes are calculated on
the basis of plays and productions, while the conformity
ratios are calculated on the basis of theatre scores, they
tell much the same story. Conformity actually decreased
(i.e., innovation increased) during the middle of the
decade--by about 20 percent in the Herfindahl index and
by approximately 30 percent in the conformity ratio--but
then returned to just below its initial level by the 1979-81
season.

Discounting broader societal factors, within the
world of resident theatre itself what explains the initial
decline in conformity in the third period and the increase
toward the end of the decade? The most notable change is
a sharp increase in the number of TCG theatres and in the
number of plays that they produced between 1973-75 and
1975-77--from 100 to 152 theatres and from 1,288 to 1,838
productions. The expansion in the number of theatres
slowed between the third and fourth periods (the total up
by only 11 percent), but the number of productions con-
tinued to increase (by another 23 percent, to double the
1971-73 number). Growth in both the number of theatres
and productions stagnated between the fourth and fifth
periods, suggesting that diversity in repertoire increases
as a field grows and decreases when activity is static.
Note that this finding is not artifactitious: If new theatres
simply performed the same plays as the old ones, an ex-
pansion of the field would not lower the conformity ratio.

The contribution of those theatres that entered the
population between the second and third periods to the
increase in diversity in the aggregate repertoire is evi-
dent when we note that the average play produced by the
62 new theatres in 1975-77 was produced by 1.194 other
theatres during the two-year period. By contrast, the
average play produced by the 88 theatres that were not
new to TCG was presented by 1.609 other theatres. In
other periods, new theatres were more similar in conformity

TABLE 6.2

Herfindahl Indexes by Two-Year Intervals

High score indicates homogeneity, low score diversity. NP, number of productions; NT, number of theatres.

Source: Compiled by the authors.

TABLE 6.3

Mean Adjusted Diversity Ratios over Time

Ratio

| 0.012 | 0.010 | 0.008 | 0.006 | 0.004 | 0.002 |

1971–73
NP 1085
NT 87

1973–75
NP 1288
NT 98

1975–77
NP 1838
NT 150

1977–79
NP 2281
NT 164

1979–81
NP 2420
NT 165

Figures and abbreviations as in Table 6.2.
Source: Compiled by the authors.

127

to old ones. (The reason for this inter-period difference is not obvious.)

Throughout the decade, theatres that were members of TCG for only one period were notably less conformist than those that remained in the population for two or more periods. The conformity ratios for theatres already in the population, new theatres that remained in the population for at least two periods, and new theatres in TCG for only one period are presented in Table 6.4.

TABLE 6.4

Mean Conformity Ratios for Old and New Theatres

	Period					
	1973-75		1975-77		1977-79	
	N	Mean	N	Mean	N	Mean
Old theatres	72	0.0117	88	0.0087	133	0.0090
New theatres (>1 period)	22	0.0104	51	0.0076	24	0.0107
New theatres (1 period only)	4	0.0085	11	0.0058	7	0.0054

High score indicates greater conformity, low score greater innovativeness.

Source: Compiled by the authors.

Innovative theatres had consistently higher between-period exit rates than did theatres with more conformity repertoires. (By exit rates we refer to rates of disappearance from the TCG listings. Exit usually indicates "dis"-organization, although in some cases it represents temporary inactivity or a radical scaling down of scope or ambition.) If we divide our populations into those theatres above the mean in conformity and those below the mean, we observe that between each pair of periods more than 20 percent of the less conformist theatres left the population. By contrast, exit rates of more conformist theatres varied between just 3 to 10 percent.

The creation of new, often short-lived innovative theatre companies seems to have been an important source of diversity in repertoire over the decade of the 1970s. The greater exit rates of innovative theatres, compared to those of conformist theatres, reduced diversity throughout this period. To illustrate the relative effects of varying rates of entry and exit, we portray four different time series of conformity ratios in Table 6.5. The first row contains ratios of 54 theatres remaining in the population for all five periods (relative to all other theatres); the second row presents the conformity ratios observed for the population as a whole.[6] Row 3 indicates what conformity ratios would have been had no theatres exited (assuming constant levels of conformity) during the decade, but the rate of entry had remained the same. Row 4 presents conformity ratios under the condition that theatres that lasted only one year continued in existence with the same level of innovativeness, but other entries and exits remained similar.

TABLE 6.5

Conformity Ratios under Four Different Conditions

Condition	Period				
	1971–73	1973–75	1975–77	1977–79	1979–81
54 theatres present throughout decade	0.0117	0.0116	0.0095	0.0100	0.0124
Actual observed ratios	0.0109	0.0111	0.0080	0.0091	0.0105
No exits (hypothetical)	--	0.0110	0.0083	0.0088	0.0086
No exits of one-period theatres (hypothetical)	--	--	0.0078	0.0081	0.0087

High score indicates greater conformity, low score greater innovativeness.

Source: Compiled by the authors.

Note that 54 theatres present throughout the decade (hereafter referred to as the "established theatres"), like the population as a whole, exhibit lower conformity ratios in the third and fourth periods; but that they remained markedly more conformist than their less established counterparts noted specifically in Table 6.4, above. While conformity in the population as a whole declined by 28 percent between 1973-75 and 1975-77, conformity among the established theatres declined by only 18 percent. Conformity increased between the 1975-77 and 1979-81 seasons by over 30 percent for both these 54 and the population as a whole. While the population as a whole presented a slightly more diverse repertoire in the last period than in the first, the repertoire of the "establishment" was more conformist than it had been in 1971-73.

The reader should remember that the notion of conformity is intrinsically a relational one: behavior is always conforming (or not) with respect to the behavior of some set of others. This fact is reflected in the way in which the adjusted conformity ratio is calculated. As a measure of change over time, a theatre's adjusted conformity ratio is a function not only of its own repertoire but also of the repertoires of all other theatres in the reference population. Therefore, a theatre that performed the same plays in two different seasons might have lower scores in the second (if other theatres put on a more diverse repertoire), without itself becoming any more innovative. Change over time is interpretable only as change in conformity relative to fieldwide patterns, not as reflecting change in the behavior or artistic policies of given theatres.

To illustrate this point, let us examine change in the conformity of repertoire among the 54 established theatres relative to one another, and not relative to the field as a whole. To do this, we construct the conformity ratio based only on those plays performed by theatres within this group (Table 6.6). Over the five periods (1971-73 through 1979-81), the repertoires of the 54 theatres that survived the decade came to resemble one another to an ever greater degree. In 1971-73, each play produced by a typical theatre in this group was produced, on average, by 0.87 other theatres of the 54; by 1979-81, this figure had risen to 1.66. The temporary reduction in conformity among the 54 established theatres portrayed in Table 6.5, then, reflects the influence of the emergence of

TABLE 6.6

Mean Adjusted Diversity Ratios over Time for All Ten-Year
Theatres (calculated using only their own plays)

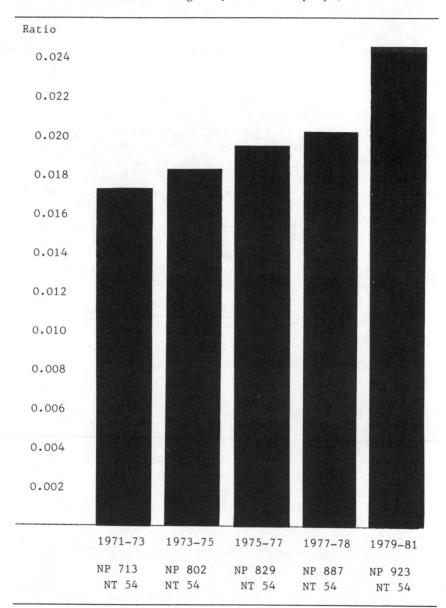

Ratio				
0.024				
0.022				
0.020				
0.018				
0.016				
0.014				
0.012				
0.010				
0.008				
0.006				
0.004				
0.002				
1971–73	1973–75	1975–77	1977–78	1979–81
NP 713	NP 802	NP 829	NP 887	NP 923
NT 54	NT 54	NT 54	NT 54	NT 54

Figures and abbreviations as in Table 6.2.
Source: Compiled by the authors.

other more innovative theatres rather than a change in the behavior of the 54 themselves.

What would have happened if there had been no exits over the decade (given the somewhat unrealistic assumption that such theatres would have continued to be no more or less conformist than they were in their last year)? In period three, the no-exit condition actually raises conformity slightly: although exiting theatres were more innovative in 1973-75 than nonexiters, their scores were higher than those of theatres that entered in the 1975-77 period. In period 4, however, the no-exit condition increases diversity slightly; by period 4 the increase in diversity is up to more than 5 percent.

If all one-term theatres had remained in the population without altering their programming style, but other entrances and exits remained the same, the cumulative effect on diversity would have been notable, with conformity reduced by 17 percent from the observed 1979-81 figure. Although the condition itself is not a realistic one, we suspect that public policies that compensated for disadvantages (faced by particularly innovative theatres sufficiently to lower their rates of death or temporary disorganization to the level faced by less innovative theatres) would within a relatively short time substantially affect the diversity of the repertoire of the resident stage.

GROWTH AND INSTITUTIONALIZATION

To return to our three explanations noted at the outset, do our data support contentions that age, growth, and institutionalization increase repertoire conformity in the theatres that were present in both the first and fifth periods? A formal analysis of these issues is beyond the scope of this paper; but a comparison of those theatres with relatively high levels of budget growth and increase in earned income (i.e., measures of institutionalization) over the decade with theatres with lower levels is illuminating.

We measure growth directly as the increase in operating expenses over the ten-year period. As a proxy for institutionalization, we take the change in the percentage of the theatre's income that is earned. An important aspect of institutionalization is the development of a stable subscription audience that will provide a measure of fiscal

certainty by renewing year after year. The growth of such a subscription audience is reflected in increases in the percentage of revenues earned at the box office; and such increases have been perceived by many public and private providers of funds as signs of institutional maturity and fiscal strength.

We divided the established theatre population at the median on budget growth, increase in earned income, and change in the conformity ratio. Both growth and increased dependence on earned income were associated modestly with increased conformity. About 55 percent of the theatres with relatively low rates of budget growth had become less conformist, while a similar percentage of high-growth theatres were in the half of the population that had become relatively more conformist. Approximately 60 percent of theatres that had become less dependent on earned income were less conformist; and 60 percent of those depending more on earned income in 1981 than in 1971 had become more conformist in their repertoire.

TABLE 6.7

Growth, Institutionalization, and Change in Conformity-- Percentage Becoming Relatively More Conformist between 1971 and 1981

Earned Income Dependence	Low Budgetary Growth	High Budgetary Growth
Earned income percentage decline	0.2143 (n = 14)	0.6000 (n = 15)
Earned income percentage increase	0.6667 (n = 15)	0.5333 (n = 15)

Source: Compiled by the authors.

Because growth and institutionalization vary independently, it is particularly instructive to look at the joint relationships of growth in budget and earned income to change in diversity (Table 6.7). Theatres with only modest budgetary growth but increased dependence on earned income tended to become more conformist. Yet when growth was high, dependence on earned income also in-

creased, and conformity actually increased less than when only growth or earned income rose. We have no firm conclusions about why this complex pattern exists, other than the obvious one that increase in innovativeness (i.e., decline in conformity) was greatest among theatres that neither had to cope with the demands of growth nor increased their dependence on earned income. Indeed such theatres were the only ones predominantly in the less conformist half of the five-period population. (Again, we are not including the consistently more innovative short-lived theatres, which account for most of the noncomformity in the field as a whole, as discussed above.)

CONCLUSIONS

The analyses reported here are exploratory and the conclusions that we draw from them are tentative. It appears, however, that the artistic vitality of the American resident stage--to the extent that vitality is related to diversity in the repertoire offered to the public--did not decline consistently during the 1970s. Diversity increased rather markedly during the middle of that decade and returned to earlier levels by the decade's conclusion. The cause of increased diversity in the mid-1970s appears to be the rapid and substantial expansion in the number of nationally active resident theatres and in the number of productions that they mounted. Conformity increased toward the end of the decade due both to declining diversity in the productions of existing theatres and to the fact that theatres with innovative repertoires were much more likely to exit from the population than were theatres with less innovative repertoires.

These findings are not inconsistent with the perception of many observers of the American stage that theatres have become more timid in their selection of repertoire in recent years. First of all, the alleged timidity may take the form of cutting costs by producing plays with small casts. We do not have any data on cast sizes, but there is no reason to believe that cast size is correlated with our measures of innovativeness. More important, critics of the resident stage tend to focus on change in the larger, more visible organizations rather than on dynamics in the population as a whole. In every period, theatres that survived the decade were more conservative in their

programming than were theatres that did not. And, as we have seen, those theatres have become steadily more conformist with respect to one another.

The decline in the adventuresomeness of repertoire among the more established theatres appears to be a function of both growth and institutionalization but not of aging per se. Established theatres (those in existence in 1971 73 and surviving the decade) that avoided rapid growth and increased dependence on earned income actually became more innovative. By contrast, other theatres were likely to become more conformist. It seems likely that theatres that kept their fixed costs low enough to avoid becoming dependent on the tastes of large audiences were able to take greater risks as they grew older.

We have ample reason to be cautious about these conclusions. Our measures of conformity do not tap variation in performance style or stage design. More systematic analyses of the fates of theatres that leave TCG are required to confirm our belief that exit represents either death, inactivity, or a scaling down of scope and ambition. Most important, more formal analyses of the effects over time of aging, growth, population dynamics, and institutionalization on diversity are necessary to draw confident conclusions about causality.

Nonetheless, if our findings are borne out by further analyses, they may have important implications for public policy toward the arts. For one thing, they suggest that artistic diversity may be better served by policies aimed at increasing the birthrates of new organizations and maintaining innovative organizations throughout their first few years than by those focusing on support for major established organizations. Second, they imply that public and private arts programs that encourage arts organizations to become larger and more dependent on earned income are likely to increase conformity in the selection of repertoire. We have found some evidence that the negative effects of growth on repertoire are softened by increases in theatres' earned-income base; however, the only theatres that became more innovative throughout the decade were those that avoided both rapid growth and increased dependence on the box office.

Growth and stability are, of course, likely to serve other objectives of public arts policy, for example, providing training and employment to artists and access to theatre for the general public outside of major centers of

populations. Policy makers must be aware, however, that policies designed to foster growth and institutionalization may threaten diversity, while policies that encourage innovation may dampen growth and threaten stability. Achieving both sets of ends may require that policy makers divide the resident stage into institutional and developmental sectors and fashion different policies for each. It may also require that they attend less to the fortunes of individual theatres and more to the contours of the field as a whole.

NOTES

1. The reader will note that, in this paper, we define diversity narrowly as variation in the range of cultural products presented by organizations in a given institutional sector of the art world. We do not address the question of diversity in its broader and (from the standpoint of public policy) equally important sense: the range of genres and forms that are supported and legitimated as art.

2. Years refer to biennial TCG membership directories. Directories report plays produced over a two-year period running from the autumn of the first year in the sequence to the summer of the third. For example, the 1979-81 period includes all productions from September 1979 through August 1981. Because a few improvisational theatres did not present or report formal repertoires, n's in some analyses are less than the total number of theatres.

3. The following example will illustrate the significance of the Herfindahl index. Imagine that in a given season 25 resident theatres produced only four different plays; and that, all told, 100 productions were mounted. Macbeth was produced 50 times (or 50 percent of all productions), Othello by 20 theatres (20 percent), The Importance of Being Earnest on 20 occasions (also 20 percent), and Plenty ten times (or 10 percent of all productions). The Herfindahl index for that period would simply be the sum of the squares of each play's share of the total number of productions $(0.50^2 + 0.20^2 + 0.20^2 + 0.10^2$, or 0.34). If all theatres produced only Macbeth, the index would be 1.00^2 (or 1.00). If no two theatres produced the same play, given a total of 100 plays, the Herfindahl index would be 0.01^2 X 100, or 0.01.

We base our measurements on the number of productions of a play rather than on the number of performances because we are concerned primarily with the ability of playwrights to have their work performed in settings that are visible to the national theatre community and accessible to interested theatregoers. Once performed under these conditions, a play is likely to enter the dramatic literature. Most theatres present as many performances of rarely performed plays as of frequently performed works. Two-year periods are employed to smooth annual fluctuations in the performance of specific plays.

4. Note that the Herfindahl index is simply a comparative measure without a common substantively meaningful metric across different applications. By contrast, the adjusted conformity measure can be converted to the raw conformity score, which is readily interpretable as the count of the number of times that a theatre's typical play was presented by all theatres in a given two-year span. Nonetheless, the evaluation of such measures as "high" or "low" depends on the values and expectations of the reader. We use them here for purely comparative purposes.

5. At the outset of this project, two doctoral students in dramaturgy (the study of the dramatic literature) were retained to develop a scheme for coding the innovativeness of theatres' repertoires. It became apparent in preliminary discussions that students of drama have no consensual definition of artistic innovation, and that any such coding would be very difficult. Nonetheless, they coded a randomly selected sample of 20 plays, estimating the extent to which each was "popular" and, conversely, the extent to which each presented one of three "risk factors," having to do with obscurity, vulgarity, or political controversy. For these 20 plays, the correlation between the number of times each was produced between 1971 and 1981 and the dramaturgists' "popularity" rating was a fairly high 0.50; the correlation between production frequency and the risk rating (a composite score) was a fairly low −0.47. (Note that this is on a score ranging from +1.0 to −1.0, with 0.0 as a middle score.) We also obtained data on the number of plays produced for the first time by each of the TCG theatres during the 1979–81 seasons. The number of new plays presented, a literal measure of product innovation, was correlated with the theatres' conformity (i.e., noninnovative) scores for that period at −0.42. These rather strong correlations in the

expected directions lead us to believe that our theatre-
level conformity scores represent an efficient if imperfect
means of measuring what most people mean when they speak
of "innovativeness" with respect to repertoire.

 6. There are 59 theatres present in the first and
fifth periods, but only 54 theatres were present in all
five periods. Five of the 59 exited the population for one
or more of the second through fourth periods. Within this
group of 59 theatres, the median theatre's budget increased
by $793,000 over the decade, dependence on earned income
increased by just under 1 percent, and conformity declined
very slightly.

BIBLIOGRAPHY

Griswold, Wendy. 1981. "American Character and the
 American Novel: An Expansion of Reflection Theory."
 American Journal of Sociology 86 (January):740-65.

Jeffri, Joan. 1980. The Emerging Arts: Management,
 Survival, and Growth. New York: Praeger.

Martenson, Edward. 1983. "Theatre Program Review."
 Arts Review 1 (Fall):8-10.

Martorella, Rosanne. 1982. The Sociology of Opera. New
 York: Praeger (J. F. Bergin).

Mathematica Research Inc. 1981. Conditions and Needs of
 the Professional American Theater. New York:
 Publishing Center for Cultural Resources.

Mueller, John H. 1951. The American Symphony Orchestra:
 A Social History of Musical Taste. Bloomington, Ind.:
 Indiana University Press.

Mueller, Kate Hevner. 1973. Twenty-Seven Major Symphony
 Orchestras: A History and Analysis of their Reper-
 toires. Bloomington: Indiana University Press.

Peterson, Richard A., and David Berger. 1975. "Cycles
 in Symbol Production: The Case of Popular Music."
 American Sociological Review 40 (April):158-73.

Poggi, Jack. 1968. Theatre in America: The Impact of Economic Forces, 1870–1967. Ithaca, N.Y.: Cornell University Press.

Zeigler, Joseph Wesley. 1977. Regional Theatre: The Revolutionary Stage. New York: Da Capo.

Zeisler, Peter. 1984. "Cost of Doing Business." American Theatre 1, no. 2 (May):3.

III

IDEOLOGICAL REDEFINITION
OF THE ARTS
UNDER CHANGING CONDITIONS

Just as artists and arts institutions are economic actors, so too they may take conscious ideological positions which contribute to the aesthetic characteristics (style, medium, etc.) of their chosen art form. Such positions may also be overtly political, or, conversely, may intend to avoid politics. Nonetheless, however "pure" artists may be in avoiding manipulation by political movements, or in not "selling out" to crass commercialism, they cannot prevent their work from being differently interpreted and used by audiences with other agendas and understandings than their own. This is to some degree inevitable, because individuals can only interpret artworks in terms of their past experience of other works, and all such experience is socio-historically limited. The more widely any artwork becomes known, the more likely it is that it will be redefined in terms different from those of the artist and any original supportive audience. In addition, elite and nonelite audiences alike may consciously use artworks to enhance their own status and ideological positions, regardless of their degree of sensitivity to the aesthetic or social concerns of the artist. (However, it is arguable that such sensitivity enhances their ability to so use and redefine the work--and themselves-- accordingly.)

These issues are undoubtedly more problematic in the modern world, where individuals (artists or audiences) can transcend their original status in society and use artworks to help redefine themselves. Leading off this section, Kimmel lays the groundwork for the whole in a discussion of the particular tensions and processes of modernization, which, while enhancing individualism and social mobility,

lead as well to a sense of rootlessness. For many, the arts have been believed to be restorative of the sense of wholeness that modernity has undermined; all the more are aesthetic ideologies linked to social and political ones. And all the more are they subject to redefinitions, as social and political contexts change, as the other papers demonstrate with other examples.

At outset, Kimmel analyzes the nineteenth-century Arts and Crafts movement in England and the United States, noting the specific political agendas that it was supposed to meet for its largely middle-class artists and patrons. Deliberately using "natural" materials and traditional "folk" media and styles, artist-craftsmen attacked the industrial and bureaucratic machines of modernity, with the ironic result of succeeding so well that modernization became more humane and acceptable, both politically and aesthetically.

Metcalf looks at another form, and another (re)definition, of "folk" art. He describes art created by individual black artists for their own unique reasons, which has been reinterpreted by elite white critics and collectors as "folk" art. Seen in this fashion, it serves—as did the products and ethos of the Arts and Crafts movement—to link sophisticated moderns to their supposedly healthier folk roots. But rather than elevating the status of the original artists, and the racial communities from which they come, such white patronage enhances its own claims to high status on the grounds of a universal aesthetic that sees the high quality and artfulness of works from every social, racial, and ethnic source.

In both of these examples, redefinitions can occur because the artworks, as objects, "freeze" time and preserve any "folk" ethos from the past and thus project it into present and future through their sheer existence. Additionally, as objects, they are inherently subject to collection, and thereby can readily serve any new uses such as status assertion by the collectors. The following two papers look instead at the performing arts, where works cannot be thus collected and where artist-performers and their audiences are more likely to share an aesthetic ideology along with a concomitant class location and status. When this ceases to be the case, then in order to survive, the performers are almost obliged to change their style of performance if they are to take advantage of changes in society that affect their audiences as well as themselves.

Björn discusses jazz, which has been subject to many of the same changes in patronage that Metcalf has described. In this case originally a genuine folk art, restricted to black ghettoes, jazz has emerged since World War I as a fine art through increasing popularity among white elites. A crucial factor in this process has been the increased sophistication and upward mobility of the black jazz musicians themselves, now in middle-class and elite strata. Again the irony of the situation becomes apparent: as these musicians have migrated "upward" (like Kimmel's crafts and Metcalf's black art), and participated in the redefinitions of their art form, they have left their original audiences behind. The folk arts that provided comfort and support for lower-class victims of modernization have ended up accommodating themselves to it, and providing comfort to sophisticated elites instead.

In contrast to these three papers, the final paper by Wyszomirski and Balfe discusses ballet, an inherently elite and sophisticated art form. As a performing art (but without the individualization possible with jazz), it requires the ongoing cooperation of participants in an arts institution, here the ballet company. Given the size and expense of any such company, ballet is all the more dependent on an audience that shares its particular aesthetic ideology. While changes in audiences have altered the original interpretation of crafts and black "folk" art (and in the case of jazz, altered its form as well) so that these arts have risen in status, similar changes have, conversely, worked to make ballet more popular. As discussed here, this would seem to have had comparable results, in that the symbolic and aesthetic meaning that the artwork had for the original audience, artists, and performers has been undermined; the art has traveled, but the audience has been left behind. In becoming appreciated by ever wider audiences, these arts (among others not discussed here) may contribute to the enjoyment and health of larger sectors of society, and may thus contribute to the well-being and cohesiveness of the society in general. At the same time, costs are paid by those, whether folk or elite in status, whose own identification with those art forms must be given up.

7

OUT OF THE GUILDS
AND INTO THE STREETS:
THE IDEOLOGY AND ORGANIZATION
OF THE ARTS AND CRAFTS
MOVEMENT IN ENGLAND
AND THE UNITED STATES

Michael Kimmel

The meaning of modernity has been a central question in Western society for over two centuries. The unbridled optimism of the French Revolution and the spectacular technological advances of the Industrial Revolution raised profound questions about the nature and direction of Western society. For some, modern society meant the unleashing of powerful forces that could lead to human liberation after centuries of backwardness, a move from the dark countryside to the gleaming city. For others, those same forces pushed man out of the forest primeval into what artist William Blake called the "dark satanic mills" of a sooty grey industrial future of enslavement. In this essay, I want to explore one particular strain of the cultural reaction against modernism: the Arts and Crafts movement. By examining its history in both England and the United States, I hope to shed some light on the nature of radical social protest as well as on the dynamics of movements in which art plays a central role.

My argument supports Max Weber's sense of tragic irony, and of the unintended consequences of action. I will detail how a movement for aesthetic and social transformation—one that attempted to reinfuse social life with,

This chapter is a preliminary statement of a larger study on the ideology of antimodernism in the late nineteenth and late twentieth centuries. I am grateful to Judith Balfe, Kate Ellis, Todd Gitlin, Natalia King, and Sarah Williams for valuable comments and suggestions.

and through, artistic meaning in the face of bureaucratic
depersonalization--ultimately led to the further encroachment
of rationalization on social life, and facilitated the further
loss of meaning. By comparing the English and American
cases, I can also illustrate how radical social movements
could dissolve and recompose themselves as other movements,
when they were not internally and organizationally consis-
tent with their original political vision.

MODERNITY AND ITS DISCONTENTS

Nineteenth-century European observers hailed the
passing of the old era and the advent of the new. "Il
faut être absolument moderne," declared Rimbaud. The
Great Exhibition at the Crystal Palace in London celebrated
the machine as the great art masterpiece of the century,
professing a utopian faith in the ability of technology to
solve all human problems while it created an aesthetically
and ethically harmonious world. However, technological
progress did not come cheaply, but rather incurred serious
cultural costs. A full century earlier, Jean-Jacques Rousseau
had foreseen these costs when he wrote that, contrary to the
euphoria of other Enlightenment thinkers, he was "beginning
to feel the drunkenness that this agitated, tumultuous life
plunges you into. Of all the things that strike me, there
is none that holds my heart, yet all of them together dis-
turb my feelings, so that I forget what I am and who I be-
long to." By the mid-nineteenth century, this double edge
of modernism was even more sharply experienced.

To be modern was to be rootless, dislocated, without
a past. In the rush of the new, older symbols and meaning
disappeared; all are jarred loose from the moorings of cul-
ture, tradition, community. Marx responded to both edges
of the sword of modernism. On the one hand, the bour-
geoisie, modernism's agents, has "put an end to all feudal,
patriarchal, idyllic relations." It has, he continued in
the Manifesto, "pitilessly torn asunder the motley feudal
ties that bound man to his 'natural superiors,' and has
left remaining no other nexus between man and man than
naked self-interest, than callous 'cash payment.' It has
drowned the most heavenly ecstasies of religious fervor, of
chivalrous enthusiasm, of philistine sentimentalism, in the
icy water of egotistical calculation" (Marx 1978: 475). On
the other hand, modernism provokes an "everlasting uncer-

tainty and agitation." In a haunting passage that evokes this traumatic anxiety as well as the potential for transformation, Marx continued:

> All fixed-fast frozen relations, with their
> train of ancient and venerable prejudices
> and opinions are swept away, all new-
> formed ones become antiquated before they
> can ossify. All that is solid melts into
> air, all that is holy is profaned, and man
> is at last compelled to face with sober
> senses, his real conditions of life, and
> his relations with his kind (1978: 476).

Marshall Berman suggests that modernity created a powerful paradox in that "the innate dynamism of the modern economy and of the culture that grows from this economy, annihilates everything that it creates . . . in order to create more, to go on endlessly creating the world anew." To be modern is to "experience personal and social life as a maelstrom, to find one's world and oneself in perpetual disintegration and renewal, trouble and anguish, ambiguity and contradiction" (Berman 1982: 288). This leads to "an insatiable drive for growth" coupled with a fear of its consequences, and thus an overwhelming desire to be rooted in the past, to have a history.

For many, though, too much was lost in the rush of the new. It was not only that modernity disposed of traditional forms, but in the process it was felt to sweep away all that was beautiful and aesthetically pleasing. Toward the end of the nineteenth century, a growing number of intellectuals and artists had broken sharply with the "complacent faith in material progress and human rationality that had ruled the Western world for two generations" (Higham 1970: 89-90). "Apart from the desire to produce beautiful things," wrote William Morris in 1894, "the leading passion of my life has been and is hatred of modern civilization" (1948: 347).

It was this hatred of the modern--the rational, the scientific, the technical--that motivated the anti-modernist impulse in late nineteenth-century Europe and America. Jackson Lears claims that anti-modernism was a broad-based critique of rationality, a "protest against a complacent faith in progress and a narrow positivist conception of reality" (Lears 1982: 36). It was an assertion of

the rural village over the industrial city, of the body and spirit over the mind, of id over ego. As a series of separate but related movements, the anti-modernist impulse sought to rescue the world from its "disenchantment" (as Weber had put it), and to re-enchant it by creating "islands of wholeness" in a fragmented society and making possible again movements of transcendent experience of the real, the natural, the cosmic (Lears 1982).

Especially in England, but also in the United States, the anti-modernist impulse rippled through intellectual circles with great strength. As a reaction to modern society, its manifestations were often contradictory. For some, anti-modernism was expressed in the glorification of individual achievement. For example, a revival of the martial ideal extolled the heroic individual against the faceless bureaucracy, and celebrated the charisma of the warrior against bourgeois morality and its "feminizing" influences. (Unfortunately, this ideal was frequently linked to a jingoistic imperialism in the guise of national purification, a military madness offering moral regeneration through war.)

For most, though, anti-modernism was expressed as a desperate longing for community. Anti-modernists advocated the annihilation of ego, the destruction of self, and immersion in a transcendent, mythic community. A resurgent medievalism, for example, expressed a wish to return to a realm of innocence in which communal values prevailed, where the arts and aesthetic responses were directly engaged. The Pre-Raphaelite poets and painters, fueled by Ruskin's adoration of the Gothic, proclaimed an explicit medievalism. Henry Adams was rapturous in his celebration of the Gothic in Antwerp and elsewhere, which allowed him to be "drunk on his emotions," which were otherwise stifled in the roar of the machine age (Adams 1964: 81). Another example of the anti-modernist impulse was a fascination with Oriental culture, cast as profoundly communal and engulfing of the individual sensibility, with meditation as the means to achieve a cosmic experience of unity with the universe. Finally, a revival of Catholic art and ritual accompanied a revival of the Gothic, and the increased Catholicization of the Church of England gave primacy to collective religious experience over individual relationships with God.

For some, however, anti-modernism did not require a thoroughgoing critique of industrial society, but simply cosmetic additions to the prevailing cultural climate. The

1890s witnessed a sports boom (especially bicycles) and a marked increase in interest in health care. Serious intellectuals extolled nature's virtues; in everyday life, there was increased appreciation and enthusiasm for the tonic freshness and openness of nature, as well as for its contribution to virility, "an indispensible remedy for the artificiality and effeteness of late 19th century urban life" (Higham 1970: 81). The Country Life movement elevated naturalism to a level of transcendence, as it "sought to preserve traditional agrarian ideals in the face of industrialism," and envisioned a new rural civilization based on the concern of man for nature (Bowers 1974: 134, 146).

For perhaps more serious observers, industrialization had so dramatically transformed the structure of work-- removing independent producers from the workshop where they experienced autonomy and placing them on the assembly line in a rapid and profound process of proletarianization--that contemporary society was seized by a moral crisis that could be solved only by a drastic transformation, not by riding bicycles, hiking, or adding a medieval or oriental flourish to vernacular architecture. That moral crisis was caused by the collapse of the work ethic, as the "calling" dissolved into the meaningless rote hum of the factory and Taylorist solutions to industrial efficiency. The culture of production gave way to a culture of consumption; the light cloak of external goods had become, to use Weber's phrase, an "iron cage" that trapped people in its ever-tightening rationalizing grip.

Such anti-modernists searched for authenticity, community, and meaningful labor. They sought to reverse the disastrous direction of history and reinfuse society with meaning. Not surprisingly, the arts were engaged toward these ends. Indeed, perhaps the most popular and cohesive example of anti-modernist sensibility was the Arts and Crafts movement, which lauded the virtue of the handcrafted over the machine-made, mass-produced commodity, and inspired and supported groups of craftsmen devoted to making the necessities of life with their own hands, and to making them beautiful as well. In so doing, the Arts and Crafts movement challenged contemporary work organization, the relationships of individuals to industrial labor, and the apparent general decline of artistic sensitivity. More than this, the movement provided a living community for many craftsmen, proclaiming the unity of the worker and the work, of the product of labor and its producer, and claimed

to have thereby rediscovered both the social and personal transformative power of art.

By exploring here the ideology and organization of the Arts and Crafts movement in late nineteenth-century England and the United States, we can see both the achievements and the dangers of such an anti-modernist vision. I shall argue that while this movement promised to infuse labor with meaning, to rebeautify industrial culture, and to transform industrial society politically, it actually facilitated the further rationalization of culture, and, especially in the United States, accommodated corporate capitalism. What began as a movement to reinfuse social life with meaning evolved into a movement that further denuded social life of meaning.

THE ARTS AND CRAFTS MOVEMENT IN ENGLAND

In England, the Arts and Crafts movement was an outgrowth of a far-reaching critique of nineteenth-century industrialization. In part bound up with medievalism, the members of the movement were "concerned with the dangerous impact of industrial development on modern society, and advocated a return to the idea of a craft utopia and social structure of a medieval world" (Lambourne 1980: 146). Modern society bound the worker to the machine in an alienating process producing debased works. Ruskin bemoaned "the degradation of the operative into a machine," which, if the machine was responsible for the debasement of the worker as well as the work, could only be reversed by a rejection of the machine altogether (1925: vol. 2, 159). For Ruskin, it was not the materials from which art was made that left it without human or aesthetic values, "but the absence of human labor, which makes the thing worthless, and a piece of terracotta, or plaster of Paris, which has been wrought by the human hand, is worth all the stone in Carrar cut by machinery" (cited in Naylor 1971: 26).

Ruskin established local craft guilds to reestablish the harmony of the intimate connection between the work of art and the artist. His writings grabbed the imagination of William Morris, then a student at Oxford. While Ruskin remained a social conservative, it was Morris who "developed the dissent from commercial civilization into outright opposition to the whole capitalist order" (Williams 1982: 78).

Just as Morris's socialist politics were grounded in an aesthetic reaction against the evils and ugliness of industrialization, so too he articulated the political aesthetics of the Arts and Crafts movement. In designs as well as in prose, Morris expressed three central principles for any Arts and Crafts project: (1) to evoke the elegant simplicity of nature; (2) to remain true to the materials; and (3) to use rich decoration without ornamentation (Thompson 1977: 106). From the time of his earliest encounters with medievalist, Gothic, and Pre-Raphaelite styles, Morris's work embodied these principles. Red House, built just after his marriage, was "revolutionary in its unashamed use of red brick, its solid undisguised construction, and absence of fussy facades and unfunctional ornamentalism" (Thompson 1977: 91). These principles were also expressed through Morris's use of natural dyes, in the strong recurring lines and heavy curling leaves and fruit of his pattern designs for textiles and wallpaper, and in the solid and unadorned designs for furniture, jewelry, metalwork, stained glass, murals, carving, embroidery, and print faces turned out by both Morris and his followers. As he wrote in 1892:

> I have tried to produce goods which should
> be genuine so far as their mere substances
> are concerned and should have on that ac-
> count the primary beauty in them which be-
> longs to naturally treated substances; have
> tried for instance to make woolen substances
> as woolen as possible, cotton as cotton as
> possible, and so on; have used only the
> dyes which are natural and simple, be-
> cause they produce beauty almost without
> the intervention of art (cited in Thompson
> 1977: 100).

With this belief that art held a uniquely liberatory potential, if created from authentic materials, Morris grafted onto his revival of traditional crafts a socialist vision of authentic human experience.

> It is the province of art to set the true
> ideal of a full and reasonable life before
> [the workman], a life to which the percep-
> tion and creation of beauty, the enjoyment

of real pleasure that is, shall be felt to
be as necessary to man as his daily bread,
and that no man, and no set of men, can
be deprived of this (Morris 1948: 659).

Following Morris's perspective, the Arts and Crafts
movement in England remained for many years an optimistic
utopian movement that developed in unexpected and com-
pelling ways the Marxian assumption that the relations of
production determine all other social relations. Through-
out the English countryside, men and women organized
craft guilds and craft communities, and set about relearn-
ing traditional crafts--lacemaking, ceramics, bookbinding,
embroidery, masonry, metalwork, carpentry, glassblowing,
stained glass--as well as painting and sculpture as means
of self-discovery and social transformation. Members of
the movement believed in both social transformation and in
personal, individual growth. "The cause of Art," wrote
Morris, "is the cause of the people" (1948: 63).

OUT OF THE GUILDS: THE FEMINIST
CRITIQUE OF THE ENGLISH MOVEMENT

But while the English Arts and Crafts movement re-
mained aesthetically committed to its founding principles,
the more radical socialist politics of many of its chief
proponents softened over time into Guild Socialism, or In-
dustrial Democracy. As the art and craftworks it produced
came to represent the highest man-made quality, they be-
came as representative of fashion as of authentic vision.
One disillusioned observer mourned that "we have made of
a great social movement a narrow and tiresome little aris-
tocracy working with great skill for the very rich" (cited
in Naylor 1971: 9). Nonetheless, many of its number re-
mained fiercely dedicated to the liberatory ethics of handi-
craft production. Foremost among these were the large
numbers of women who counted themselves among the move-
ment's most active members.

From the first, women had been active participants
in the Arts and Crafts movement, and a high percentage
were officers in local craft groups. Indeed, the fact that
the movement did accord women prominent positions helps
to explain their participation; it provided "an arena of
remunerative activity which . . . did . . . permit married

women with family commitments [as well as single women] an independent, though sometimes only semi-professional career" (Callen 1980: 218).

Anthea Callen details how women from all social classes in England became involved in craft production. Some were struggling with survival, others with repressive social ideologies, but all seemed to meet in the local workshop. Working-class and peasant women were organized and employed in the revival of traditional rural crafts. Aristocratic and upper-class women were philanthropically engaged in the organization of this rural crafts revival, as well as in the artistic training and employment of destitute gentlewomen. These became active either as waged artworkers in an employer's workshop, or as outworkers or free-lance artisans, producing craftwork discreetly in their homes. Finally, there was a small circle of middle-class, educated women, often related by birth and even more often by marriage to the key male figures who composed the vanguard of the movement (Callen 1980: 2).

Despite women's widespread participation, however, the movement remained indifferent to their specific concerns (especially for suffrage), and diffident to their desire for more equal participation in the movement itself. In 1886, at a party following an address by Morris, a Mrs. Neilson commented that "only by the extension of the franchise to women could socialism ever be obtained, as men were far too stupid and selfish ever to do away with a system that satisfied their fighting and predatory instincts" (Callen 1980: 214). Even within the immediate circle around Morris, there was little questioning about traditional gender roles, in time forcing the most politically engaged women to choose between two allegiances: socialism and feminism.

There are a number of reasons why the position of women remained subordinate to that of men within the Arts and Crafts movement, or, more accurately, why the movement did not, as part of its socialist vision, make the cause of women's suffrage its own. For one thing, there were the beliefs of the leaders of the movement, fully consistent with the patriarchal attitudes prevailing in Victorian England. Even in opposition to its materialist culture, many of the leaders of the movement retained deeply sexist views. In particular, Ruskin's medievalism, his adoration of the Gothic, was spurred by his idealization of a natural gender-based division of labor and an accompanying romanticization of women. This is most evident

in his rhapsodic fancies about the nature of the home, and woman's place within it. To Ruskin, home was a secular temple amidst pagan turmoil, and women were the high priestesses and guardians of the temple.

Within the movement's organization of the work process, the position of women was devalued. Specific crafts became associated with each sex; the more women became involved with a particular craft, the less highly valued the craft became. This was especially true of lacemaking and embroidery, the latter of which became more of a sex trait than a craft. "It is as scandalous for a woman not to know how to use a needle as for a man not to know how to use a sword," wrote Lady Mary Wortley Montague (cited by Callen 1980: 97).

Further, women were often cast as amateurs, dabblers in craft production as a result of their leisure, while men were hailed as committed to both the politics and the work for survival. Women were thought to be not doing enough to revive the old and authentic sensibilities; instead, they simply added prettiness and decoration to existing, debased, craftwork. C. R. Ashbee, writing on the problem faced by the Guild of Handicrafts in 1908, acknowledged that amateurs were not exclusively female, but he singled them out:

> In the Guild's workshops our fellows are rightly nervous of this competition of the amateur, especially the lady amateur, and albeit with the utmost consideration they speak of her as "dear Emily." I have seen a great deal of her work in the last ten years, she is very versatile, she makes jewelry, she binds books, she enamels, she carves, she does leather work, a hundred different graceful and delicate crafts. She is very modest and does not profess to any high standard nor does she compete in any line of work where physique or experience are desired, but she is perpetually tingling to sell her work before she half knows how to make it, and she does compete because her name is legion and because, being supported by her parents she is prepared to sell her labor for 2d. an hour, where the skilled workman has to sell his for 1s. in order to keep up standard and support his family (cited in Callen 1980: 103).

"It is not easy," noted the Art Journal in 1872, "for women to escape the influence of the common notions of 'amateur' as contrasted with the 'professional' work, by which, in a strange confusion of meaning, we have come to understand that to do a thing 'for the love of it' is really equivalent to doing it imperfectly" (Callen 1980: 26).

Despite the roles played by some women as officers in local craft groups, the guilds themselves remained bastions of male privilege. They had been "founded on the Victorian notion of those medieval institutions," writes Callen, and they remained "male-organized, and male dominated . . . or exclusively 'male clubs'" (1980: 218). The Art Workers Guild, one of the most influential and elite bodies of the movement, completely excluded women from its membership. Even when they were participants in certain guilds, women were usually assigned less creative tasks; often they were merely the "executants of designs by men" (Callen 1980: 219).

Certainly, there were external and practical constraints imposed on men and women in Victorian England, constraints that prevented full participation by women in all activities. But there was also a "general blindness to the oppression of women within the movement, and often an open hostility to such questions. In its sexual division of labor both in terms of traditional 'feminine' crafts and in the split between designer and executant, the movement recreated in microcosm the broader social attitudes of the day" (Callen 1980: 219). By failing to join the roles of woman and artist (the problem of amateurism) and ladies and work (the problem of idealization of women's role in the home), the movement abandoned its own egalitarian, socialist vision. Sadly, Callen concludes that a "movement with often radical social aims, which should have contained the potential for an equally radical assessment of the personal and practical relations between women and men, turned out to be reactionary in its reinforcement of the traditional patriarchal structure which dominated contemporary society" (1980: 17).

Despite the fact that the movement had provided "a crucial sphere of work and thereby autonomy and personal creativity for large numbers of middle class women" (Callen 1980: 221), feminists in turn eventually abandoned the Arts and Crafts movement to its male leaders and began their own movement, dedicated to improving their position in society as women instead of as artists or craftsworkers.

One outgrowth, then, of the English Arts and Crafts move-
ment was the birth of an independent women's movement, a
movement dedicated to the emancipation of women as women
instead of within some occupational or social category.
This legacy developed because the English Arts and Crafts
movement, however patriarchal and reinforcing of tradi-
tional masculine privilege, remained faithful to its general
political goals of equality. The critique of the movement
from within was therefore framed in political terms, stretch-
ing toward unforeseen and ultimately more progressive
ends. As women who had participated in the Arts and
Crafts movement were forced out of the guilds and into the
streets, the women's movement itself was energized to press
for social transformation and equality on new grounds,
even as many of their socialist male peers urged only
slighter modifications and reforms.

THE ARTS AND CRAFTS MOVEMENT
IN THE UNITED STATES

Following on the heels of the English movement and
becoming popular a decade or so later, the Arts and Crafts
movement in the United States followed the English leaders
as well, believing with them that the return to craft pro-
duction augured the reinfusion of meaning into labor, a
reunification of life and work, and personal and political
liberation. C. R. Ashbee made several visits to the United
States to spread the word and provide support for the
movement's mission to "compass the destruction of the com-
mercial system, to discredit it, undermine it, overthrow
it . . ." (in Naylor 1971: 63). Accordingly, when Gustav
Stickley founded the American magazine Craftsman in 1901,
he announced that United Crafts (his own crafts community)
"endeavors to promote and to extend the principles estab-
lished by Morris, both in the artistic and the socialistic
sense" (in Naylor 1971: 144). In his magazine, he pub-
lished many articles on socialism, and he appreciated the
mutual aid of the guilds, but like most Americans, he came
to regard overtly socialist political sensibilities as too ex-
treme. He preferred instead Andrew Carnegie's profit-
sharing plans as a more purely economic scheme to better
the conditions of his workers.

Similarly, other participants in the American move-
ment saw craftsmanship as the means to overcome industrial

alienation and to revive the work ethic, not to alter the political economy fueled by developing modernism. In their celebration of traditional American crafts, they offered a "struggle against domination by a machine culture" which was simultaneously a "fight to regain beauty and individuality" (Gilbert 1977: 84). William Price, founder of the Rose Valley Community of craftsmen in Pennsylvania, summed up his philosophy of the difference between craft and machine production as he rhapsodized about a "built" chair in contrast to a "made-up" chair:

> . . . your built chair is something more than a good chair, it is a message of honesty and joy to the possessor, and a cause of growth and joy to the worker. And your made-up chair is something less than the sham that it stands for, insidiously and in the guise of a blessing undoing the character alike of maker and possessor. It and its kindred shams are the symptoms of that loosening of character that is reflected in the hideous political and industrial corruption that . . . is at work undermining our social and political fabric (Price, in Clark 1972: 84).

Clearly, then, at its outset, the Arts and Crafts movement in the United States expressed the political aesthetic developed by Morris and others in England. Nature was evoked in solidly massive furniture and fluidly simple architectural lines, or in a directly imitative style. As one writer put it:

> The main idea in the design is to imitate nature as nearly as possible. For instance, the foot of a settee will be carved to appear like the trunk of a tree cut off just where the roots branch off from the body, and the same natural ideal will be carried out up the leg of the piece, and the branches of the tree will spread in graceful curves up the arm and over the back of the settee (The Furniture Worker 1902, quoted in Darling 1984: 66).

The celebration of American oak in home and furni-
ture construction and the bold assertion of craft intention-
ality expressed the twin dicta of truth to materials and
form following function.

> The chair does not reach out after the at-
> tributes of the table, nor yet does the
> round table purloin the characteristics of
> the square objects of its own kind. Each
> specimen preserves a structural distinction
> as marked as that which separates, one
> from the other, the species and varieties
> of the animal and vegetable kingdoms
> (cited in Smith 1983: 70).

Finally, honest decoration without ornamentalism be-
came an aesthetic credo as it had in England. "The secret
of success is the absence of all second-rate ornamentation,
the fewness of decorative objects, the genuine utility and
simplicity of every article, and the unbroken color har-
monies," noted interior decorator Katherine Morse in 1893.
In fact, she continued, "an over-dressed house is [were
that possible] in worse taste than an over-dressed woman"
(cited in Darling 1984: 266). "[A]nyone who starts to make
a piece of furniture with a decorative form in mind starts
at the wrong end," wrote Gustav Stickley in 1899. "The
sole consideration at the basis of design must be the thing
itself and not its ornamentation" (cited in Smith 1983: 20).
Perhaps the most consistent purveyor of the Arts
and Crafts aesthetic in the United States, Stickley ex-
pressed the artistic vision of the movement in severely
plain, primitive, and solid oak furniture. Straight-
backed. and unadorned chairs, massive sideboards and
tables and cabinets reminiscent of sixteenth- and seven-
teenth-century furniture filled his furniture catalogs and
the pages of Craftsman. Stickley's architectural plans
were similar--nothing extraneous in the design, with the
structural supports and beams frankly exposed (Smith 1983:
50). Stickley was committed to the fusion of this aesthetic
to liberatory politics, even if not to the full-blown social-
ism of Morris:

> Today, the Craftsman Movement stands for
> . . . well-built democratic homes, planned
> for and owned by the people who live in

them, homes that solve the servant problem
by their simple, pleasant arrangement, and
meet the needs of wholesome family life.
Big, light, airy living rooms that foster
the social spirit are a part of its pur-
pose. . . . Civic improvement is close to
its heart, political as well as social and
industrial progress; it desires to strengthen
honest craftsmanship in every branch of
human activity, and strives for a form of
art which shall express the spirit of the
American people . . . (cited in Smith 1983:
161).

But despite their originally close similarities, the
American Arts and Crafts movement came to diverge from
that of England, so that the two eventually stood for fun-
damentally incompatible social and aesthetic aims. Two
linked and fundamentally American assumptions demonstrate
the differences most clearly: the belief in the regenerabil-
ity of all work, and the celebration of the powers of the
machine.

The American movement believed so passionately in
the work ethic that it did not "challenge the separation of
productive labor from joyful labor, nor protest the modern
organization of work" (Lears 1981: 83). Instead, as handi-
craft work became associated with all manual labor, sug-
gesting that all work was morally and spiritually satisfy-
ing, movement writers celebrated work itself as the embodi-
ment of the American civil religion. Workers seated at
their machines experienced the poetry of their calling, ar-
gued Gerald Stanley Lee in The Voice of the Machine (1906).
"Modern religion is a machine. Modern education is a ma-
chine," he wrote. And humanity is entirely bound up with
what he saw as a positive state of affairs: "the real
problem that stands in the way of poetry in machinery is
not literary or aesthetic: it is sociological. It is getting
people to notice that an engineer is a gentleman and a
poet" (in Gilberg 1977: 66).

Such eloquence underscores the American movement's
acceptance of the life-enhancing qualities of labor, per-
formed by all classes, and by women as well as men. "By
stressing the ennobling qualities of even the dullest work,
[the craft reformers] melded preindustrial craftsmanship
with the assembly line, collapsed the critique into the

thing criticized, and legitimated the modern factory labor as a form of character building" (Lears 1981: 84). The elevation of work for work's sake excised the radical political content of the English movement and substituted an ideology of personal growth and fulfillment through labor. Even C. R. Ashbee, one of the English movement's most eloquent exponents, had come to recognize a "revival of craft skill as a substitute for social revolution" and that "theoretical socialism and labor politics have always taken a second place in the mind of the workman wherever his work was intrinsically interesting" (cited in Callen 1980: 214). This was more likely to be true in the less rigidly stratified social and economic structure of America.

But it was not simply that virtually any work could be morally good; there was a concomitant view (hence approval) of the machine itself. This is the second chief difference between the English and American wings of the movement. "The machine just happens to be speedier, relieves the workman of a good deal of drudgery and legitimately cheapens production," one observer put it (cited in Lambourne 1980: 189). Not only did the machine make easier the production of inherently valuable work, but it was also capable of producing works of art itself. In 1906, Stickley published in Craftsman an article titled "The Use and Abuse of Machinery," suggesting in it that

> the hope of reform would seem to be in the direction of a return to the spirit which animated the workers of a more primitive age, and not merely to an imitation of their method of working. . . . The real friendliness of machinery to the handicrafts would be shown in the growth of an industrial art as vital and lasting as that of the medieval craftsman toward whose method of work it is now the fashion to cast such long eyes (cited in Anscombe and Gere 1978: 32).

Louis Comfort Tiffany, whose evocations of nature came through the brilliant use of color and light in his stained glass, saw in the technical capabilities of industrial production the opportunity to return to traditional aesthetic values and the highest level of artistic achievement. Tiffany evidenced an American faith in the liberatory

power of the machine; harnessed to serve the ends of art, the machine could produce works of unparalleled beauty. The machine was the vehicle for the return to the uncompromising aesthetics of the preindustrial age.

Despite this celebration of inherently modern industrial techniques, however, Tiffany was an ardent anti-modernist, who believed that an intimate relationship with nature was necessary to liberate the human spirit. His stained glass, in which the color is in the glass and not applied to it, was a glorification of light and color, a celebration of nature. "Nature is always right," Tiffany wrote in 1917. "Nature is always beautiful. Nature indicates color's mastership." And technology could make such beauty widely available in urban settings far from the natural source of inspiration. In the words of Samuel Bing, Tiffany's promoter and the owner of the Salon de l'art Nouveau in Paris: "Through the machine, a unique concept can . . . popularize to infinity the joy of pure form" (cited in Kimmel 1980: 25).

Perhaps the most compelling American commentary on the liberatory power of the modern machine within the framework of anti-modernism was that of Frank Lloyd Wright. Early in his life, Wright agreed with the anti-modernist disdain for the city as

> . . . a place fit for banking and prostitu-
> tion and not much else . . . a crime of
> crimes . . . a vast prison . . . triumph
> of the herd instinct . . . outgrown and
> overgrown . . . the greatest mouth in the
> world . . . humanity preying upon human-
> ity . . . carcass . . . parasite . . . fi-
> brous tumor . . . pig-pile . . . incongru-
> ous mantrap of monstrous dimensions . . .
> Enormity devouring manhood, confusing per-
> sonality by frustration of individuality. Is
> this not Anti-Christ? The Moloch that
> knows no God but more? (in Muschamp
> 1983: 13).

But while he was also one of the severest critics of the handiwork emphasis of the Arts and Crafts movement in America, he was "one of its aptest pupils" (Fishman 1977: 106). Capturing the Weberian paradox, Wright was the vehicle by which the craft ethic was translated into the ideology of modernism.

Morris had argued that the artist's mission was to "be the implacable enemy of the machine; his ability to humanize labor by restoring handicrafts was the origins of his authority" (cited in Fishman 1977: 108). The machine was to be restricted to only the most mundane and degrading tasks. Wright, however, came to disagree, and suggested that Morris had "miscalculated" (cited in Clark 1972: 43). The machine provided the material conditions on which democracy could be based. It was the "artist's capacity to shape and promote industrialization that was the source of his power," so far as Wright was concerned (Fishman 1977: 108). In one of his most influential speeches, "The Art and Craft of the Machine," delivered at Hull House in Chicago in 1901, Wright outlined a major departure from the anti-modernism of Morris's version of the Arts and Crafts movement. Even as he disagreed with its primary emphasis on handicrafts, it was on the basis of the movement's ideology that, like Stickley, Wright defended the machine. It was true, he stated, that the machine, in its "automatic imitation of handicrafts," had debased the decorative arts and dehumanized workers (Fishman 1977: 107), but the machine also possessed great democratizing abilities. Wright argued:

> The day of the individual is not over—it is just about to begin. The Machine does not write the doom of Liberty, but is waiting at man's hand as a peerless tool. . . What limits do we dare imagine to an art that is organic fruit of an adequate life for the individual! Although this power is now murderous, chained to botch work and bungler's ambitions, the creative Artist will surely take it into his hand, and in the name of Liberty, swiftly undo the deadly mischief it has created (cited in Gilbert 1977: 90).

Not only can the machine create works of art, it may be a work of art itself. "The tall office building is the machine pure and simple," Wright argued. The "engine, the motor, and the battleship [are] the works of art of the century," he declared (cited in Brooks 1972: 20). Later that same year, in a heated argument with Ashbee during one of the latter's visits to the United States,

Wright exclaimed: "My God is machinery. The art of the future will be the expression of the individual artist through the thousand powers of the machine, the machine doing all the things that the individual worker cannot do, and the creative artist is the man that controls all this and understands it" (cited in Crawford 1970: 64).

Thus the acceptance of the aesthetic potential of the machine, and the promotion of all work as morally regenerative, transformed the American Arts and Crafts movement. At the outset, in England it had been an angry political movement with a vision of socialist cooperatives, and when this vision weakened into fashionable aestheticism (while retaining traditional patriarchal characteristics), much of its original thrust became reformulated in support of the women's movement. In the United States, however, there was an early accommodation to the individualized politics of personal growth, linked with a new celebration of the liberatory powers of depoliticized technology. Craft had become merely style and technique:

> The Arts and Crafts movement has been the best industry during the past ten years . . . while we have sought to develop handicraft beside it on sound and independent lines, we have succeeded in imparting something of the spirit of craftsmanship to the best kind of machine work, bridging over the former gulf between machinery and tools, and quickening machine industry with a new sense of the artistic possibilities within its proper sphere (Crane 1905: 30).

Machine production could now impart an authentically rough, handcrafted appearance to new furniture styles. Machine-produced mission furniture, marked by a rigid simplicity and starkly angular use of weathered dark oak, became popular even as the style was tuned more to mainstream upper and middle classes than to serve as an expression of, or vehicle for, political transformation. The goal was "to sell merchandise, not to preach simplicity and improve morality" (Darling 1984: 247). This is also evident in the studied simplicity of Wright's Prairie School architecture and home furnishings. Intended for elite consumption (although readily reproducible for non-elites),

such furniture was designed to fit into the already de-
signed house to create an overall unity of effect without
calling attention to individual pieces. Like his architec-
ture, Wright's furniture used natural materials, shaped
into boldly abstracted forms with crisp right angles,
straight lines, and horizontal planes, to create austere
and even uncomfortable furniture. Form had become par-
tially divorced from function, as aesthetic demands and
the drive against ornamentation become predominant. Even
its own creator came to acknowledge the consequences: "I
have been black and blue in some spot, somewhere, almost
all my life from too intimate contact with my own early
furniture," Wright mused (cited in Darling 1984: 260-61).
 But such reconsiderations came much later; mean-
while, precisely from these new styles grounded in the
Arts and Crafts ideology, Wright and others made the easy
step to a recharged modernism. With aesthetics that de-
cried ornamentation as archaic throwbacks to the pre-
machine era, and ethics that sanctified assembly-line pro-
duction as morally regenerative for the worker, livable
houses were designed for the very victims of that work
process. Thus in the United States, the Arts and Crafts
movement abandoned its political stance for a refined aes-
thetic sensibility and the promotion of even the most de-
grading factory work as a "calling." By abandoning col-
lective social transformation as its overall goal, the move-
ment could not serve as a springboard, or support, for
American feminists as it had served their English sisters.
Indeed, by accepting the moral validity of all manual
work, no matter the conditions of industrial production on
the assembly line, or of domestic production performed by
women in the home, and by celebrating the aesthetic tri-
umph of the machine, the American movement transformed
its original anti-modernist impulse. In the eyes of some,
that transformation was rather a betrayal.
 Embracing the rationalization of the production and
the domestic consumption of industrial products, the Arts
and Crafts movement facilitated the transition to a new
aesthetic modernism in which works were no longer designed
for the pleasure of the user or the maker. Although the
Arts and Crafts movement had been "dedicated to reviving
the medieval crafts . . . it proved to be an important
source of the modernist theories of the Machine Age" (Fish-
man 1977: 105). The English anti-modernist outcry against
the evils of industrial capitalist society had come full

circle: what was moved out of the guilds and into the streets of America was a revived, and revitalized, modernism.

BIBLIOGRAPHY

Adams, Henry. 1964. The Education of Henry Adams, 2 vols. New York: Time, Inc. (originally 1918).

Anderson, Timothy, Eudorah Moore, and Robert Winter, eds. 1980. California Design, 1910. Santa Barbara, Calif.: Peregrine Smith.

Anscombe, Isabelle, and Charlotte Gere. 1978. Arts and Crafts in Britain and America. New York: Rizzoli.

Berman, Marshall. 1982. All That Is Solid Melts into Air: The Experience of Modernity. New York: Simon and Schuster.

Bowers, William. 1974. The Country Life Movement in America, 1900–1920. Port Washington, N.Y.: Kennikat Press.

Brooks, H. Allen. 1972. The Prairie School. Toronto: Toronto University Press.

Callen, Anthea. 1980. Women Artists of the Arts and Crafts Movement, 1870–1914. New York: Pantheon.

Clark, Robert Judson, ed. 1972. The Arts and Crafts Movement in America, 1876–1916. Princeton, N.J.: Princeton University Press.

Crane, Walter. 1905. Ideals in Art. London: G. Bell.

Crawford, Alan. 1970. "Ten Letters from Frank Lloyd Wright to Charles Robert Ashbee." Architectural History 13:33–51.

Darling, Sharon. 1984. Chicago Furniture: Art, Craft, and Industry, 1833–1983. New York: W. W. Norton.

Fishman, Robert. 1977. Urban Utopias of the Twentieth Century. New York: Basic Books.

Gilbert, James. 1972. Designing the Industrial State: The Intellectual Pursuit of Collectivism in America, 1880–1940. Chicago: Quadrangle.

_____. 1977. Work Without Salvation: America's Intellectuals and Industrial Alienation, 1880–1910. Baltimore, Md.: Johns Hopkins University Press.

Hayden, Dolores. 1981. The Grand Domestic Revolution: A History of Feminist Designs for American Homes, Neighborhoods, and Cities. Cambridge, Mass.: MIT Press.

Higham, John. 1970. Writing American History: Essays on Modern Scholarship. Bloomington: Indiana University Press.

Hughes, H. Stuart. 1958. Consciousness and Society. New York: Vintage.

Kimmel, Michael S. 1980. "Women's Work, Women's Art." San Francisco Review of Books (October):9–11.

_____. 1981a. "The Art of Louis Comfort Tiffany." San Francisco Review of Books (July):17–19.

_____. 1981b. "Modernity and Its Discontents." San Francisco Review of Books (February):8–9.

Lambourne, Lionel. 1980. Utopian Craftsmen: The Arts and Crafts Movement from the Cotswolds to Chicago. Salt Lake City, Utah: Peregrine Smith.

Lears, T. Jackson. 1981. No Place of Grace: Antimodernism and the Transformation of American Culture, 1880–1920. New York: Pantheon.

Marx, Karl, and Friedrich Engels. 1978. "The Communist Manifesto." In The Marx-Engels Reader, edited by Rupert Tucker. New York: W. W. Norton.

Morris, William. 1948. Selected Writings, edited by C. D. H. Cole. London: Nonesuch Press.

_____. 1962. Selected Writings and Designs, edited by Asa Briggs. Baltimore, Md.: Penguin Books.

Muschamp, Herbert. 1983. Man About Town: Frank Lloyd Wright in New York City. Cambridge, Mass.: MIT Press.

Naylor, Gillian. 1971. The Arts and Crafts Movement. Cambridge, Mass.: MIT Press.

Read, Herbert. 1961. Art and Industry. Bloomington: Indiana University Press.

Ruskin, John. 1884. The Two Paths: Lectures on Arts and Its Application to Decoration and Manufacture. New York: John Wiley.

_____. 1892. Lectures on Architecture and Painting. New York: Charles E. Merrill.

_____. 1925. The Stones of Venice, 2 vols. London: George Allen and Unwin.

Scheyer, Ernest. 1970. The Circle of Henry Adams. Detroit, Mich.: Wayne State University Press.

Smith, Mary Ann. 1983. Gustav Stickley, The Craftsman. Syracuse, N.Y.: Syracuse University Press.

Thompson, E. P. 1977. William Morris: From Romantic to Revolutionary. New York: Pantheon.

Weber, Max. 1958. The Rational and Social Foundations of Music, translated and edited by Don Martindale and Johannes Riedel. Carbondale: Southern Illinois University Press.

Williams, Raymond. 1973. The Country and the City. New York: Oxford University Press.

_____. 1982. The Sociology of Culture. New York: Schocken.

Wolfe, Tom. 1982. From Bauhaus to Our House. New York: Farrar, Straus and Giroux.

8

BLACK FOLK ART
AND THE POLITICS OF ART

Gene Metcalf

Aesthetic and social issues in the history of black art in America have often been difficult to disentangle from one another. Such confusion is encountered in all art, of course, but it has been a particular burden for black Americans. Art represents and sanctifies that which is valued in a society; the ability to create and appreciate art implies heightened human sensibility and confers social status and prestige. A people said to be without art, or with a degraded form of it, reputedly show themselves lacking in those qualities that dignify human experience and social interaction. They are said to be "uncultured," "primitive," unable to participate in refined society. Definitions of art are therefore highly political. They are major battlegrounds on which the struggle for human and social recognition is waged. A people can ill afford to let others control the definitions by which their arts are classified and evaluated.

The history of black American art demonstrates the social consequences of such aesthetic control. During the

This article is adapted from the article, "Black Art, Folk Art, and Social Control," Winterthur Portfolio (Winter 1984):271-89. I am grateful to the University of Chicago Press for permission to reprint. The author appreciates the comments of Judith Fryer, Curtis Ellison, Leonard Hochberg, John Vlach, Kenneth Ames, John Fruse, Alan Axelrod, and Judith Balfe on earlier versions of this paper.

169

first centuries of black experience in America, partly to
support a social system grounded on the denial of the hu-
manity of black people, whites generally refused to admit
that blacks could make art at all. By the end of the
nineteenth century and the beginning of the twentieth,
enough black artists had mastered the white Europeanized
aesthetic tradition to argue that blacks had proved their
civility and should be allowed the benefits of American
democracy. No "people that has ever produced great liter-
ature and art," said James Weldon Johnson, "has ever been
looked on by the world as distinctly inferior" (Johnson
1931). Yet to gain a measure of acceptance from the white
art world and white society, black artists have often been
forced to conform to artistic traditions and forms that
denied their unique cultural heritage and the reality of
their American experience.

 This was not true for all black artists, however.
From the earliest years of their American captivity, blacks
had practiced aspects of the traditional arts of Africa.
Although these activities did not conform to white artistic
definitions and so were not dignified with the name art,
they did provide their makers and communities a sense of
historical continuity, a method to help merge conflicting
cultural forces into intelligible social patterns, and im-
portant support for human value in the face of a slave
system bent on denying it. Long before black Americans
learned European fine arts, and were taught to be ashamed
of their folk practices as evidence of slavery and barba-
rism, they retained mastery of African-derived traditional
art forms, the practice of which would continue to the
present as a vibrant force in black American culture.

 Despite the significance of folk art in black Amer-
ican culture, virtually no general studies of the history of
American art take seriously contributions by black Ameri-
cans. In the rare instances when any are mentioned, it
is usually only those works that have met the aesthetic
standards of academic taste and "high culture." The few
specialized exhibitions and books that have focused entirely
on the work of black American artists have also generally
adopted a high-cultural bias.[1] Such works have focused
on black academic art and have portrayed black folk art
only as an early, and now outgrown, artistic tradition
which predated, and paved the way for, the acquisition of
academic skills by black artists.[2] According to David C.
Driskell, in the catalogue of one of the largest exhibitions

of black American art presented to date, "An apprenticeship
in the crafts often served to prime talent in painting,
drawing, or sculpture, and skilled black artisans tradi-
tionally moved up the scale from journeyman to master
craftsman, then entered a particular area of the fine arts"
(Driskell 1976).

This emphasis on high art has even influenced the
few works about black art that have ostensibly sought to
focus on its folk traditions. In the recent, widely ac-
claimed exhibition, Black Folk Art in America, 1930-1980,
organized by Jane Livingston and John Beardsley at the
Corcoran Gallery of Art in Washington, D.C., the art pre-
sented is understood and evaluated in terms of the high-art
categories of painting and sculpture. Rather than being
the product of a communal or folk tradition, this art repre-
sents the unique visions of highly talented, idiosyncratic
individuals whose style, according to the catalogue, has
to do not with crafts or traditional utilitarian artisanship,
but with full-fledged, gratuitous [high] art objects, paint-
ings and drawings and sculptures" (Livingston 1982).

Why has black American folk art been understood
and evaluated in terms of high-art values and categories?
The answer lies in history; although black folk art has
been incorporated into general American art history rarely
and inadequately, the emerging contemporary interest in,
and approach to, the subject has historical precedent. In
the 1920s and 1930s two events occurred that were instru-
mental in establishing the artistic and social backgrounds
from which the modern idea of black folk art would grow.
The first of these was a black arts movement known as the
Harlem Renaissance; the second was the discovery and
popularization of American folk art. Both of these involved
the discovery and promotion of a new vision of American
art and culture through the unearthing of unique bodies of
American art.

THE HARLEM RENAISSANCE, BLACK ART,
AND WHITE ATTITUDES

The official manifesto of the Harlem Renaissance was
issued in December 1925. Entitled The New Negro and
edited by Alain Locke, a black Harvard-educated professor
of philosophy at Howard University, it contained a variety
of articles, poems, stories, and pictures by blacks and

their white supporters. The purpose of the book, said Locke, was to "document the New Negro culturally and socially--to register the transformations of the inner and outer life of the Negro in America that have so significantly taken place in the last few years." In the lead essay Locke wrote that, although old stereotypes remained, the transformation in black America had long been taking place. The transformed Negro was no longer primarily a rural Southerner, but rather lived in the great cities of the North. This migration, coupled with black American experiences in World War I, resulted in a new massing of black energy, a new black cosmopolitan view, and feelings of race pride and militancy. Nowhere was this more evident than in Harlem, the largest black urban community in the world, where "Negro life was seizing upon its first chances for group expression and self-determination" (Locke 1975).

Armed with a deep awareness of race, black artists were creating a new black American art. Yet, Locke counseled, in discovering and defining their culture, blacks should not forget that they were also Americans striving for full participation in American institutions and culture. Lower-class blacks and whites had interacted frequently in the past, Locke pointed out, and he suggested that the upper classes should do the same. Thus the great advantage in overturning the old Negro stereotypes was "the releasing of their talented group from the arid fields of controversy and debate to the productive fields of creative expression." Through this expression would come significant artistic achievement, the sign of cultural maturation. This, in turn, should cause among enlightened blacks and whites "that reevaluation of the Negro which must precede or accompany any considerable further betterment of race relationships" (Locke 1975).

Art was to be a vehicle for social uplift, and so, as historian Nathan Huggins has pointed out, during this period black intellectuals promoted the arts as if their lives depended on it. Although primarily concerned with literary arts, the period also saw the promotion of music, painting, and sculpture. All were viewed as important indicators of black cultural maturity and were promoted in deadly earnest (Huggins 1971).

Two sources that contributed significantly to the new black situation and attitude were the discovery and celebration of the black common man and his folk culture,

and the discovery of a black American heritage in Africa.
In the years after the Civil War, middle-class black
leaders saw the folk practices of the black masses as an
embarrassing legacy of slavery. However, after World
War I, the life and art of the common man took on a ro-
mantic appeal. Although most black leaders and intellec-
tuals still looked to their middle class for support, and
continued to view high culture and art as the signs of
civilization and cultural maturity, they turned, like in-
tellectuals the world over, to a study and celebration of
folk societies.3 Suddenly the culture of the black peasant
was no longer an example of everything about the black
man that was ignorant and backward, but was rather a
life seen in its essentials, which, if understood, might
yield distinctive traits of the black American character.
In such terms the art of these men was significant as a
unique American expression of folk art. Although in its
unsophisticated natural form it could not support the kind
of high-cultural pretensions Locke and the supporters of
the Harlem Renaissance demanded, it nevertheless was now
viewed as a vibrant source on which black artists could
draw to create a formidable fine art.

 Connected to this surge of interest in black folk
art was the development of an enthusiasm for African cul-
ture and art. Roughly concurrent with the development of
the modern techniques of anthropology, European intellec-
tuals and artists discovered in African culture and art a
sophistication and complexity not ascribed to them before.
African art came to be valued for its aesthetic qualities,
particularly its qualities of design, and it influenced the
works of numerous European artists, especially the Cubists.
All of this was very useful for American blacks, providing
them with a valuable cultural heritage and aesthetic tra-
dition rooted not in white Western culture and the experi-
ence of American slavery, but in a proud and vital tradi-
tion that went back centuries and to which white Western
culture was itself now turning for inspiration. Many black
sculptors, painters, poets, and writers of the 1920s plumbed
both their folk experience and their African heritage,
seeking not only images of black pride and cultural dig-
nity, but also some lesson that might help create a unique
American fine art.

 According to Huggins, the fact that black intellec-
tuals and artists of the Harlem renaissance placed such
primary emphasis on the creation of high art is not sur-

prising. (During the era of World War I blacks and whites alike commonly believed that high culture and art were the measure of civilization.) James Weldon Johnson was but reiterating a generally held assumption when he remarked in the preface to his Book of American Negro Poetry (1922) that the only measure by which cultural greatness can be recognized and acknowledged is the "amount and standard of literature and art" that the culture has produced. Thus, points out Huggins, the hope of black Americans that the production of a black fine art would announce a cultural "coming of age" was analogous to the general American struggle against European cultural hegemony, an effort to produce a distinctive American art and culture.

In his brilliant book, Harlem Renaissance (1971), Huggins shows how the black art of the period was produced by, and must be understood in terms of, the subtle interaction and often unacknowledged mutual dependencies between black and white Americans.[4] That the art of black Harlem was in many ways created for white consumption must not be overlooked. In the cultural turmoil following World War I, many white middle-class Americans, especially intellectuals and the young, were cast adrift from the institutional and ideological moorings of American society. Feeling betrayed by the war and the false hopes it had created in a society undergoing technological and demographic change, they rebelled against traditional values and behavior. Some left America entirely; others stayed. But the 1920s were, for whites as well as blacks, a time of dislocation and adjustment. Although what happened in Harlem served the needs of both groups, it was the whites who benefited more.

Crowded together for the first time in large metropolitan areas, blacks and whites discovered each other anew in the wake of the war. In New York this discovery was instrumental in the creation of the Harlem Renaissance. Seeking to liberate themselves from dull and debilitating tradition, to reinvigorate their lives, whites turned their attention to Harlem, often to get their first close-up look at black Americans.

They found only what they sought. In the years before the war, white writers had already suggested that black Americans might possess a gift of primitivism and simplicity that preserved them from the technological sterility of American society. After the war, this black American primitivism, expressed often in terms of African

origins, was discovered and celebrated by whites from all
over the world. According to French journalist Paul
Morand, a ride on the New York subway, where one could
view blacks "clinging with long hooking hands to the
leather straps, chewing their gum," was much like a trip
to darkest Africa. Indeed, in Harlem all black life seemed
to evince "an animal swiftness, a war-like zest" . . .
"savage and triumphant," a welcome antidote to "the me-
chanical rhythm of America" (Morand in Singh 1976). Sud-
denly, enlightened whites could not learn enough about
black America. Whites flocked to Harlem to dance and
drink, threw interracial parties, and supported the work
of black painters and writers. Small wonder that the
mood of many black intellectuals and artists sometimes ran
to buoyant optimism. Blacks not only were discovering
and defining themselves and their culture, but, for per-
haps the first time, they also were supported and encour-
aged in this endeavor by white America.

This support may seem surprising. These same
years saw a hardening of caste lines and a resurgence of
racism resulting in bloody riots and the rebirth of organi-
zations like the Ku Klux Klan. Yet the contradiction only
emphasizes how the Harlem Renaissance served the over-
whelming needs of both blacks and whites. For middle-
class blacks and black leaders the events of the Harlem
Renaissance seemed to promise the fulfillment of a dream
held since Emancipation—that by working through the sys-
tem and proving themselves worthy, blacks would eventually
be granted equality in white society. For enlightened
whites this new association with blacks offered not only
the self-congratulation brought by the confidence that they
were working to rid America of racial prejudice but also
the hope that some black spontaneity might be communi-
cated to them, helping them to escape the straitjacket of
their overcivilized past.

At least as early as 1908, with the publication of
Van Wyck Brooks's Wine of the Puritans, Americans had
become concerned that their Puritan heritage might be
more a disadvantage than a boon (Leuchtenburg 1958).
Blaming the Puritans for the development of a modern
American civilization in which spiritual values and plea-
sure were crowded out by a love of material objects,
Brooks and others lamented American business culture and
feared increasing mechanization, which seemed to be turn-
ing people into automatons. Yet this attack was hardly

aimed at the Puritans alone. It was also directed at nineteenth-century America, in which business and industry had flowered, and it represented a common tendency to remake the past in the service of present needs. "Every age, of course, remakes history in its own image," remarked Howard Mumford Jones of the literary critics of the 1920s, "but the special mark of these iconoclasts was a refusal of historical importance as a canon of judgment" (Jones in Hoffman 1965).

Discarding history as a basis for judgments was made possible by the discovery of another standard of judgment in the work of Sigmund Freud. Whereas before World War I Freud's name had been known primarily in medical and intellectual circles, in the 1920s his work became a popular craze. Grossly simplified and distorted by his popularizers, Freud was used in a frontal attack on American business civilization and its Puritan past. The problem with civilization, the argument went, was that it squelched natural emotions and drives for the purpose of social order and regulation. Weighed down by their Puritan past, burdened by history as a disease, Americans had sacrificed spontaneity, feeling, and fun, to achieve material prosperity, social decorum, and guilt. The result was repression, a word that came to symbolize all the evils visited on the modern human race by overbearing civilization. The only escape, it was argued, was to trust and act on one's primitive desires, to frustrate social norms and expectations. A model for such behavior existed in Harlem, it was thought, with black people, who had almost magically escaped the enervating forces of civilization and were still able to live unrepressed, spontaneous, and exotic lives.

Although a number of themes were important in the culture and art of Harlem in the 1920s, primitivism was among the most influential. Supported by the fascination with folklore and the cultural discovery of Africa, primitivism was not only a drawing card for Harlem nightlife but also an almost obligatory concern in any art form that aspired to popularity and sought to portray black Americans. Both black and white artists exploited the theme, as white patrons, promoters, and the public clamored for more. Yet despite its general acceptance and popularity, primitivism was a dangerous and potentially debilitating stereotype. On the surface it seemed to represent a step forward for blacks by offering what appeared to be valuable

historical roots, a positive black identity, and the promise of social progress. Examined more deeply, however, the promises were empty and served only to perpetuate the old status quo and white racist power.

To begin with, Africa was for most American blacks in the 1920s an unknown, "make-believe" past. Few had ever been there or knew anything about its culture and art, or about the actual relationship between Africa and the culture and art of America. From the perspective of most of the artists of Harlem, who were striving for middle-class respectability through visions of fine art, Africa remained an imaginary exotic land of verdant, mysterious forests, wild beasts, and savages. As was the case with Puritanism for white Americans, Africa for most New Negroes represented more a fanciful image than a historical reality on which one could fashion an accurate sense of the present. Moreover, the new popular stereotypes of black primitivism were remarkably similar to the old racist stereotypes of black self-indulgence and irresponsibility. Before the 1920s blacks were condemned for being childlike and shiftless. After the war they were applauded for being spontaneous and free. The image had not become more accurate; rather, white society's view of itself had changed, and some whites now used blacks to justify their rebellion against their discontents with their own civilization.

Blacks who believed that this reworked white attitude represented something significantly new were in for a cruel shock. Primitivism could easily be a negative as well as a positive image, and accounts such as Morand's description of Harlem blacks as great African apes could be used to criticize as well as commend. Generally it was hard to tell the difference between the derision and the praise. More than anything else, the cult of black primitivism allowed liberal whites to avoid the implications of their professed social ideology. By supporting and promoting black artists and their art, white patrons could believe they were working toward a more egalitarian future. But by insisting that the black behavior and art they supported conform to the unreal and potentially pejorative myth of primitivism, they were also insuring, perhaps unknowingly, that this future would be unrealized and their own social position and power would remain unchallenged. This was one of the ironies of the Harlem Renaissance. The very people to whom the New Negroes turned as the arbiters of cultural sophistication had the most invested in perpetuating the racist reality behind the primitivist myth.[5]

FOLK ART AND BLACK FOLK ART

Like the promotion of black art by the white sup-
porters of the Harlem Renaissance, the promotion of Ameri-
can folk art, which began about the same time, afforded
its supporters useful strategies for coping with the uncer-
tainties of a culture in transition. Reacting to fears of
civilized sterility and searching for models of personality
unencumbered by social repression, both art movements
pandered to the myth of primitivism. The vision of the
childlike black man was not far removed from the image
of the folk artist developed by promoters. Not only were
the adjectives of primitivism applied interchangeably, but
blacks and folk artists were both seen as inhabitants of
similar idyllic and imaginary pasts. The romanticized im-
age of Africa developed by the Harlem promoters served the
same escapist purposes as did the vision of a simpler,
more virtuous preindustrial America in which critics located
the production of the nation's folk art.

The popular enthusiasm for American folk art began
when folk pieces first caught the attention of white Ameri-
can modern artists, in the early decades of the twentieth
century. Influenced in part by the attraction primitive
forms exercised on European artists, this attention was
also affected by the perception of the American modernists
that folk objects were similar in feeling and form to the
new art they were themselves producing. This connection
helped these artists justify and substantiate a break with
the nineteenth-century impressionist and representational
tendencies in high art. As Daniel Robbins has pointed
out, American folk art offered American modernists a tradi-
tion for their new high art (Robbins 1976). Folk art
served to connect the artists of the 1920s and 1930s with
a long tradition, giving them not only historical and cul-
tural roots, but also a reply to critics of American modern
art who claimed that it was only another version of deca-
dent European civilization.

The most important early promoters of American folk
art, Edith Halpert and Holger Cahill, discovered American
folk art in 1925 and 1926. Halpert began collecting folk
art and selling it at her Downtown Gallery in Greenwich
Village. By 1931, when she opened the American Folk Art
Gallery, the first gallery devoted entirely to the promotion
and sale of American folk art, she had become a leading
impresario. Cahill, a member of the Newark Museum staff,

became the first scholar to write extensively on American
folk art, and organized a number of early exhibitions, the
most important of which was American Folk Art: The Art
of the Common Man in America, 1750–1900, mounted in 1932.
This show established folk art as a major presence in the
art world and codified a folk art aesthetic that continues
to influence scholarship and collecting today.

(According to Cahill, folk art was the product of an
earlier, more democratic America where individuality and
the virtues and values of craftsmanship and agrarian life
still prevailed.) Flourishing until the Civil War, it then
began to languish as industrialism and urbanization/cut
Americans off from the land,/eclipsed the craft tradition,
and produced a machine civilization. Thus folk art was
the antithesis of overcivilized, machine-made goods. Ac-
cording to Cahill, folk art "may be called primitive in the
sense that it is the simple, unaffected and childlike ex-
pression of men and women who had little or no school
training in art, and who did not even know that they
were producing art." Such art represented the best of
America, for it mirrored "the sense and the sentiment of a
community, and is an authentic expression of American ex-
perience." Fittingly, this American art was not produced
by "professional artists . . . for a small cultured class";
it "is the expression of the common people, made by them
and intended for their use and enjoyment." This body of
art was said to be as diverse as the people who made it.
Including paintings, weather vanes, and cigar store In-
dians, "the list of objects which come under the head of
American folk art is practically inexhaustible" (Cahill 1932).

Although such objects were commonly available,
Cahill was highly selective in gathering materials for the
exhibition. Acting on an assumption common in the folk
art field at the time (and that continues to influence it
today), he carefully sought items primarily for their aes-
thetic value while ignoring their historical and social con-
text. The emphasis was on the art, not the folk. This
aesthetic rather than historical approach was popular par-
tially because Cahill and the other early folk art promoters
knew little about the circumstances in which the art they
collected had been produced. (The concentration on aes-
thetics also sprang from a bias inherited from the study
of high art) which placed art in an ennobled realm above
history and beyond mundane human occupations. In The
Art of the Common Man Cahill stressed the aesthetic quality

of the objects he presented and grouped folk objects into the traditional high-art categories of painting and sculpture, thereby largely ignoring their functional aspects.

Despite their enthusiasm, Holger Cahill and the folk art establishment viewed folk art much as the black Harlem intellectuals viewed their folk heritage: folk culture was exciting and invigorating, an important background and inspiration for American fine art, but it could never be evidence of significant cultural sophistication or attainment. "Folk art cannot be valued as highly as the work of our greatest painters and sculptors," said Cahill in the introduction to the catalogue for the 1932 exhibition, "but it is certainly entitled to a place in the history of American art." Consequently, as an unnamed reviewer of Cahill's exhibition noted, despite its deficiencies, folk art "will always serve as a sort of touchstone as to what is genuine in feeling. Artists who find themselves growing mannered or stale will always be able to renew their appetite for expression by returning to examples of these early pioneers" (Art Digest 1932: 46). Cahill's view of the creators of folk art was no less condescending. They were childlike, primitive people who could not even be given credit for knowing that they were producing art.

While folk art was ranked aesthetically inferior to high art, the promotion of folk art, like the promotion of black art, reflected and embraced many of the attitudes associated with commerce in high art. By the late 1920s and 1930s, folk art and black art were just beginning to be valued as much as high art had always been valued: as the perquisites of the elite and socially privileged. To use Thorstein Veblen's celebrated phrase, all three kinds of art were coveted as objects of conspicuous consumption (Veblen 1953). Cahill, in fact, had studied with Veblen, from whom he learned about the implications of handicraftsmanship as a dying American tradition (Rumford 1980). Of course, Veblen's work went far beyond this particular concern, and it is doubtful that Cahill fully understood his teacher's thought. In his first book, The Theory of the Leisure Class (1899), Veblen argued that art is an instrument of social status and control. In modern society dominated by a leisure class that derives its position from not having to perform necessary social labor, the conspicuous consumption of objects (such as art) that are not necessary for basic subsistence is a sign of status and honor. Furthermore, since collecting and learning about such objects

is a waste of productive time, such conspicuous leisure is a sign that one need not employ his efforts to earn a living; thus connoisseurship becomes a symbol of particular distinction. Collecting and connoisseurship are not undertaken in a deliberate effort to waste and consume, but are inevitable consequences of the desire to live up to class norms and achieve social distinction. The standards of distinction are established by the leisure class, the only social class that can actually afford to live in a conspicuously wasteful manner; but the standards it sets are aspired to by all members of society.

In Veblen's analysis the production and appreciation of art becomes, as it was in the 1920s and 1930s, a measure of class-related civilized sensibility and cultural maturation. As the Harlem intellectuals knew, high art was the measure of such civility, but the appreciation of folk art might confer an even higher status. Such status could not attach to the producers of folk art, for many of the objects they made, like weather vanes and shop signs, were produced for obviously utilitarian and socially useful ends, but it could apply to the promoters and collectors of such objects if they were treated in a nonutilitarian way. Thus, as with fine art, the possession of folk art could be an honorific sign of conspicuous consumption, and spending one's time collecting it might serve as a symbol of conspicuous leisure. Moreover, since much folk art was originally created for utilitarian ends, the elevation of these objects to the status of nonutilitarian art, and the concomitantly high prices paid for the originally inexpensive "common" articles, raises the value of folk art above that of high art for the purposes of conspicuous display. Those who have been able to redefine--and thus revalue-- these objects could and can enjoy increased social power.

The promotion of folk art, like the promotion of black art, was carried on by an elite and served to support and extend the status of that group, often at the expense of the people whose work was being promoted. In a period of social flux and uncertainty, both Cahill's early writings and the views of the Harlem promoters helped to establish aesthetic definitions that allowed socially powerful groups to support a new and more democratic vision of American art and society while simultaneously protecting and even augmenting their exclusive social interests.

BLACK FOLK ART IN THE 1970S AND 1980S

Black American folk art became an object of sustained interest only in the 1970s, half a century after the respective discoveries of black fine art and American folk art. To be sure, individual works by blacks had been included in some books and exhibitions of American folk art, and shows of the work of individual black folk artists had occurred, but it was not until after the 1960s, following the black awareness movement and the development among American folklorists of an interest in items of material culture, that a real concern emerged for American folk art defined by its "blackness."[6]

In the beginning most of this interest did not come from the established folk art world, but from a vanguard of scholars primarily committed to the folkloristic and anthropological assumption (classically illustrated in Melville J. Herskovits's The Myth of the Negro Past, 1958) that black American folk culture and art were the products of traditional cultural patterns within the black community, patterns that could be traced to African origins. Part of a larger reexamination of the field of American folk art that was just then beginning, this view diverged significantly from the folk art dogma enunciated in the 1920s and 1930s and rediscovered and celebrated anew by popular writers during the bicentennial some 50 years later. According to the new scholarly view, in contrast to that just described, folk art was to be studied more for the qualities that made it folk than for those that made it art. The nature of folk art was to be discovered in its communal social context, not in an examination of internal aesthetic structures. Indeed, aesthetic concerns were often said to be unimportant. Such views inevitably conflicted with the established folk art movement. However, black folk art was not yet as "collectible" as other kinds of folk art and therefore not as much a part of the marketplace, so it was not centrally involved in the dispute between aesthetics and context witnessed during the 1970s.

But folklore scholars were very much at work during the 1970s identifying, studying, and encouraging black artists and artisans. As in the Harlem of the 1920s, blacks with any artistic talent began to find it difficult to avoid discovery by avid fieldworkers bent on promoting them as folk artists—sometimes against the artist's will. Some artists, in whose work very few links to African

tradition could be found, were also promoted. These were celebrated as untutored individual black artistic talents.[7] By the 1980s, black art (especially when it could be labeled as black _folk_ art) had become a marketable commodity in the established folk art world. One result of this newly established valuation was Black Folk Art in America, 1930-1980, the Corcoran Gallery exhibition, noted above. It illustrates better than any other recent example the aesthetic and social injustice that can result from confounding black art with the idea of folk art inherited from the 1920s and 1930s.

Following the pattern established by folklorists in the 1970s, the organizers of Black Folk Art in America contend that the artists in the exhibition work within a common black tradition. But this tradition is never defined historically; instead, it is linked to a common aesthetic trait said to connect the work of these 20 artists: "the overarching atmosphere of a single tradition, . . . a single style." This aesthetic is said to be one "which seems to understand the beauty which inheres in intentional crudeness or indecorum. . . . It is in great measure an aesthetic of compassionate ugliness and honesty" (Livingston 1982). Yet such an aesthetic obviously panders to dangerous and socially debilitating a priori assumptions about black people and their art. Like the concept of primitivism, the aesthetic of "compassionate ugliness" carries negative as well as positive connotations. This is particularly the case since the idea of "compassionate ugliness" is never really explained or significantly explored in terms of a black artistic tradition. Although the intent of the organizers of the Corcoran exhibition is clearly to praise rather than to disparage the artists they present, the history of the exploitation of black art and folk art should illustrate the danger inherent in using such an unsubstantiated and potentially pejorative concept as "compassionate ugliness." Like the idea of primitivism, it can be used to support the reissuance of old racist stereotypes in new and deceptively positive guises.

If we free ourselves of racial stereotypes and carefully examine the work of the artists presented in the Corcoran show we do not discover the presence of a communal aesthetic (such as compassionate ugliness) so much as we find the individual operation of powerful and intensely personal visions. Even Jane Livingston, who promotes the black art of the exhibition as _folk_ art, empha-

sizes that "virtually every artist in this exhibition claims
to have been commanded by an inner voice or by God to
make art." "On the face of it, we discover a nearly unani-
mous testament to personal revelation" (Livingston 1982).
Yet, visions or dreams are generally highly personal ex-
periences, and as such represent individual rather than
communal or folk experiences. To be part of a folk aes-
thetic, dreams must be shown to be responsive to communal
dictates. Perhaps this is possible if the visions are un-
derstood not as a primary experience to be taken at face
value, but as a method the black folk artist employs to
explain and understand, often in religious terms, a com-
munal aesthetic whose workings go beyond rational under-
standing and knowing. Such an aesthetic does exist in
black American culture and is found in virtually all tra-
ditional black art forms. It includes the aesthetic of im-
provisation, in which the artist is encouraged to experiment
freely within a form until, at last, an order emerges that
gives coherence to the finished piece. This often is
achieved after hours of tedious work, yet when it finally
appears it imparts meaning and harmony to an otherwise
disconnected, even chaotic, experience. As such it may
seem almost an epiphany, even though it was a long time
coming--something John Vlach suggested in an article on
black creativity:

> Because this additive [improvisational] ap-
> proach is incremental, even piecemeal, the
> final goal is often not seen from the outset
> of the creative process. Later at some
> critical, even magical, point when an ac-
> ceptable shape begins to emerge it may
> seem that it is the work that almost creates
> itself. In an instant what had been an
> assemblage of seemingly random elements
> comes together and it is sensed as powerful,
> evocative, or beautiful. It is not surpris-
> ing then that many black folk artists speak
> of a visionary episode as the source of
> their work (Vlach, in progress).

Yet, this kind of visionary process occurs only within the
context of a strong traditional culture that both frees and
limits the artist. We do not generally find this context
in the visionary creativity of the artists in the Corcoran

exhibition. Aesthetically, geographically, and socially
isolated, they share no communal tradition. Despite the
title and intent of the exhibition, the art it presents is
black art rather than black folk art.

Indeed, following the practice of the Cahill school
(chiefly influenced by the aesthetics of high art) Black
Folk Art in America deliberately excludes some important
folk genres, arts connected with "crafts or traditional
utilitarian craftsmanship." The exhibition features paint-
ing and sculpture (high art genres) only. Yet it is the
more utilitarian arts, such as the work of contemporary
black basket weavers and musical-instrument makers, that
are much more closely connected to black culture and life
than are the "gratuitous art objects" chosen for the exhi-
bition. As was the case in the Harlem Renaissance, real
folk objects are denigrated by treatment only as background
or precedent for the development of black talent in high-
art skills.

The full consequences of confounding black art with
folk art defined in the manner of Cahill becomes most ap-
parent when we consider a few specific works that are in-
cluded in the Corcoran exhibition. Among the most power-
ful is James Hampton's The Throne of the Third Heaven of
the Nations Millenium General Assembly. Following his
death in 1964, Hampton's Throne was acquired by the Na-
tional Collection of Fine Arts (now the National Museum of
American Art), and since then it has also been shown at
the Abby Aldrich Rockefeller Folk Art Center (Williamsburg),
the Walker Art Center (Minneapolis), the Whitney Museum
(New York), the Museum of Fine Arts (Boston), and the
Montgomery (Alabama) Museum of Fine Arts. The Throne
has appeared in numerous books, and it is currently con-
sidered a major example of black American folk art.

Actually, it is a good example of everything folk
art is not.

James Hampton was born in Elloree, South Carolina
in 1909. At the age of 19 he moved to Washington, D.C.,
and entered the army in 1922, serving until 1945. Dis-
charged, he returned to Washington, where he took a job
as a janitor for the General Services Administration. In
1950, at the age of 41, he rented a garage and soon after
began work on the remarkable project that did not receive
wide acclaim until after his death. The Throne was moti-
vated by a series of overwhelming and personal visions of
God, the Second Coming, and the Last Judgment. A gigantic

three-dimensional assemblage made of old furniture, miscellaneous objects, and tinfoil, The Throne was probably built as a monument to Jesus.

Hampton was a reclusive man whose visions were intensely private. Although he was consumed with questions of religion, he belonged to no church or religious organization. He built his work by himself, kept it in a locked garage, and seldom showed it to anyone. The very private nature of his enterprise is emphasized in the notebook Hampton kept as he worked. Entitled The Book of the 7 Dispensation by St. James, it was not intended to communicate his vision to anyone and was written in a language that remains indecipherable to this day. Hampton's art is not folk art; it is downright asocial art, drawing its power and intensity from a man consumed by, and responsible to, the art alone. Instead of functioning as a device to connect the artist to his society, Hampton's work drew him apart into a private universe where he became Saint James, master of his own world, and (to use his words) "Director of Special Projects for the State of Eternity" (Livingston 1982).

William Edmondson, another artist whose work is presented in the exhibition, is unlike Hampton in that he did make a good deal of folk art. But he also produced some work more reflective of his personal vision, and it is this art, rather than Edmondson's folk art, that is presented in the exhibition ostensibly devoted to folk art. Perhaps the best-known artist in the Corcoran show, Edmondson was born in Nashville, Tennessee, toward the end of the nineteenth century. A railroad worker until he was disabled in 1907, he then worked as a fireman, janitor, and, finally, an orderly in the Nashville Women's Hospital until it closed in 1931. After that time Edmondson did odd jobs, tended his garden, and began to carve stone. God told him to carve, he said, by presenting him with a vision of a tombstone "up in the sky and right there in the noon daylight." First carving gravestones, he later widened his repertoire to include angels, garden sculpture, and human figures. His work was "discovered" in the mid-1930s by Louise Dahl-Wolfe, a Harper's Bazaar photographer, who photographed him and his sculpture, helping to arrange for a one-man show at the Museum of Modern Art in New York, in 1937. Other exhibitions and publicity followed. Today, Edmondson's work is widely acclaimed.

Edmondson is presented in the exhibition, as he is usually presented, as a visionary artist whose work is remarkably "modern" in character. He carved in "a manner much like [that of] his more sophisticated contemporaries . . . William Zorach, John B. Flannagan and Elie Nadelman," the catalogue notes. Although he began by carving simple grave markers, he soon showed himself capable of the more elaborate and sophisticated carvings for which he is best known. These works, "functionless and . . . intended only as art," are judged to be his most important. They make up the bulk of his art shown in the exhibition (Livingston 1982).

Edmondson's actual output suggests that folk art enthusiasts misrepresent him. For Edmondson continued to carve gravestones throughout his life, and grave markers, often commissioned by members of his community, outnumber the more individualistic carvings of angels, animals, and other figures for which he is usually celebrated. Cemetery and funerary practices have long been of crucial importance in black American folk culture. The center of a complex of ideas and beliefs that can be traced back to Africa, they remain important symbols of black identity, social stability, and religious transcendence. Thus, as Vlach has noted, as a gravestone maker, Edmondson operated in his community as a stabilizer and promoter of important black cultural traditions; his gravestones cannot be viewed only as his personal expression, but must also be seen as "an ethnic statement created out of the context of well-known Afro-American rites that insure the necessary respect for the dead" (Vlach 1981).

As is the case with most black folk art, Edmondson's was not completely traditional, although his grave markers were much more traditional than his more elaborate figures. Still, the style and method of construction of the more idiosyncratic pieces can be traced in part to the traditional forms and techniques employed in the gravestones. The well-known statues Girl with Cape, and Egyptian Mother and Daughter, for example, bear striking resemblance to the severe, rectangular stone slabs—the very material of the gravestones—from which they were only partially released.[8]

The unique nature of William Edmondson's art is not due to his being almost as sophisticated as his white contemporaries or to his being remarkably modern. It lies instead in the heroic human and artistic attempt to create

meaningful images that are both stabilized in life-sustaining traditions and responsive to individual needs. To seek to understand Edmondson's art only for its nontraditional qualities, to deny the attitudes, forms, and even the large body of his works that are traditional, is to diminish not only the corpus but also the stature of his achievement and to remove it further from a context in which it can be fully appreciated and understood.

ART OR FOLK ART: ISSUES OF CLASSIFICATION

The treatment of the work of James Hampton and William Edmondson is representative of how contemporary folk art critics have handled many other black artists. Why are the individually conceived works of these black artists confounded with traditional folk art, while their genuinely traditional art is often overlooked and dismissed? Black art of the kind presented in the Corcoran exhibition is no more closely related to the outworn stereotypes developed by the folk art movement in the 1930s than it is to the black folk tradition outlined in the folkloristic definitions of the 1970s. Pushed into categories that do not fit it and stigmatized by a questionable, possibly pejorative aesthetic that does not describe it, this black art is celebrated precisely for what it is not. Its truly unique qualities become, therefore, more difficult to value and understand.

The idiosyncratic works of artists like Hampton and Edmondson are not folk pieces. Yet there is a reason for labeling them as such. One of the ways by which the notion of folk art preserves the status and power of the leisure class is by serving as a dumping ground for unusual forms of expression that might challenge the artistic and social status quo. Produced by artists uncommitted to the high-art tradition and the values and society that support it, these works pose a potential social threat. This art is at times the product of a world view antagonistic to the leisure class. To admit that it is as complex and significant as academic art suggests the validation not only of the art itself but of the culture, the attitude, and the people it represents as well. Thus the aesthetics and social dominance of the elite would be--and are--challenged.

This may begin to explain why black art created in the tradition of white academic art can be safely accorded

the status of high art while the threat posed by truly in-
dividualistic black art is defused by misdefinition as folk
art, a misdefinition traceable both to the Harlem Renais-
sance and to Cahill's aesthetics. But why should genuine
black folk art be neglected, actually pushed out by the
idiosyncratic works featured (for example) in the Corcoran
exhibition?

It may seem at first surprising that the most thor-
oughly excluded class of black folk objects is the most
utilitarian, comprising such objects as Afro-American bas-
kets and gravestones. One might think that these would
pose the least threat to the leisure class because the ob-
jects, whatever their aesthetic value, represent useful
labor, the very thing that class conspicuously eschews.
But social status, as Veblen defines it, depends not only
on the idea of the undesirability of work but also on the
wherewithal to make others do the work. Utilitarian black
folk objects represent useful work that has not been per-
formed at the behest and for the benefit of the leisure
class. Furthermore, these objects generally exhibit close
kinship to their African origins and proclaim a black
identity independent of white domination.

Neglecting utilitarian black folk objects is only the
most blatant way of neutralizing their threat. A more
subtle--or insidious--course is to redefine them as aesthetic
pieces, to consider them art. Gravestones, for example,
become sculpture. This, too, may at first seem paradoxical,
granting blacks a perquisite of the leisure class: the pur-
suit of nonutilitarian (therefore conspicuously "wasteful")
activity. But, actually, the aesthetic revaluation wholly
preempts the perquisite. For it is the leisure class that
deems the utilitarian objects art, thereby suggesting that
the black makers and the original black consumer lacked
the sophistication and aesthetic skills properly to value the
pieces in the first place. And even if this body of work
is accorded the status of art, it is, after all, a low,
primitive, childlike art--at best the charmingly crude,
"compassionately ugly" precursor of black artistic skills
that fit safely into the categories of academic art.

Nonutilitarian black folk art is easier to assimilate
into the status quo because, as we have seen, whatever
communal significance it has can be readily co-opted by
evaluating particular works on the basis of aesthetics
rather than social and historical significance. In this
way, such art can be confounded with high art, but only

as an inadequate form of high art. Although enthusiasts may celebrate and gush over such "folk art," their view precludes taking these works either as sophisticated high art or as folk art that embodies and dignifies the beliefs and values of black communities.

Nonetheless, in a few ways the view of black American art represented by Black Folk Art in America actually augurs well for the emerging treatment of such work in current scholarship and scholarship yet to come. Focusing on a body of art produced by neither New Englanders, Pennsylvania Germans, nor Spanish Americans, this approach admits black Americans as a folk-art-making group and thereby broadens the cultural base of folk-art study. In addition, unlike past presentations of folk art, [this one stresses that black folk art did not disappear when black artists learned academic skills.] Finally, this approach introduces black artists as creative adults, not as primitive or unselfconscious children: "We simply can no longer afford to countenance the notion that folk artists somehow experience a life-long childhood," writes Livingston (1982). But despite good intentions, the work of black artists is still misrepresented and undervalued. That contemporary folk art criticism is incapable of untangling debilitating folk-art myths from the historical and artistic realities of black art is powerful and tragic testimony to the continued strength of the romantic folk-art paradigm as it is applied to black American art. Definitions of art mean little in themselves, but their use to evaluate human expression and the human beings who are expressing themselves makes these definitions potent tools in the development and control of society.

NOTES

1. An important exception to this is an exhibition organized for the Cleveland Museum of Art in 1978 by John Michael Vlach, The Afro-American Tradition in Decorative Arts. It emphasizes the folk traditions in black American culture and art.

2. See Porter (1943), Dover (1960), Fine (1973), and Lewis (1978).

3. Black leader Marcus Garvey was a prominent exception to those who sought support from the white middle class. In many ways his organization, the Universal Negro

Improvement Association, was to lower-class blacks what the Harlem Renaissance was to the middle class.

4. The idea of the mutual dependency of black and white Americans in the fashioning of American experience is a major theme of Huggins's Harlem Renaissance. I am indebted to his argument throughout much of the rest of this section.

5. For example, Langston Hughes and Zora Neale Hurston were both supported by the same elderly white patron, Mrs. R. Osgood Mason. A wealthy woman, she financed Hughes for a year and Hurston for two. However, in return for her generous support, Mason expected her protégés to conform to her image of black primitivism and savagery, an image that Hughes eventually could not indulge. His break with this patron was one of the most traumatic experiences of his life. "That beautiful room that had been so full of light and help and understanding for me, suddenly became like a trap closing in, faster and faster, the room darker and darker, until the light went out with a sudden crash" (Hughes 1940: 325).

6. Horace Pippin and William Edmondson were among the first black folk artists to have one-man exhibitions. Edmondson's, presented in 1937 at the Museum of Modern Art in New York, was the first solo exhibition of the work of a black artist at that museum. A good example of the new scholarly interest is Thompson (1969). Thompson's article discovers important African continuities in Afro-American visual arts.

7. Kiah (1978) examines the process and aesthetics of the work of a black woodcarver. Kiah notes a number of African elements in his work, even though she also reports that this carver knows nothing about African continuities and directly denies that he has been influenced by African traditions. An example of presenting an artist as an untutored talent is Adler (1975).

8. Much of this information and analysis comes from Vlach (1981). Despite the numerous studies of Edmondson's art that have been done, this recent piece is by far the best and is one of the few studies to comprehend and examine the importance of Edmondson's art in a traditional black cultural setting.

BIBLIOGRAPHY

Adler, Elizabeth Mosby. 1975. "It Takes a Smart Guy to
. . . Take a Look at a Rock and Do Like That: George
'Baby' Scott (1865–1945), a Carver and His Repertoire."
Mid South Folklore 3: 1–17.

Art Digest. 1932. "American Folk Art Exhibition." 7, no.
6 (December 15):46.

Cahill, Holger, 1932. "American Folk Art." In American
Folk Art: The Art of the Common Man in America,
1250–1900. New York: Museum of Modern Art.

Dover, Cedric. 1960. American Negro Art. Greenwich,
Conn.: New York Graphic Society.

Driskell, David C. 1976. Two Centuries of Black American
Art. New York: Los Angeles County Museum of Art
and Alfred A. Knopf.

Fine, Elsa Honig. 1973. The Afro American Artist: A
Search for Identity. New York: Holt, Rinehart and
Winston.

Herskovits, Melville J. 1958. The Myth of the Negro Past.
Boston: Beacon Press.

Hoffman, Frederick J. 1965. The 20s: American Writing
on the Post-War Decade, reprinted edition (originally
1949). New York: Free Press.

Huggins, Nathan Irvin. 1971. Harlem Renaissance.
London: Oxford University Press.

Hughes, Langston. 1940. The Big Sea: An Autobiography.
New York and London: Alfred A. Knopf.

Johnson, James Weldon, ed. 1931. The Book of American
Negro Poetry, 2d edition (originally 1922). New York:
Harcourt, Brace.

Kiah, Virginia. 1978. "Ulysses Davis: Savannah Folk
Sculptor." Southern Folklore Quarterly 42: 32–49.

Leuchtenburg, William E. 1958. The Perils of Prosperity, 1914-1932. Chicago: University of Chicago Press.

Lewis, Samella S. 1978. Art: African American. New York: Harcourt Brace Jovanovich.

Livingston, Jane, and John Beardsley. 1982. Black Folk Art in America, 1930-1980. Jackson: University Press of Mississippi.

Locke, Alain. 1975. "The New Negro." In The New Negro, reprinted edition, edited by Alain Locke (originally 1925). New York: Atheneum.

Porter, James A. 1943. Modern Negro Art. New York: Dryden Press.

Robbins, Daniel. 1976. "Folk Sculpture Without Folk." In Folk Sculpture U.S.A., edited by Herbert W. Hemphill, Jr. Brooklyn, N.Y.: Brooklyn Museum.

Rumford, Beatrix T. 1980. "Uncommon Art of the Common People: A Review of Trends in the Collecting and Exhibiting of American Folk Art." In Perspectives on American Folk Art, edited by Ian M. G. Quimby and Scott T. Swank. New York: W. W. Norton.

Singh, Amritjit. 1976. The Novels of the Harlem Renaissance: Twelve Black Writers, 1923-1933. University Park: Pennsylvania State University Press.

Thompson, Robert Farris. 1969. "African Influences on the Art of the United States." In Black Studies in the University, edited by Armstad L. Robinson, Craig C. Foster, and Donald H. Ogilvie. New Haven, Conn.: Yale University Press.

Veblen, Thorstein. 1953. The Theory of the Leisure Class, reprinted edition (originally 1899). New York: New American Library.

Vlach, John M. 1978. The Afro-American Tradition in Decorative Arts. Cleveland, Ohio: Cleveland Museum of Arts.

_____. 1981. "From Gravestone to Miracle: Traditional Perspectives in the Work of William Edmondson." In William Edmondson: A Retrospective. Nashville: Tennessee Arts Commission.

_____. In progress. "The Afro-American Aesthetic." In Encyclopedia of Southern Culture, edited by William Ferris.

9

CHANGES IN THE RELATIONSHIP BETWEEN JAZZ MUSICIANS AND THEIR AUDIENCES SINCE WORLD WAR I

Lars Björn

Since its beginning in the first decades of this century, jazz has gone through several changes as a form of music, and along with this have come changes in its social organization. In this chapter I will focus on changes in the relationship between performer and audience, with special attention to the changes that occurred between the two world wars. During this period jazz changed from folk music to popular music, and toward the end of the period we saw the beginning of jazz as a fine art. These changes in musical content and social organization make the inter-war period a particularly interesting one to sociologists, as we can test hypotheses about the relationship between the content of an art form and its social organization. For example, I have earlier (1981) found support for the hypothesis that the stylistic changes in jazz during the period were largely a function of who the musicians were, not a function of changes in its audience. This paper will be less concerned with such testing of hypotheses than with describing audience–performer relationships during the interwar years and comparing these to the post–World War II period. I will argue that such a comparison has relevance for the problems that today's fine-art jazz musicians have in relationship to their audiences.

The folk–art stage of jazz is most commonly illustrated with the example of New Orleans jazz. Performers and audiences came largely from within the black community. As a result of the interaction of Afro–American and European musical traditions, the jazz style found in New

195

Orleans was only one of several regional styles that developed in black communities throughout the United States, and very few jazz historians still subscribe to the view that jazz had its sole or even primary origins in New Orleans, from which it traveled up the Mississippi. The stylistic variations in jazz were probably due to the relative weight of Afro-American or European musical traditions in the different black communities. For example, New York City jazz was more heavily influenced by concert band music than was jazz in New Orleans or the Southwest, where blues music was a more important influence instead (Hennessey 1973). The social conditions that encouraged different musical traditions within black communities is still an open question for research (Hobsbawm 1975: 55).

JAZZ AS POPULAR MUSIC

Around 1923 we find the beginnings of a new style generally among black musicians which was to dominate jazz for about two decades: big band jazz. This style of jazz differed from that found in New Orleans in its stress on written arrangements and more extensive instrumentation. Two central musical characteristics of jazz remained and further evolved in the big band form: improvisation and "swinging" rhythms. Big band jazz became the most popular music in the dance craze that had started just before World War I and reached its height in the 1920s and 1930s.

The relationship between jazz performers and audiences during the big band period was structured, to a large extent, by racial segregation. There was little integration across racial lines among audiences or performers (on stage), but black bands often played for white audiences.

Given these patterns of segregation it is not surprising that audiences and performers from the two racial categories assigned different meanings to the music. The Jazz Age label as conventionally applied to the 1920s comes closest to describing the experiences of those white audiences who saw jazz as mainly a dance music. Particularly to young middle-class whites, jazz came to symbolize youthful rebellion. In her study of college youth in the 1920s, The Damned and the Beautiful, Paula Fass describes their perceptions:

> Dancing . . . was not merely a pleasurable recreation; it was a way of assimilating to their own uses one of the truly new artistic forms of twentieth-century America. It was a form that expressed the uninhibited quality of the new century, its accelerated pace and attention to sensuous movement (Fass 1977: 306).

The widespread acceptance of dancing among young Americans during the 1920s was the culmination of a dance craze that had started just before the beginning of World War I, when Vernon and Irene Castle helped popularize the foxtrot. Before this time, social dancing was a highly communal activity, with every dancer doing the same movements at the same time, whereas modern social dance is characterized by the room given to individual self-expression (Franks 1963). This trend toward individualism in dance style was also associated with the emergence of mass public dancing rather than more class-segregated and private social forms of dancing. As the class barriers slowly eroded among the young, there was substantial concern, particularly among older middle-class people, about both the increased sexuality expressed in the new dance styles and the difficulties of supervising these public events. Fass has carefully documented how white college youth responded to these pressures by a certain degree of self-censorship while at the same time defining a new youth subculture.

While we have reasonably good data on the meaning of jazz dancing to college youth, we know far less about youths or adults from blue-collar backgrounds (Leonard 1962). The ethnic diversity of the white working class, particularly in the urban North where jazz was most popular, most likely gave rise to widely differing cultural meanings associated with jazz and jazz dancing. While these social and cultural patterns still remain to be explored by future research, we have evidence that even though public dance halls were for the masses, some had a distinct class affiliation. For example, the establishment most likely to cater to single working-class men were the taxi-dance halls, where hostesses danced with customers for five or ten cents a dance (Björn 1980).

To most dancers the rhythmic qualities of the new dance music were probably paramount (Peterson 1972), and

it is quite likely that the dancers' musical judgments in this regard were quite liberal, which is not to say that dancers were oblivious to distinctions made by musical historians. It has often been pointed out by jazz historians that the most popular jazz artists during the 1920s were white society band leaders, whose rhythmic accomplishments could have seemed substantial only if dancers compared them to those who played only traditional dance music, such as waltzes and polkas. While this older music could have provided one reference point for white dancers by which to judge white band leaders, it is also probable that for some black bands it presented an even lower, perhaps irrelevant basis for comparisons. In any event, jazz historians have recently pointed out that black big bands enjoyed relative economic success during the late 1920s and the early 1930s when they had a virtual monopoly on a "swing" beat (Hennessey 1973). They were successful especially if they could acquire a white leader to help open doors. In my own research on Detroit, this is illustrated with the white band leader and promoter Jean Goldkette, who hired a black band to replace his own society band. The black band (the McKinney's Cotton Pickers) stole the show and ended up at Goldkette's ballroom, to the delight of white dancers (Björn 1980).

Black jazz was also marketed to some segments of the white market as an exotic or "primitive" commodity. This was most evident in the emergence of the so-called black-and-tan nightclubs that provided black entertainment for white audiences. At the Cotton Club in Harlem, the best-known of these clubs, the wealthy audiences were sold a package of exotic "jungle" rhythms via dancers and bands like Duke Ellington's. Jim Haskins has summarized the appeal of this aspect of Harlem life to white audiences:

> Harlem and the Negro seemed to embody the
> primitive and thrilling quality sought by
> both intellectuals and socialites. To the
> intelligentsia, innocence was still alive in
> America in the Negro. In the Negro was
> all the sensuousness and life rhythm that
> white America had lost. To the socialites,
> Harlem represented a blend of danger and
> excitement. The exotic jungle rhythms gave
> intimations of sensuality beyond the wild-
> est phantasies of the sons and daughters

of proper New York society. . . . Harlem
was an adventure; Harlem was the unknown;
and Harlem became a fad (Haskins 1977:
20–21).

It is indicative of the extent of racial segregation
in American society in the 1920s that the Cotton Club com-
pletely excluded black customers. The Cotton Club and
other black-and-tans eventually modified their admissions
policies, and by the 1930s these clubs were actually more
integrated than other establishments where jazz was heard,
especially where it was to be danced to as well. In De-
troit the major ballrooms allowed black customers only on
one day of the week up until World War II and the major
hotel ballrooms in the city admitted no blacks. In order
to dance to the music of the big bands, black audiences
were thus confined mainly to their own communities, where
ballrooms catering to almost exclusively black audiences
were found (Björn 1980). Otherwise, audiences could hear
jazz on "race records" sold only in the black community
during the 1920s, but the radio waves were basically
monopolized by the white society bands until the end of
the decade (Leonard 1962).
In this segregated world, black jazz musicians
were seen by other blacks as representatives of the black
community to the larger white society, and their economic
success gave them substantial social prestige in the black
community. Evidence of this can be found in interviews
with musicians (Björn 1981) as well as in the coverage
given musicians in the black press (Björn 1980). In com-
paring white and black community perceptions of jazz, it
is interesting to note that moralistic concern over jazz was
less common but not totally absent in the black community,
where it took the form of middle-class or religious objec-
tions to jazz or jazz dancing (Leonard 1962). However,
these objections virtually disappeared with the economic
success of the black jazzmen, which indicates the signifi-
cance of racial and/or community pride in black percep-
tions of jazz in this historical period.
The closeness of the relationship between black
jazzmen and black audiences can be seen in the special
relationship that developed between black bands and black
dancers. In their seminal study of jazz dance, Marshall
and Jean Stearns argue that "one of the reasons for this
early development of big-band jazz at the Savoy (Harlem's

premier ballroom) was the presence of great dancers"
(Stearns and Stearns 1968: 325). Not surprisingly jazz
dancers were particularly influential in the rhythmic de-
velopment of jazz.

As part of the close relationship between black
jazzmen and their black audiences we find them adopting
an artist-craftsman occupational orientation (Becker 1976),
with no necessary conflict between artistry and popular
music production. In contrast, white jazzmen in a dance-
band setting were more likely to see themselves as frus-
trated artists (Leonard 1975). I have argued elsewhere
(1981) that this difference in occupational orientations is
rooted in patterns of social stratification and resulted in
black jazzmen playing a more crucial role in the develop-
ment of big band jazz than their white counterparts.

While a large majority of both white and black jazz
audiences enjoyed big band jazz as a dance music, we can
also see the emergence of a minority of jazz fans who saw
it as a purely musical art form during the 1930s. These
jazz fans would typically be found close to the bandstand
in the large ballrooms or at the smaller clubs and cabarets
that became increasingly important places of employment
during the 1930s. It is also among this group of listeners
that we would expect to find the larger jazz record collec-
tors. An indicator of the emergence of this segment of the
jazz audience is the appearance of jazz periodicals by the
mid-1930s. Although the pioneers were the French, in the
United States Down Beat magazine was started in 1934
(Hobsbawm 1975: 241). In a review of what is known
about this segment of the white jazz audience, Eric Hobs-
bawm concludes that they can be roughly characterized as
young (below 30), male, middle class, and to some degree
anti-establishment in attitude (1975: 257-58). These char-
acteristics are found among jazz fans in a number of coun-
tries, and the most interesting difference between those in
Europe and the United States is the lesser degree to which
critics have had an influence on the tastes of American
fans. The latter are more influenced by popular tastes
than are European fans, judging by which artists are
chosen in jazz magazine reader polls. There are a num-
ber of plausible explanations for this difference in audi-
ences on the two continents. The greater influence of a
fine art (rather than a popular art) conception could be
related to different patterns of social stratification. In
Europe, where class boundaries are perceived as more

rigid, audiences are more likely to show deference to in-
tellectual elites, such as critics, who themselves emerge
from among such strata. In the United States, on the
other hand, a more developed mass consumption society is
likely to lead audiences to a more popular conception of
music, particularly if performed by an ethnic minority in
a stereotypical entertainer role.[1]

JAZZ AS FINE ART

By the early 1940s, new jazz styles increasingly
developed within a fine-art social context among educated
upper-middle-class elites. This meant a reduction in the
size of the audience as more "elite" listeners replaced the
"masses" of dancers. At the same time that new jazz styles
developed, older styles maintained some popularity, often
in the form of revivals such as that for New Orleans jazz
in the 1940s. This was an indication that jazz had come
of age, that it had become a "classical" music. Estab-
lished jazz styles have also periodically been integrated
with current popular music, such as the fusion of jazz and
rock in the late 1960s. Unfortunately we do not have
available systematic surveys of the audiences for the vari-
ous styles of jazz, but it is possible to give a description
of the main contours of these jazz audiences in the last 40
years with the help of the existing literature (Horowitz
and Nanry 1975: 35; Kofsky 1970: 24; Merriam and Mack
1960: 211).

The bebop (or bop) style of jazz that developed in
New York City in the early 1940s signaled the arrival of
jazz as a fine art. The development of bop is commonly
seen as a reaction against the commercialization of big
band jazz (swing) in the late 1930s (Jones 1963; Nanry
1979; Peterson 1972). The swing craze was disproportion-
ately an economic boon to white big bands, partly because
it became increasingly difficult to differentiate white from
black big band styles (Wen Shih 1959). In this social
and musical context it is not surprising that the first bop
rebels were young black musicians with big band experience,
like Charlie Parker and Dizzy Gillespie, who reasserted
their differences from the white middle classes. Much of
their original experimentation took place in bars and clubs
in Harlem, and it is likely that, as Harry Reed has argued
(1979), small bars in the black community provided a vital

context for bop until the middle of the 1950s. It is also
the case that the audience for the new music went beyond
the black community and was not as strictly segregated as
it was before World War II. The character of the new
audience is captured well by Charles Nanry:

> It is clear that jazz, up until the advent
> of bop, had always drawn a major portion
> of its constituency from dancers and drink-
> ers. After bop this was no longer the
> case. Bop became a rallying point for
> many of the alienated and disaffected in
> American society. In fact, bop became
> synonymous with rebellion by the late 1940s.
> Bopsters affected the mannerisms of the bop
> musicians . . . dark glasses, berets, little
> goatees. . . . At no time, before or since,
> did a jazz generation come so close to
> forming a deviant subculture. . . . Dave
> Brubeck saw the bop audience as made up
> of "intellectuals, artists and malcontents"
> (Nanry 1979: 171-72).

With the coming of the bop generation of black jazz
musicians we can see the emergence of a new dual-occupa-
tional orientation: one part of them remained in the black
musical heritage and the other gave them the identity of
fine artist. LeRoi Jones (Amiri Baraka) sees the bop move-
ment as the beginning of black artists' "fluency with some
of the canons of Western nonconformity" as they came in
contact with white bop musicians, artists, and intellectuals
on the margins of American society (Jones 1963: 199-204).
In contrast to a black's dual-occupational orientation,
most white bop musicians adopted a strictly artistic orien-
tation to their craft (although the evidence for this is by
no means systematic) (Hughes 1974). In any event, as the
fine-art phase of jazz progressed, differences between black
and white occupational orientations again became less pro-
nounced, as had happened with their respective styles of
performance in the earlier swing era. The spatial equiva-
lent of this social change involved in bop was the move-
ment of the center of jazz activity from uptown locations
toward midtown Manhattan and finally to Greenwich Village
(Spellman 1970: 17-18).

The shift in occupational orientation toward that of a fine artist after World War II also implied a new view of audiences. Black and white jazz musicians alike saw themselves less as entertainers and developed a more distant relationship to their audiences, similar to that found in a concert-hall setting. Nevertheless, by comparison with European "classical" music the audience-performer relationship was and is still today characterized by less formality and more spontaneous participation on the part of the audience during a performance. The transition toward a fine-art model was gradual but did require some adjustment on the part of audiences and critics. When trumpeter Miles Davis adopted the practice of walking off stage when others took solos, as well as turning his back to the audience while playing, a lively debate ensued in the jazz world. While Davis's stance was once atypical, it is today one of several behaviors acceptable to audiences and critics.

The bebop style of jazz remained the dominant fine-art form of jazz until the 1960s, but stylistic variations in the 1950s are of interest here since they involved different segments of the audience. In the early part of the decade the "cool" jazz style was popular mainly among white musicians and audiences, while toward the end of the decade, it was primarily black musicians who developed a "hard bop" or "funk" jazz style. The latter movement among some black musicians can be interpreted as an effort to bridge the gap that had developed between mass black audiences and jazz artists by the late 1950s. Rhythm and blues had dominated the black music market since the 1940s with the decline of big band jazz. The hard bop style was an effort to integrate blues and gospel traditions within a modern jazz context and it did legitimate a search for roots among jazz musicians, but it did not halt the general trend of the 1950s, which was the further integration of jazz into a fine-art context. During the decade there was the beginning of some public recognition of jazz as an art form. The U.S. State Department organized tours for a few well-known bands, and jazz was increasingly heard on college campuses and in concert halls, rather than just in jazz clubs (Nanry 1979: 179).

The early 1960s saw a new creative revolution among black jazz artists that gave rise to a style that is still in evolution. The new style is commonly referred to by critics as "avant-garde" or "free" jazz, but many musicians refuse

any labeling or simply refer to it as "new music" (Wilmer 1980: 22). The "jazz" label has never been completely accepted by many who are identified by the public or critics as jazz musicians, and the conflict over labeling has intensified since the 1960s.

While the new jazz style has had a few players with some amount of popular appeal, like John Coltrane, it is reasonably safe to say that the audience for this type of jazz is even smaller than that for bebop. Many musicians in the 1960s felt there was a crisis with regard to reaching audiences, and this was particularly acute among black artists. This new generation of jazz players often saw themselves and their music in black nationalist terms, and thus their distance from black audiences was experienced much more intensely (Spellman 1970). Many musicians located the causes of the lack of black audiences in the music industry itself, and they responded by developing alternative forms of music distribution. These alternative organizational forms were often collectives of musicians like the short-lived Jazz Composers Guild formed in New York City in 1964, or the Association for the Advancement of Creative Musicians (AACM) (1965) that is still active in Chicago. In these cases, instead of relying on club or bar owners, musicians in the 1960s started to rent or buy their own performance spaces, such as lofts or storefronts. By producing their own records or putting on "live" performances, these musicians were able to bypass "gatekeepers" in the music industry who often were uninterested in the new music. Wilmer (1980: 118) reports that the AACM achieved another goal by building a relatively large following for its music in the Chicago black community. LeRoi Jones's Black Art Collective of 1963–65 was one of the first such efforts to bring jazz "back" into the black community. So successful were such efforts that in the 1970s, some musicians were able to get government grants for such concert performances. While these strategies have not always brought in sufficiently large audiences to sustain these alternative spaces as institutions for very long, the musicians found such spaces and alternative sources of support important to the unhindered development of their music (Stevens 1982).

While the strategy of producing their own performances has had some success, it has still only marginally improved the ability of avant-garde musicians to live off their art. By the end of the 1960s, with a decline in the

American popularity of jazz generally, there was an exodus to Europe of a number of these musicians in search of audiences for their music (Wilmer 1980: 250-54). France was a very lively center for recording and performance by avant-garde musicians, including some members of the AACM. There is nothing new about American jazz artists moving to Europe (Goddard 1979), but the relative size of this migration among avant-garde musicians was probably unprecedented. While the majority of these musicians eventually moved back to the United States, it is still economically necessary for them to perform and record regularly in Europe.

Another strategy for survival has also been made available to a small number of avant-garde artists: academic appointments in universities or high schools. That this route has opened up is another indication that jazz has had some recognition from dominant institutions, but the degree of recognition is still small in comparison with that given European classical music.

A strategy that has always been open to jazz musicians in search of work has been to play popular music or a music that is a mixture of jazz and popular music. Since the 1960s such music has primarily been the fusion of jazz and rock performed by artists like Miles Davis, Herbie Hancock, and Chick Corea. While this strategy has brought commercial success to some, its artistic merits are in doubt among many jazz musicians. In her study of the new avant-garde players, Wilmer points out that often the choice of playing the new jazz or the popular fusion styles becomes so politicized that it is not easy for musicians to move freely back and forth between the two musical contexts (Wilmer 1980: 27). If we compare the jazz/rock fusion to the big band jazz that was popular in the interwar period, we find that while the latter was largely a dance music, the former is more likely to be heard in concert settings. While this might point to an irreversible disjunction between jazz as a fine art and as a popular music, I would argue that a further comparison with big band jazz in the interwar years points to some possible lines of development in the future.

A major achievement of the black big band jazzmen had been to create a new and artistically viable form of music within a commercial environment; that is, the creation of jazz as a popular dance music (Björn 1981). The black jazzmen were able to carry this out by relying on

their black (folk) musical heritage and redefining it in a
new social and musical environment. Is it not possible
that today's avant-garde black jazzmen will develop an
artistically and commercially viable music from a fine-art
starting point, rather than the folk art from which the
jazzmen of the 1920s started?

I see some signs that this indeed might be at hand.
While some may argue that jazz today is far removed from
its black folk base, in terms of audiences and musical con-
tent, I see no shortage of black musicians coming out of
the free jazz movement who would argue that their music
still is basically an Afro-American one. These musicians
are also likely to see their Afro-American heritage in a
more international context than did the earlier jazz pio-
neers. To use one example, the reggae music of the Carib-
bean is seen as very close to this heritage. Some musi-
cians, like Oliver Lake and Ronald Shannon Jackson, have
also begun to explore the possibilities of developing a
musical form that is danceable by combining jazz, funk,
reggae, and Latin music. Such a music could have a spe-
cial meaning to larger black and white audiences alike
than those who presently listen to jazz, and might be
widely popular in an era of international cultural fusion.

Still, in addition to transcending differences of
race and musical style, such musicians must deal as well
with issues of class, and this may be more difficult. This
historical sketch has illustrated the complexity of the rela-
tionships between jazz performers and audiences, depending
in part on the various patterns of social stratification
that underlie the development of this particular art form.
Starting out as a subcultural music, jazz soon spread be-
yond the black community to become a popular music for
large numbers of white consumers as well. This transcen-
dence of the black ghetto by its music was not a linear
development: rather, there was a dialectic at work which
provided the impetus for black artists to redefine and re-
establish their cultural heritage as they moved ever more
easily into the wider white society.

As we have seen, the development of jazz accompa-
nied the expansion of the black middle class. In the
early 1920s, it was middle-class black jazzmen who devel-
oped the new style of jazz which became a central part of
the cultural repertoire of all blacks in a new urban con-
text, and which could be appreciated by whites as well.
But to the degree that the black community itself has be-

come increasingly polarized along class lines since World War II, middle-class black musicians have found it increasingly difficult to develop an art form that is meaningful to all segments of that fragmented community. Since the bop generation of the early 1940s, jazz has increasingly developed within a fine-art context, with its bias toward the middle and upper classes, regardless of race. The problem now facing the present generation of black avant-garde musicians involves creating an art that transcends social class, as well as ethnicity.

NOTES

1. A similar argument about the relative importance of class and ethnicity as explanatory variables for popular (rock) audiences in the United States and England has recently been developed by Frith (1981).

BIBLIOGRAPHY

Becker, Howard S. 1976. "Art Worlds and Social Types." American Behavioral Scientist 19 (July-August):703-18.

Björn, Lars. "Black Men in a White World: The Development of the Black Jazz Community in Detroit, 1917-1940." Detroit in Perspective 4 (Fall):1-20.

_____. 1981. "The Mass Society and Group Action Theories of Cultural Production: The Case of Stylistic Innovation in Jazz." Social Forces 60, no. 2 (December): 377-84.

Fass, Paula S. 1977. The Damned and the Beautiful. New York: Oxford University Press.

Franks, Arthur H. 1963. Social Dance: A Short History. London: Routledge and Kegan Paul.

Frith, Simon. 1981. Sound Effects. New York: Pantheon Books.

Goddard, Chris. 1979. Jazz Away From Home. New York: Paddington Press.

Haskins, Jim. 1977. The Cotton Club. New York: Random House.

Hennessey, Thomas J. 1973. "From Jazz to Swing: Black Jazz Musicians and Their Music." Ph.D. dissertation, Northwestern University, Evanston, Ill.

Hobsbawm, Eric J. 1975. The Jazz Scene. New York: DeCapo Press.

Horowitz, Irving Louis, and Charles Nanry. 1975. "Ideologies and Theories About American Jazz." Journal of Jazz Studies 2 (June):24–41.

Hughes, Phillip S. 1974. "Jazz Appreciation and the Sociology of Jazz." Journal of Jazz Studies 1 (June): 79–96.

Jones, LeRoi. 1963. Blues People. New York: Morrow.

Kofsky, Frank. 1970. Black Nationalism and the Revolution in Music. New York: Pathfinder Press.

Leonard, Neil. 1962. Jazz and the White Americans. Chicago: University of Chicago Press.

_____. 1975. "Some Further Thoughts on Jazzmen as Romantic Outsiders." Journal of Jazz Studies 2 (June): 45–52.

Merriam, Alan P., and Raymond Mack. 1960. "The Jazz Community." Social Forces 38 (March):211–22.

Nanry, Charles. 1979. The Jazz Text. New York: Van Nostrand.

Peterson, Richard A. 1972. "A Process Model for the Folk, Pop and Art Phases of Jazz." In American Music: From StoryVille to Woodstock, edited by Charles Nanry. New Brunswick, N.J.: Transaction Books.

Reed, Harry A. 1979. "The Black Bar in the Making of a Jazz Musician: Bird, Mingus, and Stan Hope." Journal of Jazz Studies 5 (Spring–Summer):76–90.

Spellman, A. B. 1970. Black Music. New York: Schocken Books.

Stearns, Marshall, and Jean Stearns. ' 1968. Jazz Dance. New York: Macmillan.

Stevens, Charles. 1982. "Artists and Musicians: The Dilemma of Jazz Musicians in the American Society." Contributions to the Sociology of the Arts: Reports from the 10th World Congress of Sociology, 264-76. Sophia, Bulgaria: I.S.A. Research Committee 37 and Research Institute for Culture.

Wen Shih, Hsio. 1959. "The Spread of Jazz and the Big Bands." In Jazz, edited by Nat Hentoff and Albert McCarthy. New York: Rinehart.

Wilmer, Valerie. 1980. As Serious as Your Life, The Story of the New Jazz. Westport, Conn.: Lawrence Hill & Co.

10

COALITION THEORY
AND AMERICAN BALLET

Margaret Jane Wyszomirski
and Judith Huggins Balfe

The American Ballet Theater (ABT), although founded in 1940, did not succeed in becoming a national ballet company of international stature until the years between 1967 and 1977. During this decade, the company presented many of the world's best dancers in a varied repertoire of major and minor classics of both traditional and contemporary vintage to a large and enthusiastic audience.

During the 1982-83 season, however, the company sustained a disruptive nine-week dancers' strike (which resulted in the cancellation of six weeks of touring engagements) and suffered a $1.8 million deficit as audience attendance fell off to a mere 63 percent of house capacity. The public found ABT's repertoire "overly repetitious" and generally lackluster (Kisselgoff 1983). Its contingent of principal dancers had become smaller and less internationally mixed than in the past.

This disastrous season reflected, in part, the problems and unresolved issues involved in the company's protracted directoral succession crisis. In turn, this incomplete transition and the bad season provoked further internal debate and managerial instability. The board of directors demanded the resignation of the executive director, then left the position vacant for seven months. The chairman of the board resigned. The artistic director offered (or threatened) to resign, and his offer remained "on the table" for months before an awkward accommodation was worked out.

Thus, ABT seemed to shift from a popularly acclaimed, artistically vital, administratively coherent (although always financially precarious) institution supported by a loyal and expanding audience to a destabilized organization beset by artistic and administrative quarrels, audience erosion, and serious financial difficulties. Such a rapid decline is particularly astounding given the assets of the company. ADT had an established national and international reputation of the first rank, a roster of excellent dancers, an extensive and diverse repertoire, and a superstar (Mikhail Baryshnikov) as artistic director. In addition, ballet in general was attracting a larger live audience (and was reaching an even larger one by television) than at any other time in history.

Despite these advantages, ABT floundered. Although a weak economy and threatened loss of government funding for the arts contributed to its problems, they were clearly not its main cause, since similar conditions had no comparable effect on the other major American ballet company, the New York City Ballet. For ABT, the primary difficulty lay in precipitously implemented changes in artistic policy. In seeking to move quickly in new directions, ABT seemed to abandon many of the very aspects that had established and maintained its reputation, ability, and audience. As a consequence, the "old" coalition of artistic and audience interests that had heretofore supported the company began to disperse. Concurrently, its revised artistic policies seemed to provide only a tenuous and problematic foundation for the building of a "new" and sufficient coalition for the future.

This interpretation is advanced in this chapter. An explication and adaptation of coalition theory is first necessary to establish the aesthetic and analytical contexts in which the performing arts, specifically ballet, operate. Next, the organizational attributes of a national ballet company are identified and employed to assess the development and status of ABT as such an organization. The succeeding three sections present examinations of (a) the company's aesthetic ideology as it is manifest in the repertoire, (b) the composition and quality of ABT's performers and productions, and (c) the character and tastes of its audience. The final section illustrates how changes in the values and components of this aesthetic coalition have had a multifaceted destabilizing effect on ABT and points

to the various financial, administrative, audience, and artistic deficits that may be attendant on these changes.

COALITION THEORY IN AESTHETIC ENVIRONMENTS

Coalition theory has generally been applied to the study of partisan and legislative politics, as well as of international affairs (Riker 1962; Stinchcombe 1975). This article proposes to put the principles of coalition theory to another purpose: the analysis of artistic policy and administration as it has been conducted by a specific organization. In doing so, it acknowledges that some basic assumptions about how and why coalitions form and fragment in political arenas must be reassessed and adjusted to fit the quite different milieu of the nonprofit, performing arts world.

Perhaps the most significant difference between political and aesthetic coalitions concerns presuppositions regarding optimal size and composition. Whereas coalition theory commonly assumes that the potential contribution of each participant is nominally interchangeable (i.e., one vote is as good as another), here a constellation of differing (and noninterchangeable) contributions is characteristic. That is, performers, creators, patrons, and consumers each make desired and unique contributions that are necessary to an effective aesthetic coalition.

This, in turn, has an impact on analytical conceptions regarding optimal size. The optimal political coalition is thought to be a "minimum winning coalition" (or as close to minimum as imperfect information will allow). Such an alliance is preferred since it is large enough to secure collective aims, yet by minimizing the number of claims on those gains, it maximizes the benefits obtained by each member of the coalition. If a performing arts institution is conceived to be a coalition in which each member makes a unique but necessary contribution, then an aesthetic coalition must be an inclusive alliance of all the requisite artistic and patronage groups. Hence, inclusiveness rather than minimization makes for a "winning" coalition in an aesthetic environment.

Furthermore, it would appear that in theory, each constituency of an aesthetic coalition can enhance its own gains by expanding the benefits accrued by every other member. Thus, when audience demand is satisfied, it

supports the expansion of repertoire and rosters, thus increasing the numbers of and opportunities for dancers and choreographers, which in turn maximizes the benefits that the artists derive from the coalition. Quantitatively, the maximizing potential of such a coalition is limited primarily by the physical capabilities of the institution (e.g., length of season, size of house, etc.). Qualitatively, however, there are significant but less tangible constraints on both the inclusiveness and the size of the coalition.

The members of any organizational coalition must share a basic understanding of their common values and goals. Deviance from this shared understanding is likely to entail responses from other coalition members and changes in organizational dynamics and resources (Smelzer 1963). Such changes can range from consent to conflict over a redefinition of basic values or goals, and may, in turn, affect the membership, size, and resources of the coalition collectively, as well as the benefits secured by members. Furthermore, "a succession of goals" generally involves changes in product characteristics (Merton 1940; Sills 1957). In a performing arts institution, the values are aesthetic and, therefore, highly subjective and normative. The parameters of the coalition's shared aesthetic (or more popularly, "taste") set limits on the legitimate character, diversity, and activity of each coalition member. Artistic creations and performances constitute the "products" that are likely to manifest change in response to variations in values and/or goals.

From such an analytical perspective, ABT's 1982-83 season and its continuing problems becomes more understandable. In essence, the new artistic director has been advocating a different definition of aesthetic value for the institution and its supporting coalition. Other coalition members, notably audience, patrons, and critics, have been skeptical or even unwilling to accept this redefinition. As a result, the coalition that ABT built over 40 years has been disrupted.

THE DANCE COMPANY AS AN INSTITUTION

Like any other nonprofit institution, a dance company is directed by, dependent on, and accountable to multiple constituencies (Wyszomirski 1983). In general, these constituencies can be grouped into two broad categories: artists and audience. Each category is, in reality, composed of a number of distinct groups. Every group makes different demands, has different expectations, and contributes differently to the maintenance of the institution.

While the artistic constituencies include designers (sets, costumes, and lighting), musicians, choreographers, and dancers, this analysis focuses on the latter two. The dancer constituency has also been further divided into two distinguishable subgroups: corps and principals. All artistic constituencies are coordinated by the artistic director, who may or may not be an artist.

Like the dancers, the audience can be divided into two distinct but overlapping groups: general attenders and patrons. While patrons are members of the general audience, they differ in that they take a more active role in the sustenance and direction of the company through the contribution of financial support and, sometimes, personal time, energy, and expertise. However, not all patrons will be equally involved in an organization. Customarily, members of the board are major financial supporters and exercise considerable directoral influence. Particular individuals may also be crucial. For example, for over 35 years, Lucia Chase was ABT's artistic director as well as its patron of first and last resort. Other less influential but more numerous patrons constitute an organization's guild members or "friends."

In a sense, both patrons and principal dancers constitute the elite component of the respective general dancer and audience groups and are, in some ways, similar to another elite artistic group, the choreographers. Although treated as groups, principal dancers, patrons, and choreographers are, in fact, collections of idiosyncratic individuals; each can be regarded (and usually regards himself or herself) as virtually unique. Furthermore, as knowledgeable and committed activists, they tend to have well-developed aesthetic ideologies. Thus, they are likely to exercise a more significant influence on the institution than their mere numbers might suggest. The same, of course, can be said of the artistic director.

Since the production and presentation of dance is, for the most part, a collective effort, both the artists and the audience must work through an organizational medium, the dance company. Within the dance company each constituent element imparts a sense of direction to the whole. The choreographers design the artistic products; their particular styles affect the character and quality of those products. The availability of choreographers, in turn, influences the organization's potential for artistic innovation. Dancers realize and interpret these designs, im-

printing them with their own interpretation and style. Performers, particularly star principals, seek and sometimes demand new choreography to give fuller rein to their particular talents.

Both choreographers and dancers help to attract and cultivate an audience (or market) for the company's products. For example, while the New York City Ballet is composed of excellent dancers, essentially it has been a vehicle for the Balanchine choreographic product, and it has attracted audience and patrons accordingly. In contrast, Rudolf Nureyev or Mikhail Baryshnikov are "star" dancers who attract an audience to anything they perform. Hence, many different choreographers seek to create for them and use them to attract either a greater or a different audience than they might otherwise command.

Dance must not only be conceived and performed, but produced and viewed. Here, the audience connection becomes apparent. The audience not only consumes the dance product, but helps to finance its presentation. As noted earlier, this is particularly true of the patrons. Clearly, the taste of both general attenders and patrons is an element influencing which works will or will not be supported. These tastes turn on, among other things, the style of the work as well as the reputation and stature of its choreographer and/or performers. While patrons may have a particular effect on what dance pieces get on stage, the general audience has an influence on what becomes popular and stays in the repertoire. Yet the audience alone does not determine the success or continuance of each dance work. Those decisions are also influenced by critical reviews, performer preferences, and an appetite for novelty that is evidenced by all the constituent groups.

For the most part, the aims of the artistic and audience elements of any aesthetic coalition must be mutually supportive and complementary if the coalition is to survive and flourish. There are, however, inherent tensions both within and between the various constituencies. For example, patrons and the general audience may exhibit different tastes and thus disagree over the value of specific artistic products. In some cases, choreographers and principals can dispute whether the dance or the dancer is to be the "star." In another case, corps dancers and non-star principals may resent and regard as excessive the preferential choreographic, managerial, and/or remunerative treatment accorded to star principals.

Finally, it should be noted that although the artist-audience relationship is close in any performing arts organization it is particularly intimate and personalized in dance. In part, this is due to the nature of the art form. The immediacy of dance requires an audience if it is to exist at a professional level. Furthermore, since dancers' bodies are their creative instruments, this personalizes their work and puts an age limit on their creative lives. From the audience side, the involvement is also personalized since it entails sensory-emotive responses that vary with each member of the audience, each performer, and each work. Since only a small proportion of the audience is likely to have had technical training in ballet, the intensity and depth of their response will, in large part, depend on an intellectual understanding and appreciation of the art work as it is presented.

BUILDING A NATIONAL BALLET COMPANY

Among the most common types of dance organizations are the national company (e.g., the Royal Ballet), the choreographer-centered company (e.g., Balanchine's New York City Ballet or the Martha Graham Company), the impresario-originated organization (e.g., Diaghilev's Ballets Russes), and the star vehicle (e.g., Nureyev and Friends). Since its inception, ABT has striven to be a national ballet company.

In the tradition of Western ballet, national companies seem to have displayed the greatest potential for longevity. An examination of a number of national ballet companies (e.g., The British Royal Ballet, the Royal Danish Ballet, The National Ballet of Canada) reveals the following common attributes:

- a ballet repertoire that mixes the internationally recognized classics, works that display a distinctive "flavor," and a selection of contemporary pieces;

- high standards of artistic excellence in production and performance;

- a company of artists recruited from throughout the country (and often trained at a company-affiliated school);

- a loyal and nationwide audience; and

- a home base in the cultural capital of the nation, where it performs at the major opera house and enjoys official patronage.

Thus, it is clear that a complex set of attributes must be acquired if a group such as ABT is to become a national ballet company. (Of course, given the political traditions and conditions of the United States, it would be impossible for the federal government to accord official recognition and sponsorship to a single ballet company as the national company.) To achieve such stature required the founding and nurturing of an institution capable of attracting and holding a coalition of diverse production and consumption constituencies and their resources. ABT's progress in developing that coalition and the requisite attributes of a national ballet company can be divided into three periods. Discussion here will focus on a comparison of the last two stages.

A growth phase from 1939 through 1966. During this period the company slowly cultivated its various constituencies as well as gathered production, administrative, financial, and reputational resources (Payne 1978).

A maturing phase from 1967 through 1977. At this time the company capitalized on the foundations laid earlier (Payne 1978). It expanded its repertoire (particularly of full-evening classical works); acquired a permanent and prestigious home (the Metropolitan Opera House in New York) as well as a secondary base (Kennedy Center in Washington, D.C.); established a standard season in New York City; was awarded substantial public patronage from both the federal and state governments; and presented an array of dance stars of national and international fame.

In short, ABT became a full-fledged national ballet company that enjoyed more of everything: more ballets, stars, dancers, performances, and a larger audience. By expanding in all ways, ABT could maintain continuity and sponsor innovation. Since this accommodated the various aesthetic ideologies of its different constituencies, the company retained the support of a winning coalition, each member of which received adequate benefits from the collective effort.

A reform phase from 1978 to the present. This was the time when the company experienced major artistic, administrative, and financial change. Private patronage became a less significant (and sought after) part of its financial support, while box office receipts became more important (Colin 1984). The star system began to dim. The classics became a less predominant part of the repertoire, while modern dance choreographers and styles became more evident.

Although many of these shifts were developing slowly throughout the reform phase, they did not become clear until after directoral control had been wrested from Lucia Chase and Oliver Smith. Indeed, even though Mikhail Baryshnikov assumed the post of artistic director in September 1980, given the schedule of advance planning necessary in an enterprise of this size and complexity, the full impact of his new leadership was fully manifested only with the 1982-83 season. At that time, it was obvious that Baryshnikov was advancing a new aesthetic ideology for the company. Heretofore, ABT had presented the "best ballets of the past and present" (Payne 1978); now it was to present "every possible style of dancing" (Olshan 1984).

THE REPERTOIRE

"A company's repertory of ballets is really what proclaims its identity to the public as well as to the world of dance" (Kendall 1983: 42). Thus, repertoire can be regarded as an indicator of a ballet company's aesthetic ideology. Shifts in the character and composition of the repertoire are, therefore, manifestations of changing aesthetic values and are, in turn, likely to entail changes within and among the members of an organization's supporting coalition. A historical analysis of ABT's repertoire reveals that distinctive stylistic changes have taken place since 1978, with the most significant variance occurring in 1982 and 1983.

The repertoire of a national ballet company, as indicated earlier, is composed of three major components:

- The classics. Including both full-length and short works (e.g., Swan Lake, Giselle, and Les Sylphides, Etudes, or excerpts from ballets by the great nineteenth-century choreographer, Marius Petipa);

- **National ballets.** In this case, "Americana" (e.g., Rodeo, Fancy Free); and

- **Contemporary Ballets** (e.g., works by choreographers such as Tudor, Feld, Balanchine, Ashton, or MacMillan).

The first component, the classics, has been essential to the cultivation and preservation of ABT's reputation as a ballet company. The classics comprise not only the core of the ballet repertoire, but also constitute an internationally recognized standard of artistic excellence. A national ballet company must be capable of performing the classics well.

Before 1967 ABT had already gone far in acquiring the basis of a classical repertoire. With the 1967 premiere of the company's first full-length Swan Lake, its classical repertoire began to flourish. During the following decade, new classics were added frequently: five full-length ballets were premiered, another three were remounted, and six short classics were added or remounted. During the reform phase, however, the classic component of the repertoire expanded at a much slower rate. Since 1978, only three full-length classics have been premiered, another remounted, and two new short works introduced.

To put this somewhat differently, during ABT's maturing phase, the classical repertoire not only absorbed the bulk of the company's resources and attention, but it became the dominant element of its New York season. During these years and despite substantial variation in the length, timing, and location of its New York season, the classics constituted an average of 62.7 percent of ABT's New York programs. Except for the early years of this phase, full-evening works generally represented one-third to one-half of each season's offerings; the shorter romantic ballets added another 5 percent or more.

Although this pattern continued into the initial years of the reform period, drastic changes occurred once the full impact of the new artistic director could be felt. In 1982, only 48 percent of the programs presented the classics, while a mere 29 percent of the performances consisted of full-evening ballets (Table .10.1). That same year, and for the first time in 12 years, Giselle was not treated as a full-evening ballet, but was instead combined with various modern ballets on a number of split-bill programs.

TABLE 10.1

Season Repertoire, 1967–84
(as percent of season performances)

Year	Classical[a]	Americana[b]	Contemporary
1967	57	8	35
1968	56	--	40
1969	70	9	21
1970	49	5	46
1971	60	4	36
1972	57	6	37
1973	61	5	35
1974	66	6	29
1975	66	--	34
1976U[c]	56	4	40
1976M	75	--	25
1977	79	--	22
1978	71	--	29
1979	61	3	36
1980	70	9	21
1981	69	3	28
1982	48	7	45
1983	49	5	47
1984	64	3	34

[a]Includes full-evening, multi-act, and short classics.

[b]Includes Fall River Legend and Rodeo (by Agnes DeMille); Fancy Free and New York Export: Opus Jazz (by Jerome Robbins); and Billy the Kid (by Eugene Loring).

[c]The 1976 New York season was split, with six weeks at the Uris Theatre (U) from December 1976 to February 1977, and three weeks at the Metropolitan Opera House (M) in June of 1976. An additional two weeks of Raymonda, which the company presented at the Uris Theatre in November 1976, has not been included in this analysis because it was not a repertory season.

Source: Compiled by the authors.

In 1983, the dilution of the classical component of the season became even more evident. Again a low 49 percent of programs consisted of classics, and full-evening ballets (<u>Don Quixote</u> and <u>La Bayadere</u>) comprised even less of the season (19 percent). Furthermore, <u>Swan Lake</u>, which had been a staple since 1967, was not performed at all, nor were any of the Fokine ballets. Thus, many of the classical hallmarks of the company's repertoire were omitted from the 1983 season.

Although Americana ballets have never comprised a large part of the season, they have added a distinctively American "flavor" to the company's repertoire. Generally, each year two of these Americana works have been given a total of five to eight performances, thus accounting for 4 to 9 percent of the season (Table 10.1). Although no Americana works were presented in 1975, 1977, and 1978, more than the usual number were performed during ABT's fortieth anniversary season in 1980 (24 performances, or 9 percent of the newly expanded eight-week season). They were also quite evident in 1982 (three pieces, 14 performances, or 7 percent of the season). Since the company was de-emphasizing full-length classics that year, the Americana signature pieces might have provided an anchor for a stable company image.

In 1983, however, the Americana element was reduced as well as changed. Of the four pieces traditionally in this genre, only <u>Billy the Kid</u> appeared on the programs (five performances, or 2.8 percent of the season). In addition, a new (to ABT) Robbins Americana piece was introduced (<u>New York Export: Opus Jazz</u>). In 1984, the decline of Americana works continued (to 3 percent).

The third and final component of ABT's repertoire consists of works by contemporary choreographers. This is an amorphous, highly differentiated, stylistically varied, and changing collection of works, ranging from the classically based but individualistic styles of the likes of Antony Tudor, George Balanchine, Kenneth MacMillan, and Eliot Feld, through modern ballet choreographers such as Glen Tetley, Birgit Cullberg, and Roland Petit, to pieces by modern dance choreographers such as Alvin Ailey, José Limon, Lar Lubovitch, and Twyla Tharp. While a full analysis of this component of the repertoire would require more space than is available here, even a partial analysis reveals a number of noteworthy developments.

Since ABT's establishment, an important element of its contemporary repertoire has been provided by resident choreographers. The most significant of these has been English-born and trained Antony Tudor, who joined ABT at its very beginning and created some of the company's early triumphs with a dramatic, psychologically powerful style. Thereafter, Tudor became an integral part of the organization, becoming artistic administrator for its first London season in 1946, later its associate director (1974), and finally its choreographer emeritus (1981). In the period between 1967 and 1977, three or more Tudor ballets were repertoire staples, usually constituting between 6 and 12 percent of the season's programs. Thus, the Tudor oeuvre itself became a hallmark among the company's contemporary offerings.

This situation began to change, however, during the reform period. During 1982 and 1983, only two Tudor works were presented each season, accounting for only 5 and 4 percent of the program offerings, respectively. Concurrently, the character of much of the rest of the contemporary repertoire began to shift in a number of ways. More Balanchine ballets were performed more frequently (9–10 percent of the season in 1982 and 1983, as compared to approximately 3 percent during the early 1970s). These additions put ABT into direct competition with Balanchine's own company, the neighboring New York City Ballet. More pieces by modern dance choreographers, particularly Twyla Tharp, were presented more often. Tharp works constituted 4 percent of the season's offerings in 1983 and, with four pieces in the repertoire, 5 percent in 1984. In other words, the repertoire currently includes more works by this one modern dance choreographer than by Tudor or from the Americana genre. Also, many "mediocre" works by secondary choreographers were premiered then quickly abandoned (Kisselgoff 1983).

In sum, the shift in repertoire has been clear and, obviously, away from the established ABT "tradition." There were fewer full-length ballets, fewer classical pieces, fewer Americana works, and fewer Tudor ballets. These repertoire trends seem to have peaked in 1983, a year also characterized by a long labor dispute between ABT and its dancers, by audience disaffection and financial losses at the box office, and, ultimately, by managerial instability. In other words, changes in the artistic product seem to have been accompanied by (and perhaps have been pro-

vocative of) shifts in audience consumption patterns and organizational management.

STARS AND STANDARDS

ABT was founded as a repertory company that was to give equal status to the dancers, designers, composers, and conductors. As its 1940 advertisements stressed, "America's First Ballet Theatre" would present "the greatest Ballets . . . staged by greatest collaboration in ballet history" (Terry 1980: 11).

During its first 25 years, ABT adhered for the most part to the repertory principle and avoided adopting a guest-star system. This is not to say that the company lacked stars, only that they were usually resident members of the company rather than transient or part-time visitors. As a repertory company, ABT was characterized by considerable continuity among its dancers and minimal status divisions. Such cohesion was relatively easy to achieve in the compact company during its growth phase; it numbered only 40 to 50 dancers, less than a dozen of whom were principals who exhibited a diversity of stylistic strengths, including romantic, classical, contemporary, character, dramatic, and bravura.

As the company moved into its mature phase, it required not only more dancers, but more principal dancers. As ABT's stature grew and as New York City developed into an international dance capital, dancers from all over the world were attracted to the company. Consequently, ABT began to expand its roster of principals and to build a star system. The number of stars began to rise, fed by the importation of foreign guest artists (such as Carla Fracci, Erik Bruhn, Yoko Moroshita, and Antony Dowell) and the addition of American principals (such as Cynthia Gregory, Fernando Bujones, and Gelsey Kirkland). By 1976, the number had increased to 21 and included, among others, the three Russian superstars—Makarova, Nureyev, and Baryshnikov.

Concurrently, the overall scale of the company increased. The number of dancers rose as high as 150. Its New York season doubled in length from four to eight weeks. The number of ballets offered each season increased from about 12 to approximately 24. In addition, ABT's audience grew, first as the season was extended and later, when the

company moved into the Metropolitan Opera House, a theater with nearly twice the seating capacity of the other theaters ABT had used during its growth phase.

The development of such a star system had both its pluses and minuses. On the positive side, it brought the company popular and critical acclaim and, in its wake, growing box office receipts. It also generated artistic excitement and growth among the dancers, exposing them to the different styles, techniques, and interpretations of the guests. Furthermore, the presence of so many different artists with such a range of styles and dancer traditions tended to expand ABT's repertoire in three ways. Particular stars inspired choreographers to create new works that used their special talents. The stars, in turn, were eager for new artistic challenges and, indeed, were attracted by opportunities to experiment with different choreographic techniques. Finally, dancers from different countries and schools often sought to expose ABT's audiences (and dancers) to examples of these other traditions. Hence, guest stars frequently added works from their personal repertoires to that of the company. Occasionally, they even dabbled in original choreography.

On the negative side, the star system provoked tensions and resentments among some of the soloists and the American principal dancers. Recruitment from outside limited the chances for promotion within the company. The media attention lavished on foreign artists, particularly Soviet defectors, made some American principal dancers feel overlooked and undervalued (Terry 1980: 14). Company need and individual ambition (in both positive and negative aspects) led to a greater turnover and a consequent decline of the almost familial feeling among company members that had prevailed in the developing years.

Concentration on showcasing "name" dancers seemed to be accompanied by a lack of concern for the corps, which began to look, and was criticized for being, under-rehearsed. At the same time, the expansion of the classical repertoire demanded an expansion of the ranks of both the corps and soloists within a single stylistic tradition. Since the company school could not meet this need, new dancers were recruited from everywhere. Meanwhile, the increasing diversity of the repertoire required training and performance skill in many different dance techniques. Thus, high turnover, variable recruitment, and diverse stylistic demands produced a corps de ballets that was so

flexible that it often seemed uneven in technique and lacking in polish.

Financially, the star system also had positive and negative effects. While it increased ticket sales and contributions, it also increased operating costs, in large part because of the increasingly high fees these artists commanded. Expenditures were also increased by the need to mount elaborate new productions which would feature the stars or satisfy their own choreographic urges. Furthermore, as the company increased in size and star power, it experienced a diminishing sense of cohesiveness. With less collegiality and rising guest star fees, the economic differences between the various performing ranks became more apparent. Awareness of this differential contributed, in turn, to the length and acrimony of dancer strikes in 1979 and 1982 in which wages, touring conditions, and job security were major issues.

At first, the star system continued to flourish as ABT moved into the Met, peaking at 25 principals in 1978. Then, as the reform period progressed, the star system began to erode, with the number of principals falling to 12 in 1982 and 1983. Indeed, the new artistic director rejected the guest star system and instead concentrated on polishing the corps, developing young talent within the company, and attempted to turn the company into "the star of ABT" (Olshan 1984).

These reforms (and others) had many positive effects. The corps began to dance as a more finely tuned unit, the ensemble character dancing acquired more flair and flourish, and the roster of principals took on a more American cast. In his quest to develop new talent, artistic director Baryshnikov gave many young dancers exceptional performance and promotion opportunities. He also reorganized the company's school to accept 20 scholarship students (Kisselgoff 1981). In addition he sought to encourage new choreographers and choreography. A choreography workshop was instituted, and the company experimented with premiering new works by a variety of choreographers.

On balance, however, the negative effects of reform have seemed to predominate. The general emphasis on more consistent technique and on pushing young dancers into challenging roles seems to have produced performances that display technical ability but lack artistry and dramatic power (Kisselgoff 1983: 6). Indeed, uniformity of

style was in danger of making the company dull and life-
less (Resnikova 1984). The quick promotion of very young
dancers and the thinning of the soloist ranks frustrated
and alienated many of the dancers in the company's middle
ranks and prompted some of the principals to feel that the
absence of experienced soloists in character roles dimin-
ished the texture of specific productions as well as of the
organization itself (Terry 1982). Indeed, Baryshnikov's
paradoxical preferences for academic classicism and for
abstract modernism seem to have been indulged "at the ex-
pense of the company's traditional dance dramas and dra-
matic dancers" (Kisselgoff 1984a).

Perhaps the most controversial change in standards
that Baryshnikov implemented concerned his revisions of
ballets of the classical repertoire. In changing the male
variation of Les Sylphides, he claimed his was the original
version danced by Nijinsky, despite protests that since
the work's own choreographer, Michel Fokine, had set the
piece for ABT, that was the authentic version (Kisselgoff
1981). He has also been criticized for "Sovietizing" the
great ballet classics, Giselle and Swan Lake. In doing so
he has only altered choreography or inserted substitute
versons, but he has changed dramatic characterizations,
and sometimes the very concept of these works (Terry 1982;
Resnikova 1984). Indeed, New York Times dance critic
Jack Anderson (1984) commented that the current production
of one of the company's classical hallmarks, Swan Lake,
had "been so tampered with . . . that it has lost choreo-
graphic authenticity and dramatic motivation . . . (and)
. . . has also become extremely boring." Even its expen-
sive, new production of Cinderella has been criticized as a
"slick," "too street-smart" ballet parody characterized by
"startling cynicism" and "classroom level" choreography
(Kisselgoff 1984b).

It has become clear that the different aesthetic val-
ues the new artistic director has sought to instill in ABT
have also had definite effects on the company's performers
and performance standards. Although the abandonment of
the star system has valid organizational precedents in
ABT's growth phase, it marks a reversal of the practices
and expectations established during its mature phase.
Serious questions about the authenticity and quality of its
productions are being broadly debated. Such questions
can, in turn, cast doubts on the stature of the company
itself. A perceived failure to maintain high artistic stan-

dards can erode its audience and patronage (public and private) support, diminish artistic creativity and capacity, and, ultimately, bring an end to organizational stability and coherence.

THE BALLET AUDIENCE

The widely chronicled dance boom of the 1960s and 1970s (Sussman in press) obviously depended on the development of a large national audience. ABT's success in its maturing phase both contributed to, and was the beneficiary of, this enlarged audience. But as the dance audience grew, it became broad enough to support competing ballet companies, both in New York and elsewhere, as well as many modern dance companies with widely varying styles of choreography. With more dance idioms to choose from, inevitably the dance audiences began to segregate into specialized audiences for ballet and for modern dance. Indeed, the two dance forms had seemingly recruited from different bases to start with. This became a matter of considerable importance to ABT and other companies as they struggled to maintain their growth during the economic stresses of the mid-1970s. It was particularly problematic for ABT once it moved into the Met. With seating capacity increases, an extended New York season, and rising costs and ticket prices, it needed to attract a larger and more affluent audience than ever. Accordingly, it became crucial to find out who its existing audience was, so that the tastes of the loyalists might be satisfied and that likely recruits from other existing dance and performing arts audiences might be attracted.

Surveys of modern dance audiences indicate that they are highly educated, affluent, "arts omnivors" (Peterson 1982), who frequently attend a variety of performing arts (Sussman in press). Presumably some of these might be attracted to ballet in general, and to ABT in particular. As for the existing loyalists, their tastes were evident from the 1976 survey that the company commissioned (ABT 1976).

Not surprisingly, the 1976 ABT audience, like dance audiences generally, was "elite": well-educated professionals. Thus, demographically, the ABT audience was similar to modern dance audiences. But its aesthetic tastes were different. Unlike the "omnivors" of the modern

dance audience, ABT's audience was dominated by "arts
purists"--in this case, sophisticated "balletomanes" whose
taste was attracted to, and reflected in, the company's
classical repertoire. These audience members clearly pre-
ferred ballet in general to the other performing arts (in-
cluding modern dance), and even preferred ABT in particu-
lar to other ballet companies. Many of these fans had
come to identify with ABT as a community, becoming formal
Friends (or patrons) of the company and took advantage
of membership perquisites such as attendance at galas,
parties, and open rehearsals. They came to recognize
each other from standing in lines at the box office and
from frequent attendance at the same performances by fa-
vorite dancers or of favorite works. Such mutual recogni-
tion and sense of audience cohesion was enhanced by ABT's
policy of making casting notices available to Friends at
the time advance tickets went on sale. As a result, fans
could follow particular dancers, just as they selected from
the repertoire which works to attend.

Thus, many of ABT's artistic and administrative
policies enabled it to build not only a loyal audience, but
an increasingly sophisticated one. Indeed, given the
lengthy and difficult training necessary to dance ballet,
there are insufficient numbers of ex-ballet dancers to sup-
port such a company as knowledgeable consumers. A re-
cent study found that only 14 percent of ballet audiences
were currently studying it as dancers (Robinson 1984),
while surveys of modern dance audiences found that be-
tween 35 and 70 percent were dance students (Robinson
1984; Sussman in press). Without formal dance training,
the ABT audience had to be educated if it was to support
a national company. ABT accomplished this educational
process with the consistent quality of a standard classical
repertoire, established choreographers with distinctive
styles, and, perhaps most importantly as drawing cards,
star performers.

Given such stable elements to build on, innovation
was achieved within recognizable conventions and could be
understood and appreciated by the increasingly knowledge-
able audience. Thus, new stars were presented, new pro-
ductions of old works were staged, new works were intro-
duced, and new choreography premiered; but always, only
one or two artistic elements changed at any one time.
Hence, continuity was maintained without risk of dullness,
while the audience learned gradually to appreciate the
balletic artistry presented.

Once in residence at the Met, ABT faced the twin necessities of attracting and holding large numbers of newcomers and of satisfying what it knew to be the tastes of its loyalists. ABT's strategy was to build ever more insistently on its distinctive strengths as a company. Therein seemed to begin the unravelling of its successfully nurtured and mature aesthetic coalition. As already discussed, Ballet Theatre's established star system served as a useful vehicle for recruiting new audiences, as well as for distinguishing it from its chief "local" competitor, the New York City Ballet. In turn, such stellar dancers wished to expand their own range, and given ABT's tradition of presenting works from many choreographers, new works in more contemporary styles of dance were increasingly offered to an increasingly heterogeneous audience that was less familiar with the aesthetic of traditional ballet. Indeed, by expanding its contemporary repertoire, ABT was obviously trying to attract members of the already developed modern dance audience.

Seeking to satisfy both its innovation-seeking star dancers and its newly recruited audience factions, the company commissioned new works from young choreographers working in nontraditional idioms with increasing frequency. But as the classical repertoire was cut back, so too was rehearsal time for classical works, and the performance quality of the corps suffered. On both counts, the traditional balletomane audience felt that its ABT-developed tastes were being neglected and disaffection set in.

Other policy changes furthered this discontent. As the superstars aged, or readily free-lanced elsewhere, they appeared less frequently or less exclusively with ABT. In order not to lose their fans, ABT stopped announcing casts far in advance, so that when one purchased tickets through the advance notices sent to Friends, one gambled on who was to appear in any particular work or at a specific performance. Security of choice had been one means of maintaining audience loyalty to ABT; now this was denied. At the same time, the stars were appearing with their own "pick-up" companies in Broadway theatres for brief seasons, as well as on television and in the movies. For their fans, such performances presented the advantages of being guaranteed, predictable, and often considerably cheaper than ABT. Such star vehicles also probably pulled away many new and potential attendees.

Thus, in its reform phase, the traditional (classical) tastes that ABT had been so instrumental in teaching the

loyal audiences of its maturity were no longer catered to. Yet the new, presumably large, less ballet-educated audience is not focused on ballet; rather, it is eclectic, participating in many alternative art forms. With wide-ranging (and perhaps more shallow) tastes, the "new crowd" is certainly more democratic and open to innovation, but it can also find that newness in many places other than ABT.

To be sure, there are "new" audience replacements with the traditional tastes of the "old" audience members. Indeed, they make up a large proportion of the ABT Friends who filled out a questionnaire distributed by the company in 1983 (ABT 1983). Consistent with the tastes of the 1976 general audience, these members are attracted to ballet rather than to dance in general (for example, 42 percent subscribe to Ballet News, while only 24 percent subscribe to Dancemagazine). They seldom even attend the other performing arts.

Within ballet, their preferences are for full-length classics, followed by mixed bills of short classical works, and with the least interest in contemporary choreography. Most current Friends are attracted to the security of the traditional ABT repertoire rather than to more innovative works. This preference may be related to the degree of innovation already present in the lives of many of ABT's audience members. Nearly three-fourths are professional women, with a median age of mid- to late thirties; over 40 percent had done some graduate study, and nearly half are unmarried (only 22 percent had children). While they may be seen as followers or beneficiaries of feminism, few are overtly so: one-third read the Wall Street Journal, but only 6 percent read Ms. magazine. Few find peer support for their interest in ballet among members of their households.

Their very presence in a ballet audience is a mark of personal innovation since most are newcomers: only 25 percent had subscribed to ABT for as long as five years. While they want to learn more about staging ballet and about dance technique, they have little awareness of, or interest in, choreography. For the most part, then, the security of the traditional ABT repertoire and company practices, combining the classics and various non-startling innovative elements, was attractive for social-psychological and aesthetic reasons. Given this patron profile, it would also seem to be in the institution's interest to follow these

traditional forms if it is to stabilize such new and mobile audience members into a loyal support constituency.

Whether this core of new traditionalists is large enough to take the place of the disaffected former loyalists remains to be seen. Perhaps even more significantly, one must contemplate the continuity of these new audience members. Indeed, with a 30 to 35 percent annual nonrenewal rate and a nonattendance rate greater than 10 percent for Friends in 1984, this poses a serious concern, particularly when questions about the reliability of the "new" patrons are considered in light of the poor general attendance in the 1983 New York season. Hence, it would seem that neither the new "traditionalist" patrons nor the new audience of "discerning eclecticists" can be depended on to fill the house or subsidize the company. Paradoxically, in trying to appeal to both the old and new factions in its audience, ABT seems to be risking dissatisfying both.

Clearly, the ABT repertoire has changed in order to adjust to changes in the necessary size of its audience, and hence in its composition. By playing to market tastes, it would seem to be contributing to the flight of its traditional audience. New recruits to its membership are ballet-focused, as were the traditionalists who have already left, and many of these too are likely to drop out unless their tastes are catered to with more consistency than has been the case during the "reform" phase. In fact, scheduling for the 1984 season suggests that the company may be seeking to reestablish a more balanced repertoire in an effort to win back some of these former audiences.

THE ABT AESTHETIC COALITION: EVOLUTION OR DEVOLUTION?

For 40 years, ABT was, in large part, guided by its artistic director, Lucia Chase, who from the very beginning sought to develop it into a national ballet company within the full meaning of that concept as it has been defined earlier in this chapter. For most of those years, her vision, ambitions, and money sustained the company. It was Chase's policies (realized in collaboration with co-director Oliver Smith and an array of artists) which promulgated and propagated the aesthetic values that the company came to embody and its audience and patrons came to embrace. It was this convergence of interests and ideals

that mobilized ABT's aesthetic coalition. Indeed, Chase's success in this regard may, in part, have benefited from her personal understanding of many of ABT's constituencies, a familiarity acquired from her own multiple roles as foremost patron, participating performing artist, and enduring impresario.

As artistic director, Mikhail Baryshnikov pursues a different vision, articulating different aesthetic values, and implementing them through different artistic policies. Put simply, the fundamental changes in aesthetic ideology that he proposes would effect the transformation of the American Ballet Theater into the American Dance Company. Consequently, changes have occurred (and are likely to continue) within the company's aesthetic coalition. Whether a new and sufficient coalition will evolve in support of this new ideology remains to be seen.

That some changes were pending, both within individual constituencies and among them, was obvious. For example, with the aging, injury, or retirement of many of the stars of the 1960s and 1970s, adjustments within the dancer constituency and in the star system were inevitable. Similarly, the move into the Met set off a double-barreled expansion in production: the season was extended in length and the audience capacity for each performance was greatly increased. This, in turn, prompted a quest for a matching expansion in consumption. As a result, changes within the audience constituency were induced and, apparently, accompanied by a divergence between the tastes of the patrons and those of the general attenders.

If a "new" coalition is to evolve, it is likely to require considerable time to develop. After all, it took over three decades to acquire and interweave the various artist and audience constituencies into the "old" coalition that had supported and sustained the growth and maturation of ABT into a national ballet company. While organizational objectives seldom remain static (Simon 1965), this would seem particularly true of artistic organizations if they are to maintain their creativity and artistic vitality. Indeed, considerable evolution occurred in the values and the constituent composition of ABT between its growth and its mature phases.

If the arts institution is the change, so too must the coalition that constitutes and supports such an organization. One limit to the extent of change that such aesthetic coalitions can sustain is, however, apparent: the

inclusive membership of requisite constituent groups must
be maintained. Thus, change and adaptation are likely
to be concentrated within individual constituencies. In-
deed, at another level of analysis, each constituency
(dancers, choreographers, general attendees, and patrons)
could be conceived of as itself being a "mini-coalition."
The ABT case suggests that such mini-coalitions, having
more focused interests and perhaps more "pure" aesthetic
ideologies than the grand organizational coalition analyzed
here, may be more likely to operate as the type of coali-
tion more commonly described in the literature, that is,
exclusive and minimal in composition. A full examination
of this possibility must, however, await future research.

From this perspective, a reform period is a "natural"
organizational phenomenon. What may prove to be "unnatu-
ral" is the scope, speed, and stress of current changes.
When ABT entered its mature phase, it was a small organi-
zation with an intimate support coalition. By virtue of
size, the organization was capable of effecting significant
change relatively quickly; by virtue of constituency sizes
and relationships, these changes seemed to have consensual
support and, therefore, legitimacy.

ABT entered its reform phase as a large institution
with an increasingly segmented support coalition. With an
annual budget of $15 million and a performance season of
26 weeks, the company is now one of the major performing
arts institutions in the country, only two of which are
dance organizations. Large, complex organizations re-
spond to change more clowly than do small, simple ones.
The greater the proposed change, the more time it may re-
quire to effect full organizational adaptation or the more
leadership and new resources it may require to induce the
proposed changes. Without sufficient time or additional
resources and skills, attempts to institute substantial
change are, therefore, likely to produce organizational
stress and coalition strain, as well as incur an artistic
deficit.

Stress was apparent in the company's financial and
managerial problems of 1983. Changes in repertoire, per-
formance style, and company composition have been imple-
mented partly in response to interests of various artistic
constituencies (e.g., the artistic director, talented and
ambitious young dancers, and established and loyal prin-
cipals) and partly in the expectation that these would at-
tract more and new audience members. While the reforms

have produced some positive results, the net effect seems to have been negative. Discontent among the dancers played a part in their Fall 1982 strike against the company. In courting and failing to attract a sufficient audience in New York City, the company has experienced both financial and artistic deficits. The financial loss of nearly $2 million in 1983 was clear evidence of audience disaffection rather than attraction. While perhaps less obvious, artistic deficits were nonetheless apparent with regard to the quality of performance artistry, dramatic integrity, and choreographic authenticity. Furthermore, all of these deficiencies were noted with increasing frequency in critical commentaries.

These significant changes have been implemented at ABT within a very short time; yet, as of this writing (1984), the new company leadership does not seem to have brought substantial new resources to these tasks. This seems particularly true of the new artistic director. Baryshnikov is not a choreographer and thus has not provided a new creative force. Furthermore, he is not only not administratively skilled but has decided to work on only a voluntary and part-time basis; and since he has danced infrequently and has not wished to perform for fund-raising purposes, he has done relatively little to attract and stabilize new money or audiences for the company.

The future of ABT's aesthetic ideology and coalition is unclear. That they are likely to change in the future, as they have in the past, is probable. Evolution is therefore somewhat assured. As an aesthetic coalition such evolution must, however, occur within an environment of dynamic equilibrium; that is, the inclusive coalition of constituencies must be maintained. If change proves to be too great, too fast, or too controversial, that equilibrium may be disrupted and necessary coalition constituencies may be lost or severely weakened. Should that occur, evolution could become a devolution wherein the very continuance of the organization and its supporting coalition is jeopardized.

BIBLIOGRAPHY

American Ballet Theatre. 1976. Audience Survey. New York: American Ballet Theatre.

_____. 1983. Questionnaire. New York: American Ballet Theatre.

Anderson, Jack. 1984. "Dance: Van Hamel-Bissell 'Swan Lake.'" New York Times, May 30, p. C18.

Colin, Justin. 1984. Interview with the chairman of the executive committee of the board of directors, American Ballet Theatre. New York, January 28.

Kendall, Elizabeth. 1983. Dancing. New York: Ford Foundation.

Kisselgoff, Anna. 1981. "The New Baryshnikov: Will He Star Backstage?" New York Times, April 19, pp. 1, 17.

_____. 1983. "What Did Ballet Theatre Do Wrong?" New York Times, July 17, p. 6.

_____. 1984a. "Two Ballet Companies in Search of a Future." New York Times, April 22, pp. 1, 14.

_____. 1984b. "Ballet: New 'Cinderella.'" New York Times, April 26, p. C20.

Merton, Robert. 1940. "Bureaucratic Structure and Personality." Social Forces 18: 560–68.

National Research Center of the Arts Inc. 1976. "The Joffrey Ballet Audience." New York: National Research Center of the Arts Inc.

Olshan, Alan. 1984. Interview with the director of development, American Ballet Theatre. New York, January 16.

Payne, Charles. 1978. American Ballet Theatre. New York: Alfred A. Knopf.

Peterson, Richard A. 1982. "Social Correlates of Five Patterns of Arts Participation." Paper presented at the Social Theory and the Arts Conference, St. Paul, Minn.

Resnikova, Eva. 1984. "Missteps." The New Criterion, January 30, pp. 29–31.

Riker, William H. 1962. The Theory of Political Coalitions. New Haven, Conn.: Yale University Press.

Robinson, John. 1984. "Cultural Indicators from the Leisure Activity Survey." American Behavioral Scientist 26 (March–April):543–52.

Sills, David. 1957. The Volunteers: Means and Ends in a National Organization. Glencoe, Ill.: Free Press.

Simon, Herbert A. 1965. Administrative Behavior, 2d ed. New York: Free Press.

Smelser, Neil J. 1963. Theory of Collective Behavior. New York: Free Press of Glencoe.

Stinchcombe, Arthur L. 1975. "Social Structure and Politics." In Handbook of Political Science, vol. 3, edited by Fred I. Greenstein and Nelson W. Polsby, 557–622, esp. 574–84. Reading, Mass.: Addison-Wesley.

Sussman, Leila. In press. "Anatomy of the Dance Company Boom, 1958–1980." Dance Research Journal.

Terry, Walter. 1980. "Impossible Dream: ABT's Fortieth Anniversary." Ballet News (May):11–14.

_____. 1982. "Why Baryshnikov Is Under Fire." Saturday Review (January):36–38.

Wyszomirski, Margaret Jane. 1983. "Toward a Typology of Organizations: Public, Private, and Actuative." Unpublished paper.

IV

AESTHETIC IDEOLOGIES
AND PUBLIC POLICY

Artists and arts institutions operate within the larger social, economic, and, of course, political environment. They respond to economic and social conditions, as well as to aesthetic concerns, not only in terms of the style and content of their artistic products, but with regard to the processes of disseminating their work and of courting patrons (whether public or private, individual or general audience). These interactions involve choices, by individuals, by institutions, and within fields. Implicitly, such choices (e.g., of marketing strategy, of repertoire, of mission or message), constitute policy decisions by artists and by arts institutions.

Earlier sections have examined instances of social, economic, or aesthetic influences on such artistic policies, as well as the effect and effectiveness of such policies in achieving the individual, institutional, or aesthetic goals inherent in those decisions. This section will focus on various political interests and programs that have been concerned with the arts. Again this is a two-way interaction. Not only do political ideologies and attitudes influence public policy choices and strategies toward the arts, but they also influence the choices and strategies of artists and of arts institutions. Similarly, aesthetic ideologies of various constituencies (government officials, political interest groups, the general public, artists, and other art world participants) have an impact on the goals and effects of cultural policies enacted and implemented by governmental institutions.

Furthermore, political attitudes concerning the legitimate functions of the state, in addition to but distinct from views on the public value of the arts, have influenced the course of public policy toward the arts. For example, conservatives, with their preference for limited and decentralized government, tend to regard support for the arts as a task primarily (if not exclusively) for private and individual initiative rather than for state action.

Conversely, the liberal notion of a more expansive, activist, and centralized government can easily accommodate a role in the arts. Similarly, liberal endorsement of pluralistic ideas can be transferred readily to support for cultural pluralism and diversity, while conservative interests in tradition can be associated with a preference for traditional (or elite) art forms and for established arts institutions.

Although U.S. governments at every level have always made policies that have had an effect on the arts, historically such policies have been indirect, implicit, and sporadic. As discussed in the McWilliams and Payne essay in Part I, American political attitudes toward the arts were, in large part, conditioned by perceptions of their social and symbolic utility. The often intangible benefits to be accrued from the arts seemed to require little explicit government attention. Hence for the first century and a half of the Republic, policy regarding the arts usually involved indirect public support for arts institutions. This was implemented largely through tax laws which, at the state and local levels, freed arts institutions from property tax liabilities and, later, at the federal level, exempted them from most income tax levies and provided an incentive for private citizens to contribute financially to the support of cultural activities and institutions.

Similarly, government support for individual artists was sporadic and most often motivated by nonaesthetic concerns. Generally, such support took the form of public commissions awarded to individual artists for specific works (statues, monuments, murals, frescoes, paintings) of a commemorative and/or patriotic character or for public buildings that had both symbolic and practical purposes. Political patronage might also be advanced to individual artists in the form of sinecures, which supported them while they practiced their art or placed them in positions where they acted as official (or unofficial) public representatives either at home or abroad.

In other words, the American tradition in public policy has been to support and/or use art and artists for various and changing public purposes which are not primarily aesthetic. This tendency remains an important consideration in public policies and programs of the last half century, even though these policies have changed in other important ways, namely, that they exhibit an explicit and direct concern for the arts.

The papers in Part IV survey the development and implementation of national policies and programs concerning the arts. Cornwell begins by presenting a chronicle of the appearance of arts and cultural concerns as a subject for inclusion in the platform of political parties. Underlying the changing character of this partisan concern are two important, though perhaps implicit, circumstances. First, the platforms of the two major parties reflect (rather than initiate) social, economic, and political interests and conditions. (This is not as clearly the case with regard to third-party platforms, which often raise issues or recognize changes as they are emerging.) Therefore, the appearance of an arts plank in these party platforms constitutes a recognition that in the last 50 years the arts in American society and culture have become more important to more citizens than was the case previously. Second, these platforms display a fundamental agreement that the arts are publicly valuable. They can, therefore, be regarded as indicative of a bipartisan support base which, in effect, places the arts beyond common partisan politics. Assuredly, the two parties differ in many regards concerning the goals, substance, and implementation of arts policy, for example, in what may be considered as art (or at least as publicly valuable art), in what the proper roles of the public and private sectors should be in supporting the arts, or in the character and procedures of public programs concerned with the arts. Despite such variations, however, Cornwell demonstrates that the arts have both arrived as an item on the public policy agenda and that they enjoy broad political support.

Next, Townsend discusses the first major public program to be directly concerned with the arts, the New Deal Federal Art Project of the Works Progress Administration. Despite a general lack of public interest in the arts, Franklin Roosevelt's administration initiated federal programs to help support artists and to foster the arts. Townsend identifies three distinct reasons for these precedent-breaking programs. Practically, the Art Project was an emergency labor relief program for artists. Aesthetically, it was designed to maintain the artistic development the nation had experienced during the 1920s as well as to help spur an egalitarian American artistic renaissance. Finally, by recognizing the potential of art to either support or undermine the sociopolitical system, the WPA Art Project hoped to channel these creative

impulses into the political cause of engendering a more
unified national identity and ideology and, even more
important, helping to revive business in the depression-
troubled country.

In discussing federal art programs of the 1930s,
Townsend also indicates many of the interests and issues
that will continue to reappear in later arts policy debates,
such as differing regional concerns, the particular needs
of the dominant (especially the New York City) arts commu-
nities, issues of federal versus local control, and the role
of general public opinion.

Following the disestablishment of the New Deal art
programs in 1943, there was a gap of two decades during
which no federal agency existed that was consistently
concerned with a broad spectrum of art forms or artists.
Thus, there has been a common misperception that between
the demise of the WPA art projects and the 1965 creation
of the National Endowment for the Arts (NEA) the arts
attracted little political attention. To the contrary,
Larson's paper recounts a history of considerable federal
concern for the arts, particularly as a means of public
diplomacy and as a reflection of national stature in the
international arena. Here again public policy sought to
use the arts, especially the visual arts, for nonaesthetic
purposes, primarily as a tool of foreign policy. Concur-
rently, throughout the late 1940s, the 1950s, and into the
early 1960s, an undercurrent of public recognition for the
intrinsic (aesthetic) value of the arts helped to support
growing official interest in establishing some program of
government sponsorship for the arts.

These developments culminated in the creation of
twin agencies to administer federal policies and support
for cultural and artistic activities, institutions, and
individuals: the National Endowments for the Humanities
(NEH) and for the Arts (NEA). Mulcahy's paper surveys
the structure, programs, impact, and politics of the NEA
and of national arts policy for the past 20 years, during
which the federal government has acted as a patron of the
arts. He clearly demonstrates both the positive and nega-
tive political legacy of the New Deal arts programs in more
recent federal arts policies and agencies. He identifies
and examines many of the political and administrative
factors that affect arts policy, such as style of bureau-
cratic leadership, metropolitan versus localistic patterns
for the distribution of benefits, standards and the tension

between expertise and "politicization," constituency-building efforts, and the populist–elitist–pluralist controversy. Finally, in surveying the recent "attacks" of the Reagan administration on "public culture," Mulcahy points to an apparent paradox: although there has come to be a political consensus that the "principle that the survival of arts institutions, greater accessibility to arts activities, and the preservation of cultural pluralism is a public good that merits government support," there is also a tendency to expect arts policy and publicly supported arts activities and institutions to satisfy "higher" standards than are applied to most other policy areas.

Last, Joseph Wearing presents a comparative glimpse of the issues and conduct of arts policy in another English-speaking, multi-cultural, federal political system: Canada. Although most of this volume has concerned itself with the situation in the United States, this piece performs the very useful task of reminding us of some of the commonalities we share with other nations. Among the similarities Wearing demonstrates are the artist's persistent wariness of interference from political sponsors; the tendency of governments to support the arts for nonaesthetic reasons and to use them as means to achieve other ends (such as economic development or social integration); how electorally endorsed changes in political ideology can have an impact on cultural policies; the increasing mobilization of the arts community as an interest group capable of influencing public policy decisions; the recurrent debates over issues of distribution, "national content," federal versus state/provincial responsibilities, and the character of public and private patronage; and the tensions between big, elite arts institutions and the many, populist/pluralist artists and arts organizations.

By noting such similarities and hinting at some differences, the Wearing paper alerts both reader and analyst to the fact that the preceding pieces, although focused on the arts and on arts policy in the United States, nonetheless have a broader, cross-national reliance and utility.

11

PARTY PLATFORMS AND THE ARTS

Terri Lynn Cornwell

> All the skill of the actors in the political
> world lies in the art of creating parties.
> A political aspirant in the United States
> begins by discerning his own interest, and
> discovering those other interests which may
> be collected around, and amalgamated with
> it. He then contrives to fine out some
> doctrine or principle which may suit the
> purposes of this new association, and which
> he adopts in order to bring forward his
> party. . . . This being done, the new
> party is ushered into the political world.
>
> —Tocqueville, 1835

Every four years since 1840, "actors" in the American political world have gathered to nominate presidential candidates and adopt formal party doctrines. From a simple list of nine or ten principles, these statements have grown to volumes containing tens of thousands of words. The 1984 Democratic platform, for example, contains 40,000 words, 30 times the number found in the Declaration of Independence. This platform is typical of the Democrats, who throughout history have "outpledged the Republicans" (Chester 1977).

Traditionally, party platforms have been greeted by a skeptical public: "Few aspects of American political parties invite skepticism and cynicism as do the party platforms" (Sorauf 1976). The introduction to Porter and

Johnson's 1961 collection of national party platforms pro-
vided this commonly accepted description:

> It has been asserted that the platforms of
> our major parties are unnecessarily long,
> repetitious, bombastic, evasive, equivocal,
> and couched in what President Theodore
> Roosevelt called "weasel words." They are
> often silent on matters of vital concern to
> the nation, not binding on the candidates,
> and forgotten by the party leaders.

This unfavorable opinion of party platforms has been prev-
alent since before 1850, when these documents were "re-
garded with suspicion" (Mayer 1967), and delegates pre-
pared only small statements or none at all.

But even as platforms expanded, the perception that
they were merely hollow statements quickly forgotten after
the election has continued throughout the twentieth century.
During the television broadcast of the 1980 Republican
convention, former Texas Governor John Connally remarked,
"A week from now, everyone will forget what's in that
platform" (Shales 1980). The drafting efforts of the Demo-
cratic Platform Committee the same year were described as
a "journey into fantasy land" (Evans and Novak 1980),
and in 1984, speaking on ABC-TV, former President Ford
assured a nationwide audience that the president virtually
"ignores" the platform (Ford 1984).

Despite the persistent skepticism, platforms continue
to survive and much effort goes into formulating them.
Extensive scholarly analysis of platforms indicates that
pledges are fulfilled at a much higher rate than the public
perceives: for the period from 1944 to 1966, more than
half of all pledges were fulfilled by direct congressional
or executive action; nearly three-fourths of all promises
were kept by full action, executive action, similar action,
or appropriate inaction; and only one-tenth were completely
ignored. Furthermore, a full 85 percent of all bipartisan
pledges (those contained in both major party platforms)
were fulfilled (Pomper 1971). For the period 1968-78, a
time of much political turmoil, the percentages are only
slightly lower. All pledges were still fulfilled at a rate
of nearly two-thirds (Pomper 1971).

Paul David believes this impressive record of ful-
fillment has been possible because the platforms offered a

series of "coherent proposals that were currently ready for public debate and definitive national action" (David 1979). President Eisenhower, for example, was so committed to the 1952 Republican platform that he used many of its statements as guidelines for his staff in formulating a legislative program (Chester 1977).

BACKGROUND AND OVERVIEW OF PARTY PLATFORMS

The Democrats were the first to construct a platform and adopt it at their national nominating convention in 1840 (Porter and Johnson 1961). By 1852 the practice of adopting a platform before nominating a candidate had stabilized,[1] and since that time each party has constructed its platform every four years—a testament to their perceived value, if only as "general statements of policy" (Reagan 1980). Because these "general statements of policy" evolve from conventions concerned mainly with nominating presidential candidates, they can be considered "instruments of parties attempting to gain control of the government" (Porter and Johnson 1961). Generally constructed during the months prior to the convention by a temporary platform committee, which reviews testimony from numerous special interest groups intent on ensuring that their issues appear in the statement, the platform presents favorable past records, cites weaknesses in the opposition party, and by incorporating certain ideas into various "planks,"[2] reflects political trends. In this last respect, platforms act as "one barometer of opinion in American political history" (Porter and Johnson 1961).

A brief examination of party platforms since 1840 gives a clearer picture of this "political barometer." In 1844, the Democratic, Whig, and Liberty party platforms discussed slavery and states' rights. War with Mexico was mentioned in 1848, and in the same year the Free Soil Party advocated free government for territories and another concern still common today: "We demand CHEAP POSTAGE for the people" (Porter and Johnson 1961). Party platforms from 1852 through 1892 reflected America's continued concern with slavery and states' rights, as well as the new issues of immigration, payment of the public debt, public education, and women's suffrage. By 1896 platform statements, which by then included social welfare issues, had grown so lengthy that the Democrats began to use major subheadings.

The number and variety of political parties also grew during this period, and social trends were reflected in their names: National Democratic, National Silver, People's, Prohibition, Socialist Labor, Silver Republican, Social Democratic, Independent, and Progressive. By 1908 the Democratic and Republican platforms contained sections describing the differences between the two major parties, and the adoption of platforms at the conventions became less flamboyant and more orderly.

Between 1896 and 1924 each convention had at least one issue brought to the floor for a roll-call vote, but after 1928, voting on individual platform issues became rarer. At the 1968 Chicago convention, for example, many roll-call votes occurred on matters of procedure, but only one on a platform issue--the minority plank on the Vietnam War--was rejected before adopting the platform as a whole.

During the twentieth century, the party of the incumbent president has become increasingly influential regarding the formation of the party's platform. However, the statement still must be approved by the platform committee, generally a heterogeneous group with equal representation from each state. Despite such an archaic structure, progress in improving the quality and significance of platforms has occurred (David 1979). In addition, the range of issues has widened to reflect the increasing variety of contemporary public policy concerns. Often new issues appear on the agenda of a minority party platform first, only to eventually become incorporated into most platforms (Chester 1977). The origin of the arts and humanities plank, now established in both Republican and Democratic platforms, is one outstanding example of this progression.

CULTURAL ISSUES AND PARTY PLATFORMS

Until the early twentieth century, no mention had been made in any party platform of American cultural concerns. The arts were almost exclusively supported by the private sector and therefore not considered an item on the public agenda. Cultural issues, if mentioned at all, fell under the category of "human resources." The Progressive party platform of 1912 was the first to mention human resources: "The supreme duty of the nation is the conservation of human resources through an enlightened measure of

social and industrial justice" (Porter and Johnson 1961).[3] This statement probably did not reflect concern for artistic human resources, but was a step in the direction of a legitimate arts and humanities plank. The Republicans adopted the Progressive party's statement exactly in their platform of 1920.

At the time of the construction of the 1928 platforms, the arts in America were still not part of public policy debate. Statements concerning the new technology of radio (later grouped with television and film in discussions of American technological arts or "media arts") did, however, find their way into the major party platforms of that year. The Democrats observed: "Government control must prevent monopolistic use of radio communication and guarantee equitable distribution and enjoyment thereof." The Republicans agreed that radio required "wise and expert government supervision," to ensure that the "educational and inspirational values of broadcast programs" be adequate in number and varied in character. The major parties began to construct a foundation for future arts planks on these references to the regulation of broadcasting.

Four years later, in 1932, another minority party, the Prohibition party, included a statement about a newer technological art, motion pictures: "We favor federal control at the source of the output of the motion picture industry to prevent the degrading influence of immoral pictures and insidious propaganda connected therewith." This tiny threat of federal censorship was repeated by the same party in 1936, while a limited form of regulation in the form of radio licensing was opposed by the Republicans in 1940. The Democratic platform that year also suggested that radio should be protected from censorship: "Radio has become an integral part of the democratically accepted doctrine of speech, press, assembly, and religion." Even though mention of the arts did not appear in either major party platform during the 1930s, the federal government under the Roosevelt administration instituted various programs that supported artists and the arts. The largest and most long-lived of these were the arts projects of the Works Progress Administration (see Chapter 12).

The year 1948 saw the first specific statement in any party platform concerning culture:

> The Progressive Party recognizes culture as
> a potentially powerful force in the moral

and spiritual life of a people and through
the people, in its growth of democracy and
the preservation of peace, and realizes
that the culture of a democracy must, like
its government, be of, by, and for the
people.
 We pledge ourselves to establish a
department of government that shall be
known as the Department of Culture, whose
function should be the promotion of all the
arts as our expression of the spirit of the
American people, and toward the enrichment
of the people's lives, to make the arts
available to all.

Once again, a minority party introduced several new con-
cepts: the contributions of culture toward peace, the
call for a governmental "Department of Culture," the pro-
motion of the arts as an expression of the American people,
and the issue of making the arts available to all. These
themes later reappeared in the platforms of the two major
parties in the 1960s.
 The proposal to establish a federal agency concerned
with culture reappeared in the 1960 Democratic platform,
which thereby became the first major party statement to
include a specific arts plank. Rather than a Department
of Culture, the Democrats suggested a "federal advisory
agency":

 The arts flourish where there is freedom
 and where individual initiative and imagi-
 nation are encouraged. We enjoy the bless-
 ings of such an atmosphere.
 The nation should begin to evaluate
 the possibilities for encouraging the ex-
 panding participation in and appreciation
 of our cultural life.
 We propose a federal advisory agency
 to assist in the evaluation, development,
 and expansion of cultural resources of the
 United States. We shall support legislation
 needed to provide incentives for those en-
 dowed with extraordinary talent, as a
 worthy supplement to existing scholarship
 programs.

Although the Democrats presented the idea of an ad-
visory agency and the suggestion of assistance to artists
in a rather vague manner, the statement reflected the
emerging public dialogue on cultural issues and served as
a building block for the arts planks of future years.
Government was also beginning to move into the arts arena,
as could be demonstrated by the congressional hearings
focusing on establishing federal arts and humanities agen-
cies and plans for a national cultural center--later to be
named the John F. Kennedy Center for the Performing Arts.[4]

Consequently, by 1964, when the Democrats drafted
their next arts plank, they were able to enumerate specific
accomplishments of the incumbent Democratic administration:
the actual creation of an arts advisory commission and the
establishment of a cultural center in Washington, D.C. In
addition, reference to media arts appeared in the education
plank as the Democrats recognized "the potential of educa-
tional television." The Republicans did not have an arts
plank.

Despite the creation of twin federal cultural agen-
cies, the National Endowments for the Arts and for the
Humanities (NEA and NEH), in 1965, and their three-year
record of administering government support for cultural
activities and institutions, neither major party included an
arts plank in its 1968 platform. The Republicans had not
yet formulated an arts policy stand, while the Democrats,
who had previously evidenced a concern for the arts, were
preoccupied with the controversial war in Vietnam.

During the six years that intervened between the
Democratic platform statement of 1964 and the early 1970s,
despite the official neglect shown by party platforms,
American cultural activity had blossomed and a federal
arts agency had been founded. The number of state and
local arts agencies had also grown extensively and all
arts disciplines had experienced a tremendous increase in
artists, audiences, and organizations. All this activity
naturally led to the proliferation of arts and humanities
interest groups which, in turn, supported the inclusion of
cultural issues in subsequent platforms. Thus, in 1972,
the arts, now coupled with the humanities, finally appeared
as a concern of both major parties. This marked a crucial
development in arts policy. Although never the subject of
partisan dispute, the inclusion of an arts plank in both
party platforms in 1972 recognized the nascent public con-
sensus that the arts were a general concern rather than a

partisan one. Support for the arts, if not above politics, did command a bipartisan support base.

Four cultural themes began to emerge with the 1972 platforms: (1) the importance of support for the arts and humanities; (2) the federal role in that support; (3) the economic problems of the arts; and (4) the importance of keeping the arts free from censorship. Although both parties agreed on these general themes, the Republicans stressed private support. Below is a brief comparison of the 1972 Republican and Democratic arts planks:

Democratic (1972)	Republican (1972)
Support for the arts and humanities is important	Support for the arts and humanities is important
Great arts institutions have economic problems	The federal government should support public and private efforts for cultural development
More federal support for the Endowments is needed	More federal support for the Endowments is needed
Public broadcasting, insulated from political pressure should be supported and not "muzzled" as was attempted by the Nixon administration	The Republican administration has: created an Expansion Arts Program in the NEA; encouraged federal agencies to use the arts in their programs; and expanded the funding for public broadcasting

In contrast to the fairly predictable statements from the Republicans and Democrats, the 1972 People's Platform contained the following: "A Department of Culture and the Arts is as relevant to our society as is a Department of Agriculture." This minor party platform also commented that compared to other countries, the United States spends too little on the arts, that our public buildings are barren, and that we must "deprofessionalize" the arts, encourage and fund local arts groups, and commission works commemorating "people-oriented occasions."

By 1976 more specific issues had begun to emerge. The major themes of the importance of the arts, economic concerns, and censorship still appeared. But to these were added labor issues, as well as copyright and tax

concerns. Once again, the Republican platform stressed the preeminent role of private support:

Democratic (1976)	Republican (1976)
The arts and humanities are important	The arts and humanities are important
Federal economic support for artists and arts institutions is needed	Federal support for the arts has increased
Artists should remain free of government control	Federal presence should never dominate
Anti-recession employment program for artists should be supported	Copyright reforms are needed
Copyright reforms are needed	Tax laws unfair to artists need revising
Tax laws unfair to artists need revising	One percent of the cost of government buildings should be for art
Public broadcasting should be supported	Public broadcasting, mainly supported in the private sector, should receive only federal assistance
	Government policy that facilitates charitable contributions should be encouraged

Fulfillment of the 1976 platform pledges was evident as funding for the National Endowments for the Arts and Humanities continued to grow. NEA appropriations, for example, increased from less than $100 million in 1976 to nearly $150 million in 1979. In addition, a major jobs program in the Department of Labor, the Comprehensive Employment and Training Administration (CETA), included a substantial program for the employment of artists, and a variety of specific tax legislation of benefit to artists was introduced in both houses of Congress.

THE 1980 NATIONAL PARTY PLATFORMS

Between 1976 and 1980, special-interest groups devoted to cultural concerns developed into mature, effective, and influential organizations. For example, the American Council for the Arts, the American Association of Museums,

the National Assembly of State Arts Agencies, the National
Assembly of Local Arts Agencies, and the American Arts
Alliance presided over an extensive network of arts advo-
cates. To many of these groups, inclusion of an arts
plank in the party platform is an important part of a
comprehensive arts advocacy program. This belief is re-
flected in these statements by Keefe (1972):

> No group can expect to move far toward the
> attainment of its objectives without coming
> to terms with the realities of party power;
> the parties, after all, are in a strategic
> positon to advance or retard the objectives
> of any group . . . [and parties] are more
> solicitous toward the claims of organized
> interests than toward those of unorganized
> interests.

The "organized arts interests" participated in the
process of formulating the 1980 major party platforms, as
did numerous other organized interests. All were invited
to submit written statements or designate a representative
to testify at hearings held by the platform committees dur-
ing the months prior to the conventions.
 Because all prospective candidates are generally in-
vited to participate in the construction of the platforms,
one arts advocacy organization, the American Council for
the Arts, contacted the major candidates early in the 1980
election campaign to determine their arts policies. One
question, published in the organization's magazine, Amer-
ican Arts, was: "In playing a leading role in the formu-
lation of your party's platform, what specific provisions
do you advocate be included for the arts?" The following
is a brief summary of the comments received:

 JOHN ANDERSON: I shall see that the arts in our
country are afforded the attention they deserve."

 GEORGE BUSH: Bush considered the two Endowments
a "vital priority," but felt they should remain politi-
cally independent. He believed the federal government
has a "supportive role in funding the arts."

 JIMMY CARTER: "In an open society like our own,
the relationship between government and the arts must
necessarily be a delicate one. . . . No matter how

responsive to the wishes of its people, it can never be government's role to define exactly what is good or true or beautiful. Instead government must limit itself to nourishing the ground in which art and the love of art can grow."5

EDWARD KENNEDY: Kennedy listed nine items he supported: increased funding for community arts programs, representation of all cultural traditions, increased support for arts education and arts programs for the handicapped, a White House Conference on the Arts and Humanities, the creation of a National Art Bank, increased support of arts employment programs, the Federal Building Enhancement Act, and a national survey on a state-by-state basis showing economic benefits of the arts.

RONALD REAGAN: "Party platforms for the most part represent general statements of policy." He hoped that statements regarding the control of inflation to help arts institutions and shifting the responsibility of individual Endowment grants to various arts institutions would be included in the platform.

The above statements were published in May, several months into the process of formulating the platforms and organizing the conventions. This process generally involves the organization of temporary platform committees chosen by the party chairpersons a few months before the convention. In 1980, the Republican temporary platform committee held hearings in order to receive testimony from various interest groups. Several of the major national arts advocacy groups participated in this process. Written testimony was submitted by the American Arts Alliance, one of the national advocacy groups, and stressed several major issues: the aesthetic impact of the arts, the economic impact of the arts, and three problems facing the country, with suggested changes that would help the arts—inflation (changes in tax policy), energy (increased funding to help arts outreach programs), and the country's moral climate (recognition of the importance of the arts in "lifting our nation's spirits").

Similarly, the Democrats formed a temporary platform committee and held public hearings and received written testimony. At their Seattle hearing in April 1980, testimony from the American Arts Alliance was delivered in

person by Francis LeSourd, a former board member of the
Seattle Opera. LeSourd's testimony documented the role of
the arts in economic revitalization, asked for platform
language supporting full appropriations for the Endowments,
stressed the importance of cultural revitalization, and re-
quested language supporting a tax policy to generate more
private support.

At the completion of all hearings, both the Repub-
lican and Democratic temporary platform committees drafted
their respective platforms, which were reviewed by the
permanent platform committees at the time of the conven-
tions and brought to the convention floors for formal
approval.

Interestingly, the third major party of the 1980
election, the Independents led by John Anderson, also pre-
pared a platform statement. The themes of the importance
of the arts, economic problems of the arts, and concern
about censorship were present, but the statement included
an assortment of specific proposals, many of which had
been mentioned by Edward Kennedy in his statement for
American Arts.

Democratic platform (1980)

The arts and humanities are a "precious national resource"
Accomplishments
 Federal commitment and funding have increased
 Federal Council on the Arts and Humanities was reactivated
 High standards of creativity have been fostered
 Federal programs for citizens in large and small communities
 have been encouraged
Pledges
 Continued federal support for arts and humanities
 institutions
 Encouragement of business support
 Exploration of a variety of mechanisms to nurture creative
 talent and build audiences
 Support for "strong, active" National Endowments and
 strengthening the Public Broadcasting System
 Greater recognition for the rich cultural tradition of
 minorities and encouragement of their participation in the
 performing arts at a national level
 Grants for arts in low-income neighborhoods

Republican platform (1980)

Accomplishments
 Strengthened the partnership of private and government support
 Expansion of artistic and scholarly endeavors
Weaknesses in Opposition
 Politicized programs
 Lowered standards of excellence
 Increased federal control
Pledges
 Restore a sound economy (which will allow the arts to thrive)
 Restore the integrity of federal cultural programs
 Support broader tax incentives to continue to encourage
 private support

Independent platform (1980)

The arts have played a key role in enriching the lives of all
 Americans
"John Anderson affirms the essential role the arts play in
 American society."
Government should foster the development of the arts without
 controlling their content
Areas in which the government can assist the arts
 National Endowments. Adequate funding, public access to
 the Endowments' programs
 White House Conference on the Arts and Humanities.
 Anderson will continue to support this effort
 Cultural Heritage Preservation. "Government should take
 measures to assure that the nation's cultural heritage
 . . . is protected and preserved."
 Art Bank. Government should purchase works of American Art
 and lease them for exhibition in public buildings
 Private support. Encourage private sector to take advan-
 tage of current tax advantages of contributions to the
 arts; Challenge Grant program should continue; a patron's
 award program should be established
 Fair compensation. Improve copyright law in order to give
 artists fair compensation; institute a tax credit when
 an artist lends talents to public performances
 Taxes. Institute the Artists Tax Equity Act[6]
The economic impact of the arts should not be overlooked

Beginning in 1981, the Republican administration attempted to fulfill its platform pledges, most notably with regard to private support for the arts. Initially the Republicans attempted to decrease drastically federal arts funding, but were rebuffed by tremendous public and congressional opposition. Eventually a President's Committee on the Arts and Humanities was established to identify and encourage outstanding programs of private support for cultural activities. This committee was also instrumental in moving various tax proposals encouraging charitable contributions through key congressional committees.

THE 1984 NATIONAL PARTY PLATFORMS

The procedures followed to draft and approve the 1984 platforms were essentially the same as those of 1980 with one major difference: the Republicans chose not to hold public hearings and accepted only written testimony. The Democrats, on the other hand, held a series of regional hearings during the spring: "In 1984, the Democratic Party Platform Committee will be reaching out--and listening--to Americans from every part of this country and from every walk of life" (1984 general information letter from the Democratic National Committee). Numerous special interest groups answered the call of the Democrats:

> The American Dental Association had a platform plank, as did (to mention just a few) the American Chemical Society, the Institute of Aeronautics and Astronautics, the Screen Extras Guild, the Asian Pacific Caucus, the Society of Civil Engineers, the Euromissile Action Network, the Disabled American Rally, Aid for Afghan Refugees, the American Flint Glass Workers, the Imported Automobile Dealers, the Gay and Lesbian Democratic Clubs, the Farm Animal Reform Movement and the California Marijuana Coalition (Reid 1984).

Among the arts groups, the Graphic Artists Guild submitted specific testimony referring to pending legislation and called on the Democratic Party to:

. . . reflect in its platform, its commitment
to copyright justice as a democratic right,
protect the integrity of creators' rights as
the brilliant dreams of new technologies are
realized, and protect our national cultural
heritage by remedying tax inequities suf-
fered by artists (Graphic Artists Guild 1984).

The American Arts Alliance, on the other hand,
drafted a general "arts plank" listing ways for the federal
government to maintain its leadership position in the arts
by "ensuring adequate funding for the federal agencies
that assist the arts and humanities," "appointing the
highest quality professionals" to these agencies, developing
private support programs, and "making the arts accessible
to all Americans" (American Arts Alliance 1984).

Other arts organizations did not submit formal testi-
mony, but contacted the major presidential candidates for
statements regarding their positions on the arts. In his
statement, Walter Mondale outlined the role of the arts in
American society and his plan for bringing "desperately
needed leadership to the arts and humanities." Specific
goals included honoring American artists and scholars;
making the White House a showcase for the best in the
arts; supporting "reliable, adequate funding" for federal
cultural agencies; appointing "the highest quality profes-
sionals" to federal arts programs; expanding arts support
throughout the federal government; increasing emphasis on
international arts exchange; and carefully monitoring the
role of the tax code in arts support.

Although the Democratic candidates, through their
representation on the platform committee, were able to in-
fluence construction of the platform, minor planks, like
those devoted to the arts generally received little public
debate. Guided by the chairperson of the Democratic plat-
form committee and later vice-presidential candidate,
Rep. Geraldine Ferraro (D-NY), the committee drafted "a
document for denouncing the President and his policies"
(Washington Post 1984). This document, nearly 45,000
words in length, "also was a vehicle designed to unite
the three presidential contenders" (Granat 1984c).

Consequently, the arts plank contained a few non-
specific pledges and presented the usual general rhetoric
about the importance of the arts:

Democratic Platform (1984)

The arts and humanities are at the core of our national
 experience
All Americans "have a stake in a nation that honors and
 rejoices in intelligence and imagination"
Pledges
 Set a new national tone of respect for learning and
 artistic achievement
 Strengthen federal cultural agencies
 Free these agencies from "political intimidation"
 Make the White House a place where "American cultural and
 intellectual life--in all its rich diversity--is honored"
 Be committed to the survival of public television and radio

　　　In contrast to the rather orderly, democratic process
adhered to by the Democrats in drafting their 1984 plat-
form, the Republican procedure was surrounded by contro-
versy. Problems started in January when public hearings
were canceled and replaced by "town meetings" suggested
by a group of conservative house members (Granat 1984a).[7]
Domination of these meetings by conservatives further
angered Republican moderates who never gained control
throughout the entire process. In general, the 1984 Re-
publican platform "bears the imprint of the party's most
conservative forces and in some cases tilts farther to the
right than the White House wanted" (Dewar and Dickenson
1984).
　　　The extremely conservative Republican platform
contained no subsection entitled "arts and humanities."
Cultural concerns were considered as a mere afterthought
to the section on education. Following several paragraphs
on technology, mention of the arts and humanities by the
Republicans is contained in four sentences that emphasize
private support and broadened access:

Republican Platform (1984)

　　　The arts and humanities flourish in the private
sector, where a free market in ideas is the best guar-
antee of vigorous creativity. Private support for the
arts and humanities has increased over the last four
years, and we encourage its growth.

We support the National Endowments for the Arts
and Humanities in their efforts to correct past abuses
and focus on developing the cultural values that are
the foundation of our free society. We must ensure
that these programs bring the arts and humanities to
people in rural areas, the inner city poor, and other
underserved populations.

These few sentences contain no mention of specific
accomplishments of the Reagan administration nor particular
pledges for future action. Drafters of the Republican arts
plank obviously did not consult a statement on cultural
policy submitted by President Reagan to the American Asso-
ciation of Museums for publication in Museum News. In
his statement the president emphasized private arts sup-
port, as usual, but added that his administration "will
always strive to preserve the economic and social climate
necessary for that spirit to flourish." He mentioned
support for the Challenge Grant Program of the National
Endowment for the Arts; the establishment of the Presiden-
tial Committee on the Arts and Humanities; and the creation
of a National Medal of Arts. He concluded: "The federal
government will continue to support the arts, not as a
substitute for private efforts, but as a stimulus." Draft-
ers of the few sentences pertaining to the arts in the
Republican platform would have been wise to borrow a few
eloquent phrases from the president.

SUMMARY

Since 1840, when the first formal platform was
adopted by the Democrats at their national nominating
convention, party platforms have appeared every four
years amid much public debate. Although the public per-
ception of these documents as hollow statements still per-
sists, research indicates that much of what is promised is
actually fulfilled. David (1979) agrees:

> The generally derogatory views of platform
> action that have lingered on in American
> political mythology are no longer valid, if
> they ever were. In the contemporary

situation, the major party platforms have
become important as alternative and partly
overlapping national plans on which a sub-
stantial degree of execution can reasonably
be expected. It is time they were recog-
nized as such.

Whether platform statements help assure that various
policies are implemented or whether the statements merely
reflect policies that are well on their way to fulfillment is
difficult to determine. Whatever the case, having a plank
devoted to its particular interests is extremely important
for any advocacy group, and over the past two decades
the arts have won this recognition.

Beginning with a few sentences in minority party
platforms, cultural issues have come to occupy a regular
plank in the major party platforms, and consequently,
parties have taken action on arts pledges. Furthermore,
certain policies have progressed from minor party state-
ments to major party statements to actual implementation.
The 1948 Progressive party pledge to establish a department
devoted to support of American culture was fulfilled with
the creation of the National Foundation on the Arts and
Humanities nearly 20 years later. If these trends continue,
arts policies in the twenty-first century may have already
been articulated in the political statements of the 1980s.

NOTES

1. Sorauf (1976) describes the typical convention:
"The convention begins in low key with stiff formalities
and the business of organization. It warms up with the
keynote address, tries to maintain momentum and expecta-
tion through consideration of the platform, and reaches a
dramatic peak in the nomination of the presidential and
vice-presidential candidates."

2. Since the "platform" is the state of what the
party "stands on" for four years, each "plank" (or indi-
vidual issue) is a very important part of the whole.

3. All references to platform statements through
1960 are from Porter and Johnson (1961).

4. The "arts" were paired with what were perceived
to be the politically "safer" and, at that time, better or-
ganized humanities community. This included universities

and libraries, and the alliance helped to move cultural legislation more easily through Congress.

 5. Martin D. Franks, director of research for Carter's campaign committee, answered for President Carter. He wrote that his statements "accurately reflect President Carter's views." Martin quoted from a 1978 speech from Carter.

 6. Legislation that allowed artists to receive a charitable contributions tax deduction equal to the fair market value of the works they contributed (rather than merely receiving a deduction equal to the cost of their materials) was known as the Artists Tax Equity Act.

 7. The disarray in the Republican ranks regarding the 1984 platform was unusual, considering that a Republican administration was in power. Not only were moderate Republicans unhappy with the drafting process, but much public disapproval was evident. Witnesses at an independent platform hearing called by Sen. Lowell Weicker (R-CT) "were quite right in their criticism of Mr. Reagan's party for not holding more platform hearings," and the Washington Post itself concluded that policies to be pursued by the Republicans should be publicly discussed and "[p]latform hearings around the country would have been a good place to put them on exhibit" (Washington Post 1984).

BIBLIOGRAPHY

American Arts Alliance. 1980. Testimony before the Republican and Democratic Platform Committees.

_____. 1984. Statement submitted to the Democratic Platform Committee (Spring).

American Association of Museums. 1984. "America's Commitment to Cultural Institutions: Reagan and Mondale on the Record." Museum News (August):50-53.

Bone, Hugh A. 1971. American Politics and the Party System, 4th edition. New York: McGraw-Hill.

Chester, Edward W. 1977. A Guide to Political Platforms. Hamden, Conn.: Archon Books.

Clark, Timothy. 1984a. "Drafting of the GOP Platform is a Low-Key, Almost Invisible Affair." National Journal, June 2, 1094-96.

_____. 1984b. "A Mondale Platform." National Journal, June 30, 1278.

David, Paul T. 1979. "Party Platforms as National Plans." Public Administration Review (May-June): 303-15.

Democratic National Committee. 1979, 1983. Final call for the Democratic National Convention. Washington, D.C.: Democratic National Committee.

Dewar, Helen, and James Dickenson. 1984. "Laxalt Terms GOP Platform Non-Binding." Washington Post, August 19.

Evans, Rowland, and Robert Novak. 1980. "The Democratic Platform: It's Only Make-Believe." Washington Post, June 27.

Ford, Gerald. 1984. ABC-TV broadcast of Republican National Convention, August 21.

Granat, Diane. 1984a. "GOP Fractured Over Platform: Reagan Helps Unite Democrats." Congressional Quarterly, March 17, 630-31.

_____. 1984b. "Democrats Concoct 1984 Platform in Harmony." Congressional Quarterly, June 30, 1972-75.

_____. 1984c. "Democrats Agree to Platform that Sparks Little Enthusiasm." Congressional Quarterly, July 21, 1739-55.

Graphic Artists Guild. 1984. Testimony submitted to the Democratic Platform Committee, June 11.

Keefe, William. 1972. Parties, Politics, and Public Policy in America. New York: Holt, Rinehart and Winston.

Mayer, George H. 1967. The Republican Party 1854-1966, 2nd edition. New York: Oxford University Press.

Mondale, Walter. 1984. Letter to American Council for the Arts, April 6.

"National Party Conventions, 1831–1976." 1979. Congressional Quarterly (Washington, D.C.) (September).

Pomper, Gerald M. 1971. Elections in America. New York: Dodd, Mead & Co.

Porter, Kirk H., and Donald Bruce Johnson. 1961. National Party Platforms 1840–1960 (revised edition compiled by D. B. Johnson, 1978). Urbana: University of Illinois Press.

Reagan, Ronald. 1980. "The Candidates Respond." American Arts (May):16–21.

Reid, T. R. 1984. "'Glory of the Party' Seeks Platform Spot." Washington Post, June 13, p. A2.

Republican National Committee. 1980. Chairman's Report 1980. Washington, D.C.: Republican National Committee.

Shales, Tom. 1980. "Live, from Detroit: Glitter and Bah-loney." Washington Post, July 16.

Sorauf, Frank J. H. 1976. Party, Politics in America, 3d edition. Boston: Little, Brown and Co.

Tocqueville, Alexis. 1956. Democracy in America, edited by Richard D. Heffner. New York: New American Library.

Washington Post. 1984. Editorial, "Platform Dustup." August 1.

12

THE SOCIAL ORIGINS OF THE FEDERAL ART PROJECT

Helen Townsend

Within the American art world change of two kinds provided the basis for government art patronage in the 1930s. First, changes in the prevailing beliefs about the function of art and its relationship to society led to an interest in American art. Second, changes in the size and composition of the art world led to concern for the continued development of the community of artists. Although the Depression was the catalyst that forced the government to act, these two significant changes legitimized the government's precedent-breaking move. Indeed, without these changes, government participation in the arts most probably would not have occurred.

Art historians have held that with encouragement from the arts community, government support for the arts in the United States was prompted by a sensitivity to the needs of depression-plagued artists and by a desire to spur an American renaissance grounded in an egalitarian ideal (Baigell 1974; Larkin 1960; Richardson 1956; McKinzie 1973; O'Connor 1971). These explanations are inadequate, however. Another and third condition was also critical to the initiation of the federal art projects. This was the perceived need for a more unified national ideology (President's Research Committee on Social Trends 1933). The arts were seen as a vehicle for teaching ideology.

The purpose of this chapter is to integrate this ideological factor into a further, more sociological explanation of the New Deal arts projects. To that end I will examine the relationship between ideology and art policy,

demonstrating both how ideology was translated into policy during the 1930s and, conversely, in what ways those policies reflected ideology.[1] I will explain why the federal government became involved in the arts during the Depression and illustrate how the motives and purposes of certain influential groups shaped the major art project of the era, the Federal Art Project of the Works Progress Administration (WPA/FAP).

THE UNDERLYING CHANGES

By the early 1930s the confluence of urban expansion and change at home, of European cultural "decadence" and fascism abroad, and of economic depression throughout the world, had provided the foundations for significant development in the prevailing beliefs about the function of art and its relationship to society. Typically, these changes included a rejection of European artistic leadership and with it the expatriate lifestyle, along with a devaluation of elitist art. Instead, there was an acceptance of "environmentalism," a philosophy that held that artistic meaning derived from the environment (Baigell 1974: 41). In these terms, it was popularly held that creative individuals received their inspiration from the land, people, history, and mythology most familiar to them and that it was the artists' responsibility to live among the people and to communicate the inspiration of that shared experience with them. Art, particularly painting, was judged accordingly.

In time, two artistic movements emerged. Regionalism found expression in indigenous art and incorporated the belief in an American "renaissance." Like the historical event it recalled, this renaissance was to produce an "efflorescence of art, literature, science, philosophy, and social accomplishments" (Panofsky 1971: 441). Its aim, however, was to reawaken native tradition rather than antiquity as the ideal of the artist and thus elicit the "free but accurate reproduction of the external world" (Greenhill 1974: 445). The second movement, Social Realism, evolved in reaction against the European modernism of urban elites as well as against the presumed biases in the Regionalists' approach to their subject matter. On both counts, it was precipitated by the Great Depression and manifested in art of social protest. Whereas artists working within

the Social Realism movement accepted the same basic tenets of the environmentalist philosophy held by the Regionalists, the Social Realists frequently saw society in terms of its injustices and, as Shapiro has observed, "attempted to use art to protest and dramatize injustice to the working class—the result, as these artists saw it, of capitalist exploitation" (Shapiro 1973: 3).

Differences notwithstanding, the values and beliefs of both movements were exhibited in representational and realistic styles which treated topical, local, and anecdotal subject matter, whether urban or rural. The stated goal of both movements was the establishment of egalitarian art in the United States. This shared goal provided the aesthetic rationale for government participation in the arts.

A second, practical or political rationale developed with the Depression. As conditions worsened, concern grew for the large community of impoverished artists in New York City. During the late 1920s that community had become both larger and more diverse; it included not only new and established fine artists, but returning expatriates and an expanding population of practical artists as well. While precise figures are not available, a rough and most probably low estimate suggests that the New York artist community increased 63 percent, growing from 10,600 in 1920 to 17,200 in 1930.[2]

In 1933 that community was seriously threatened. Businesses were failing; there were few patrons of the arts and most artists were unemployed. After the collapse of the stock market in 1929 there was little money available for necessities and even less for luxuries such as art. Art sales plummeted and, regardless of their artistic proclivities, all but a very few established artists found it difficult to make a living. The market for American art, small to begin with, now virtually disappeared. First, private buyers vanished, then museums and galleries reduced exhibition schedules, all but eliminating American artists' opportunities to exhibit their work (Shapiro 1973). As detailed by one scholar, "a 165 market price index for art in 1929 had shriveled to 50 by 1933. Art importation was down over 80 percent and the production of artists' materials was off by almost half" (McKinzie 1973: 4). As a result, those who had congratulated America on the growth in the arts during the 1920s now feared that the Depression would do irreparable harm.

IDEOLOGY AND THE ART PROJECTS

The explanations commonly provided for government support for the arts highlight the concern felt by prominent individuals within the art establishment. These describe the way in which those individuals publicized the artists' plight, attempted to organize independent or citywide relief, and intervened directly on behalf of the artists (Baigell 1974; McKinzie 1973; O'Connor 1971). The government's response is, in turn, pictured as possibly ideological (Larkin 1960) and probably altruistic (Baigell 1974; Larkin 1949; McKinzie 1973; O'Connor 1971). Baigell concludes that the U.S. government set out to buy a renaissance (Baigell 1974).

Without question the efforts of individuals like George Biddle and Audrey McMahon brought the plight of American artists to the attention of the world outside of New York City. They made the potential crisis in the American art world known to the president. The government's response did demonstrate concern. However, the motives and purposes underlying government participation in the arts during the 1930s were more complex than these interpretations suggest. A closer look at those motives and purposes provides a fuller picture.

Audrey McMahon, editor of Parnassus, the official journal of the College Art Association, in her article "May the Artist Live?" (1933: 1-4) argued that artists were like other workers; they were unable to find work and were starving. Their plight was "a vital problem concerning the eight thousand families about which we possess specific knowledge as well as additional anonymous thousands" (McMahon 1933: 1). Artists, however, were different. While they could do regular work (i.e., manual labor), if they were to leave their art there was always the risk that they would not return to it and that art in America would suffer a loss from which it might not easily recover. She asked, "Shall cultural aridity succeed economic failure?"

McMahon then pointed to the mural project undertaken by artists under the Emergency Work Bureau in New York City. She described the way in which these projects benefited both artists and the community. She cited Harry Knight, liaison officer for the Work Bureau and the College Art Association:

> It has not only helped the artist finan-
> cially, but . . . equally important, it has
> been of immense cultural benefit to the
> various communities in putting art where it
> can reach the people (Knight in McMahon
> 1933: 2).

She continued, describing the situation as she perceived it:

> . . . in 12 neighborhood houses over 750
> young people have been kept off the streets
> and occupied constructively, have had the
> germs of art appreciation instilled in them
> at a time when the depression was deepest
> and the outlook for youth most drear. And
> one hundred artists, men of talent and of
> highly sensitive natures, men who form
> part of a large group which might easily,
> under adverse and difficult conditions, be-
> come a distinct social problem, have not
> only been kept from final distress, but
> their gifts have been directed into the
> channel of public benefit (McMahon 1933: 4).
> (Emphasis added)

In this way Mrs. McMahon, who was to have a major role
in the design of the WPA Federal Art Project, exhibited her
concern and argued that the artist was a leader whose tal-
ents might be used for the public good if he were sup-
ported or for ill if he were not.

There were distinct political and ideological over-
tones to Biddle's actions as well. George Biddle, an art-
ist and old school friend of Roosevelt's, approached the
president directly, using an overtly political example to
suggest a political solution. Looking at the government
support that the Mexican muralists and their syndicate had
received, Biddle argued that mural art was ideal for art-
ists and for the public in a depression-ridden country.[3]
It could be both instructive and constructive. It need
not be expensive. In his 1939 autobiography, An American
Artist's Story, he wrote:

> Every artist in America, every intelligent
> and outlooking student of his times, knew
> that life here was drab and often pitiful

or tragic. They knew that it could have
justice and beauty. . . . Through trial
and error we must somehow reshuffle the
constituent parts that formed the dreary
design of our national life. For among
those elements somewhere lay the picture
of democratic justice and spiritual beauty
(Biddle 1939: 267).

He concluded that artists could lead a depressed
public toward an ideal of beauty. On May 9, 1933, he
wrote the president:

Dear Franklin:

. . . There is a matter which . . .
might interest your administration. The
Mexican artists have produced the greatest
national school of mural painting since the
Italian Renaissance. Diego Rivera tells me
that it was only possible because Obregon
allowed Mexican artists to work at plumbers'
wages in order to express on the walls of
the government buildings the social ideals
of the Mexican Revolution . . . (Biddle
1939: 268).

Thus it seems that leaders of the artistic community were
not only interested in American art, and with its artists,
but also were concerned with the artists' potential for en-
couraging unrest. It was, in short, a directly ideological
concern.

In 1933, the worst year of the Depression, over 12
million men and women (or 24.8 percent of the work force)
were unemployed. Employment in manufacturing industries
had fallen over 40 percent, and for those fortunate enough
to hold their jobs, weekly wages dropped from $28 in 1929
to $17 in 1932. There were 31,000 reported commercial and
industrial failures that year. Loss in value of major
stocks was reported to be as high as $2 billion. The
total incomes of all individuals fell from $82 billion to
$40 billion (Rauch 1944).

In some states 40 percent of the population was on
relief (Brown 1940), with the percentage reaching 90 per-
cent in some counties in those states. Across the United
States nearly one family out of every six was dependent

on some form of welfare. In Pennsylvania (where in 1932 only two-fifths of the working population had full-time jobs) the governor requested federal help, estimating that "if $60,000,000 were spent among the unemployed of Pennsylvania, it would give each of them 13 cents worth of food per day for one year" (Hopkins 1936: 92). In Arkansas Senator Joseph T. Robinson reported, "approximately 1,500 families are without shoes or clothing and they have not a dollar in money" (Hopkins 1936: 93). He further observed that conditions were so severe among sharecroppers that state officials feared there would be a serious social and economic disturbance (Hopkins 1936).

Clearly there were more pressing problems than the nurturing of an artistic renaissance. The most immediate of these was how to cope with the poverty and distress brought about by a depression that had turned being poor, hungry, and in need of financial help from a private into a public tragedy. The long-preserved illusions of personal merit and fault no longer held. Discontent grew as people gradually began to blame the system rather than themselves for their distress (Piven and Cloward 1971). It is not surprising, therefore, that local authorities turned to the federal government for help, nor that the government assumed that responsibility. It is surprising, however, that government support for the arts was initiated at this time, since this was an unprecedented move.

Prior to 1933, government patronage had been limited to federal commissions for architecture, painting, and sculpture in Washington, D.C. (Netzer 1978). In addition, there was only one federally sanctioned art organization, the National Commission of Fine Arts, which was excessively conservative and could not be counted on to support either the idea of broad federal patronage or the more contemporary art forms it would produce.[4]

Furthermore, the American public had little interest in art. In 1930, most Americans were artistically uninformed and regarded art as a pastime for the idle rich. In their survey of art in America in the years just prior to the depression, Keppel and Duffus, while pointing to a growing interest in the arts, note that nonetheless, ". . . for the vast overwhelming majority of the American people the fine arts of painting and sculpture, in their non-commercial, non-industrial forms, do not exist" (Keppel and Duffus 1933: 15). Given this, the American people could not be expected to support or to encourage a govern-

ment art program; and, if the American public did not
want to support art, no more did they want to support
artists. During the 1920s and early 1930s the general
public held a somewhat limited view of the artist and the
artistic life. The highly publicized bohemian life styles
of some artists during the 1920s had left an impression
which persisted. It was widely argued that, at a time
when so many working men and their families were going
hungry and looking for honest labor, support for artists
who were nonproductive and self-indulgent would be frivo-
lous at best.

Despite these problems, the Public Works of Art
Project (PWAP) was launched in December 1933. Generally
held to be a "trial balloon" (McKinzie 1973; O'Connor 1971),
this program folded after seven months, along with its
parent organization, the Civil Works Administration (CWA).
The PWAP had, however, established the viability of gov-
ernment support for the arts in the United States (McKinzie
1973; O'Connor 1971). It was succeeded by several other
government programs which lasted until 1943: the Treasury
Section on Painting and Sculpture (Section); the Works
Progress Administration Federal Art Project (WPA/FAP); and
the much smaller and briefer Treasury Relief Art Project
(TRAP).[5]

Over the ten years of their collective existence,
these various art projects cost the government $39,717,229,
with close to 90 percent of the funding ($35,000,000) going
to the WPA/FAP. For the government to initiate so exten-
sive a program of support for the arts implies something
beyond a basic concern for the fine arts. In particular,
the disproportionate funding for one program suggests that
an examination of that specific program might provide in-
sights into federal motivation for funding of the arts dur-
ing the 1930s. Such an examination starts by raising
three questions: First, what was the WPA/FAP? Second,
how was the WPA/FAP different in policy and structure
from the original PWAP and the less-funded Section? Third,
in what way do those differences reflect a specific ideo-
logical bias to government arts participation?

THE WORKS PROGRESS ADMINISTRATION
FEDERAL ART PROJECT

Despite several attempts at large-scale federal eco-
nomic assistance, by 1935 President Franklin Roosevelt had

not succeeded in easing the impact of the Depression across the country. Over 6 million men and women were still unemployed and on relief. State welfare agencies, whose resources had been all but depleted in the early years of the Depression, were ill-equipped to deal with the magnitude of human need and despair. In view of the persistence of the economic crisis (perhaps noting, too, that 1936 was an election year) and acting on the recommendation of his advisors, President Roosevelt used his executive power to create a new relief agency: the Works Progress Administration (WPA). It was instituted by executive order on May 6, 1935. Although some 50 existing agencies were to receive small grants from the WPA to administer independently, after May 1935 most of the money available for the unemployed, including those in the arts, would come from the WPA.

In both concept and implementation the WPA was a wide-ranging program of social improvement and work relief. It was organized and administered under two classifications: non-federal and federal. Eight projects carried the federal designation; all other projects were non-federal. The non-federal projects required a sponsor in each state, some agency that would pay a part of the cost (usually set at 40 percent but in practice generally less) in return for work that supplemented its own activity. In Tennessee, for example, these included the construction of farm-to-market roads, swamp drainage for malaria control, and clothing manufacture and distribution. The state sponsor retained a high degree of autonomy. While the federal government provided advice and assistance, in general it deferred to local authorities in planning and implementation. In contrast, federal projects required no local sponsor, undertook work that would presumably go undone, and received a larger part of their direction from WPA officials in Washington. Although local sponsorship was solicited and a sponsoring agency was required, their contribution was small (often less than 5 percent) and their input was expected to be proportional (Bourne 1946).

Among the WPA's federal projects were the programs that concern us here: those for artists, writers, musicians, and actors. These fell within the Professional and Service Projects Division of the WPA and were collectively referred to as Federal Project Number One, or more commonly Federal One. All four operated under identical guidelines: state WPA officials would be responsible for the nonpro-

fessional aspects of the cultural programs such as payrolls, offices, and relief certification. Professional staffs in Washington would approve the project proposals, direct the creative work, and vouch for its quality. These arrangements gave the federally based project directors a mandate to design and direct each project as they saw fit.

Within Federal One, the project for artists, sculptors, and painters was entitled the Federal Art Project (FAP). It was directed by Holger Cahill, a museum curator, organizer of art exhibits, writer, and administrator who "if a tyro, perhaps, in national politics . . . knew well the machinations of art politics" (Blesh 1956).[6] Philosophically, Cahill's art project was rooted in the pragmatic populism of John Dewey and specifically in the theories of art that Dewey had outlined in his book, Art as Experience (1934). Dewey contended that the elitist bias that differentiated between "high" and "low" art was an artifact of capital accumulation. He defined art as any act of thoughtful creation whose purpose was to communicate a shared experience. Because it placed the origins of art in experience, especially in the everyday social experience of the common man, Dewey's philosophy closely paralleled that of the environmentalist school and was widely accepted (Baigell 1974).

In practice the Project attempted to balance the growing disaffection for the industrial Northeast, which was widespread in the country at large, with the need to alleviate the unemployment and unrest in the art community in New York City (Cahill 1936). To accomplish these dual and perhaps contradictory goals, the Project supported both the practical and the fine arts, and in so doing hoped to break down so-called artificial barriers and return art to the community. The organizational and procedural bulletin for the Federal Art Project of the Works Progress Administration (no. 7120) stated:

> . . . the Federal Art Project provides for
> the employment of artists in various enter-
> prises. Through the employment of crea-
> tive artists it is hoped to secure for the
> public outstanding examples of contemporary
> American art; through art teaching and
> recreational art activities to create a
> broader national arts consciousness and
> work out constructive ways of using leisure

time; through services in applied art to aid
research projects to clarify the native back-
ground in the arts. The aim of the project
will be to work toward an integration of
the arts with the daily life of the commu-
nity, and an integration of the fine arts
and the practical arts (National Archives
RG 69, no. 7120).

Thus both the regional sentiments of the general
population and the needs of the artistic community were to
be insured. The project was further designed to guarantee
Cahill optimum control. Local advisory committees, serv-
ing on a volunteer basis, were recruited to "help the art
directors to maintain high standards of performance" (Na-
tional Archives RG 69, no. 7120: 2). However, most real
authority rested with a staff of field advisors, regional
and state art directors, and district art supervisors who
were appointed and screened by Cahill. The project staff
was organized so that the local directors acted under state
directors, who, in turn, were responsible to regional direc-
tors (National Archives RG 69, no. 7120). Cahill reserved
for himself the right to appoint every director at all levels
and assumed responsibility for all. He used the power in
this right to insure a uniform philosophy throughout the
project and to direct the local projects from the national
level.

GOVERNMENT SUPPORT FOR THE ARTS:
THE FAP, PWAP, AND SECTION

As noted above, although the budget for the FAP
was small relative to the total WPA budget, it nonetheless
constituted close to 90 percent of all government funding
for the arts during the Depression. Indeed, it so over-
whelmed the other federal art programs that all art of the
Depression era subsequently came to be known as WPA art
(Baigell 1974; Mavigliano 1984). Despite this, both the art
produced under the WPA/FAP, and the philosophy of art it
represented and implemented, differed from that of the
other federal art programs. Differing policies had, in
turn, different political implications.

Edward Bruce, the director of the original, short-
lived Public Works of Art Project (PWAP), had believed

that the future of government art patronage depended on
the success of this preliminary program. He knew that
the decision to continue government patronage of the arts
would be political. He therefore designed the PWAP to
please the widest possible public (McKinzie 1973). His
method was to establish a policy for the selection of art
and artists that virtually insured that no one would be
offended by either the subject matter or the style of PWAP
art. This often meant appeasing local leaders and their
skeptical publics.

Funds for the PWAP projects went directly to local
political and cultural leaders who selected artists and
specified the work to be done. Local leaders selected
"favorite son" painters and popular projects. When con-
flict did occur, local groups censored art and changes
were made. In this way the PWAP became self-regulating
and Bruce was able to carry through on a policy of
"thwarting art which might bring awkward public outbursts
that would embarrass or anger Congress and the President"
(McKinzie 1973: 21).

After the PWAP folded, the succeeding Treasury Sec-
tion on Painting and Sculpture (Section), also headed by
Bruce, controlled the art produced by taking similar "grass
roots" tastes into account. Section guidelines required
American Scene painting and often offered specific ideas as
to subject matter. Artists were chosen by competition. A
newsletter, the Section Bulletin, published Section news
and competition information. It was circulated among the
art community and some of the more radical artists con-
tended that their names were not on the Section mailing
list (McKinzie 1973).

Inviting artists to compete for post office murals,
the Section Bulletin of April 1, 1935 recommended subjects
be taken from the history of the U.S. Postal Service. The
Bulletin then listed possible themes: abstract qualities
such as speed, endurance, courage, and reliability were
listed first. Then American Historical episodes such as
"Colonists get ship mail from England in Reputable Tavern"
or "Lincoln who carried the Post Office in his hat" were
followed by nineteenth-century methods: coach service,
mail riders, the Erie Canal (1825), and the Pony Express.
There were suggestions for delivery scenes, the colonists,
the newest methods, outside activities, and inside activities
(National Archives, Bulletin no. 2). Although these sug-
gestions were presumably provided only as guidelines, it

was clear that the "Section staff knew the kind of art it wanted, made it clear to artists, and handled the commissions in a manner that gave some control if the work went wrong" (McKinzie 1973: 53).

Ultimately, however, there was a considerable amount of "give and take." As Karal Ann Marling noted:

> . . . whatever the experts' personal hobbyhorses, the implicit partnership of interests between patron, painter, and public favored compromise rather than control and negated the private ambitions of public servants. The patron shaped the mural to the extent that Washington chose the painter and supervised his or her progress. The painter shaped the mural, but did so under the guidance of varying degrees of pressure from the Section experts and the general public. Then the people spoke . . . their judgment determined whether the mural would enjoy a vital existence in the life of the community (Marling 1982: 14).

In contrast to these programs, the WPA/FAP under Holger Cahill had no restrictions on either subject matter or style. Although the artistic style of its projects ranged from classical to modern, most artists were of either the Regionalist or the Social Realist style. In New York, however, it was the Social Realists who dominated the FAP projects, and their political rhetoric and advocacy for an art of social protest prevailed at artists' meetings (Shapiro 1973; Wolfe 1979).

An atmosphere of unrest often pervaded these projects. Meyer Wolfe, an artist from Tennessee who lived and worked in New York City during the Depression, recalled:

> We had meetings and the meetings were terrible. A few always disrupted them. . . . Of course, it was the times. . . . The people who ran the project . . . and that fellow in Washington . . . couldn't have been nicer. They took just about everything—some really bad work. [It was] artists [who] were the agitators—just "some of the boys" (Wolfe 1979).

He added that the same artists always seemed to disrupt meetings and that one particularly divisive meeting ended in a chair-throwing brawl.

Such demonstrations and the strong feeling they generated provided a forum from which artists expressed their views and through which the more verbal or more ideologically committed could easily influence other artists. They almost certainly were an outlet for anger and frustration. As such, they may also have functioned as a safety valve to defuse the potential political unrest such artists may have otherwise fomented.

Nonetheless, it appears contradictory that these artists and their outbursts were tolerated while, at the same time, FAP restrictions that prevented local project heads from making aesthetic decisions discouraged the growth of regional art. To be sure, local artists were given positions as project heads and gallery directors (National Archives RG 69, DC 105-106). However, in these capacities they had very little official autonomy and were required to clear project ideas with Washington (O'Connor 1974). For example, in Tennessee local project directors regularly presented their ideas to Washington for clearance or were criticized for not doing so (National Archives RG 69, DC 105-106).

As noted, the FAP "top-down" managerial approach was markedly different from that in either the earlier PWAP or its successor, the Section. The PWAP had, perhaps, the most regionally oriented policy. Because under PWAP rules local leaders could select art, artists, and the location, local politics played no small part in the decision. Burton Callicott, a Memphis artist, recalled his PWAP commission:

> The first thing I was aware of was newspaper articles publicizing Mrs. Roosevelt's concern and activities giving employment to artists. . . . Then, gradually it trickled down. . . . There was a committee formed on the state level. Now, whether it was that same committee that visited Memphis or whether they got a subcommittee of Memphians, I don't know. I do know that several of the people were Memphians. One, luckily for me, was my stepfather.

>This committee . . . was to appoint artists
>and survey the area to determine where art
>could be placed. . . . The committee
>wanted a mural for the Pink Palace (a
>local mansion converted to a natural his-
>tory museum) . . . the subject of DeSoto's
>trek through this area to discovery (of the
>Mississippi) was chosen, too, by this com-
>mittee. . . . They awarded me the com-
>mission. It wasn't a competition, they
>just decided. So that was handed to me.
>. . . I was a young artist and knew I
>could do good work. I was very excited
>about it and went right to work on the
>design and drawings.[7]

But while the later Section also gave the power of
selection to local "culture barons," it was a gift of power
in appearance more than in reality. McKinzie reports:

>. . . Local juries headed by local culture
>barons, plus the anonymous submission of
>artists' sketches, gave the system an aura
>of fairness. Bruce hoped to make the
>award decisions--ultimately made by his
>own staff--palatable to losers and factions
>among artists.

>The emphasis on competitions confused the
>Senator with the artist friend, a great part
>of the interested public, and many of the
>artists who participated. . . . And work
>awarded through competitions could not but
>reflect the conscious and unconscious bias
>of the juries, the chairmanship of which
>the Section controlled (McKinzie 1973: 54).

By leaving artistic judgments to local cultural lead-
ers--first in actual practice and then in appearance--
national leaders hoped to satisfy regional publics. In
practice dissatisfaction came from another source. Artists,
in particular the more radical New York City artists, were
unhappy with both the PWAP and, in turn, the Section.
They argued that too few artists were hired and that selec-
tion procedures were arbitrary. They became increasingly

outspoken and militant; their vocal militancy contributed, perhaps, to the urban focus of the FAP and to the lesser degree of local control permitted under that program.

ARTISTIC UNREST, THE PWAP, AND THE SECTION

In December 1933, Bernada Bryson, a leader of the Unemployed Artists Group, headed a delegation of about 50 artists to the Whitney Museum to confront Mrs. Juliana Force, PWAP director for New York City. Bryson demanded an accounting: Why were established artists receiving commissions while many needy artists were being ignored? Mrs. Force refused to discuss her policies with the artists and "in effect the Unemployed Artists were thrown out of the office" (McKinzie 1973: 16). Two weeks later the group, now militant and 100 strong, marched to the Whitney a second time. This time they were turned away by the police.

By the time that the Section was established, the artists' reactions were less openly antagonistic. The protest was largely limited to the conservative approach of the Section, and was expressed in articles and editorials in Art Front, the official publication of the Artists' Union. Using the magazine as a public forum, the artists argued that Section juries were controlled and that Section aesthetics were at best limited and at worst, fascist (Art Front 1934a). They contended that local juries of school principals, library directors, and prominent local citizens were judging poorly, that those selected to be on juries were rejecting work by artists whose work they were not qualified to judge.

In order to mitigate these perceived biases, the union demanded that artists be on Section juries. They also requested that every organization of 50 artists or more be represented in a national artists' group from which juries could be selected. They objected to the hardship created by the competition rules. As McKinzie further reports:

> Credible sculpture and mural designs required technical, theoretical, and emotional concentration over an extended period . . . and artists . . . could devote the necessary time to competition only at considerable

> personal sacrifice and expense. Since the
> artists designed the work for a specific
> building, it had no usefulness elsewhere;
> competition wasted energy of all but one
> artist. . . . And private clients, influ-
> enced by government practice began to ex-
> pect artists to furnish competitive designs
> without compensation. . . . The militant
> artists of New York demanded the Section
> limit competitions to invited artists who
> would receive salaries while they designed
> (McKinzie 1973: 55).

The objections that had been raised by the militant
artists in late 1933 and throughout 1934 focused the sense
of solidarity among New York artists on one overriding
need: employment. In November 1934, Art Front published
an article entitled "The History of the Artists' Union." The
article pointed out that the Artists' Union was growing,
motivated by "the needs and conditions necessary for him
as an artist" (Art Front 1934b: 4). It noted how in Decem-
ber of the previous year the union had presented a peti-
tion to relief administrator Harry L. Hopkins, which in-
volved plans for teaching, mural and easel painting, and
commercial and applied art jobs for all unemployed artists.
The article protested the limitations of the PWAP. It ar-
gued that the so-called merit system did not meet the re-
quirements of the many thousands of fine and applied art-
ists who needed work and relief. It called for more dem-
onstrations and noted that the Artists' Union was growing
and spreading to cities across the United States: St.
Louis, San Francisco, Los Angeles, Chicago, Detroit, Cleve-
land, and Pittsburgh all had organized union activities.
 In another article, "For a Federal Art Project," Art
Front suggested that the first goal of the Artists' Union
would be the creation of a Federal Art Project to employ
all needy artists. The article concluded, "The necessity
of precisely such provision by the Government was so keen-
ly felt by the artists that throughout the country, spon-
taneously, organizations were formed with this as their
major objective" (Art Front 1934b: 8). It was observed
that the PWAP had been inadequate. "Throughout the ex-
tent of the project about thirty-five hundred artists were
employed, each averaging about one or two months' work.
. . . [Artists] were juggled in and off the payroll . . .

until the project ended and they were faced with the same callous disregard [as before]" (Art Front 1934b: 8).

Art Front suggested that the Artists' Union spearhead the struggle to meet the immediate needs of artists. The union therefore published the following list of demands in the November 1934 issue:

1. Permanent jobs for all unemployed artists. These were to include:
 expansion of the former PWAP for all unemployed artists;
 Regional Federal Art Museums and Lending Libraries to serve as a clearing house and exhibition center for all works produced under the project for circulation among public institutions and the general public;
 mural painting and decoration in public buildings;
 monumental and decorative sculpture in public buildings;
 miscellaneous fine and commercial art work projects;
 the teaching of arts and crafts; and a permanent Federal Art Project

2. That no discrimination be shown artists of any derivations, influences, and trends in contemporary art today

3. That wages and conditions be specified at $30.50 per week for a 30-hour minimum and that artists be allowed complete freedom in conception and execution

4. That there be representation of artists elected by artists to all art administrative bodies

5. Adequate home relief until placement on jobs

6. Passage of Workers Unemployment HR 7498

7. The establishment of a Municipal Art Center by New York City (Art Front 1934b: 11)

The artists wanted a voice in the establishment of art pol-
icy. Employment in a wide range of artistic endeavors
was a primary concern. Their demands were recognized
and, in turn, reflected in the WPA/FAP policies established
in 1935.

IDEOLOGY, ARTISTIC UNREST, AND THE WPA/FAP

Although, in part, the government was reacting to
the concerns of the art community when it became involved
in support for art, it reacted most decisively to the prob-
lems posed by the militant artists. In this context three
factors appear to have contributed in a major way to the
decision to provide the bulk of support under the work-
relief rules of the WPA. First, artists were perceived as
leaders whose energy had to be channeled in the "right"
direction. Second, public disaffection and unrest among
the art community made revolutionary art a distinct possi-
bility. Third, artists were seeing themselves as a commu-
nity of workers which included fine and commercial artists,
practical artists, designers, craftsmen, and teachers. They
were coalescing as a group and, therefore, increasing
their political power. As they grew in number, they
gained energy; skills were being mobilized.
The artistic philosophy of Holger Cahill, director of
the Federal Art Project, fit the artists' perceptions of
themselves, addressed the concerns of national cultural
leaders, and made the demands appear reasonable. Thus
Cahill could argue that broad support was necessary be-
cause ". . . it is not the solitary genius but a sound gen-
eral movement which maintains art as a vital, functioning
part of any cultural scheme" and in so doing justifies re-
lief for artists (Cahill 1936: 18). He further noted "The
importance of an integration between the fine arts and the
practical arts . . . as an objective desirable in itself
and as a means of drawing together major aesthetic forces
in this country" (Cahill 1936: 19). He stated that a major
concern was "the problem of the young artist of distin-
guished but still emergent gifts" (Cahill 1936: 19) and
above all expressed the firm belief that

> American artists have discovered that they
> have work to do in the world. Awareness
> of society's need and desire for what they

can produce has given them a new sense
of continuity and assurance (Cahill 1936: 41).

Cahill's sentiments support the assertion that the
projects were ideological. More broadly, they justify an
argument that social groups do use public organizations to
gain practical ends and in the process infuse those same
organizations with ideological biases. For public policy
to be effective, however, it is necessary for the ideas it
incorporates to be acceptable to key social groups. Fur-
ther, in a pluralistic society, acceptance is most easily
achieved when organizational goals appear to meet the
needs of two or more groups coincidentally. Thus policy
should be most widely accepted when two or more conflict-
ing and converging groups assume that policy will meet
their particular needs. The Depression era arts projects
met the needs of two groups who were becoming self-con-
scious and whose needs coincided: unemployed artists and
concerned national leaders in art and government. Ulti-
mately, however, it was the fact that work relief for art-
ists addressed the interests of yet a third group, business,
which led to the establishment of the WPA/FAP as the gov-
ernment's primary art project, in contrast to the more
aesthetically focused Section.

ART AND BUSINESS IN AMERICA

The 1920s had been a time of prosperity for the art-
ist as well as for America (O'Connor 1971: 60). This new
prosperity had fostered expansion within the arts. Accord-
ing to census figures, the number of artists, sculptors, and
teachers of art increased from 35,402 in 1920 to 57,265 in
1930 (U.S. Bureau of the Census 1932). As noted above,
the core of this developing art world could be found in
the large population of artists in New York City. Although
many were fine artists, in general the major change within
the art world was in the growth and development of the
practical arts. O'Connor notes,

> The demand for professional artists in all
> phases of art increased, as Americans be-
> came more interested in aesthetic satisfac-
> tion. Industries had discovered that they
> had to present their wares in the most

> pleasing form possible in order to attract
> the attention of now affluent customers.
> Most large companies hired art directors
> or committees or even fully manned art
> departments . . . (O'Connor 1971: 60).

He discusses the importance of the "salaried artists who
were prominent in advertising, illustrating and designing
and includes magazine illustrators, hand craftsmen, in-
terior decorators, and clothing designers" (O'Connor 1971:
60).

Both O'Connor (1971) and McKinzie (1973) note that
during the 1920s, the art market expanded, the number of
firms producing artists' materials increased, and the value
of the product rose by 25.4 percent. Further, universities
became interested in art education and "education in art
. . . was drawn into the mainstream of education by the
pressure placed on educators by the increased demand for
artists" (O'Connor 1971: 61).

Writing in 1933, Keppel and Duffus note that prac-
tical artists, in particular, were singled out for praise.
Advertising artists and industrial designers would be "men
of the future" and would lead the country to a new aesthet-
ic awareness (Keppel and Duffus 1933). Although this par-
ticular perspective is a consistently recurring theme in
art journals during the 1920s, by 1934 it had taken a
more precise focus. According to the report of the Presi-
dent's Research Committee on Social Trends (1933) produc-
tive capacity in the United States had outstripped the
need for the products it was creating. The report noted
that good design and advertising could contribute to eco-
nomic recovery. Indeed, it implied that they had become
a necessity.

> Masses of people need to learn new tastes and
> new ways . . . there is a need for publicity
> to create needs and a system of installment
> buying must be set up . . . (President's
> Research Committee 1933: xxxvi).

Thus the development of what came to be known as
the consumer ethic appears to have been seen as an im-
portant factor in economic recovery. To the extent that it
was important to create needs and teach new ways, artists
could play a variety of roles. They could design more

attractive products and create needs through advertising; they could shape the visual and symbolic world.

Given this, it appears that the federal government's interest in art during the Depression was in large part ideological in both economic and political senses: it recognized that the business community would derive some benefits from such a project and, in turn, the government itself would be legitimated (Useem 1976). In sum, the converging interests of business and government were related to the establishment of the WPA/FAP as the major art project of the decade. The relatedness of these interests and events is borne out when the conditions influencing government funding of art during the 1930s are examined in light of WPA/FAP concerns, goals, and accomplishments.

GOVERNMENT PARTICIPATION IN THE ARTS
IN THE 1930S: AN ANALYSIS

The multiple crises that occurred during the early years of the Depression complicate any analysis of causation. Despite this, a pattern emerges and dominant motivations can be established. First, although federal intervention was in part prompted by a crisis in art brought on by the Depression, it was a lesser program, the Treasury Section on Painting and Sculpture, which provided most support for establishment art and artists. The Section sought to obtain the "best art possible" by mandating American Scene art and by granting commissions based on competitions controlled by local art establishments. The emphasis on American Scene art and on mural art in public buildings also suggests that the Section was strongly ideological in an aesthetic sense. Section funding amounted to less than 10 percent of the total government art program support.

Conversely, the WPA/FAP, which comprised 90 percent of the total art budget, was a work-relief project. It supported artists rather than art and supported those artists regardless of their artistic style, philosophy, or ability. The WPA/FAP program therefore appears to have been organized in response to the economic crisis rather than to an aesthetic crisis. The FAP addressed this economic crisis at both the specific level of artistic unemployment and, equally importantly, at the general level of business activity.

The connections were noted earlier, but bear repeating. Although various early programs of the Roosevelt administration had provided relief for bankers and farmers, business still suffered. Production was down and factories remained closed. Within government circles it was felt that the root of the problem lay in the fact that production had outstripped the country's capacity to absorb the products it had created (President's Research Committee 1933). It was further believed that this dilemma could be overcome by creating a desire for new and better products in the public.

Artists were seen as central to both the problem and the solution. They could promote unrest; they could also stimulate business. As industrial designers, artists could design more attractive products. Through advertising, artists could help to persuade a public unused to purchasing goods for their "beauty of line" to do so (Keppel and Duffus 1933). As teachers or practitioners, artists could encourage an art consciousness and foster a desire for harmony and beauty in future and present generations. Thus Cahill would write of the Project, "We are interested in raising a generation . . . sensitive to their visual environment and capable of helping improve it" (Cahill 1936).

With this philosophy in mind the FAP incorporated both the fine and the practical arts and employed practical as well as fine artists. Further, as the FAP developed it became increasingly focused on the practical arts. By April 1940, over 4,100 of the total 5,818 workers on WPA/FAP projects worked in practical projects (McKinzie 1973). While these projects varied, they nonetheless clustered around two needs. Technical projects focused on ways to improve the quality and reliability of the practical arts. Practical projects sought to make people more aware of their visual environment and sensitive to their role in improving it. For artists there were design laboratories, a program in paint analysis and arts research which led to the development of carborundum etching. The Index of American Design employed 300 commercial artists for six years. Other artists were given the opportunity to learn techniques of restoration and preservation, to teach, to manage community art centers, and to direct galleries.

In part through the efforts of these workers, in programs such as art classes for children and adults, people

throughout the United States became more sensitive to their visual environment. Classes were given in painting, sculpture, and ceramics, in creative home planning, in fashion design for the homemaker, and in "recreational art." The newly art-sensitive public attended art shows at local galleries and joined in a wide range of activities at community art centers.

At the same time, the WPA/FAP fine arts projects fit with the New York/federal government belief that regional growth would strengthen and legitimate both the national government and big business. This progressive form of "regionalism" was designed not just to encourage the development of the regions, but also to promote inter-regional understanding and homogeneity. It was hoped that, as cultural change minimized regional differences and as the public became more sensitive to an aesthetic environment, the desire for a "modern life style" would increase and resistance to industrial development would diminish. Thus, despite its so-called regionalism, the WPA/FAP was organized so that regional art programs provided an outlet for New York City art and the progressive culture it embodied; the industrial Northeast was reinforced in its role as the producing center for culture; and a regional network of galleries and art centers promoted cultural change and development.

In this way the FAP served the purposes of three influential groups: the expanding community of artists was maintained, the cultural unity sought by public officials was promoted, and business was given a boost. Thus it is simplistic to say only that the FAP was grounded in "ideology." It was the overlapping interests and respective ideologies of three important groups that provided both the motivation for government involvement in the arts and gave direction to the major program. The result was a program of broad support for the arts which focused on employment for both fine and practical artists and on the development and application of their art. It tended to concentrate artistic production in the major cities, where experimentation with new forms was encouraged, while it spread interest in art and arts activities into other regions. Thus the motivations of the interest groups influenced the government, shaped the Federal Art Project and, in turn, gave direction to and influenced the shape of art in America.

NOTES

1. The term ideology will be used in its broadest sense. It will refer to "a system of interdependent ideas (beliefs, traditions, principles, and myths) held by a social group, which reflects, rationalizes and defends its particular interests and commitments" (Theodorson, George A. and Achilles G. Theodorson. 1969. A Modern Dictionary of Sociology. New York: Thomas Y. Crowell Company.

2. According to the 1930 census, during the 1920s the number of artists, sculptors, and teachers of art in the United States increased from 35,402 in 1920 to 57,265 in 1930. It is also known that approximately 90 percent of all artists who filed for relief under the FAP were located in urban areas, with over one-third of these in New York City.

3. In 1921 a group of young Mexican artists who identified themselves with the Mexican and Russian revolutions formed a syndicate which they called the Syndicate of Technical Workers, Painters and Sculptors. They were supported by the Mexican government and produced a series of monumental frescoes which glorified the Mexican revolution. The syndicate enjoyed complete freedom from censorship as well as government support. In 1922 it came under attack by conservatives and the press. The commissions of most artists were withdrawn; some murals were damaged. Despite the short tenure of the syndicate, the work of the Mexican muralists was highly regarded and still stands as a major artistic occurrence. Three artists who worked with the syndicate emerged as major figures: Jose Clemente Orozco, David Alfaro Siquieros, and Diego Rivera.

4. The Commission had been established by then President Taft in 1919. McKinzie reports that "it advised upon the design and location of buildings in the national capital, upon selection and location of public monuments, fountains and statues," and upon "questions involving art . . . with which the government is concerned." He continues by observing that they ". . . opposed all that smacked of the twentieth century and a good part of that which belonged to the nineteenth" (McKinzie 1973: 6).

5. In 1933 $1,039,000 was allocated to the first of the government arts programs, the Public Works of Art Project (PWAP). The PWAP operated from November 1933 to June 1934. During this time 3,749 artists turned out 15,663

pieces of art and crafts. The Treasury Section on Painting and Sculpture was the second art program to be established. It operated concurrently with the Federal Art Project (October 1934 to June 1943) at a cost of $2,572,267. The Section was responsible for commissioning works of art to decorate newly constructed federal buildings. For this purpose, 1 percent of construction costs were to be set aside. When the costs exceeded the estimates the art allocation was the first to go. Because the artists had to absorb the cost of models for competition and because there was a high degree of artistic control the program was not popular and did not reach a broad spectrum of artists. The third program, the Treasury Relief Art Project (TRAP) was a subprogram of the WPA, organized under the Department of Treasury. It accounted for $833,784. This program attempted to combine the structure of the Section and Section leadership with WPA/FAP ideals of work relief. A "master artist" of known reputation and not on relief received a commission for a major work of art. Relief artists were employed to work for him as apprentices. From July 1935 to June 1939, 446 artists were employed on this project. They produced 89 murals, 43 pieces of sculpture, and 10,000 paintings.

By comparison to these smaller projects, the Federal Art Project employed up to 5,000 artists during a six-month period. These artists created over 108,000 paintings, 2,500 murals, 18,000 pieces of sculpture, 200,000 prints from 11,000 original designs, and 2 million copies of 35,000 original design posters. Over and above these creative activities, the FAP was responsible for important technical innovations: the perfection of color lithography, seriography for creative purposes, and the invention of carborundum etching. Under the FAP an extensive system of Community Art Centers was established, local school systems developed programs in art education, and the American craft heritage was preserved in the Index of American Design. The program ran from August 1935 to April 1943.

For extensive discussions of these programs, their administration, organization, goals, and accomplishments, see McKinzie (1973), O'Connor (1971), Marling (1982), and Park and Markowitz (1984). The books by McKinzie and O'Connor stand as the first major reference works on the government art programs of the 1930s. All contain extensive bibliographies.

6. Holger Cahill was educated at Columbia and the New School for Social Research. He joined the staff of the Newark, New Jersey Museum as an advisor in American art. From 1932 to 1935 he worked with Alfred H. Barr in the Museum of Modern Art. See Chapter 8 for more on Cahill's activities.

7. Burton Callicott, personal interview, Memphis, Tennessee, June 4, 1979.

BIBLIOGRAPHY

Art Front. 1934a. "For a Permanent Federal Art Project." 11 (November):4–5.

_____. 1934b. "History of the Artists' Union." 11 (November):8.

Baigell, Matthew. 1974. The American Scene: American Painting of the 30's. New York: Praeger.

Biddle, George. 1939. An American Artist's Story. Boston: Little, Brown.

Blesh, Rudi. 1956. Modern Art USA: Men, Rebellion, Conquest, 1900–1956. New York: Alfred A. Knopf.

Bourne, Frances T. 1946. "Preface." Record Group 69: Records of the Works Progress Administration; Preliminary Checklist of the General Correspondence Files of the Works Progress Administration and Its Predecessors: 1933–1944. Washington, D.C.

Brown, Josephine C. 1940. Public Relief 1929–1939. New York: Henry Holt & Co.

Bruce, Edward. 1935. "Art and Democracy." The Atlantic Magazine 156 (August):149–52.

Cahill, Holger. 1936. New Horizons in American Art. New York: The Museum of Modern Art.

Dewey, John. 1934. Art as Experience. New York: G. P. Putnam & Sons.

Greenhill, Eleanor S. 1974. Dictionary of Art. New York: Dell Publishing Co.

Hopkins, Harry. 1936. Spending to Save, The Complete Story of Relief. New York: W. W. Norton.

Keppel, Frederick, and R. L. Duffus, 1933, The Arts in American Life. New York: McGraw-Hill.

Larkin, Oliver W. 1960. Art and Life in America. New York: Holt, Rinehart and Winston.

Marling, Karal Ann. 1982. Wall to Wall America. Minneapolis: University of Minnesota Press.

Mavigliano, George J. 1984. "The Federal Art Project: Holger Cahill's Program of Action." Art Education (May):26-30.

McKinzie, Richard D. 1973. The New Deal for Artists. Princeton, N.J.: Princeton University Press.

McMahon, Audrey. 1933. "May the Artist Live?" Parnassus 5 (October):1-4.

Minton, John D. 1959. "The New Deal in Tennessee." Ph.D. dissertation, Vanderbilt University, Nashville, Tenn.

National Archives. Bulletin no. 2. 1935. Section of Painting and Sculpture Public Works Branch, Treasury Department. April 1.

_____. Record Group 69, DC 105-106. Works Progress Administration. Federal Art Project files: Archives of American Art (Tennessee). Microfilm.

_____. Record Group 69, no. 7120. 1935. Works Progress Administration. "Federal Art Project of the Works Progress Administration."

_____. Record Group 69, no. 8236 (N6512.A52). 1936. Works Progress Administration. "Federal Art Project of the Works Progress Administration."

Netzer, Dick. 1978. The Subsidized Muse: Public Support for the Arts in the United States. Cambridge: Cambridge University Press.

O'Connor, Francis V. 1971. Federal Support for the Visual Arts: The New Deal and Now. Greenwich, Conn.: New York Graphic Society.

Panofsky, Erwin. 1971. "Renaissance and Renascences." In Modern Perspectives in Western Art History, edited by Eugene Kleinbauer, 413–31. New York: Holt, Rinehart and Winston.

Park, Marlene, and Gerald E. Markowitz. 1984. Democratic Vistas: Post Offices and Public Art in the New Deal. Philadelphia: Temple University Press.

Piven, Frances Fox, and Richard A. Cloward. 1971. Regulating the Poor: The Functions of Public Welfare. New York: Vintage Books.

President's Research Committee on Social Trends. 1933. Recent Social Trends in the United States--Report of the President's Committee on Social Trends. New York: McGraw-Hill.

Rauch, Basil. 1944. The History of the New Deal. New York: no publisher given.

Richardson, E. P. 1956. Painting in America. New York: Thomas Y. Crowell.

Shapiro, David. 1973. Social Realism: Art as Weapon. New York: Ungar & Co.

U.S. Bureau of the Census. 1932. Occupation Statistics for the United States. "Persons 10 years old and over gainfully employed," Table 4.

Useem, Michael. 1976. "Government Patronage of Science and Art in America." In The Production of Culture, edited by Richard A. Peterson, 123–42. Beverly Hills, Calif.: Sage Publications.

Wolfe, Meyer. 1979. Personal interview, Nashville, Tennessee, November 19.

13

FROM WPA TO NEA:
FIGHTING CULTURE WITH CULTURE

Gary O. Larson

When Ronald Reagan, in his 1980 acceptance speech, invoked the words of Franklin D. Roosevelt, surely the last embers of active anti-New Deal sentiment in America had been extinguished. FDR's sprawling administration, it seems, had receded sufficiently far into the past that the three-term patriarch was capable of such political trans-figurations. The irony of Mr. Reagan's pronouncement was staggering, nevertheless, not the least for those of the rival sect who resented, quite frankly, such a brazen in-cursion into the Democratic shrine. In American politics, it seems, a fine line is drawn between ecumenism and trespassing.

For other observers of American politics, those re-moved from current political squabbles, the president's statement brought to mind an earlier period, when Republi-can assessments of the New Deal were far less amiable. Students of public policy in the arts, in particular, can cite any number of instances in which the federal arts projects were vilified by congressmen eager to find chinks in the New Deal armor. According to Rep. Martin Dies of the House Un-American Activities Committee (HUAC), for ex-ample, the Federal Theater and Federal Writers Projects were "doing more to spread Communist propaganda than the Communist Party itself" (Mangione 1972: 308). And when the arts projects were not attacked in Congress as a radical plot, they were parodied as the silliest of New Deal boondoggles. Such was the fate of the now-legendary "Coffee-Pepper Bill" (which owed as much to Rep. William

Sirovich as it did to the more colorfully named John Coffee
and Claude Pepper), a hopeless plan to place the four
arts projects under a permanent Bureau of Fine Arts (U.S.
Congress, Senate 1938; Congressional Record 1938: 9497).

Not surprisingly, in light of the conservatives'
twin-barreled attack, nothing more was heard from the
handful of friends that the WPA arts projects still had in
Congress. A full decade elapsed, in fact, between Coffee-
Pepper and the first of a new generation of far more tepid
federal arts proposals. It was more than a sense of
futility that silenced the federal arts advocates, however.
The entire WPA structure (of which the arts projects were
only a minute part) had run its course by the early
1940s, as the nation turned its attention to the war. Nor
were the initial postwar years any more hospitable to vi-
sions of a new domestic arts program. Once again the
nation looked abroad, as another war, the curious, nerve-
wracking cold war, gripped the American imagination.

Yet there was federally funded art in the 1940s,
included in the numerous cultural exchange efforts that
can be traced back to the late 1930s. This was not the
scrappy, democratic art of the New Deal projects, perhaps;
it gave us no colorful state guides or controversial "Living
Newspapers," no post office murals or Index of American
Design. Admittedly, it was not even intended for domestic
consumption. Yet, in the final analysis, these early efforts
at cultural diplomacy wielded a much greater influence on
the subsequent movement for a new federal arts program
than the WPA--still anathema in the 1950s--could ever
exert. In short, it was the spirit of the cold war, the
drive to "fight culture with culture" abroad rather than
visions of a cultural democracy at home, that lent momentum
to the movement that had stalled for over a decade.

Even a purely domestic measure such as the 1958
bill to create a National Cultural Center (i.e., the Kennedy
Center) had more to do with the State Department's inter-
national advertising campaign than with the numerous com-
munity art centers spawned by the New Deal: "This Act is
intended," the legislation's Statement of Policy and Purpose
declared, "to strengthen the ties which unite the United
States with other nations and to assist in the further
growth and development of friendly, sympathetic, and
peaceful relations between the United States and other
nations of the world by demonstrating the cultural inter-
ests and achievements of the people of the United States"

(U.S. Congress, Senate 1958: 2). Rep. Frank Thompson (D-NJ), the leading congressional arts advocate of the 1950s, had put it more succinctly three years earlier, calling the proposed cultural center "one of the very best and most effective ways to answer the Russian lies" (Congressional Record 1955: 5876).

If the American government was a latecomer in the field of public arts support, waiting for a national emergency to prompt its first large-scale cultural program, it was equally tardy in sending its culture on official junkets abroad. While Germany and France had initiated their cultural relations programs in the nineteenth century, a practice emulated by most other Western nations following World War I, it was not until 1938 that an official American program began. Clearly, the American motives were mixed (a combination of national pride, Good Neighborliness, and latter-day mercantilism) and were given an added urgency by the Axis powers' efforts in propaganda and cultural exchange. Initially, the United States' focus was on Latin America, where Roosevelt's Good Neighbor policy had begun to undo years of fear and mistrust, and where an open field existed for experiments in the kinds of cultural diplomacy that would later be extended throughout the world.

Clearly, the challenge in South America was posed both by the Axis presence and especially by the dubious yanqui reputation; while the former would change over the years, as the Soviet Union and Communist China replaced Germany and Italy as our diplomatic foes, the latter thrust--the doubtful international stature of American culture--remained constant. Sumner Welles stated the problem explicitly as early as 1935, expressing a formula that would be repeated again and again over the years. "In Latin America," the assistant secretary of state observed, "there is frank skepticism as to the existence of interest here in the things of the mind and of the spirit. There is admiration of our capacity for organization and achievements in industry and business, but open credulity of our interest in literature, music, art, and philosophy" (Welles, 1935: 10). Thirty years later, Sen. Edward Kennedy offered essentially the same counsel in support of the National Foundation on the Arts and Humanities bill, contrasting the nation's great strides in science and technology with the far more precarious state of American culture: ". . . we will be dull and listless men, amid all these

wonders," the senator warned, "if we do not also expand the human mind and spirit" (U.S. Congress, House and Senate 1965: 7).

Given such doubts about America's standing abroad, it is not surprising that it was the American delegation to the Inter-American Conference for the Maintenance of Peace, held in Buenos Aires in 1936, that raised the issue of "intellectual cooperation." The U.S. proposal for a regular program of educational exchange was greeted enthusiastically at the conference, and the following year Congress ratified the resulting agreement, the Convention for the Promotion of Inter-American Cultural Relations. In 1938, finally, the American cultural relations effort was officially launched with the establishment of two bodies: the Interdepartmental Committee on Cooperation with the American Republics, and the State Department's Division of Cultural Relations (McMurry and Lee 1947: 208–14).

While the interdepartmental committee was primarily concerned with technical projects, the Division of Cultural Relations (DCR) took an active, if financially modest, interest in a variety of arts activities. On paper, at least, Departmental Order 367 gave the new division

> general charge of official international activities of [the State] Department with respect to cultural relations, embracing the exchange of professors, teachers, and students; cooperation in the field of music, art, literature, and other intellectual and cultural attainments; the formulation and distribution of libraries of representative works of the United States and suitable translations thereof; the preparations for and management of the participation by the government in international expositions in this field; supervision of participation by this government in international radio broadcasts; encouragement of a closer relationship between unofficial organizations of this and of foreign governments engaged in cultural and intellectual activities; and generally, the dissemination abroad of the representative intellectual and cultural works of the United States and the improvement and broadening of the scope of

our cultural relations with other countries
(U.S. Department of State 1939: 1)

In practice, however, the new cultural unit's activ-
ities were not quite so wide-ranging, focusing initially on
travel grants, the Buenos Aires convention, and the ex-
change of educational films, and relying heavily on such
private organizations as the Institute of International
Education, the American Library Association, and the
American Council on Education to carry out its program
(Thomson and Laves 1963: 38-41). With more adequate
financial backing (through 1943 the division's budget
totaled only $1,690,000), the division might have accom-
plished much more. That it had larger ambitions is sug-
gested by the series of four two-day conferences it con-
ducted in Washington in the fall of 1939, bringing together
over a thousand arts experts from around the country to
discuss cultural relations in the fields of art, music, edu-
cation, and libraries/publications. These were well-
organized, well-attended affairs, notable for gathering not
only the expected State Department and Carnegie/Rockefeller/
Guggenheim foundations crowd, but representatives as well
of the WPA arts projects and other assorted cultural vi-
sionaries, including artist and WPA administrator George
Biddle, Rene d'Harnoncourt of the Museum of Modern Art,
painter Stuart Davis, composer Aaron Copland, and New
Music's John J. Becker (U.S. Department of State Bulletin
1939).
Ultimately the State Department's cultural program
was limited as much by its self-defined role "as a clearing-
house and coordinating agency for the activities of private
agencies" as it was by its budgetary constraints. Con-
gress, in particular, needed to be assured that the State
Department was not contemplating a New Deal version of
Hitler's and Mussolini's propaganda machinery. "The con-
ception of an 'official culture,'" Assistant Secretary Welles
made clear, "is altogether alien to us" (Welles 1939: 493).
Nor would the new program possess the New Deal's central-
izing tendencies. "In a democracy such as ours," DCE
chief Ben Cherrington told the annual convention of the
National Education Association in 1939, "the initiative for
cultural exchange quite properly resides with private
agencies and institutions" (Cherrington, 1939: 21). Thus
the Division of Cultural Relations rejected the more activist
approach to cultural affairs taken by the WPA arts projects,

and anticipated by a quarter-century the National Endow-
ment for the Arts' "junior partner" philosophy with regard
to federal arts support ("primarily a matter for private
and local initiative," according to the 1965 legislation).

Just as the Depression had precipitated the drastic
measures of the New Deal, however, the crisis in Europe
prompted the creation of a unique agency in the summer
of 1940, the Office for the Coordination of Commercial and
Cultural Relations between the American Republics, which
prompted many of the cultural duties that the State Depart-
ment was either unable or unwilling to assume. Although
primarily concerned with economic, health, and defense
matters, this agency (renamed the Office of the Coordinator
of Inter-American Affairs [CIAA] in 1941) had a strong
cultural thrust as well, reportedly at the behest of Roose-
velt himself. It was the president's hope, in any case,
that the CIAA, "by effective use of Governmental and pri-
vate facilities in such fields as arts and sciences, educa-
tion and travel, the radio, press and cinema, would further
national defense and strengthen the bonds between the na-
tions of the Western Hemisphere" (U.S. Office of Inter-
American Affairs, 1947: 8).

More importantly, the man Roosevelt selected to
direct this effort, 32-year-old Nelson Rockefeller, was
ideally suited to bring art into the realm of foreign af-
fairs. Having visited every Latin American country in
1937 (surveying, among other things, his family's extensive
oil interests), Rockefeller was also president of the Museum
of Modern Art (MOMA), which his mother had helped estab-
lish in 1929. But the coordinator's efforts were not with-
out controversy. His office was immediately attacked in
Congress as yet another New Deal boondoggle, and some of
his more colorful projects (such as good-will tours by
actor Douglas Fairbanks and former major-league catcher
Moe Berg and, inevitably, touring exhibitions of modern
art), provoked debate. The State Department, whose own
Latin American program was dwarfed by Rockefeller's
budget (more than $60 million in 1943), was especially
piqued. The CIAA "abounded in money and in bright
ideas, not all of which were good," observed the American
Council of Learned Societies' Waldo Leland, who served on
the joint committee Roosevelt established in 1941 to prevent
any further conflict between Rockefeller and the State De-
partment; "it was like setting up a four-ring side-show
just outside the one-ring main tent" (Leland 1943: 20).

But for all of its pizazz, Rockefeller's "side-show" had important implications for future federal cultural undertakings. His program excelled in that particular blend of private expertise and public authority (in this instance bringing representatives of private philanthropic and cultural organizations into the federal arena) that later became the hallmark of the federal arts and humanities program. This public-private approach formed the basis of the plan for an advisory arts council that first emerged during the Eisenhower years (a plan that Rockefeller helped draft while a Department of Health, Education and Welfare undersecretary), and is at the heart of the Arts and Humanities Endowments' panel and council structure. While the State Department may have consulted with the private sector, as it did during the 1939 conferences and on countless other occasions, it was Rockefeller's office that used extensive public funds to put the private sector to work. The CIAA, another former DCR chief recalled in 1947, "brought into the government program a sure hand and a wide sweep in the fields of art, music, sculpture, painting, theater and ballet. CIAA brought experience in the operation of charitable foundations which had subsidized the creation of cultural institutes in Latin America. . . ." (Thomson 1948: 149). Rockefeller also saw that MOMA got into the cultural relations act during this period; the museum fulfilled some 38 contracts (totaling $1,590,234) for cultural materials, working not only for the CIAA (assembling 19 exhibitions of contemporary American painting), but for the Library of Congress and the Office of War Information (OWI) as well (Cockcroft 1974: 39-40).

Among the experts Rockefeller tapped for federal service, both in staff positions and on the several advisory committees the CIAA employed, were John Hay Whitney, MOMA vice-president (and president of the museum's film library, which had a contract with CIAA to carry out its motion picture operations); Hollywood producer Walter Wanger (Stagecoach, Foreign Correspondent) and director Frank Capra (Lost Horizon, Mr. Smith Goes to Washington); John Abbott, executive vice-president of MOMA; librarian of Congress (and future assistant secretary of state for cultural and public affairs) Archibald MacLeish; Henry Allen Moe, director of the Guggenheim Foundation; and William Benton, then vice-president of the University of Chicago and subsequently MacLeish's successor as assistant

secretary of state. It was Benton (who served on the CIAA's policy committee and was already known for his collection of modern art) who suggested sending art on tour to Latin America. One such effort was the exhibition in several Latin American cities of some 300 contemporary works on loan from the Metropolitan Museum of Art, the Brooklyn Museum, the Whitney Museum of American Art, the American Museum of Natural History, and MOMA, a project that foreshadowed a much more controversial tour the State Department organized in 1946, while Benton was assistant secretary (U.S. Office of Inter-American Affairs 1942).

Dr. Robert G. Caldwell, dean of humanities at the Massachusetts Institute of Technology, directed the CIAA's cultural relations division, which established advisory committees in the areas of education, literature, publications, music, art, and exchange fellowships. It was the smallest of the CIAA divisions, and its operations were curtailed after Pearl Harbor, but a number of its projects established patterns for future federal efforts. In the summer of 1941, for example, the CIAA sent Lincoln Kirstein's American Ballet Caravan on a 28-week tour of Latin America. At President Roosevelt's suggestion, sculptor Jo Davidson was commissioned to visit ten Latin American republics to make portrait busts of their presidents. And in 1942, the CIAA arranged through RKO Pictures for Orson Welles and his Mercury Players to produce It's All True, a feature film on Latin America. (Although Welles shot 150,000 feet of film in Brazil over a period of several months, because of a dispute between Welles and RKO, the film was never completed.) (U.S. Office of Inter-American Affairs, 1947: 91-95)

In the face of more pressing short-term projects directly related to the war, the CIAA's art and music projects were transferred to the State Department's cultural division in 1943; OWI also assumed some of these cultural duties, supporting the creation of libraries abroad, and working in England, for example, with the Tate Gallery and Studio magazine to help establish an American cultural presence. Following the appointment of Rockefeller to the post of assistant secretary of state in charge of relations with the other American republics .in late 1944, the much-reduced CIAA and the now-obsolete OWI were terminated in 1945. Meanwhile, the State Department's cultural unit, having endured myriad organizational shifts and name changes during and after the war, emerged in the late

1940s as one of the chief participants in the nation's ideo-
logical war with the Soviet Union. As before, that battle
involved cultural materials; and, as before, federal spon-
sorship of such material provoked controversy. The WPA
arts projects may have been long dead in 1947, but the
fears and suspicions in Congress that killed those projects
(fear of art with a political meaning and, now, suspicion
of seemingly "meaningless" art) were still very much alive.

If there were any WPA veterans in the late 1940s
who entertained notions of a postwar revival of the federal
arts projects, the events of 1946-47 surely must have put
those visions to rest. Abandoning its customary coordinat-
ing role for an uncharacteristic entrepreneurial stance, the
State Department (using leftover CIAA and OWI funds, iron-
ically), actually purchased a collection of 79 contemporary
American paintings in 1946. The plan was to tour the de-
cidedly modern (and, at $49,000, budget-priced) collection
in two parts, covering both Latin America and Europe.
J. Leroy Davidson, the State Department's art expert, per-
sonally selected and purchased the paintings, a singular
departure from the jury system normally employed in such
exhibitions (Mathews 1976: 777-78). But although several
of the artists represented (including Stuart Davis, Marsden
Hartley, John Marin, Philip Evergood, and Georgia O'Keefe)
had been included in both the CIAA's 1941 tour and more
recently in the State Department-sponsored tour of art from
the collections of American businesses, the fact that the
government actually owned these works rankled conserva-
tive artists and conservative congressmen alike.

For these artists, whose attack was spearheaded by
the American Artists Professional League (AAPL), the State
Department's show, Advancing American Art, represented
yet another victory for the modernists, who had already
scored a number of triumphs in American museums and
galleries. And this latest triumph, securing the govern-
ment's imprimatur, in effect, was especially threatening to
the academic artists. To groups like the AAPL (which
could at least understand the regionalist/realist aesthetic
of New Deal art, if not its welfare element and political
ferment) and the National Sculpture Society (which enjoyed
a near monopoly of official art sanctioned by the Commis-
sion of Fine Arts), the thoroughly modern State Department
collection must have seemed like a cultural coup d'état.
"Our associated groups," AAPL vice-president Albert Reid
declared in response to Advancing American Art, "question

the cultural value of any exhibit which is so strongly marked with the radicalism of the new trends in European art. This is not indigenous to our soil" (Art Digest 1946: 32).

Conservatives in Congress, meanwhile, were concerned with a different brand of radicalism—those leftover New Deal sentiments that were especially susceptible to the virus of Communism—and they quickly took up the Academy's cause. Secretary of State George Marshall was caught off guard by the sudden brouhaha, and Assistant Secretary William Benton proved to be no match for House Appropriations Committee Chairman Karl Stefan (R–NB). Armed with "many hundreds of letters" generated by the AAPL attack and ridiculing the State Department for its folly, Stefan forced the closing of the exhibition at its two initial stops, in Port-au-Prince, Haiti, and Prague, Czechoslovakia. A week after Stefan's committee issued its common-sense, populist recipe for cultural exchange ("we should try to impress the average individual rather than a certain segment of the art colony"), Rep. Fred Busbey (R–IL) got to the heart of the matter for postwar America (U.S. Congress, House 1947: 6–7). For Busbey and many of his colleagues in Congress, it wasn't the style of the art so much as the alleged politics of the artists that proved offensive. Using HUAC files to bolster his case, Busbey claimed to have uncovered a Communist conspiracy in the State Department's art show, offering a diatribe reminiscent of those that put the Federal Theater Project out of business eight years earlier, and providing a preview of the rhetoric that would become the trademark of the McCarthy years. "The records of more than 20 of the 45 artists are definitely New Deal in various shades of Communism," Busbey declared. "Some we found to be definitely connected with revolutionary organizations" (Congressional Record 1947: 5221).

Not surprisingly, Davidson was relieved of his duties, Benton returned to the private sector, and the State Department quickly jettisoned its controversial art program. Following a final showing at the Whitney Museum, the paintings were sold off by the War Assets Administration, a fire sale that brought ten cents on the dollar. Despite this unfortunate episode, the efficacy of art in international relations was not lost on others in the federal government. The CIA subsequently sponsored a number of covert federal arts activities, channeling its funds through foundations and other private organizations (Braden 1967: 10). Like MOMA's quasi-official efforts, the

CIA's "undercover" art activities escaped the pressure, as Eva Cockcroft expressed it, "of unsubtle red-baiting and super-jingoism applied to official government agencies" (Cockcroft 1974: 40).

Nevertheless, while one version of the postwar communist menace—subversion from within—was used to drive the federal arts venture underground, another version—Soviet propaganda abroad—helped set up a new cultural enterprise. The U.S. International Information and Educational Exchange Program (Smith-Mundt Act of 1948) may have lacked the entrepreneurial flair of Rockefeller's CIAA or Davidson's experiment, but it at least provided a useful alternative to the anti-art harangues of Busbey and, later, Rep. George Dondero (R-MI). Moreover, the new cultural relations program provided a model for the domestic arts legislation that followed in the 1950s.

Rep. Sol Bloom (D-NY) made the first legislative attempts, in 1945 and 1946, to pull together the various strands of federal cultural policy after the war (the State Department's coordinating, "clearinghouse" role, the remnants of Rockefeller's more ambitious program, OWI's libraries and mass-media techniques) with a bill to create a permanent cultural relations and information program. Considering Congress's well-publicized opposition to the Voice of America and its impending attack on Advancing American Art, it is not surprising that Bloom's bills never got out of committee. In 1947, however, a similar measure with Republican sponsors, North Dakota's Rep. Karl Mundt and New Jersey's Sen. Alexander Smith (who wisely substituted the term "educational exchange" for "cultural relations") made much more progress. Although not without its enemies, the proposed consolidation of past information and cultural programs carried the House by a 272 to 97 vote in June 1947 by effectively standing Busbey's anti-art, anti-communist argument on its head. The enemy was not State Department subversion (a dubious cause, since General Marshall, appointed secretary in 1947, was now on hand to "clean house"), but rather Soviet slander abroad. The new information and exchange program, Rep. Mundt promised, would provide "an arm of the federal Government able and adequate to answer and refute slanderous falsehoods about us and to expose the fallacies and motives of vicious propaganda directed against us and our way of life" (Congressional Record 1948: 316).

The Smith-Mundt Act passed the Senate in 1948, creating the Office of International Information and the Office of Educational Exchange. Thus the two-pronged program attempted, not always successfully, to maintain a delicate balance between propaganda and culture, between nationalistic information tactics and longer-range, ostensibly multilateral, cultural relations (Ninkovich 1981). Given the political climate of the time, however, many in Congress and the State Department agreed with the Bureau of the Budget's penetrating analysis of the use of cultural material in foreign affairs. "Culture for culture's sake has no place in the United States Information and Educational Exchange Program," the bureau flatly stated. "The value of international cultural interchange is to win respect for the cultural achievements of our free society, when that respect is necessary to inspire cooperation with us in world affairs. In such a situation, cultural activities are an indispensable tool of propaganda" (Thomson and Laves 1963: 86). Certainly, in practice, cultural relations and foreign policy were often mixed, especially in Congress, where art and politics in the 1950s were frequently brought together, almost always with disastrous results.

When the lessons of the 1930s (WPA) and the 1940s (cultural diplomacy) were applied to the arts legislation of the 1950s, the results had campaign-slogan simplicity. "Hands off!" was the cry of those who recalled the direct government involvement in the arts of the New Deal era, and who were firmly opposed to another version of those wholly owned federal subsidiaries, the four WPA arts projects. "Show the world!" was the other demand, a recognition of the need to include a cultural thrust in the nation's ideological war with the Soviet Union. If not exactly logical corollaries, the two themes were not incompatible, either, and they surfaced repeatedly in the domestic arts legislation that began to appear in the 1950s.

It was Jacob Javits, a member of the House in 1949, who launched the new era of arts legislation. His initial proposal was modest, calling for a "constitutional convention" of arts representatives to be convened to discuss the possibilities for a national theater, opera, and ballet. Moreover, Javits was careful to distinguish his plan from the New Deal projects ("WPA schemes for unemployment relief") and he was prepared as well for conservative opposition to any federal encroachment in the arts. "I realize

full well," he assured his colleagues in the House, "the dangers of the paralyzing hand of Government control of the arts, of the use which can be made of them to control thought. . ." (Congressional Record 1949: 514).

The early 1950s saw a spate of similarly timid cultural legislative proposals—various plans for the presentation in Washington of the arts productions of land-grant colleges, for an assistant secretary of the interior for fine arts, for a national arts commission and a Washington performing arts center, for an American Academy of Music, Drama, and Ballet. Most ambitious, and hopelessly premature, was the American National Arts Act of Rep. Charles Howell (D-NJ), a 1953 omnibus measure embracing an arts commission and a capital arts center, fellowships to artists and grants to the states, and support for both "the preparation and preservation of professional and amateur fine arts productions and programs" (Larson 1983: 67-92).

All of these bills, implicitly if not explicitly, shared a disdain for the direct federal involvement in the arts of the WPA projects, and a preoccupation with America's image abroad. The latter concern was especially apparent. The aforementioned land-grant college art bill, for example, vowed "to contribute to a better understanding of our Nation throughout the world," while Howell's American National Arts Act promised to help destroy "the Communist myth that Americans are insensitive, materialistic barbarians." Howell's bill, moreover, anticipated by 20 years the linking of arts and humanities that eventually brought legislative success to the congressional arts advocates. ". . . It is the humanities," the bill pronounced, "more than science or statistics, which provides the real answers to communism." Others in Congress, including Sen. Herbert Lehman (D-NY), one of the leading spokesmen on behalf of cultural exchange, were equally aware of the propaganda value of the arts. "I believe that the fine arts . . . ," the senator declared in 1954, "provide one of the most effective ways of transmitting to the peoples of the world the true essence of democracy" (Congressional Record 1954: 5735). Similarly, Jacob Javits warned of the Soviet threat in this regard: "There is an enormous propaganda weapon which the Russians are using against us, with the most telling effect, all over the world. They are posing, and getting away with it, as the people of culture, as juxtaposed to us who are painted to the world as people who don't care for culture" (U.S. Congress, House 1954: 30).

Other reasons for a new federal arts program were put forth (the model of European state-supported culture, the need to strengthen American culture and to disseminate the arts, and the inherent economic problems of the arts), and there were as many arguments against government patronage, generally revolving around the themes of federal profligacy, state's rights, and the entrenched system of cultural laissez-faire. But the foreign affairs angle was the most popular, and it proved to be the most difficult for the conservative opponents of arts legislation to counter.

In any case, one of the proponents of federal arts support dared suggest the WPA projects as a model for a new program, and some, as Javits had in 1949, frankly disavowed the New Deal program. For example, a measure introduced by Rep. Howell in 1954, focusing on the arts commission plan, made its distaste for the WPA model quite explicit. The proposed arts commission would, among other functions, preserve, enhance, and develop the fine arts "in time of war, depression, or other national emergency, in order to prevent our cultural institutions from shrinking in importance or passing out of existence and to avoid the often deplorable standards exemplified by art projects of Federal agencies at such times in the past" (Larson 1983: 92). Not until the 1960s was the reputation of the WPA projects sufficiently rehabilitated that they could be cited for their positive spiritual effect on the nation, if not for their organizational principles; today, of course, the reputation of the projects has ascended to the realm of legend.

With congressional hearings conducted almost every year in the 1950s, arts legislation proposals continued to have a life of their own. The advisory council plan, which received President Eisenhower's state-of-the-union blessing in 1955, was particularly resilient, resurfacing yearly in its decade-long struggle to become law. Yet these measures were never far removed from the cultural relations effort that provided much of their philosophical urgency. And cultural exchange itself was never so free of controversy that it did not raise serious questions about the wisdom of any federal arts program. Although buoyed by Eisenhower's establishment of the United States Information Agency (USIA) in 1953, by his use of the President's Emergency Fund for cultural relations in 1954 and 1955, and by the passage of the International Cultural Exchange and Trade Fair Participation Act in 1956, America's cultural relations never completely managed to break out of

the mold established by the Advancing American Art fiasco. This was art with a purpose, after all; whether an exhibition or a jazz ensemble or a dance company, it was a "tool of propaganda" for use abroad, according to the Bureau of the Budget, and thus never far from becoming a political tool at home, too. "Art exchange is not yet officially viewed here as being intrinsically desirable or necessary," lamented Robert Breen, director of the interna tional touring company of Porgy and Bess, in 1956. "It is used, as it were, in 'combat,' as a tactical arm— fighting. culture with culture—a new but not-so-secret weapon for use in various, ever-changing 'target areas'" (Breen 1956: 1).

Moreover, every time the federal government stumbled in its handling of the arts, turning from propaganda abroad to politics at home, many in the private and public sectors alike wondered whether the American government could ever become involved in the arts in any substantive way without bringing embarrassment upon itself and upon the arts in the process. "It's like watching a gorilla trying to thread a needle," quipped painter Larry Rivers after a decade that witnessed more congressional hysteria (Dondero and Busbey again in 1952, 1953, and 1956), a full-scale investigation of allegedly subversive New Deal art (Anton Refregier's Rincon Annex murals in 1953), more canceled exhibitions (Sport in Art and 100 American Artists of the Twentieth Century, both organized by the American Federation of Arts for the USIA in 1955-56, along with a tour of the Symphony of the Air), another HUAC investigation (of the American National Exhibition in Moscow, 1959), and any number of arts bills defeated in Congress. As late as 1963, August Heckscher, President Kennedy's special consultant on the arts, only slightly overstated the case when he observed that "the majority in political life still tend to talk of culture as if they were telling an off-color story" (New York Times 1963: 19).

Still, the fact that Kennedy had a special consultant on the arts indicates the progress that had been made in the long campaign for a new domestic arts program. That the mood in Congress had begun to shift became apparent in 1958, when two pieces of domestic cultural legislation (providing for a site for the National Collection of Fine Arts and a National Portrait Gallery and authorizing a new national cultural center) passed both houses with comparative ease. The use of art in cultural diplomacy took

an upturn during this period, too, with two controversial exhibitions (at the Brussels World's Fair in 1958 and in Moscow the following year) that at least managed to survive the usual congressional outrage. Eisenhower is perhaps best remembered in the latter episode for his "I'm not sure what art is but I know what I like" homily, but the essence of his response ("I'm not going to be the censor") did much to deflate Rep. Francis Walter's (D-PA) HUAC inquisition. (Thirty-four of the 67 artists in the Moscow exhibition, according to Walter, had Communist ties, including 22 with "significant records of affiliation with the Communist movement in this country" [Congressional Record 1959: 9756].) Congress still wasn't sure what art was, perhaps, but it was at least growing accustomed to the State Department-USIA cultural exchange projects, and to the persistence of a handful of congressmen who annually introduced proposals for a domestic arts program.

Philosophically, too, the arts movement waxed stronger, outgrowing the stark imagery of the early 1950s (the need to combat communism versus the threat of federal control, the vision of a cultural democracy versus the specter of federal extravagance) to embrace loftier concepts as the new decade opened. Eisenhower's Commission on National Goals included the arts within its broad sweep ("it is evident that cultural attainments have not kept pace with improvements in other fields," the 1960 report warned) (President's Commission, 1960: 127), and President-elect Kennedy promised a "New Frontier in the Arts" (". . . we stand, I believe, on the verge of a period of sustained cultural brilliance") (Musical America 1960: 8). The point is not that such rhetoric actually meant very much, but that it was uttered at all, and that it was uttered so often. "Some Congressmen," Sen. Javits observed in 1959, "say that only four years ago they could not have suggested an arts program without being laughed at back home. Practically nobody is laughing any more" (Javits 1959: 28).

They certainly weren't laughing during the Kennedy years, when the arts became a measure of the "maturity" of American civilization, of the progress the young nation had made in its "pursuit of happiness." No longer a political liability, the arts enjoyed a new status in Washington. Artists and intellectuals were regularly invited to the Kennedy White House; Secretary of Labor Arthur

Goldberg, with much fanfare, settled the Metropolitan Opera strike in 1961 (with a ruling that counseled government arts support, as did August Heckscher's 1963 report to the president, The Arts and the National Government); and Kennedy issued an executive order to create the long-delayed advisory arts council (whose members were to have been announced upon the president's return from Dallas) (Larson 1983: 151-80).

Ironically, the humanities, rather than the arts, were most important to the passage of cultural legislation in 1965. A late entrant into the lengthy federal cultural debates, the humanities forces, boasting a prestigious Commission on the Humanities and all manner of impressive academic affiliations, had a much greater impact in convincing Congress of the need for a new arts and humanities program than the arts advocates alone could ever have managed (Commission on the Humanities 1964). "When this legislation came to the home stretch in Congress," veteran arts lobbyist Harold Weston of the National Council on the Arts and Government observed, "the arts were hanging onto the coattails of the fast-running sponsors of the humanities" (Weston 1965). And those sponsors were legion, as the arts and humanities bill emerged as the single most popular legislative item in Congress in 1965.

The National Foundation on the Arts and Humanities Act, establishing separate Arts and Humanities Endowments guided by their respective advisory councils, embraced the various aspects of arts advocacy that had developed over the previous two decades. Distinct from the New Deal's federal arts franchise, the new program was to supplement existing "local, state, regional, and private" cultural efforts, to look beyond "science and technology" to the "other great branches of man's scholarly and cultural activity," to foster "wisdom and vision" in the citizenry, and, as always, to garner "worldwide respect" (U.S., Statutes at Large 1965: 845). If this inevitable international thrust proved to be the most persuasive argument, nearly as many in Congress were struck by the image of post-Sputnik America--itself one of the products of the cultural relations debates--as a strictly materialistic society, one whose technological feats far outstripped its cultural achievements. Thus the new arts and humanities program, as Rep. Frank Horton (R-NY) described it, was designed specifically to address this issue: "As we continue to clear new hurdles in science and technology and as we

race toward the moon, the schism between science and the humanities deepens. The Nation has reached a stage of maturity in which the arts and the humanities demand equal status with science and a redressing of the imbalance of the two cultures is required now" (Congressional Record 1965: 36–37).

In Johnson's Great Society, as on Kennedy's New Frontier before it, the old arguments against a federal arts program, the expense, state's rights, the threat of federal control, and the general satisfaction with the status quo, had lost much of their strength. So, too, had the Communist bugbear passed out of favor on the national scene, however much the tension betwen the United States and the Soviet Union remained. Equally important, the arguments in support of a new federal cultural program, for years a linsey-woolsey outfit of cold war rhetoric, impressionistic accounts of the status of American culture, visions of cultural democracy, and pioneering (i.e., rough-hewn) studies of the economics of the arts, were now draped in the pious robes of statesmanship. "You and I have an opportunity that is not unlike that of the men and women who first settled these New England states," intoned President Johnson in a Brown University address in support of the arts and humanities legislation. "We have the opportunity to plant the seed corn of a new American greatness and to harvest its yield in every section of this great land" (Public Papers of the President 1965: 1141).

In short, one should not underestimate the ceremonial, symbolic value of the cultural legislation of 1964 (the National Arts and Cultural Development Act, establishing the National Council on the Arts) and 1965 (creating the Arts and Humanities Endowments). In a sense, at least for the majority in Congress who now supported the bills after years of indifference, these acts were every bit as utilitarian as the WPA projects themselves. The similarity ends there, however; the 1965 program, unlike its 1935 forebear, was more concerned with spiritual than physical and economic relief; certainly the resulting administrative structure, an arms-length support system that neither produced art itself nor directly hired artists, was a different breed entirely.

But if the WPA model had long been discarded, the national self-doubt that fueled cultural relations efforts during the 1940s, and the cold war pressures that animated cultural debates in the 1950s, were both in force in 1965.

". . . The world leadership which has come to the United States," the arts and humanities act declared, "cannot rest solely upon superior power, wealth, and technology, but must be solidly founded upon worldwide respect and admiration for the Nation's high qualities as a leader in the realm of ideas and of the spirit. . ." (U.S., Statutes at Large 1965: 845). Here, then, was an answer, an appropriately civilized response, to the "frank skepticism" abroad that had concerned Sumner Welles and the State Department in 1935, and to the "Russian lies" that troubled Rep. Frank Thomson, and so many other Americans, in the 1950s.

BIBLIOGRAPHY

Art Digest. 1946. 21 (November 15):32.

Braden, Thomas. 1967. "I'm Glad the CIA is 'Immoral.'" Saturday Evening Post, May 20, 10.

Breen, Robert. 1956. "Cultural Envoys: Some Thoughts on Our Arts-Exchange Plan." New York Times, August 5, Sec. 2, 1.

Cherrington, Ben. 1939. "The Role of Education in International Cultural Relations." U.S. Department of State Bulletin 1 (July 8):19-24.

Cockcroft, Eva. 1974. "Abstract Expressionism, Weapon of the Cold War." Artforum 12 (June):39-41.

Commission on the Humanities. 1964. Report. New York: American Council of Learned Societies.

Congressional Record. 1947-65. Washington, D.C.

Javits, Jacob K. 1959. "Plan to Aid Our Lagging Culture." New York Times Magazine, April 5, 21.

Larson, Gary O. 1983. The Reluctant Patron: The United States Government and the Arts, 1943-1965. Philadelphia: The University of Pennsylvania Press.

Leland, Waldo. 1943. International Cultural Relations: Historical Considerations and Present Problems. Denver, Colo.: Social Science Foundation, University of Denver.

Mangione, Jerre. 1972. The Dream and the Deal: The Federal Writers' Project, 1935-1943. Boston: Little, Brown and Co.

Mathews, Jane De Hart. 1976. "Art and Politics in Cold War America." American Historical Review 81 (October): 762-87.

McMurry, Ruth, and Muna Lee. 1947. The Cultural Approach: Another Way in International Relations. Chapel Hill: The University of North Carolina Press.

Musical America. 1960. "Nixon, Kennedy View Music and the Arts." 80 (October):8.

New York Times. 1963. May 24, 19.

Ninkovich, Frank. 1981. The Diplomacy of Ideas: U.S. Foreign Policy and Cultural Relations. Cambridge: Oxford University Press.

President's Commission on National Goals. 1960. Goals for Americans. Englewood Cliffs, N.J.: Prentice-Hall.

Public Papers of the President, Lyndon B. Johnson, 1963-64, vol. 2. 1965. Washington, D.C.: U.S. Government Printing Office.

Thomson, Charles. 1948. Overseas Information Service of the U.S. Government. Washington, D.C.: Brookings Institution.

Thomson, Charles, and Walter Laves. 1963. Cultural Relations and United States Foreign Policy. Bloomington: Indiana University Press.

U.S. Congress, House. 1947. Hearings before the Subcommittee of the Committee on Appropriations on the Department of State Appropriations Bill for 1948. 80th Cong., 1st Sess.

_____. 1954. Federal Grants to Fine Arts Programs and Projects. Hearings before a Special Subcommittee of the Committee on Education and Labor. 83rd Cong., 2d Sess.

U.S. Congress, House and Senate. 1965. National Arts and Humanities Foundations. Joint Hearings before the Special Subcommittee on Arts and Humanities of the Committee on Labor and Public Welfare, U.S. Senate, and the Special Subcommittee on Labor of the Committee on Education and Labor, House, on Bills to Establish National Foundations on the Arts and Humanities. 89th Cong., 1st Sess.

U.S. Congress, Senate. 1938. Bureau of Fine Arts. Hearings before a Subcommittee on Education and Labor on S. 3296, a Bill for a Permanent Bureau of Fine Arts. 75th Cong., 3d Sess.

_____. 1958. Public Buildings. Hearings before a Subcommittee on Public Works on S. 1985, a Bill to Authorize the Preparation of Plans and Specifications for the Construction of a National Air Museum, S. 3335, a Bill to Provide for a National Capital Center for the Performing Arts, and S. 3560, a Bill to Authorize the Construction of a Courthouse and Federal Office Building in Memphis, Tenn. 85th Cong., 2d Sess.

U.S. Department of State. 1939. Inter-American Relations. Washington, D.C.: U.S. Government Printing Office.

U.S. Department of State Bulletin 1. 1939. 303-04, 339-41, 361-66, 408-15, 489-93, 614-25.

U.S. Office of Inter-American Affairs. 1947. History of the Office of the Coordinator of Inter-American Affairs. Washington, D.C.: U.S. Government Printing Office.

U.S. Office of the Coordinator of Inter-American Affairs. 1942. Report on the Exposicion de Pintura Contemporanea Norteamericana. Washington, D.C.: U.S. Government Printing Office.

U.S., Statutes at Large, vol. 79. 1965. 845-55.

Welles, Sumner. 1935. The Roosevelt Administration and Its Dealings with the Western Hemisphere. Washington, D.C.: U.S. Government Printing Office.

_____. 1939. "The Policy and Program of the United States Government in International Cultural Relations; Remarks by Under-Secretary Welles." U.S. Department of State Bulletin 1 (November 11):491-93.

Weston, Harold. 1965. Harold Weston Papers, interview by Alvin Reiss, October 20. Washington, D.C.: Archives of American Art, Smithsonian Institution.

14

THE NEA AS PUBLIC
PATRON OF THE ARTS

Kevin V. Mulcahy

Historically, federal government support for the arts has been very limited. However, such public patronage has never been completely absent. The Smithsonian Institution, which was chartered by Congress in 1846 as a non-profit corporation, has grown from the "nation's attic" to a vast holding company of museums and special collections. Similarly, states and localities typically administer or support a variety of art, historical, and natural science museums as well as commemorative sites and "cultural parks." National copyright laws have protected individual artistic creators and creations. The second- and third-class postal rates subsidize publishing and fund-raising activities of arts organizations. More recently, the U.S. government has sponsored international cultural exchange programs; and most significantly, provided tax relief for individuals and corporations making donations to cultural organizations. Localities typically exempt these organizations from paying property taxes and may assist in the maintenance of their buildings. A recent Twentieth Century Fund report argues that two-thirds of public support for the arts comes through such tax exemptions (Feld et al. 1983).

Significant as this support for the arts has been, its nature was largely indirect, episodic, and marginal. No public arts agency existed on the national level comparable to the British Arts Council, let alone to the state-run cultural institutions found in most European nations. In short, in the United States before 1965, "there was no

large-scale and continuous tradition of direct subsidy by
the government, such as was common in Europe" (Cummings
1982: 142).

As public culture in the United States has developed
since the 1960s, the political legacy of the WPA experiment
of the 1930s has remained uppermost in the minds of policy-
makers and the interested public.[1] Indeed, the New Deal
programs that supported artists and the arts almost suc-
ceeded in preventing any future government support for
the arts. The Treasury Department's Section on Fine Arts,
which commissioned artwork for public buildings, and the
even more controversial arts projects of the Works Progress
Administration, frequently embroiled the federal government
in public battles over the aesthetic and political content
of the art produced. In fact, as Gary Larson has dis-
cussed in the preceding chapter, the legacy of the New
Deal's arts projects was decidedly mixed. In the long
run, the formal innovativeness and thematic boldness of
much of what was produced has gained almost legendary
status. In the next two decades, however, New Deal art
was the subject of almost ritual denunciations of the evils
of government subsidies in general, and of public culture
in particular. Again, as Larson points out, even propo-
nents of public support for the arts dared not suggest the
WPA projects as the model for a new federal program; in-
deed, they often explicitly disavowed the New Deal prece-
dent.

The political controversies that resulted from the
New Deal projects served to point up the dangers as well
as the benefits for the arts that might come with an offi-
cial embrace. The principle was established (correctly or
not) that any cultural programs were, in future, to be
politically inoffensive and artistically safe. Public arts
agencies would be very sensitive to any charges of ideo-
logical bias and would seek in both their organizational
structures and programmatic policies to prevent its occur-
rence. As America's preeminent public patron, the National
Endowment for the Arts (NEA) has been particularly aware
of these precedents and problems, and has sought to de-
velop a model of public patronage that would avoid previ-
ous pitfalls. In the discussion of the NEA's programs and
policies that follows, certain major themes will recur that
reflect this ongoing concern with political acceptability
and popular approval.

First, although established as the foremost national public arts agency, the NEA was nonetheless meant to play a highly circumscribed role. It was not to function as a "ministry of culture," that is, as a cabinet-level department that would be responsible for comprehensive cultural policymaking that would administer the nation's artistic activities.

Second, the limited scope of public commitment to the arts was underscored by the low level of public funding that would be made available. Not only would appropriations for the NEA (and related arts agencies) remain small; but the NEA was not to provide subsidies that would underwrite the general operating costs of cultural institutions.

Third, the fate of the New Deal's arts projects provided ample evidence of what could happen when the government assumed responsibility for artistic production. Consequently, the NEA would take no lead in identifying and promoting cultural developments. While public support would be concerned with greater access to and awareness of the arts, the government was not to become identified with a particular aesthetic judgment.

Fourth, the NEA's record as a public arts agency does indeed testify to a conscious political strategy of avoiding extremes in both funding and programming. The guiding decision-making principle has been a commitment to "cultural pluralism," that is, a broad definition of the arts to include as many diverse cultures and art forms as possible and as wide a distribution of public funds as possible.

Overall, the Arts Endowment has sought to build a broad base of public support, from within the arts world and without, while also broadening the nation's cultural base in both its variety and availability. The very success of the NEA's strategy, however, has been the source of much of the criticism of public culture and public arts agencies. Despite its determination to avoid "politicization," the NEA has reluctantly discovered that politics is both necessary and inevitable in the formulation and administration of public arts policy.

THE NEA AS A PUBLIC ARTS AGENCY

Public Law 89-209 created the National Foundation for the Arts and Humanities in 1965; this enabling legislation defined the arts broadly as including but not limited to:

> . . . music (instrumental and vocal),
> dance, drama, folk arts, creative writing,
> architecture and allied fields, painting,
> sculpture, photography, graphic and craft
> arts, industrial design, costume and fashion
> design, motion pictures, television, radio,
> tape and song recording, the arts related
> to the presentation, performance, execution,
> and exhibition of such major art forms,
> and the study and application of the arts
> to human environment.[2]

Unlike the New Deal projects, which were "emergency re-
lief," this legislation represented a permanent commitment
by the federal government to support the arts. As Larson
observes in the conclusion of the preceding chapter, the
1965 program, unlike its New Deal forebearer, "was more
concerned with spiritual than physical and economic re-
lief." However, Larson also observes what will become
even clearer in this discussion: both the 1965 and the
1935 programs had strongly utilitarian foundations for
their creation and in their administration.

As an administrative entity, the NEA's functions
were to be limited and indirect ("an arms-length support
system"). The federal government would not stand accused
of policies that smacked of a "state-imposed culture that
had little to do with America's laissez-faire tradition"
(Larson 1983: 79-80). Rather than providing direct subsi-
dies for operating arts, or employing artists, or producing
cultural products, the Arts Endowment was to be a grant-
making agency providing discretionary funding on a com-
petitive basis to partially underwrite the costs of cultural
policy making. While the NEA is not the sole federal pro-
gram concerned with the arts, no other public arts agency
enjoys such prestige in the arts world or exercises com-
parable influence on cultural institutions.[3] While not a
Cabinet department, the NEA as an independent agency in
the Executive branch reports directly to the president and
enjoys considerable political prestige. Its chief adminis-
trative officer is a chairman appointed by the president
for a four-year term upon Senate confirmation. The chair-
man is responsible to a 26-member National Council on the
Arts which is appointed by the president, after Senate
confirmation, to staggered, six-year terms. The chairman
may appoint such subordinate officials (for example, deputy

chairmen) as is deemed necessary; administrative arrangements have varied with different incumbents. On the other hand, the basic building blocks of the NEA's administrative structure have remained the various program areas that embody the legislative intent of PL 89-209 (see Figure 14.1). Each program comprises staff and advisory panelists who largely determine the agency's grant-making decisions and shape its cultural programming.

By statutory provision all grant-making decisions are made by the chairman; while this means that the NEA chairman may approve or disapprove grant applications at will, this has occurred only rarely.[4] Each of the NEA's program areas advises the National Council and the chairman about grants to be awarded on the basis of recommendations provided by specialized panels. (As will be discussed more fully in the section on the NEA's budget, each of these programs [for example, music museums, opera, theatre, expansion arts, artists in education] represents a major interest in the cultural community.) The panels are, in many ways, the bedrock of the Arts Endowment's administrative organization. Panel members are appointed by the NEA chairman for terms of up to four years on the recommendation of the NEA staff, arts lobbyists, cultural administrators, Council members, elected officials, and other concerned parties from the cultural community. On one level these advisory groups serve to provide expert, presumably disinterested evaluations of the grant proposals submitted to the program areas into which the Endowment is organized. On another level, the panels serve to help prevent "cultural porkbarreling" and to keep "politics" out of the grant-making process. On a more basic level, panels serve as the principal means for insulating the NEA from charges of political influence, and for deflecting adverse criticism about the wisdom of having made a particular grant.

As typifies any group of consultants, the panels (like the National Council) cannot be convened more than five or six times a year and for periods of only a few days. Although proposals are distributed to panelists in advance, the average panel has about 11 days a year in which it must evaluate perhaps 1,000 grant applications. The bases for making a grant are, of course, the artistic value of the proposed project and its contribution to the community's cultural development. Panel members also serve as individuals and not as representatives of their

FIGURE 14.1

Administrative Organization of the National Endowment for the Arts

Source: Adapted from the NEA Staff Directory, October 1983 (updated September 1985).

institutions. However, it is not always easy to ascertain
when an institutional interest may influence decision mak-
ing or when, like any group of successful professionals,
NEA panelists make decisions on the basis of predetermined
assumptions about what constitutes a "good" project. These
professional norms may serve to create a bias in favor of
proposals from applicants whose work is familiar to the
panel members (Mooney 1980: 330-74). The bias here is
not simply personal or organizational favoritism; rather it
is due to the common and often unarticulated belief that,
if an applicant's work is unknown, it is not worth knowing.

As a result, because of a lack of time, divided at-
tention, and incomplete information, panels cannot provide
fully independent evaluations. Panels depend on the En-
dowment staff (as does the National Council) for structure,
direction, and guidance. Inevitably, the values of En-
dowment staff members, especially those of the program
directors who are largely recruited from major cultural
institutions, will strongly influence granting decisions.[5]
But it does not seem warranted to suggest that such an
administrative arrangement unfairly skews the decision-
making process any more than might occur in other grant-
making agencies such as the National Science Foundation.
Policy consensus is as strong in the cultural sphere as it
is in other policy areas (although policy views are cer-
tainly never monolithic anywhere); and it should not seem
surprising that panelists and staff members share common
values. Rather, the primary influence that staff members
exercise on panelists is to push them along a clearly de-
marcated bureaucratic path.

In sum, panels serve four important functions that
reflect the current goals and past history of public cul-
ture in the United States. First, the selection of panel-
ists allows for the representation of relevant and diverse
interests from the arts' world in the process of cultural
policy making. Second, the panel system is an important
symbolic assurance that government support for the arts is
not to be "politics as usual," but will allow objective con-
siderations to determine grant decisions. Third, by ac-
tively involving artists and arts administrators in the
grant-making process, the NEA tries to secure a large
measure of legitimation for its decisions and also empha-
sizes the "partnership" aspect of its funding arrangements.
Fourth, the panel system helps to protect the Arts Endow-
ment from political interference and censorship. It allows

the chairman to justify his opposition to such intrusions as deference to the considered judgment of a group of experts rather than an assertion of his own opinion or that of the NEA staff.

Given the frequent criticism of the New Deal arts projects as variously unrepresentative of community preferences, ideologically motivated, politically unaccountable, and in need of censorship, the administrative procedures of the Arts Endowment represent a good example of successful bureaucratic politics. Of course, how one judges such political tactics depends ultimately on one's assessment of the policy outcomes. Nonetheless, it must be emphasized that the administrative organization of the National Endowment for the Arts is not simply a bureaucratic convenience. It is a reflection of political realities, past and present. The history of cultural politics in the United States had strongly suggested the advisability of a grant-making agency with limited authority and only indirect responsibility for specific art products as compared to a comprehensive cultural department with broad authority and direct responsibility for artistic production. This may not have been the most "rational" administrative arrangement, but it was the most likely to succeed in the policy-making process.

It can be noted here only in passing that one of the Arts Endowment's greatest political successes, and one providing strong testimony to the success of its administrative arrangements, is the role that it has played in the creation of state arts agencies. Eighteen state arts councils predated the NEA, but with the singular exception of the premier New York State Arts Council, these public arts agencies were not particularly active. Following the establishment of the NEA, the number of arts councils grew quickly to include all the states and territories (a total of 56). The impetus for this spectacular growth was the provisions of PL 89-209 that required the existence of a state arts agency as a condition for receipt of federal funds and provided a once-only basic grant of $50,000 to establish such an agency if none existed. Consequently, all states have now become official patrons of the arts.

Most states administer public culture according to the following model: an independent agency with a small staff; a council or commission with an average of 15 members appointed by the governor to staggered terms to formulate policy; and advisory panels to review grant applica-

tions and recommend awards (Svenson 1980: 36–37; Svenson 1982: 200). Decisions about awarding grants are typically made by the state arts councils, and most states provide for representation of professionals from the visual, literary, and performing arts on their arts councils (National Conference of State Legislatures 1981: 41–42). While most states distribute funds following an administrative model that is similar to that of the NEA, 20 states have line–item appropriations for one or more of their cultural institutions. A line item in the state budget is certainly welcomed by any cultural institution as a more stable and predictable source of financial support than that provided by the grants program of the state arts agency. However, these direct appropriations are often quite controversial. For many arts administrators, line–items violate the council and panel review system that is designed to insure that the allocation of arts funds be based on cultural need or value and be free from political pressure. Allegations of "playing politics" with public culture can be particularly intense if an art organization's line–item appropriation constitutes a disproportionate share of the arts budget, or if a line–item has been sought to override a decision by the state arts council.

From its inception, the NEA envisioned active participation by the states in the grant–making process. Indeed, not less than 20 percent of the Arts Endowment's budget must be distributed to the states, with no state (or territory) receiving less than $200,000. These funds are then distributed by the state arts agency as the "federally mandated conduit" (U.S. Congress, House Committee on Government Operations 1983: 14–15). Total spending by the states in 1983 amounted to $125,732,153, with an average appropriation of $2.3 million. Forty-three of the 56 states and territories appropriate more funds for the arts than they receive from the NEA. Given the absence of a tradition of arts administration in the states, the NEA has been a catalyst and model for policies, programs, and administrative organization. In essence, the state arts agencies function as "little NEAs" in their close association with the national arts agency and its cultural goals. Moreover, the state arts agencies constitute a constituency base for the NEA, articulating support for its policies while also serving as institutionalized advocates for continued public funding for the arts.

THE ARTS BUDGET

The administration of the New Deal arts projects involved the government in a variety of allocational, supervisory, employment quota, and subject matter conflicts which imparted a negative connotation to federal support for the arts. Given the government's role as direct patron of the relief artist, this may have been inevitable, but it nonetheless served to involve these projects in debilitating political controversies. By contrast, the Arts Endowment operates on the principle of indirect sponsorship through matching grants (up to 50 percent of the cost) for special projects to be undertaken by established cultural institutions and state and local arts councils. Perhaps more importantly, the NEA keeps its distance by not ordinarily subsidizing the operating costs of cultural institutions, nor directly commissioning works of art.

Rather, the NEA has chosen to insulate itself by working through intermediaries (public and private) and avoiding a permanent commitment to particular arts organizations (or artistic schools). Eschewing direct patronage has not completely spared the NEA from being tarred by the brush strokes of controversial projects. By sharing responsibility with cultural institutions in the private sector and relying on the panel system for grant making, the NEA has largely avoided the political criticism that undermined the effectiveness of the New Deal arts programs.

By the end of Richard Nixon's tenure in office, the basic contours of the cultural budget had been established as the Arts Endowment successfully passed through its "initial survival threshold." A sure sign of having navigated this passage is the allocation of enough resources so that an agency "can rapidly expand to meet the needs its members have long been advocating" (Downs 1967: 9). Table 14.1 shows the NEA's appropriations (and rates of yearly change) for the decade starting with the end of the Nixon administration to the mid-point of Ronald Reagan's (1974-1984). In this decade, the Endowment reached an appropriations plateau of over $100 million, and went from no growth to spectacular growth. Over the past decade, the Arts Endowment has enjoyed a regular, steady upward growth in appropriations that has only recently slowed in the face of strong (yet largely unsuccessful) efforts by the Reagan administration to impose sharp (and disproportionately high) cuts.

TABLE 14.1

Budget Growth of the National Endowment for the Arts, 1974-84

Year	Appropriations (in millions of dollars)	Change (%)
1974	64	--
1975	80	20
1976	88	9
1977	100	12
1978	124	19
1979	149	17
1980	154	3
1981	158	2
1982	143	-10
1983	144	1
1984	162	13

Source: National Endowment for the Arts.

As noted earlier, the Arts Endowment is organized administratively according to its major programmatic activities. Table 14.2 shows the allocation of the 1981 NEA budget (its last "normal" budgetary year in the outgoing Carter administration) among these programs by amount and as a percentage of total program funds. These budget figures illustrate some major characteristics of the NEA as a public agency. Clearly there is a strong emphasis on support for traditional art forms and major cultural institutions. Almost three-quarters of the 1981 budget was awarded to museums, music, theatre, visual, and media arts. Nonetheless, less established and less elite programs (such as folk arts) and those that represent explicit "outreach" efforts (such as artists-in-schools) account for almost 25 percent of the budget. (The commonality in these programs is their orientation to developing support for, and an awareness of, the arts.) An additional, but minuscule percentage of NEA funding is allocated for ancillary services (such as research and evaluation). Perhaps as evidence of its nonpartisan appeal (and therefore its political success), it is important to recognize that

TABLE 14.2

Comparison of NEA Spending by Clusters of Programs, Fiscal
Year 1981

Program	Budget (in millions of dollars)	Share (%)
Traditional Arts		
Dance	9.0	8.4
Museums	13.0	12.1
Music	16.2	15.1
Opera/Musical Theater	6.2	5.8
Theater	10.7	9.9
Literature	4.8	4.5
Visual Arts	7.4	6.9
Media Arts[a]	12.4	11.6
Cluster Total	79.7	73.3
Outreach Activities		
Education	5.0	4.7
Design	5.2	4.9
Expansion Arts	8.6	8.0
Folk Arts	3.0	2.8
Special Projects	5.7	5.3
Special Constituencies	0.4	0.4
Cluster Total	27.9	26.1
Ancillary Services		
Research	1.2	1.1
Evaluation	0.3	0.3
Partnership Coordination	0.6	0.6
International Fellows	0.4	0.4
Cluster Total	2.5	2.4

Total regular program funds: $110.1

These figures exclude the 20 percent of appropriations
mandated by Congress to go to the states as well as adminis-
trative costs. Challenge grants, most of which were awarded
to major art institutions, are also excluded. Total percent-
ages add up to 100 percent because of rounding.

[a]A significant segment of this program spending is used
to support the filming and broadcast of the traditional arts
such as Dance in America and Live from Lincoln Center.

Source: National Endowment for the Arts.

this pattern of distribution among programs has stayed almost the same over the past decade, regardless of changes in party or administrative personnel.

Given this record of bipartisan support, the budget cuts recommended by the Office of Management and Budget in 1981 were highly unusual. However, these cuts were also a healthy shock to an overly complacent cultural community that had come to expect steady increases in the cultural budget. They also demonstrated the political and ideological considerations at work in the Reagan administration. In 1981, the Office of Management and Budget (OMB) proposed cutting the Arts Endowment's appropriations in half, from $158 million to $88 million. In assessing the probable reaction to the drastic cuts that it proposed, OMB officials forecasted (correctly) that there would be strong opposition from a vocal and well-connected constituency

> . . . ranging from university presidents
> to museum directors to individual artists
> and scholars. In addition, most artistic
> and cultural institutions maintain strong
> ties to business and corporations through
> honorary appointments on boards of direc-
> tors (Democratic Study Group 1981: 35).

Interestingly, NEA officials emphasized "dollars and sense" consequences, instead of arguing against the cuts in the arts budget on normative or aesthetic grounds. For example, Chairman Livingston Biddle argued that the Arts Endowment had been a catalyst for the growth in corporate support of the arts from $22 million in 1966 to more than $435 million today.

But the Arts Endowment was not to rely on rhetorical argument alone; it also engaged in some budgetary politics of its own by announcing program reductions for a "worst case" 50 percent budget cut. Artists-in-Education, Challenge Grants, and Media Arts were targeted for the greatest reductions. Strategically, these programs were unlikely to undergo such cuts because they enjoyed particularly strong congressional support, were politically attractive as means for drawing in private funds, or enjoyed nationwide audience support. Additionally, certain minor programs were to be sacrificed, and what remained was to be cut across the board.

This "worst case" budget was clearly a stratagem to comply with the rules of the budgetary game. The NEA would implement OMB's mandate but in such a way that Congress would reinstate the cuts. In fact, this occurred in the reconciliation stage when the NEA budget was set at $143 million, a reduction of 10 percent rather than OMB's recommended 50 percent. In sum, the cultural community and its congressional allies had managed to fend off a major offensive in the battle for the 1982 budget and, while accepting losses, had succeeded in keeping the NEA's programmatic structure intact. By 1984 the NEA succeeded in raising its appropriations to a higher level of funding (albeit uncorrected for inflation) than at the end of the Carter administration.

POLITICS AND PUBLIC CULTURE

The reputation of the National Endowment for the Arts has benefited in its administrative history from some particularly astute political leadership. The NEA chairman sets the tone for the agency and is widely viewed as the official spokesman for the cultural community in national policy making. Despite the NEA's minuscule budget (especially when compared to overall federal government spending), the Endowment chairman has strong symbolic powers and represents a vocal constituency. While the demonstration of intense conflict over so small an agency may seem incomprehensible, NEA bureaucratic politics has hardly been the civilized affair that one might expect of a public arts agency. Indeed, President Carter was said to have quipped that he was devoting more time to the appointment of an NEA chairman than he was to the Strategic Arms Limitation talks.

The power of the chairman, and the role of the NEA in cultural policy making, was shaped largely by Nancy Hanks, who held the position from 1969 to 1977 during the presidencies of Nixon and Ford. During the tenure of her predecessor, Roger Stevens (1965–69), the NEA budget stayed at about $8 million. During the Hanks chairmanship, the Arts Endowment's budget grew from $8 million to over $82 million, a tenfold increase. She also mustered support for the arts from the culturally unsympathetic Nixon White House through her friendship with presidential assistants, Leonard Garment and Frank Shakespeare. As

someone with a background in Republican politics (among other things as an arts consultant to Nelson Rockefeller), she was able to insure that an agency seemingly associated with Democratic party principles would be acceptable to the new administration. Most important, Nancy Hanks forged a strong political constituency in support of the Arts Endowment that included well-placed congressional allies and a well-organized network of grass-roots supporters. As has been evidenced during the Reagan administration, this network could be orchestrated to give voice when NEA programs were challenged and to provide evidence of strong local appeal. Above all, the Hanks era saw the Arts Endowment achieve national visibility and the principle of government support for the arts recognized as an established public policy.

The first rumblings of a "kulturkampf" (or cultural fight) were heard during the Carter administration (Mulcahy 1980: 48-53). It was probably inevitable that once tax revenues came to be spent on the arts in a major way, political controversies would arise. As art went public, citizens and their elected representatives assumed the role of art critics. When the battleground was the gallery or auditorium and the combatants were bohemians and the bourgeoisie, the struggle could remain fairly localized. But when artistic spokesmen and cultural institutions squared off against elected officials and powerful interest groups for control of the arts budget, the consequences of cultural warfare loomed larger. Regardless of the issue, time, or place, few public policies attract unanimous political support; still, issues of arts policy seem to generate a disproportionate amount of dissension.

Indeed, whatever hopes the framers of the 1965 enabling legislation may have had for an agency exempt from political criticism, the Endowment's administrative mandate almost insured that problems would arise. For one thing, the very act of making federal grants required the establishment of guidelines about what standards of cultural judgment should prevail--for instance, artistic excellence or social utility. Another problem involved the primary purpose of Endowment funding: was it to make artistic production easier for the artist or to make art more available to the public? Yet another problem was what modes of artistic production would be supported. The arts were defined in the statutory provision cited earlier to include (among others) music, dance, drama,

creative writing, painting, design, and sculpture. But was this listing meant to include classical whistling, mime troupes, street theater, amateur poetry, and graffiti--let alone distributing six perfectly rounded stones about Hartford, Connecticut's town square, or a serenade for the whales migrating along the California coast?

A related question is the extent to which the Endowment should have a metropolitan emphasis, as distinct from a localistic one--that is, whether public funds should be used to subsidize companies with a national orientation or those of regional importance. The first Endowment chairman, Roger Stevens, was disposed to support the Metropolitan Museum; Nancy Hanks would have looked with equal favor on the Center for Contemporary Arts in New Orleans. Her successor, Livingston Biddle, would want to help both organizations; and Reagan's NEA chairman, Frank Hodsoll, would want to force a choice between the two. The metropolitan emphasis is popular with established cultural institutions and organized arts groups; the localistic emphasis is popular with grass-roots cultural groups and their congressional representatives. Neither emphasis, however, addresses the question of what cultural policy objectives are best for a national public arts agency. This would require specifying the relationship between the social and aesthetic goals of arts policy.

Certainly, much of the NEA's political and budgetary success in the 1970s can be attributed to Nancy Hanks's bureaucratic style, which avoided overly specific formulations of policy goals. Whereas Ronald Berman, her counterpart at the National Endowment for the Humanities, could be characterized as a bureaucratic "zealot" concerned with the correctness of a narrow policy viewpoint, Mrs. Hanks was an "advocate" concerned with broad goals and agency growth (Downs 1967: 88–89, 101–11). Berman was a forthright, outspoken, and often combative defender of what he saw as the classical values of the liberal arts. He regarded this defense as a sacred trust, and he remained loyal to that policy in the face of strong congressional criticism of the Humanities Endowment for its elitism and unrepresentativeness.

Nancy Hanks stood in sharp contrast to Ronald Berman: the cultural advocate as opposed to the cultural zealot. Rather than lecture congressmen on their moral obligation to save Western civilization with the taxpayers' money, she would remind them of the economic benefits that

the arts contributed to their districts. She also cultivated
a grass-roots cultural constituency that would lobby in
support of NEA programs. In classic advocacy fashion,
Mrs. Hanks built a public arts agency engaged in support-
ing a wide range of artistic activities and having broad
political support from the arts community and the culturally
conscious public. Her goal, as she put it, was to preside
over "a concerted effort by all elements of our society--
private and government alike--to assure that the arts can
make the contribution of which they are capable to the
quality of life for all Americans." Whatever one might
think of the wisdom of the policy, from a political stand-
point it was inspired. The Endowment went through a
period of dramatic growth in its size, appropriations,
political esteem, cultural impact, and public support. In-
deed, the last two chairmen of the Arts Endowment, Living-
ston Biddle and Frank Hodsoll, can be characterized as ad-
ministrative "conservers" seeking to retain the levels of
bureaucratic power, resources, and prestige achieved dur-
ing the Hanks era (Downs 1967: 96-101; Mankin 1983).

For all the Endowment's political success, however,
it has not been immune from criticism within the cultural
community that the arts have been "politicized" as a result
of NEA policies. Of course, the Arts Endowment, like any
other bureaucratic agency, has been involved with politics.
It should not be a cause for surprise to note that Frank
Hodsoll was an aide to Reagan's chief of staff, James
Baker; or that Livingston Biddle was the staff director of
Senator Pell's subcommittee that oversees the Arts Endow-
ment. Personalities aside, however, the major criticisms
of the NEA have concentrated on its programmatic goals.
Representatives of diverse ideological viewpoints have ex-
pressed disfavor with the current state of public culture.
The question of politicization has proven particularly frac-
tious where there have been charges that aesthetic excel-
lence was sacrificed to considerations of geographic dis-
persion, ethnic and racial representation, and artistic
diversity in grant making and panel composition.

In fact, the NEA has long advocated policies that
would increase public accessibility and promote cultural
responsiveness. The NEA has also emphasized the user or
consumer of the arts, and has sought to promote cultural
products that meet diverse constituent demands. This ap-
proach argues that, since the arts mean different things
to different people, public culture is well advised to sup-

port "populist" art forms (attractive to less developed cultural constituencies) as well as "elitist" fare (emphasizing the established fine arts). As a public arts agency operating without official aesthetic guidelines, this latitudinarian cultural policy can be defended in terms of cultural equity as well as political expediency.

THE RECORD OF PUBLIC CULTURE

Ironically, the most recent attacks on public culture have been less concerned with its content (populist or elitist) or its emphasis (local or metropolitan) than with the very fact of subsidy itself. In Policy Review (a publication of the Heritage Foundation), Ernest van den Haas spoke in opposition to cultural subsidies and argued that the arts must make some special claim to justify public support. Otherwise, they are on the same footing as whiskey and religion, which also give pleasure and employment to some but do so unsubsidized. An adequate argument for federal support of the arts must show, according to van den Haas, that they yield indivisible collective benefits. Only if the arts yield such benefits, and at a sufficient magnitude, is the government justified in exacting compulsory benefits (taxes) to provide support (van den Haas 1979: 72).

The NEA has also been criticized for pursuing a "middle brow" cultural policy. Ronald Berman describes such artistic fare as follows:

> The models are the Kennedy Center and
> Wolf Trap Farm, large establishments heavi-
> ly supported by government, corporations,
> and foundations, and offering a combina-
> tion of mass-audience programs and enough
> adversary culture to stay ahead of the
> media (Berman 1979: 49).

Yet what programming alternative does a public arts agency have in the United States where there is broad cultural heterogeneity, little history of official sanction for a special cultural canon, and even less popular deference to any claims by a social class to cultural superiority? If the Arts Endowment restricts its patronage to the established repertory, it is attacked as elitist and culturally

imperialist. If it subsidizes non-European and grass-roots
culture, it is condemned for populism and funding enter-
tainment.

 The NEA has responded to these criticisms by em-
phasizing that it is specifically forbidden from producing
art and that its concerns are with fostering, maintaining,
and disseminating the nation's cultural heritage. The NEA
would also cite the dramatic increase in the number of arts
organizations, the expansion of audiences, and the growth
of private support of the arts which has occurred since
1965. Some examples will suffice (Presidential Task Force
on the Arts and Humanities 1981: 20).

- In the decade prior to the Endowment's establishment,
 private support for the arts rose 3 percent; since 1965
 this support has shown a 13-fold increase (corporate
 giving grew at the fastest rate--a 20-fold increase).

- In 1965 there were about one million tickets sold for
 dance performances, principally in New York; today,
 there are about 16 million ticket buyers, 90 percent of
 whom live outside of New York; the orchestral audience
 has risen from 10 million to 23 million; annual museum
 attendance has risen from 22 million to over 43 million.

- Since 1965, the number of professional arts organiza-
 tions has grown by almost 700 percent. Professional
 orchestras have increased from 58 to 145; professional
 opera companies from 31 to 109; professional dance
 companies from 35 to 250; professional theatre companies
 from 40 to 500.

 This is an impressive record of cultural growth--
even if the question of quality is not answered by the
data alone--and the NEA can rightly claim credit for con-
tributing to this success. Still, some critics of public
arts agencies criticize these programs for draining funds
from elite arts organizations by subsidizing mass entertain-
ment (Brustein 1977). Put crudely, but not untypically,
the NEA has been funding "cultural clambakes" at the ex-
pense of "national treasures." The NEA responds that for
the past decade "6.2 percent of the nation's arts organi-
zations received 51.6 percent of the Endowment's dollars"
(Presidential Task Force on the Arts and Humanities 1981:
22-23). (Such an admission will doubtless fuel the fires
of the Endowment's populist critics.) What the NEA has

sought to accomplish involves two broad (and to some extent, contradictory) objectives: supporting established institutions (while also funding touring and satellite companies to serve grass-roots cultural constituents); and promoting the broad dissemination of quality cultural resources (thus aiding the creative activities of grass-roots artists and expanding cultural equity).

By its own admission, a primary goal of Endowment policy has been to get the arts to the people. Although government support for the arts has sometimes been characterized as a "transfer payment for the upper-middle class" (Gans 1974), much of the NEA's outreach efforts have supported nontraditional programming and community-based cultural activities in an attempt to reach what has been termed an "unrepresented cultural constituency." As described by DiMaggio and Useem, this constituency constitutes a sizable group of Americans who are "cultural dropouts,"

> . . . individuals with no apparent artistic
> or cultural interests. . . . Cultural depri-
> vation then is not a matter of choosing
> performances or hobbies that diverge from
> upper-middle class norms; rather, it con-
> sists of having no creative or expressive
> pastimes, enjoying no performances of any
> kind, and being equally immune to the
> claims of galleries, zoos, or public parks
> (DiMaggio and Useem 1980: 65).

Such efforts to reach a broader arts public are likely to be undermined by further attacks on public culture. Cutbacks in public support for the arts are likely to wound, perhaps mortally, small, nonestablishmentarian arts groups. The major orchestras, opera companies, dance troupes, and museums will continue to operate regardless of the level of public support. Rich patrons (or more likely, corporations taking advantage of the tax benefits) could guarantee basic operating expenses even if public support were abolished. Less likely to survive are community-based and minority-oriented institutions that depend almost solely on NEA, or NEA-generated, funds. This would result in a decided step back from past public commitments to artistic pluralism and cultural democratization.

Government support for the arts in the United States has always shown a good return on the investment, politically as well as culturally. Nancy Hanks and Leonard Garment made this pragmatic argument for public subsidy in a memorandum to President Nixon:

> For an amount of money which is minuscule in terms of the total federal budget, you can demonstrate your commitment to "reordering national priorities to emphasize the quality of life in our society."
>
> The amount proposed . . . would have high impact among opinion formers. It is on the merits, justified, i.e., the budget for the arts and humanities is now completely inadequate. Support for the arts is, increasingly, good politics. By providing substantially increased support for cultural activities, you will gain support from groups which have hitherto not been favorable to this administration (quoted in Cummings 1982: 185).

Even some of the more doctrinaire members of the Reagan administration, who were disposed toward a negative appraisal of the Endowment's performance, have come to believe that the case for federal subsidy is stronger than they had originally thought. Consequently, they have "not fundamentally altered the agency's philosophy or mission or its standards for awarding grants" (New York Times, July 6, 1983: 8).

In all the controversy about the Endowment's programs and the Reagan budget cuts, it is very easy to lose sight of the magnitude of the issue in monetary terms, and to forget that the government's role has been a distinctly minor one. The NEA's budget amounts to less than one-tenth of a percent of total federal spending (or less than the Defense Department spends on military bands). Moreover, public funds from all sources (federal, state, and local) account for only about 15 percent of the operating expenses of arts organizations in the United States. Nonetheless, this makes the Endowment the biggest single source of support for the arts in the nation and means that it exerts an influence vastly greater than the dollar amounts would suggest. Since the magnitude of NEA support is in

inverse proportion to the size of the recipient institutions, public subsidy can sometimes determine whether a small art institution will survive at all. Yet, even for the large art organization, public support may often determine the hours that a museum can be open, the schedule of a civic arts center, or the repertoire of a theatre company. As important, even crucial, as public support has been, however, it has not been decisive or dominant.

Besides the financial margin of survival that the NEA sometimes provides, it is possible to identify three qualitative contributions provided by government support for the arts. First an NEA grant constitutes an imprimatur for the smaller and newer arts organizations; that is, it provides a respected and recognized official seal of approval. In the amorphous arts world this can constitute some basic criterion of cultural excellence and help to generate funding from foundation and corporate sources. Second, an Endowment grant often allows cultural institutions to do what they otherwise would be unable to consider. Public funds, for example, can make possible low-cost concerts for groups outside the usual subscription clientele; allow exhibitions and performances in smaller communities, at the workplace, shopping malls, health care facilities, and custodial institutions; and promote the development of younger and nontraditional artists through commissions and sponsorships. Third, as a public arts agency, the Endowment has properly addressed itself to concerns of cultural equity that cannot easily (or appropriately) be the responsibility of a private arts institution. The Endowment's policies have sought to further the accessibility of culture to people socioeconomically and ethnically different from those of the traditional culture-consuming public, even as it continues its support for elite, standard-setting cultural institutions.

In effect, the Endowment has sought to democratize the arts world while respecting the autonomy of the individual artist and the independence of arts organizations. Such a goal does not, of course, mean that the record of public culture has been without reproach. Given the evidence presented above, it is not surprising that the Arts Endowment has not developed a well-established set of principles to direct public culture. If a guideline exists, it has been the negative injunction: avoid the experience of the New Deal arts programs. As we discussed, this judgment is not based on an analysis of the cultural value

of the Treasury and WPA projects. Rather, it is a warn-
ing against supporting any project that may result in po-
litical controversy or run the risk of giving public offense
(Larson 1983: 29). In a democratic system these are not
bad things to avoid, but mere avoidance does not amount
to a cultural policy. This would require public arts agen-
cies to specify which arts were to be favored, what types
of institutions were to receive funding, and whose taste
preference would receive official support. In effect, this
would mean guaranteeing some commonly accepted minimum
of cultural awareness and participation as part of the gen-
eral quality of life. For a nation as heterogeneous as the
United States, such a policy formulation would hardly be
uncontroversial even if successfully completed.

Such criticisms may be unfair to public arts policy
in holding it up to standards of judgments that are higher
than those applied to other policy areas. Few public poli-
cies can be characterized by the specificity and selectivity
that seems to be expected of government support for the
arts. Moreover, there is the danger than an overly de-
fined public culture could become an "official culture,"
that is, one propagated by the state to serve its interests
and legitimate its activities. For the government to favor
a particular style or mode of expression is to risk the of-
ficial establishment of that cultural form. By contrast,
government programs that encourage "grass-roots" and
"outreach" efforts by major cultural institutions are prin-
cipally concerned with who is to have access to culture
rather than the content of the culture itself. The public
policy goal should be procedural, not substantive. If
government is to act as a benefactor, its goals would seem
to be to broaden access, to foster greater cultural equality,
to acknowledge diversity, and to further representativeness.
Consequently, arts policy making has cast government in
the role of a guarantor of equity in the distribution of
cultural opportunities.

There is nothing new or atypical in an approach to
public policy making that is essentially pluralist in its
administration and benefits. Public culture may be plural-
ist by default (an inability to define a public cultural
interest), as its detractors maintain; on the other hand,
there is a strong argument for a pluralism of choice (rec-
ognizing that it is not in the public interest to define the
content of culture) as most appropriate for a heterogeneous
democracy. A pluralistic policy can seek to insure that

the broad range of cultural heritages in this country is recognized and supported. Public arts agencies might also promote the subcultural programming advocated by Herbert Gans through increased funding for arts programs that are sensitive to audiences of different ethnic backgrounds, social classes, educational levels, ages, and places of residence (Gans 1974: 142). What has been realized over the past two decades of NEA patronage is a commitment to the principle that the survival of arts institutions, greater accessibility to arts activities, and the preservation of cultural pluralism is a public good that merits government support.

NOTES

1. Public support for the arts in the United States has traditionally been directed to those organizations that operate on a nonprofit basis and are classified by the Tax Code as 501(C)(3) organizations. Commercial art activities, such as the recording industry, Broadway theatre, and Hollywood, fall outside the usual concern of arts policy making.

2. The National Endowment for the Humanities (NEH) was created at the same time to provide public support for studies in the following academic disciplines: history, philosophy, languages, linguistics, literature, archaeology, jurisprudence, history and criticism of the arts, ethics, comparative religion, and those aspects of the social sciences employing historical or philosophical approaches.

3. Other major federal-level cultural programs are the National Endowment for the Humanities, as well as the Corporation for Public Broadcasting, the Institute of Museum Services, the Historic Preservation Fund, and the cultural exchanges administered by the United States Information Agency. The national government also operates a variety of cultural institutions: principally, the Smithsonian complex of museums, the National Gallery of Art, the National Archives, and the Library of Congress. In addition, the General Services Administration commissions art work for federal buildings.

4. In his first year as NEA chairman, Frank Hodsoll exercised a "chairman's veto" on 20 of a total of nearly 6,000 panel-endorsed applications. However, these actions were considered highly unusual. "Hodsoll's prede-

cessor, Livingston Biddle, could not remember one instance of his overruling either a panel or Council recommendation during his entire four-year tenure" (Wyszomirski 1983: 14).

5. These characteristics of the panel system reflect the observations of the various NEA staffers interviewed by C. Richard Swaim (Swaim 1982: 169-204). This writer reached similar conclusions during the time in which he served as a panelist for the Louisiana Council on the Arts and for the Arts and Humanities Council of Greater Baton Rouge.

BIBLIOGRAPHY

Banfield, Edward L. 1984. The Democratic Muse: Visual Arts and the Public Interest. New York: Basic Books.

Berman, Ronald. 1979. "Arts v. the Arts." Commentary, November 1979, 47-50.

Brustein, Robert. 1977. New York Times. December 18, 1977. Sec. B, 1, 35.

Cummings, Milton C., Jr. 1982. "To Change a Nation's Cultural Policy." In Public Policy and the Arts, edited by Kevin V. Mulcahy and C. Richard Swaim, 168-94. Boulder, Colo.: Westview Press.

Democratic Study Group. 1981. "Special Report: The Stockman Hit List." Washington, D.C.: House of Representatives. Mimeographed.

DiMaggio, Paul, and Michael Useem. 1980. "The Arts and Cultural Participation," Journal of Aesthetic Education 14 (October):55-72.

Downs, Anthony. 1967. Inside Bureaucracy. Boston: Little, Brown.

Feld, Alan L., et al. 1983. Patrons Despite Themselves: Taxpayers and Arts Policy. New York: New York University Press.

Fox, Douglas M. 1976. "Government Support for the Arts: A Review-Essay." Public Administration Review 36 (July/August):451-54.

Gans, Herbert. 1974. Popular Culture and High Culture. New York: Basic Books.

Larson, Gary O. 1983. The Reluctant Patron: The United States Government and the Arts, 1943–1965. Philadelphia: University of Pennsylvania Press.

Mankin, Laurence. 1983. "The National Government and the Arts: The Biddle Years." Paper presented at the Annual Meeting of the American Political Science Association, Chicago, Ill.

Mooney, Michael McDonald. 1980. The Ministry of Culture. New York: Wyndham Books.

Mulcahy, Kevin V. 1980. "Government and the Arts: A Symposium." Journal of Aesthetic Education 14 (October): 21–54.

_____. 1982a. "Ideology and Public Culture." Journal of Aesthetic Education 16 (Summer):11–24.

_____. 1982b. "The Attack on Public Culture" and "The Rationale for Public Culture." In Public Policy and the Arts, edited by Kevin V. Mulcahy and C. Richard Swaim, 33–57; 303–22. Boulder, Colo.: Westview Press.

_____. 1984. "Official Culture and Cultural Repression: The Case of Dimitri Shostakovich." Paper presented at the Conference on Social Theory and the Arts, College Park, Md.

National Conference of State Legislatures. 1981. Arts and the States. Denver, Colo.: NCSL.

National Endowment for the Arts. 1979. General Plan, 1980–84. Washington, D.C.: Government Printing Office.

_____. 1984. Five Year Planning Document 1986–1990. Washington, D.C.: Government Printing Office.

Netzer, Dick. 1978. The Subsidized Muse: Public Support for the Arts in the United States New York: Cambridge University Press.

Presidential Task Force on the Arts and Humanities. 1981.
"Advancing the Arts in America." Cultural Post 7
(September–October):19–23.

Straight, Michael. 1980. Twigs for an Eagle's Nest: Gov-
ernment and the Arts, 1965–1978. Berkeley, Calif.:
Devon Press.

Svenson, Arthur. 1980. "The Administrator in the Admin-
istration of State Arts Agencies." Journal of Aesthetic
Education 14 (October):35–41.

_____. 1982. "State and Local Arts Agencies." In Pub-
lic Policy and the Arts, edited by Kevin V. Mulcahy
and C. Richard Swaim, 195–211. Boulder, Colo.:
Westview Press.

Swaim, C. Richard. 1982. "The National ENdowment for
the Arts, 1965–1980." In Public Policy and the Arts,
edited by Kevin V. Mulcahy and C. Richard Swaim,
168–94. Boulder, Colo.: Westview Press.

U.S. Congress, House. Committee on Appropriations. 1979.
Report on the National Endowment for the Arts and
Humanities. 96th Cong., 1st sess.

_____. Committee on Government Operations. 1983.
The Interrelationship of Funding for the Arts at the
Federal, State, and Local Levels. 98th Cong., 1st sess.

van den Haas, Ernest. 1979. "Should the Government Sub-
sidize the Arts?" Policy Review 10 (Fall):63–73.

Wyszomirski, Margaret J. 1980. "Arts Policymaking and
Interest Group Politics." Journal of Aesthetic Educa-
tion 14 (October):28–34.

_____. 1982. "Controversies in Arts Policymaking." In
Public Policy and the Arts, edited by Kevin V. Mulcahy
and C. Richard Swaim, 11–31. Boulder, Colo.: West-
view Press.

_____. 1983. "The Reagan Administration and the Arts,
1981–83." Paper presented at the Annual Meeting of
the American Political Association, Chicago, Ill.

15

GOVERNMENT AND THE ARTS IN CANADA: RECENT REASSESSMENTS AND INTERNATIONAL PERSPECTIVES

Joseph Wearing

Canadian historians have often remarked that, when important nation-building jobs had to be done, Canadians did not hesitate to use the state, especially when they had doubts about the ability of the private sector to do the job (Lower 1952). Some government initiatives in the arts have been confidently statist: the National Museums (dating back to 1880), the Canadian Broadcasting Corporation (1936), the National Film Board (1939), and the National Arts Centre (1969). But Canadians are periodically beset with recurring doubts about the role of government in culture. Or perhaps the country retains some of the Presbyterian ethic of its early days: anything as frivolous as the arts could hardly be considered an aspect of nation-building!

The federal government's first attempt to develop a comprehensive and coherent cultural policy came only in 1949 with the appointment of a royal commission on "National Development in the Arts, Letters, and Sciences," better known as the Massey-Lévesque Commission. The Commission found that the artistic life of the country was underdeveloped and beset with financial problems. There was a good deal of amateur activity in the arts, but only four cities had professional orchestras and theatres; there was no national theatre school and no national ballet school. The publicly owned Canadian Broadcasting Corporation (CBC) was virtually the only significant avenue for developing Canadian artists to advance their careers and, as a consequence, many were forced to emigrate. Further-

more, with only a few honorable exceptions, the Canadian plutocracy did not patronize the arts in the manner of their American counterparts. State support, apart from the National Film Board, and several museums and art galleries, was also lacking.

One of the Commission's principal recommendations was that the government give financial aid to already established private arts institutions and to individuals through an arm's length granting agency, the Canada Council. State intervention was thus to be minimized by a device that kept government as far removed as possible from cultural matters. The cultural politics of Hitler and Mussolini were a vividly remembered warning of what political interference in the arts could lead to, so the Canada Council (like its predecessor and role model, the Arts Council of Great Britain) was created in 1957 as a means of keeping government out of the arts.

The Canada Council now consists of a 21-member board which is appointed by the federal government. When the Council was established, Parliament gave it an endowment, the interest from which provides a small part of its present income, as do occasional private donations. By far the largest share of its revenue, however, comes in the form of an annual grant from Parliament, the size of which is determined by the government of the day as part of its annual expenditure estimates.[1]

The Canada Council gives grants to arts organizations and individuals, it runs an art bank and a touring office, and it awards prizes. It is aided in its decisions by a 27-member advisory panel of artists from various disciplines as well as a number of juries, selection committees, advisory boards, and its own staff. Of the ten provinces, some have arts councils similar to the Canada Council, others prefer to deal directly with the arts through ministries of culture, and some have both systems. Ontario folowed the federal lead and created the Province of Ontario Council for the Arts (later the Ontario Arts Council) in 1963. The Council consists of 12 members appointed on the initiative of the premier's office for three-year renewable terms. The Council, which meets four times a year for three-day meetings, receives assistance from various independent experts, juries, and its own full-time officers in the various disciplines.

By way of comparison, the National Endowment for the Arts received a congressional appropriation of

$144,000,000 in 1983, while the Canada Council received a grant of $65,581,000 (Canadian), even though Canada's population is roughly one-tenth that of the United States. The New York State Council on the Arts had a budget of $36.6 million in 1982-83. Ontario is similar to New York in that it has the greatest concentration of artists and leading arts organizations in the nation. With slightly less than half the population of New York, the budget of the Ontario Arts Council is slightly less than half that of NYSCA. (The lower value of the Canadian dollar actually puts the Ontario Arts Council [OCA] below NYSCA on a per capita basis.)

Even though arts councils were supposed to free governments of direct responsibility in the arts, the arm's length approach has never been adhered to completely. It is a myth to believe that an arm's length agency can completely insulate artists from all political pressures. It suits everyone to leave a granting council free of petty political meddling in its routine decisions, but if a minister feels strongly about an issue, a granting council can scarcely be unmindful of its patron. Even the birthplace of arm's length bears testimony to that. The Arts Council of Great Britain dropped plans to show the works of an IRA artist when the Office of Arts and Libraries suggested, quietly, that it would be inappropriate for a publicly funded body to do so. Similarly, when the Ontario minister for culture expressed his unhappiness over the OCA funding the Body Politics, a gay journal, which his colleague the attorney general was prosecuting, the grants stopped.

Secondly, the federal and Ontario governments have always funded directly certain agencies such as the major museums and art galleries, broadcasting organizations and, in the case of Ottawa, film organizations. Moreover, capital funding has never been one of the Ontario Arts Council's responsibilities, even though the Arts Council of Great Britain looks after capital grants in the country. The justification for the Ontario practice is that political considerations enter into the making of capital grant decisions, but this sort of political intrusion into the arts is considered to be relatively harmless. Conceivably this is because, once the building is up, the grant cannot be rescinded, even if the arts group proceeds to fall out of favor with its political rulers. The inconsistency in this division, however, is that capital grants inevitably entail operating grants in subsequent years. One of the reasons

why the OCA's list of clients has grown is because of capital grant decisions made by the government over the years.

For a number of years, neither Ottawa nor Toronto had any cultural policy as such, except that of aiding the arts through their arts councils, which in turn set the criteria for awarding the grants. It was not long, however, before a basic problem of accountability became apparent. Although the councils were funded with legislative appropriations, they reported to their respective legislatures in only a very general way. In 1963, the responsibilities of the federal secretary of state were reorganized to bring the various cultural agencies, including the Canada Council, into the portfolio, and in 1972 an Arts and Culture branch was created within that department to assist in policy formulation. A similar reorganization in Ontario led to the creation of a Ministry of Culture and Recreation in 1975. (Ontario uses the term ministry which is the same as a department in the federal government.)

These were more than mere shufflings of responsibilities, because the two governments were beginning to develop activist cultural policies. In Ottawa the main focus was on promoting bilingualism and national unity, particularly after the victory of the separatist Parti Québeçois in the Québec provincial election of 1976. It also saw the provision of cultural institutions as being linked to its regional development strategies (Roberts 1979). In Ontario, which has the greatest mix of new immigrants, new government initiatives sought to integrate ethnic groups into Canadian society by giving support to their cultural activities. (Unsympathetic critics have added that multicultural grants also seem to be aimed at integrating these ethnic groups into the ruling Conservative party's electorate.) The federal government also has a multicultural program which, in recent years, has been one of the fastest-growing areas of federal expenditure on culture (Canada, Statistics Canada 1983), although multicultural funding is done separately from arts and culture funding.

Another factor leading to increased government participation in the arts was the discovery of lottery revenues. Lotteries undoubtedly did conflict with the Presbyterian ethic and for many years were outlawed. But mores change and the federal government discovered that lotteries were a good way to cover the enormous costs of the Montreal Olympics. In 1975, the Ontario government followed suit and

launched Wintario, which almost overnight drew millions of
dollars into provincial coffers. It decided to earmark
those profits for culture and recreation, and that put the
Ontario Arts Council into a serious dilemma. The money
was tempting, but the OAC was afraid that lottery popu-
larity might prove to be ephemeral, so it decided to rely
only on tax-based appropriations (MacSkimming 1983). That
was probably a tactical error. Lottery revenues have
grown faster than tax revenues and the Ministry of Culture
and Recreation initiated its own granting programs funded
by Wintario.

In both Ottawa and Toronto, the arts councils'
positions became increasingly anomalous in the face of
governmental activism in the arts. The federal secretary
of state, Hon. John Roberts, put the problem bluntly when
he said in 1979 that the government had to develop its
own views on cultural policy matters such as the geograph-
ical distribution of cultural institutions, Canadian content
goals, the balance between public and private funding,
and the relationship between federal and provincial prior-
ities. And, he added, the government had to answer to
Parliament and the country on those policies. The arts
councils, however, have resisted political direction such as
the earmarking of funds within their annual appropriations
from the legislatures. The two departments (federal and
provincial) have reacted by simply setting up their own
programs and gradually squeezing the funds going to the
arts councils. The resulting arrangements have very little
rationale. The Ontario Ministry of Citizenship and Culture
(the successor to Culture and Recreation) gives grants for
book publishing, which the Ontario Arts Council and the
federal Department of Communications (the successor to
secretary of state) also do. The Ontario Ministry gives
grants to the Ontario Federation of Symphony Orchestras
for operational expenses, while the Ontario Arts Council
gives it program grants as well as funds the orchestras
themselves. There is inevitably an overlap in personnel
between the Arts and Culture Branch and the Canada Coun-
cil in Ottawa and between the Culture Division and the
Ontario Arts Council in Toronto.

By the late 1970s budgetary restraints led to cut-
backs in government arts funding. In August 1978, Prime
Minister Trudeau announced a comprehensive package of
budget cuts which included most of the federal cultural
agencies (Figure 15.1). The result was that Canada's

FIGURE 15.1

Federal Government Expenditures on Arts and Culture in Constant
1981 Dollars, 1974–84

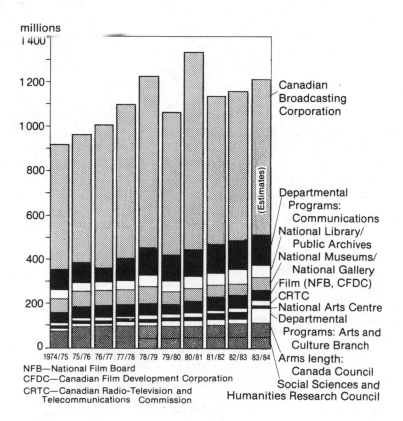

The Canada Council was split into two smaller units in
1978. As its name suggests, the Social Sciences and Humani-
ties Research Council took over research grants for the social
sciences and humanities, while the Canada Council retained
responsibility for arts funding.

Some adjustments have been made to account for non-
budgetary items. Excluded from Arts and Culture Branch,
1982–83, was a nonrecurring item, payments to the post office
for costs associated with cultural mailings.

Source: Public Accounts of Canada.

347

artistic community was thrown into an unprecedented flurry of political activity. Protests were staged by 30 arts organizations, who gave themselves the somewhat bizarre name of the 1812 Committee (in reference to the war that the Canadians successfully waged against the Americans in 1812; presumably this 1978 campaign was intended to be equally successful).

The consequence of all these concerns expressed by government and artists alike was that, when a federal election occurred in 1979, cultural policy actually became something of an issue. Although both major parties (Liberals and Conservatives) are generally centrist in ideology, they differed from each other in the cultural field. The Liberal secretary of state, John Roberts, favored a more interventionist approach by government, while the Conservatives' cultural critic, David MacDonald, called for an immediate reversal of "the most dangerous trend of recent years to direct political control over arts funding" (Edinborough 1979). Following the Conservative victory in that election, MacDonald became secretary of state and established an Advisory Committee on Cultural Policy. But shortly thereafter, the Conservative government was defeated in Parliament on another issue. When the Liberals subsequently were returned to power, the advisory committee was renamed the Federal Cultural Policy Review Committee, better known as the Applebaum–Hébert Committee, after its two co-chairmen (or familiarly shortened to Applebert). Applebert received 1300 briefs and conducted public hearings in 18 cities across the country and presented its final report in November 1982.

The report was notable more for what it did not say than for what it did. (Robert Fulford of Saturday Night described it as "Plenty of Nothing.") The most sensational reactions were directed toward its broadcasting recommendations: that the government–owned radio and television network, the CBC, cease to rely on commercial revenue and that it abolish most of its production facilities, becoming a kind of Canadian PBS (Recommendations 65 and 67). Its recommendations with respect to museums, visual and applied arts, and performing arts were merely anodyne. Although the Committee admitted that governments wanted to be able to give political direction to their cultural agencies (that the U.K. government had such powers, which it exercised infrequently and "without arousing fears of untoward political interference"), the report concluded "that the

safeguarding of cultural values and purposes requires, as a matter of public interest, that their operations be immune from political direction," at least to the extent that their functions "require the exercise of impartial, critical judgment in the support of cultural activity" (Recommendation 2). Direct funding by the Department of Communications should occur only when "a funding program is manifestly inappropriate for any cultural agency to undertake, and is sufficiently impervious to being subjugated to political ends."

The report also called, but in a very general way, for more funds to go to the various agencies, but with no indication of how much funding was needed, how it would be allocated, or even why, in specific terms, the government should provide more funding for the arts. Although various figures appear in the text, it is astonishing that the report is absolutely devoid of tables and charts. The reader (and conceivably that includes the federal government) who wants to know something about the specifics of the situation is left more or less in the dark. I have attempted here to fill the gap to some extent by providing figures in constant dollars for federal government spending on arts and culture, including broadcasting, film, and new communications technology (Figure 15.1). The Canada Council has not done as well overall as those cultural agencies that carry out their own activities, although national museums have done worse. The government's own activities in the Arts and Culture Branch and in the Department of Communications have grown the fastest of all.

Soon after Applebert reported, the Ontario government launched its own study of provincial arts policy. As with the Ottawa study, the problem with arts funding was provoked initially by the government itself. In 1983, the Ministry of Citizenship and Culture threatened the Ontario Arts Council with a 15 percent cut in its appropriation. An orchestrated cry of anguish from the Arts Council's clients made the Ministry back off, but it continued to have serious misgivings about the manner in which the Arts Council had spread its money even more thinly among a growing number of clients (Conlogue 1983). Furthermore, the Ontario government, in a spirit of neo-Thatcherite, neo-Reaganite budgetary restraint, wanted to see the private sector take on a larger share of arts funding. A particularly ticklish problem was what to do with the so-called Big Six, the province's largest performing arts

companies. The Canadian Opera Company, the National
Ballet, the Shaw Festival, the Stratford Shakespearian
Festival, Toronto Arts Productions, and the Toronto Sym-
phony have been most vociferous in their claim that gov-
ernment funding has neither kept pace with inflation nor
with the increased public demand for their product--the
"income gap" made famous by Baumol and Bowen.

In 1980, their appeal for help from the government
was answered by a Wintario Challenge Fund, which, sig-
nificantly, was administered by the Ministry, not the OAC.
The Fund matched, with two dollars from lottery profits,
every dollar that the province's 35 largest institutions
could raise from private sources (Table 15.1). But the
program ran for just three years, so the Big Six were soon
back in the financial predicament they had been in before
(Presidents 1982; Macaulay Sec. 10, 20-22).

The solution to the problem, according to the top
appointed official in the Ministry, was to take the Big Six
away from the OAC and add them to the Ministry's list of
directly funded agencies (Conlogue 1983). The Toronto
Symphony, for one, was quite happy about that prospect
(Macaulay Sec. 9, 18). It is not difficult to see why.
Grants to the Big Six from the Canada Council and the OAC
have fallen by 30 percent and 20 percent, respectively, in
constant dollars since 1975. Direct funding by the pro-
vincial government, especially through the Wintario Chal-
lenge Fund, has shown dramatic increases (Table 15.1).
Grants to the province's directly funded agencies have not
been as badly ravaged by inflation (see Figure 15.2 on
Major Museums and Galleries) as were those from the OAC
to the Big Six. Besides, the latter's boards of directors,
who tend to have good political connections, no doubt
counted on being able to mount an effective lobbying ef-
fort with the government.

By virtually any criteria the Ontario Arts Council
has underfunded the Big Six, with the possible exception
of Toronto Arts Productions. This is vividly demonstrated
through an analysis of the Arts Council's grants in terms
of funding per spectator, funding as a proportion of earned
revenue, and funding as a proportion of private donations.
We are struck by the extent of the differential treatment
that various groups receive at the hands of the Arts Coun-
cil and also by the fact that the grants to the Big Six
are generally lower when measured in these three ways.
A modern dance company gets a grant equal to 200 percent

TABLE 15.1

The Big Six—Growth of Sources of Income Adjusted to Inflation (in millions of dollars)

	1975	1976	1977	1978	1979	1980	1981	1982
Box office	$8,235	$9,008	$9,254	$10,015	$9,535	$9,763	$3,987	$9,880
Fund raising	1,755	2,242	1,946	1,895	2,100	2,481	2,489	2,492
Canada Council	2,763	3,021	2,979	2,788	2,797	2,448	2,229	2,207
Other federal	13	41	41	492	36	15	420	273
Ontario Arts Council	1,581	1,616	1,557	1,426	1,356	1,220	1,880	1,095
Other Provincial	200	114	217	1,854	1,477	1,243	769	1,385
Total revenues	$15,936	$17,077	$17,340	$18,962	$17,750	$17,747	$17,077	$17,772

Source: Presidents, Canadian Opera Company, National Ballet of Canada, Shaw Festival, Stratford Shakespearean Festival, Toronto Arts Productions, Toronto Symphony to Arthur Gelber, Chairman, Ontario Arts Council, October 27, 1982.

FIGURE 15.2

Ontario Government Expenditures on Arts and Culture in Constant
1981 Dollars, 1974–83

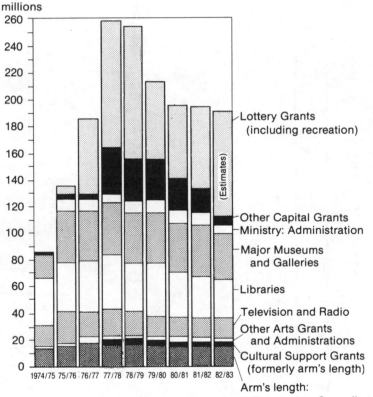

of its earned revenue, while the Toronto Symphony, the National Ballet, Shaw, and Stratford each get less than 15 percent. The audience of three semi-professional regional orchestras are subsidized by over $6.00 for every ticket they buy, while those of Shaw, Stratford, and a number of other theatres are subsidized at less than $1.00 a ticket. A dozen small dance and theatre companies get grants that are much more than double the amounts which they are able to raise privately, while over half the companies receive less than matching grants, and these include all the Big Six, except for Toronto Arts Productions (Wearing 1983b).

It is obvious, of course, why some organizations are high on the various lists. They are small companies in remote areas, they are in an experimental vanguard, they are fledgling companies, or they provide an important training ground for young artists. But one is tempted to ask: If an organization cannot increase its audience or get its existing audience to pay more or get more private funding—if it fails on all three counts, does it really merit quite such disproportionately favorable treatment by the Arts Council? The OAC is very proud of having stood for "more than grants," but one cannot help wondering if perhaps it has tried to do too much with its increasingly limited resources.

One has to acknowledge, however, that the OAC has been in an impossible situation as its funding has shrunk progressively over the years. A glance at the government's public accounts explains how this fits into the broader picture (Figure 15.2). In its seven years as a separate ministry, Culture and Recreation increased cultural spending dramatically, even after allowing for inflation. Most of the Ministry's agencies, including the OAC, fell back gradually over the years, with libraries being hardest hit after 1979. The increase was concentrated in just two areas, capital spending and the administrative functions of the Ministry itself. These are the areas where the Minister of Culture and Recreation could exercise the greatest direct control and the greatest discretion for political advantage.

The Applebert Committee of 20 took three years to complete its work; the Macaulay Committee of three took less than a year. Applebert was headed by a composer and a writer; Macaulay himself was a former politician and Treasurer of Ontario. While written with less elegance

and philosophical breadth than Applebert, the Macaulay Report is marked by a political, pragmatic realism that was distinctly lacking in Applebert. For example, the Committee had been told by officials in the Ontario Treasury that, according to a government-commissioned poll, 61 percent of the Ontario public thought that the arts should be cut first, if budget reductions were necessary. The Committee commissioned its own poll which revealed that (a) the public assumes that government funding is greater than it is, and (b) when informed of the correct figure (22 cents out of every $100), they were in fact willing to incur a tax increase to support the arts (Sec. 3, pp. 1, 9-10; Sec. 8, p. 14).

The Macaulay Report was also enhanced by some revealing statistical analysis of the sort that was absent from Applebert. Government officials had suggested that financial problems in the arts were due to poor marketing and empty seats rather than underfunding by government (Sec. 5, p. 3). Macaulay, however, produced a comparison of performing arts revenue by source and province which showed that box office revenue per capita is highest in Ontario, while provincial government support is lower than the national average (Sec. 8, pp. 8-9).

There are a number of factors that give Ontario and Toronto a leading role in the development of arts and culture in Canada. Not only is Ontario the most populous province, but 70 percent of its population lives within a three-hour drive of Toronto. Half of the arts labor force is in Ontario, and 75-90 percent of what the cultural industries produce in English comes from Ontario (Macaulay, Sec. 4, p. 3; Sec. 13, p. 2). (The cultural industries include broadcasting, recording, film, and publishing.) The country's preeminent museum (the Royal Ontario Museum), two of the leading art galleries (the National Gallery and the Art Gallery of Ontario), the leading opera company (The Canadian Opera Company), one of the two top orchestras (the Toronto Symphony), the principal ballet company (the National Ballet), and the main classical repertory theatre in English (Stratford) are all located in Ontario.

Ontario's position is not unlike that of New York State, and per capita provincial expenditures on museums reflect the responsibility that accompanies preeminence. It is striking, however, that the second-largest province, Québec, which is the home of 89 percent of the country's

francophone population, devotes considerably more than
Ontario to performing arts, film, recording, libraries, and
broadcasting.

What is remarkable about arts funding throughout
Canada is the degree to which the arts are financed from
a variety of sources: box office, individual donors, cor-
porations, and three levels of government. The Macaulay
Report affirmed that "the vitality and freedom of the arts
. . . depend on plural funding." "Neither the tyranny of
the box office, nor the favouritism of the corporate world,
nor the. pragmatism of government [should] be the dominant
arbiter of artistic expression" (Sec. 8, p. 17). But the
report went on to show how the Ontario government's share
had fallen in real terms, especially for arts organizations
that are funded through the OAC (Sec. 8, pp. 3, 7). The
report chastised the government for its ambivalent attitudes
toward the arts and found that government underfunding
had been one of the main causes of arts organizations'
deficits, which in turn discourage private, especially cor-
porate, donations (Sec. 5, p. 10; Sec. 11, p. 16). Public
officials who had been urging a greater reliance on private
donors cannot be pleased with the report's assertion that
"a major shift in funding responsibility away from govern-
ment support and toward increased private support would
be a retrograde step for the arts and for the province"
(Sec. 11, p. 4).

Underfunding has forced arts organizations to seek
more revenue by raising ticket prices and museum entrance
fees. There is concern, however, that these publicly sup-
ported institutions have become less accessible to the very
taxpayers who help to support them. Indeed, the Macaulay
Committee's survey found that the frequent attenders, the
core of the arts audience, are buying fewer tickets--per-
haps a cause for alarm.

Unlike Applebert, Macaulay was very specific about
how to solve the underfunding problem. The government
should supplement the OAC's grant with a special two-year
allocation from its lottery profits. It recommended a 20
percent supplement for the first year and a 10 percent
supplement for the second (Sec. 9, pp. 22-23). Further-
more, the government should not earmark any of these
funds for specific purposes, but leave the OAC free to
distribute the money according to its own determination of
artistic needs and achievements. The report thus came
down firmly on the side of the arm's length approach to

funding the arts (Sec. 9, p. 5). It acknowledged the high esteem in which the Arts Council is held by Ontario's arts community. This contrasted with the criticisms it made of the OAC's parent ministry, Citizenship and Culture, regarding its rapidly rising administrative expenses and awkward attempts at formula funding (Sec. 7, pp. 7-16). The report went so far as to recommend that certain responsibilities, which the Ministry had taken over in lieu of increasing the OAC's grant, should be returned to the Arts Council and funds increased accordingly.

On the question of the Big Six, the Macaulay Report clearly reaffirmed the primacy of the arm's length principle. If the Ministry took over the funding of the major performing arts organizations, "the OAC would be left with severely lowered prestige and credibility," the report concluded. Instead, the Arts Council should be given more money and allowed to solve the problem itself (Sec. 9, pp. 18-20).

Two questions remain unanswered by the Macaulay Report and they lie at the very heart of the arm's length problem. First, why should the minister with responsibility for the arts see it in his/her political interest to fight the cabinet for increased appropriations to an arts council that is left to distribute the money on its own? A former federal minister for the arts, Hon. John Roberts, spoke from the minister's point of view when he compared two cabinet portfolios he had held. As Environment minister, he had been able to take the issue of acid rain and, building on public concern, give it (and himself) a high profile. As secretary of state, with responsibility for the Canada Council, it was much more difficult to make the same sort of headway with arts policy. The minister was blamed for the problems, but the Canada Council kept the "line" responsibility for dealing with those problems and got any credit for solving them. The Macaulay Report calls on the Ontario Minister of Citizenship and Culture "by leadership and example" to "be an advocate for the arts" (Sec. 16, p. 1) but it remains to be seen whether hard-nosed ministers will find it worth their while to do so.

The other problem lies in how much direction the government ought to give an arm's length granting body. The Macaulay Report seems to favor no direction. The OAC, if it gets its extra funding, is to use complete discretion as to its distribution. There is nothing to prevent the

OAC from continuing to distribute its largesse as broadly and as thinly as it has in the past. Macaulay counts on it "to make those difficult but necessary decisions for which it was established," even though it has not done so in the past. Why can one assume that the Council will do so in the future?

CONCLUSION

Support of the arts does not fit easily into the procedures of a democratic state. The debate over the big versus the many has some parallels with similar controversies in the United States between elitist and populist views on arts funding (Wyszomirski 1982). Similarly in Britain, where the Big Four national companies get 40 percent of the Arts Council's grant for England, British populists argue that this leaves little remaining for the non-London, nonprestigious, smaller companies. The Big Four were given a boost, when a time-and-motion expert, appointed by Mrs. Thatcher's office, put the Royal Opera House under close scrutiny and found it to be quite an efficient operation. The report even recommended a larger subsidy, but, unlike the Ontario Macaulay Report, suggested that the national companies be funded directly by the government. That in turn provoked a rousing defense of the arm's length from friends of the Arts Council of Great Britain (Economist 1983).

The arm's length debate is perhaps couched too simply as one alternative or the other. A Canadian Royal Commission on Financial Management and Accountability (Canada, Royal Commission 1979) concluded that, with any independent government agency, general issues of policy, such as the re-ordering of priorities "are matters for which the Government and Parliament must accept responsibility. They cannot be left to be settled at the discretion of the agency, no matter how independent it is intended to be. . . . The concept of political directives is not antithetical to the concept of Independent Deciding and Advisory Bodies," provided they are public and do "not pertain to specific individual cases . . . but to broad policy matters" (see Recommendation 18.5). Nevertheless, the chairman of the Canada Council rejected this, calling it not accountability but "dirigisme" (Canada, Canada Council 1978-79). But surely it is nonsensical to suggest

that arts councils should be free of all political direction.
That is not what democracy is about. Government can set
guidelines for the awarding of grants without interfering
in individual grant decisions. The record of the OAC
suggests that guidelines would benefit arts institutions, if
the guidelines resulted in more equitable and predictable
funding from year to year. It is the variability of gov-
ernment grants that causes arts administrators their big-
gest headaches. They prefer funding schemes which link
government grants to an arts organization's own success
at raising revenues through box office or private donations.
Alberta Culture has what is probably the most highly re-
garded program in Canada. It offers assistance "up to
25% of the previous year's eligible operating expenditures
matching dollar-for-dollar non-government net fund raising
revenues received by the organization" (Usher 1981). The
problem with such a formula, however, is that it can be
too rigid, leaving no discretion to an arts council. Per-
haps the answer is to guarantee a minimum grant, related
to an organization's revenue-producing ability, to any
arts organization that, in the arts council's view, is
artistically meritorious. The arts council could then
award additional funds to organizations with special prob-
lems or needs.

Government guidelines for arts councils would also
help to alleviate the accountability problem, if that were
coupled with giving legislatures a real opportunity to ex-
amine the operations of ministries of culture and their arts
council. At the present time in Ontario for example, the
Standing Committee on Social Development spends just eight
hours a year examining the estimates of the Ministry of
Citizenship and Culture. That makes a mockery of the
accountability process and stands in stark contrast to the
British Education, Science and Arts Committee of the House
of Commons, which wrote an impressive report on "Public
and Private Funding of the Arts" (United Kingdom, House
of Commons 1982). It was the product of two years of
work and of evidence received from over 200 individuals
and organizations. The report was very sympathetic to
the financial problems of the arts in Britain and concluded
that "in terms of international comparisons British arts
organizations are irresponsibly underfunded."

The British experience would suggest that Canadian
arts organizations have little to fear from closer parlia-
mentary scrutiny. Judging by attendance, the arts are as

popular with Canadian voters as they are almost anywhere
(see for example the comparison between Ontario and
Baden-Wurttenberg in Wearing 1983a). Putting the arts
into the political process might also put the elitist-populist
controversy into some perspective, since it is the suppos-
edly elitist institutions which appear to be the most
popular.

NOTE

1. It should be noted that, although Parliament
has to approve these estimates in the form of spending
appropriations, we are talking about a parliamentary sys-
tem where the cabinet clearly dominates. Unlike the U.S.
Congressional system, where government spending proposals
are frequently altered by Congress, it is extremely rare
for the Canadian Parliament (or a provincial legislature)
to alter the dollar amounts (which anyway, according to
Canadian law, can only be decreased). Lobbying on be-
half of the Canada Council's appropriation has to be
directed at the cabinet. MPs are useful allies, but they
are by no means the independent actors that congressmen
are.

BIBLIOGRAPHY

Baumol, William J., and William G. Bowen. 1966. Per-
 forming Arts, The Economic Dilemma. Cambridge,
 Mass.: MIT Press.

Canada. Canada Council. 1978–79; 1982–83. Annual Re-
 port. Ottawa: Canada Council.

Canada. Federal Cultural Policy Review Committee. 1982.
 Report. Applebaum-Hébert Committee. Ottawa: In-
 formation Services, Department of Communications,
 Government of Canada.

Canada. Royal Commission on Financial Management and
 Accountability. 1979. Final Report. Ottawa: Min-
 istry of Supply and Services.

Canada. Royal Commission on National Development in the Arts, Letters, and Sciences, 1949–1951. 1951. Report. Massey–Lévesque Commission. Ottawa: King's Printer.

Canada. Statistics Canada. 1983. Culture Statistics: Government expenditures on culture in Canada, 1979–1980 and 1980–1981. Ottawa: Minister of Supply and Services, Canada.

Conlogue, Ray. 1983. "Hey buddy, can you spare $2-million?" Globe Mail, September 10, Entertainment, 7.

The Economist. 1983. "Music to their ears," October 8, 50.

Edinborough, Arnold. 1979. "Something new in campaigning: Talk about our cultural policies." Financial Post, May 19, 40.

Fulford, Robert. 1983. "Plenty of Nothing." Saturday Night, February, 3–4, 7.

Lower, A. R. M. 1952. "The Massey Report." Canadian Banker (Winter):22–32.

Macaulay. Special Committee for the Arts. 1984. Report to the Honourable Susan Fish, The Minister of Citizenship and Culture. Ontario: Ministry of Citizenship and Culture.

MacSkimming, Roy. 1983. For Arts' Sake: A History of the Ontario Arts Council, 1963–1983. Toronto: Ontario Arts Council.

Minihan, Janet. 1977. The Nationalisation of Culture: the Development of state subsidies to the arts in Great Britain. London: H. Hamilton.

Mulcahy, Kevin V., and C. Richard Swaim, eds. 1982. Public Policy and the Arts. Boulder, Colo.: Westview Press.

New York. New York State Council on the Arts. 1982–83. Funding Report.

Ontario. Ontario Arts Council. 1982–83. Annual Report. Toronto.

Ostry, Bernard. 1978. The Cultural Connection. Toronto: McClelland and Stewart.

Presidents. 1982. (Canadian Opera Company, National Ballet of Canada, Shaw Festival, Stratford Shakespearean Festival, Toronto Arts Productions, Toronto Symphony). Letter to Arthur Gelber, Chairman, Ontario Arts Council, October 27.

Roberts, John. 1979. "Statement on Cultural Policy by the Honourable John Roberts, Secretary of State, to the Canadian Conference on the Arts," May 4.

United Kingdom. Arts Council of Great Britain. 1982–83. Thirty-eighth Annual Report and Accounts. London: Arts Council of Great Britain.

United Kingdom. House of Commons. Eighth Report from the Education, Science, and Arts Committee, Session 1981–82, October 18, 1982. London: Her Majesty's Stationery Office.

United States. National Endowment for the Arts. 1982–83. Annual Report. Washington, D.C.

Usher, C. Les. 1981. "Financing of the Arts in Alberta: A Study." Edmonton: Alberta Culture.

Wearing, Joseph. 1983a. "Funding the Arts: A Cross National Perspective." Paper presented at the 25th Annual Conference of the Western Social Science Association, Albuquerque, New Mexico, April 29.

_____. 1983b. "Appropriate Areas for Government Involvement in the Arts in the 1980's" in Ontario. Papers Commissioned by the Special Committee for the Arts, 1983–1984, 58–76.

_____. 1983c. "Financing the Arts in Ontario," in Ontario. Papers Commissioned by the Special Committee on the Arts, 1983–1984, 77–93.

White, Eric W. 1975. The Arts Council of Great Britain. London: Davis-Poynter.

Wyszomirski, Margaret Jane. 1982. "Controversies in Arts Policymaking." In Public Policy and the Arts, edited by Kevin V. Mulcahy and C. Richard Swaim, 11-31. Boulder, Colo.: Westview Press.

V

CONCLUSION

John Adams spoke of his obligation "to study politics and war" so that future generations would have "the right to study painting, poetry, music, architecture. . . ." This volume might be seen as following a reverse progression: the sociological study of the workings and context of individual artists facilitates a better understanding of arts institutions, fields, and audiences, which in turn informs and explains political decisions and public policies regarding the arts.

While each of the foregoing papers stands alone, each has also been enriched by, and provided enrichment to, its predecessors and successors--both those of each section and those of the entire collection. Together, they demonstrate that the practical and ideological workings of individual artists and arts institutions need to be fully appreciated when, as "social actors," they compete against others in the field for audience support. In turn, they suggest that if political decisions are, at best, to foster the arts and preserve our cultural heritage and, at least, to "do no harm," then they must pursue agreed upon and informed goals.

Thus, sociology can help to ground political science, while, conversely, discussions of public policy issues have helped to establish a broader significance for the sociological phenomena and their analysis. Such intellectual collaborations have become familiar regarding other areas of social affairs, for example, educational policy, urban affairs, and civil rights. But such interdisciplinary cross-fertilization is relatively new in the area of cultural affairs. Adapting such a broad perspective requires both comprehensiveness and specificity in explanation and analysis, both of which have been, in our view, too frequently absent from other and earlier works which have tended to focus on only a part of the whole, whether that part be the production, the character, or the consumption of culture, or the enactment, administration, or consequences of arts policies.

In contrast, we believe that the papers, as or-
ganized here, have demonstrated some of the variety of
the social uses and functions of the arts. Accordingly,
they have, though hardly exhaustively, presented empiri-
cal examples indicative of the precarious and ever-changing
character of arts support (both public and private), and
identified the major political issues and interests involved
in the relation of art and government in the United States
(as well as suggesting that these concerns and patterns
are not unique to this socio-political system, but are also
characteristic of other countries, such as Canada).

Additionally, throughout the progression of papers
presented here, four themes, often only implicit, can be
discerned. First, from the evidence presented here (and
elsewhere) it is obvious that the arts and the responses
they evoke are ideologically colored, both aesthetically
and politically. Thus, aesthetic ideologies manifested in
art styles (both reacted and performed) and in the tastes
(of consuming patrons or audiences) embody beliefs about
the nature, function, and value of the arts in general as
well as about specific art forms and artworks. Similarly,
broader, nonaesthetic political ideologies may involve atti-
tudes not only about the valid functions and activities of
government or the utility and value of the arts, but also
attitudes concerning the "proper" interrelationship of gov-
ernment and art, and the character of the shared obliga-
tion of the public and private spheres to support the arts.
Therefore, since the production, consumption, reaction to,
and funding of the arts inherently involve a compounding
of aesthetic and political ideological elements, any consid-
erations of art and of arts policy (even overtly nonpoliti-
cal inquiries) tend to become, in practice, politically con-
troversial. To be sure, in this regard art policy resem-
bles other public policy concerns that are, perhaps, more
commonly perceived as ideological (for example, abortion,
civil rights, economic redistribution). Still, with the
arts, as elsewhere, ideological components tend to evoke
passions and sometimes unrecognized class interests, and,
in turn, to generate heated debate.

This volume demonstrates that art and politics in-
volve ideological choices, not between more or less "purity"
or "ideological innocence," but rather between one ideology
and another. As noted in the introduction, and as dis-
cussed implicitly and explicitly throughout, there is no
such thing as "art for art's sake." If the arts were not

socially meaningful, they would have little use or interpre-
tation. Hence, they would not be politically effective. The
arts can both support tradition and the status quo or help
to promote change. By providing spheres of fantasy, play,
escape, or release from social structures and restrictions,
the arts can facilitate social change. Yet as disciplined
(and hence repeatable or collectible) forms of individual
and social activity, even avant-garde forms can become
institutionalized, and thus enhance tradition.

Either way, the arts facilitate social cohesion by
"putting form on intuition" so that individual, often inar-
ticulate, experience can be made manifest and shared with
others. So expressed and shared, once-private troubles
can become motivations for groups to act to change their
society or, conversely, to stabilize chaotic elements, either
of which can choose to then employ explicitly political
processes. But such processes and uses must be examined
on a case-by-case empirical bais, if they are to be under-
stood and, in turn, replicated.

This leads into our second theme: the arts, their
ideological interpretations, and the public policies that
affect them are both influenced by and have impacts far
beyond the "worlds" of artists and arts audiences. While
census data and other surveys indicate that only about 10
percent of the American public can be directly included in
these "art worlds," the ideas that this minority absorbs
are perpetuated and acted out in the wider society. If
divisions premised on class, race, or ethnicity can be
eroded through the arts, then the effects will be felt by
those whose own self-definitions are being thus redefined,
even if they are artistically uninvolved.

Conversely, if subcultural boundaries can be ce-
mented by arts too "authentic" and specialized in appeal
to be attractive to outsiders, the consequences will be ex-
perienced by both insiders and outsiders as well as in
fields far removed from the arts. Even those who are
quite disinterested in the arts, or who have their tastes
satisfied by forms of commercialized popular culture through
television and radio, find their lives affected by the
changes, or stabilizing effects, wrought by art world par-
ticipants. If for no other reason, the ideological and
political aspects of the arts must be considered with ut-
most seriousness.

A third theme runs through most of the papers in
this volume. In opposition to the generalizability of the

arts and the potential cultural and political significance of these shared experiences and perceptions, there is an emphasis on the individuality of, and the importance of individuals to the development and fortunes of, specific art forms, art institutions, public art agencies, and public policy and the arts in general. Thus, in Part II, for example, Rosenblum and Bodinger-deUriarte have discussed the impact and strategies of individual artists seeking to enhance their ability to successfully practice their arts. DiMaggio and Stenberg demonstrated how the artistic decisions of particular resident theatre companies (and thus, within these of individual personnel), have a cumulative effect on the vitality and diversity of regional as well as national theatre in the United States. In turn, most of the papers in Part III suggest various ways in which the styles, strategies, and reception of individual artists, art products, and art groups respond to and, in turn, influence broader social currents. Particularly in the piece by Wyszomirski and Balfe, the actions of an individual artistic director are explored as having an impact on the fortunes of his company, as influencing and being influenced by audience preferences and, as an example of how the interaction of artist, arts organization, and audience can, in the long run, have an impact on the preservation and presentation of particular artworks and of a particular art form. Finally, many of the papers in Part IV demonstrate the importance of individual politicians and administrators, ranging from the president or prime minister of a country, through individual legislators, to the heads of art agencies or ministries.

This progression brings our analysis back through the micro and the macro levels, to return full circle. Artists and politicians must operate within an existing context that can facilitate or impede the character and acceptance of their actions. In turn, the actions of individuals have an effect on the very situation in which these occur and leave a legacy for subsequent artists and policy makers.

Accordingly, our fourth theme demonstrates that the consequences of any artistic activity, or program designed to promote or inhibit one or another form of it, cannot be fully anticipated. We can explain the evolution of art forms and arts institutions or public policies, after the fact. Somewhat more tentatively, we can examine the processes of their evolution as it is occurring. Like artists themselves, we can learn from our own experience. From

the history of the actions, policies, and results of others
we may, as Santayana advised, learn not to repeat the
mistakes of our predecessors.

The past can provide some guides from the past as
to what to do next, primarily by providing negative exam-
ples of what not to do next. Yet by the time our prac-
tices or policies are in effect, the broader situation is
likely to have changed sufficiently to undermine the valid-
ity of such precedents. Thus, to be successful as social
analysts of the arts or as a public policy maker affecting
them, one must be more than a sociologist or political
scientist. One must also be something of an artist, inte-
grating creativity and intuition with skill and knowledge.
Additionally, having acknowledged the uncertainties of our
changing social, political, and economic context, one must
also be lucky, if one's actions or analyses are to be
viewed as being successful.

In our case, the analytical and political scope of
this volume has been wide. Still we realize that a num-
ber of topics have not been addressed and many issues
have not been raised. Except in passing, we have scarcely
considered the arts audience, either its general composi-
tion, its variation from one art form to another, or issues
of audience building, audience support, or the impact on
art products and art organizations of appealing to a
"mass" audience.

Nor have we discussed the many and varied aspects
and patterns of patronage, whether public, corporate, or
individual. As for the first of these, while Townsend,
Larson, and Mulcahy discuss elements of federal arts pa-
tronage at different times during the twentieth century,
each is looking at only a part of the federal patronage
picture. There were other New Deal arts projects and
programs, just as there are today other agencies and pro-
grams that support the arts, including, for example, the
National Endowment for the Humanities, the Corporation for
Public Broadcasting, the Art-in-Architecture Program of the
General Services Administration, or the ArtsAmerica Pro-
gram of the U.S. Information Agency. In addition, no one
has discussed at length those institutions that are directly
administered by the federal government, such as the
Smithsonian Institution or the National Gallery.

Below the national level, public patronage exists
and has had a long and varied history. Most major cities
support museums and cultural facilities of various types.

During the past 20 years, state arts councils have prolif-
erated and developed into important and influential ele-
ments of the public patronage system, but have been men-
tioned only briefly in this volume.

While direct methods of public support for the arts
have been the focus of concern here, this has left unexam-
ined the many indirect ways and means by which public
policy has affected and, at times, supported the arts. For
example, the postal system accords arts organizations spe-
cial, discounted rates that amount to an implicit public
subsidy. Laws concerning copyright and social security
coverage, as well as labor and zoning regulations, all
have an effect on the arts in the United States but none
of these subjects has been examined here. More important,
state, local, and federal tax systems have been used to
exempt cultural (as well as other charitable and philan-
thropic institutions) from property, sales, and income tax
liabilities since the founding of the Republic. The federal
income tax system also seeks to stimulate private support
for these activities by according tax advantages to indi-
viduals and corporations that make contributions, both of
which are crucial patronage sources that we have not here
discussed.

In a more sociological vein, there are numerous
topics that have not been considered. For example, the
critical role of various types of "gatekeepers" such as
curators, gallery owners, impresarios, or critics has only
been glimpsed in a few segments of this book. Each kind
of gatekeeper merits further study, to say nothing of com-
paring the functions, styles, and impacts of each across
different art forms.

Other largely untouched sociological areas include
the issue of center versus periphery, both in terms of arts
institutions, innovative styles and practices, and matters
of geographic or class mobility. The discussion here of
jazz and ballet merely suggests the richness of this area
of sociology of the arts, and the organizational and politi-
cal ramifications that come in turn. On issues relating to
social control over the arts, we have scarcely touched di-
rectly on the generally accepted antagonism between
managerial/bureaucratic practice and artistic practice--
between rules to be followed according to the book and
rules to be broken and books yet to be written. Addition-
ally, much remains to be said about the arts and social
control over others, a thorny question that inevitably in-
volves issues not merely of arts patronage and management,
or of artistic form and content, but also those of aesthetic

quality. Here the social scientist, perhaps rightly, sur-
renders the field to those more schooled in the arts them-
selves.

Even among the inherently social (and hence social
scientifically approachable) aspects of the arts, the indi-
vidual studies in this book have only incompletely sampled
the sociology, politics, and ideologies of the various art
forms, as arts. Although a cross section of fine and folk
art forms has been discussed, not all art forms have
been the subject of extended analysis here. For example,
among the fine performing arts, aspects of dance and the-
atre have been examined, but there has been little, if any-
thing, on opera or orchestra and chamber music. While
free-lance and jazz musicians, painters, and sculptors
have been included in other pieces, vocalists, actors, di-
rectors, designers, and other kinds of artists have not.
Little attention has been given to the creative and literary
artists (composers, playwrights, choreographers, poets, or
writers) as opposed to the performing artist. Although
one piece dealt with community art centers, no one has
examined national art centers such as the Lincoln or Ken-
nedy Center. Nor have we looked at arts festivals or
summer arts centers such as Spoleto USA, Tanglewood, Sara-
toga, or the Newport Jazz Festival.

Finally, although most of the pieces in this volume
have been concerned with nonprofit art and art institutions,
there is an entire universe of commercial art activity that
remains to be considered and compared with the nonprofit
variant. Broadway and musical theatre; recorded popular,
country, and rock music; commercial film and television;
popular dance from disco and break to folk and ballroom;
graphic art; fashion, furniture, and architectural design—
all these are other faces of art activity in the United
States, that because of their very profitability and self-
sufficiency have usually been treated differently by public
policy and by policy makers. Yet, in contrast, many so-
cial scientists and artists see nonprofit and for-profit arts
activities as forming a continuum rather than being dichot-
omous.

Still, the identification of such a wealth of topics,
each with its artistic, ideological, and political facets,
though untreated here, does not detract from the breadth
of this volume. It merely points the way to future re-
search agendas and, hopefully, will whet the appetite of
readers, scholars, artists, arts administrators, and policy
makers to know and understand more about the interaction
and relationship of art, ideology, and politics.

ABOUT THE EDITORS AND
THE CONTRIBUTORS

JUDITH HUGGINS BALFE is Lecturer in Sociology at Rutgers University, where she teaches a course on the sociology of the arts. Originally trained as an art historian and after a decade of work in art museums, she wrote her sociology dissertation on the social meanings of abstract art. She has published a number of articles on the sociology of art, and is currently working on a book on the social locations and patterns of the institutionalization of Realism and Abstraction in twentieth-century American art. Together with Margaret Wyszomirski, she chaired the 1983 conference on Social Theory, Politics, and the Arts, from which many of these papers were collected. They also cochaired the subsequent 1984 conference, held at the University of Maryland.

MARGARET JANE WYSZOMIRSKI is on the faculty of the Government Department of Georgetown University and of the Cornell University Public Policy Program in Washington, D.C. and regularly teaches a seminar on "The State and the Arts." Her interest in the arts has resulted in various papers, articles, and chapters on arts policy and politics, as well as activities as president and dramaturgist for a civic ballet company, as a dance auditor for the New York State Arts Council, as a financial/administrative panel member for the New Jersey State Arts Council, and as a Management Fellow in the Evaluation Division of the National Endowment for the Arts. She has also written on the subject of presidential advisory organizations and is working on a book-length study of presidential personnel from Roosevelt to Reagan.

LARS BJÖRN is Associate Professor of Sociology at the University of Michigan in Dearborn. He is working on a project on the social history of jazz in Detroit. He has also published work on women auto-workers and comparative redistributive politics.

CRISTINA BODINGER-DeURIARTE has been a Teaching Fellow in the Department of Sociology at Harvard University and taught courses in the sociology of music and in popular culture at the University of California at San Diego. She has worked for two major social science research institutions, and has done studies on artificial intelligence.

TERRI LYNN CORNWELL is a Ph.D. candidate in Public Communications at the University of Maryland and holds graduate degrees in music and theatre. Since 1981 she has been Legislative Director of the Congressional Arts Caucus in the U.S. House of Representatives.

PAUL DIMAGGIO is Executive Director of the Yale University Program on Non-Profit Organizations and Associate Professor of Sociology in the Institution for Social and Policy Studies and School of Organization and Management. He has written on the sociology of culture and on cultural policy for a variety of journals and is preparing a book manuscript on the social organization of high culture in the United States.

LINDA MARIE FRITSCHNER is an Associate Professor of Sociology at Indiana University, South Bend. At present she is studying the social structure of literary communities in England between 1890 and 1920.

HERBERT J. GANS is Professor of Sociology at Columbia University. His most recent books are an updated and expanded edition of The Urban Villagers (Free Press 1982) and Deciding What's News (Pantheon Books 1979). He is currently working on a book about work sharing and related policies against unemployment, and beginning a study about the impact of the news media on politics.

MILES K. HOFFMAN is the Vice-President of a market research corporation and a member of the adjunct faculty in Political Science and Sociology at Indiana University, South Bend.

MICHAEL S. KIMMEL is Assistant Professor of Sociology at Rutgers University. After completing a structural analysis of revolution in seventeenth-century Europe, he is currently working on a comparative analysis of liberatory social movements. He is also beginning a study of the social construction of masculinity in late nineteenth-century America.

GARY O. LARSON is the National Council Coordinator of the National Endowment for the Arts. He holds a Ph.D. from The University of Minnesota in American Studies and is the author of The Reluctant Patron, The United States Government and the Arts, 1943-1965.

WILSON CAREY McWILLIAMS teaches political science at Rutgers University. He is author of The Idea of Fraternity in America (1973) and is Contributing Editor of Worldview, a journal of religion and international affairs.

GENE METCALF is Associate Professor of Interdisciplinary Studies at Miami University in Oxford, Ohio. He is presently an NEH Fellow at Winterthur doing research on folk art.

KEVIN V. MULCAHY is Director of the Institute for Government Research at Louisiana State University in Baton Rouge. The author of numerous publications on the arts, he is also co-editor of Public Policy and the Arts, has been co-chairman of the Fine Arts Advisory Committee of the Louisiana House of Representatives, a member of the Governor's Conference on the Arts and Humanities, and has served on advisory panels for various public art agencies. He is also the co-author of America Votes, and the forthcoming President and Foreign Policy-making and White House Government.

RICHARD A. PETERSON is Professor and Chair of the Sociology Department at Vanderbilt University. An industrial sociologist, for the last decade he has focused his research on the cultural industries, exploring both the production and consumption of the arts and culture.

BARBARA ROSENBLUM is Associate Professor and Director, Graduate Program of Vermont College, San Francisco Regional Office. She has written in the area of sociology of art and culture. Her book, Photographers at Work (1978), examined social-organizational determinants of three photographic styles. She is now researching and writing on alienation among artists.

KRISTEN STENBERG is an Associate in Research at the Yale University Program on Non-Profit Organizations. She has been extensively involved in empirical research on arts organizations and on the managers and staff of art museums, symphony orchestras, resident theatres, and local arts agencies.

HELEN TOWNSEND is Social Planner for the city of Charlottesville, Virginia, where she is currently engaged in a study of the effects of established patterns of education and employment on race relations in the city. She is completing her dissertation on the WPA Federal Art Project at Vanderbilt University and is writing and developing other research in the sociology of art.

JOSEPH WEARING holds degrees in politics, economics, and music from Western Ontario, Toronto, and Oxford Universities. He is Professor of Political Studies at Trent University, Peterborough, Ontario, and is the author of a book on the Liberal Party of Canada, The L-Shaped Party.